The Gallery Companion

Understanding Western Art

The
Gallery Companion

Understanding Western Art

Marcus Lodwick

Thames & Hudson

Contents

First published in the United Kingdom in 2002 by Thames & Hudson Ltd, 181A High Holborn, London WC1V 7QX

British Library Cataloguing-in-Publication Data. A catalogue record for this book is available from the British Library.

ISBN: 978-0-500-28358-5
Printed and bound in Singapore

To find out about all our publications, please visit www.thamesandhudson.com. There you can subscribe to our e-newsletter, browse or download our current catalogue, and buy any titles that are in print.

INTRODUCTION

'Every picture tells a story' but for most visitors to art galleries the tales depicted in many of the world's great paintings are a mystery. Admittedly a painting can be admired for its composition, colour or the painter's technical skill, but for character-based paintings, a knowledge of the subject matter is fundamental to a full appreciation of the picture.

For many centuries, artists have drawn their inspiration from the rich pool of biblical and classical stories that

were, for much of the last millennium, as familiar as today's TV soap storylines or popular films. The mythical, historical and religious dramas that are portrayed on canvases are often just as gripping, tense and emotionally moving as the modern-day counterparts. However, for most people these stories are either distant memories from school days or a complete mystery. The aim of this book is to help make sense of some of Western art's greatest pictures.

In 153 entries, concise background stories are supplied to characters drawn from Greek and Roman myth and history, as well as from the Bible and Christian history. Drawing upon the European and North American painted art of the past 800 years, each entry is accompanied by a representative painting which either depicts one main event or, and often additionally, illustrates some of the symbols or attributes commonly associated in art with the characters shown. The comprehensive text covers the other major scenes in which the

▼ *The Arrival of Aeneas in Italy* by Claude Lorraine is a breathtaking landscape, but who was Aeneas and why was his arrival in Italy important?

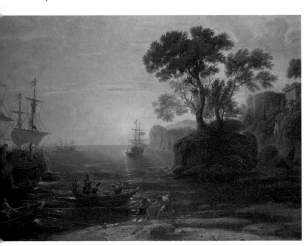

	2000 BC	1900 BC	1800 BC	1700 BC	1600 BC	1500 BC
HISTORY				1st Babylonian Empire (intermittent) (1760–1150)		
	Time of Abraham *c.*2000					
	Minoan civilization (Europe's first) on Crete (2000–1450)					
	Mycenean civilization in Greece (2000–1150)					
ART	Minoan art (2000–1450)					
	Mycenean art (2000–1150)					

characters are commonly depicted, as well as explaining the meaning of some of the more obscure symbols. Separate coloured boxes clearly list these symbols, so important for character identification, while also cataloguing just some of the famous paintings in which each character appears.

Given this book's premise, the main criterion for a character's inclusion was for him or her to be widely represented in painted art rather than being merely well-known or historically important. So, for instance, Joshua, Plato and Nero are absent. Even allowing for this, the final selection of entries from so vast a cast list was a difficult task. Just as it became apparent that many worthy figures would have to be excluded, it was equally obvious that Jesus Christ and the Virgin Mary, both painted more than any other subjects in art, required multiple entries for the different stages of their lives. In a similar vein, Arcadia, a geographical region, required an entry as an important classical subject.

To maintain a coherence throughout, it seemed appropriate to place all the classical characters into a single alphabetically arranged section and biblical/religious figures into another.

▲ Mythical creatures, like the Minotaur above, have haunted the imagination of many artists, authors and audiences.

The result is an A to Z of classical characters and biblical/religious figures whose stories have proved inspirational for artists; this book provides easy-to-access, concise, and relevant information for anyone interested in art.

1400 BC	1300 BC	1200 BC	1100 BC	1000 BC	900 BC	800 BC

Time of Moses c.1300 Assyrian Empire (1150–600)

Jerusalem capital of ancient Israel c.1000

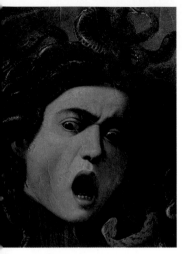

▲ The snaky-haired Gorgon, Medusa, as portrayed by Caravaggio – one of the many world-renowned artists whose work is illustrated in this book.

▶ Was Raphael the first to portray the three Graces in their typical triple-pose?

Classical Characters

The characters in the classical section include gods, mythical humans (from heroic warriors to victimized women), mythical creatures, and historical persons, all drawn from the civilizations of ancient Greece and Rome. Each of these four categories is indicated by a separate icon placed at the top of each entry to help the reader quickly place the characters within their basic contexts.

In the field of Classics, characters often have up to three main versions of their names – Greek, Latin, and English (usually anglicized Latin) – each sometimes spelled in a variety of ways. In this instance the anglicized Latin names have been used, not only because they are the most familiar to many English readers but also because they are derived from the Latin names

that are the basis of many Western paintings.

The variation in many classical names and the diversity in their spelling stems from the fact that many of the classical gods and mythical characters were Greek in origin with names naturally spelled in the Greek alphabet. When the Romans started 'importing' Greek culture (in art, architecture, myth, literature and so on) into their society, Greek names had to be changed into the Roman Latin alphabet (the basis of the English alphabet). This change, or transliteration as it is technically known, is sometimes

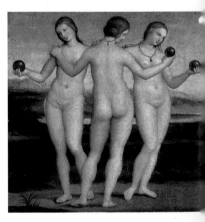

	700 BC	600 BC	500 BC	400 BC	300 BC	200 BC
HISTORY	Rome founded 753		Roman Republic (510–27)			
			Jews exiled to Babylon (586–539)			
	Assyrian empire ends		Persian Empire (557–331)			
		2nd Babylonian Empire (626–539)			Alexander the Great dies 323	
ART	Greek Archaic (700–480)			Greek Classical (480–323)	Greek Hellenistic (323–60)	
	Homer and Hesiod active *c.*700					

slight (e.g. Helene →
Helena; Patroklos →
Patroclus), sometimes
more radical (e.g.
Herakles → Hercules).

However, in the case
of gods and goddesses,
there is a further
complication, for the
Romans did not replace
wholesale their own long-
established deities with
Greek ones. Rather, over a
period of undocumented time, the
Romans saw which of their own
deities – generally shapeless 'spirits' of
nature – presided over the same spheres
of influence as a particular Greek deity,
and then grafted onto their Roman god
various aspects that belonged to the
similar Greek god. Such adopted aspects
included the visualization of their gods
in a human shape, their lives and
genealogies, their attributes and their
mythology. However, the Romans
retained the original names of their
Roman gods. Thus Venus, the Roman
spirit of fertility and procreation was
seen to be similar to Aphrodite, the
beautiful Greek goddess of love; Venus

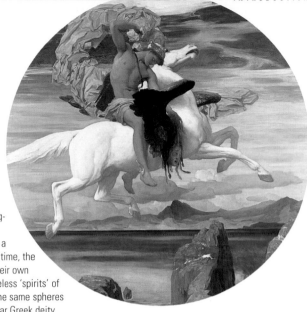

kept her Roman name but was given all
of Aphrodite's Greek attributes and
mythological 'baggage'.

To reflect the substantial differences
between the names of the classical
Olympian gods, and the fact that they
are often known by either name, this
book provides the god's Roman name
followed by the Greek equivalent in the
main title of each relevant entry – e.g.
Bacchus/ Dionysus.

▲ Lord
Frederick
Leighton may
have been one
of the great
artists of the
Victorian age
but did Perseus
ever ride upon
the winged
horse Pegasus?

100 BC	50 BC	0	50 AD	100 AD	200 AD	300 AD

Julius Caesar assassinated 44 BC

Jesus Christ crucified c.30 AD

Roman Empire legalizes Christianity 313

Destruction of Pompeii 79

Roman Empire (27 BC–476 AD)

Romans take Jerusalem 70

Roman Imperial 27 BC–476 AD

Virgil active c.40 BC

Coloseum dedicated in Rome 80

▶ The sign INRI was placed on the cross of Jesus Christ – but what does it stand for?

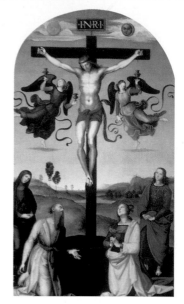

Biblical and Religious Characters

The characters in this section are drawn from the Bible's Old and New Testaments, the Apocrypha, which is part of only some Christian Bibles, and early and medieval Christian saints, both legendary and historical. Limitations of space curtailed the selection of the seemingly innumerable saints that I could include, and I am all too aware that not all of Jesus' core twelve disciples are given a separate entry. I can only apologise for omissions in what had to be, in the end, a personal selection, albeit based on the criterion of the character's popularity as an artistic subject.

The characters, somewhat coincidentally, are almost equally divided between the Old Testament, the New Testament, and post-biblical saints. Each of these three main categories is also represented by an icon placed at the top of each entry to help the reader quickly place the characters within their basic context.

▶ The 'writing on the wall' for Belshazzar in Rembrandt's famous painting.

Attributes

People in paintings – especially religious paintings of saints – can often be identified by the particular 'attributes' or symbols that each may hold, wear, or be near. These are nearly always linked to

		400 AD	500 AD	600 AD	700 AD	800 AD	900 AD
HISTORY	Constantinople becomes capital of Roman Empire 330						
	Byzantine or Eastern Roman Empire (330–1453)						
				St. Augustine of Canterbury brings Christianity to Britain c.597			
ART	Byzantine (330–1453)						

▶ St. Catherine leans on a spiked wheel, the intended instrument of her martyrdom.

episodes from the person's life-story or to the form or derivation of his or her name; sometimes an attribute can even extend to a character's behaviour. The use of symbols was especially important for saints in medieval times, when the cult of the saint was at its height in Europe, and many ordinary people were illiterate. Thus the spiked wheel immediately identifies Catherine of Alexandria whose execution by such a device was miraculously prevented. More complex attributes can include the colours of the Virgin's clothes or, in Christian paintings, the symbolic allusion of an apple to man's fall from innocence in the Garden of Eden and Christ's redemption of man.

To avoid constant repetition, two attributes common to many Christian characters have not been recurrently listed, but are noted here. The halo or nimbus – a disc or circle of light surrounding the head of a divine or sanctified person – was used originally in depictions of the classical sun-gods Helios and Apollo, and later adopted by Roman emperors. The halo first appears in Christian art around the fifth century AD, and is used especially for Jesus, the Virgin Mary, angels and saints. The martyr's palm leaf – originally a classical symbol of victory and fame – was adopted by early Christians to represent Christian victory over death. It became the particular attribute of all Christian martyrs, people who died for their faith.

Classical characters also have their symbols although they are not as ubiquitous as with Christian figures. Certainly a lionskin cloak and a large wooden club would identify Hercules, while an eagle and a lightning bolt are Jupiter's special attributes as king of the gods.

Each character's attributes are listed in a separate highlighted box and may also be referred to in the text together with a fuller explanation of their significance.

1000 AD	1100 AD	1200 AD	1300 AD	1400 AD	1500 AD	1600 AD
	1st Crusade 1098		Golden Legend *c.*1266			
				1st English Bible 1382		Beginning of Protestant Reformation 1517
					Columbus discovers Americas 1492	

Baroque (1600–1700)

Gothic (1220–1475)

Renaissance (1320–1520)

Mannerism (1520–80)

Bayeux Tapestry 1080

Michelangelo paints ceiling of Sistine Chapel, Vatican (1508–12)

► Ancient
trademarks: St.
Francis wears
his brown habit
tied with a
three-knotted
cord while
St. Andrew
carries his X-
shaped cross.

►► Mary
Magdalene
tries to touch
Jesus after his
Resurrection.
Why does Titian
depict her with
long hair and
holding a jar?

Golden Legend (*Legenda Aurea*)
compiled around 1266 by the Italian friar
Jacobus de Voragine. This was one of
the most widely read and copied
manuscripts of the Middle Ages and was
hugely influential upon much subsequent
religious art.

For classical references I have had to
be even more selective on account of
the numerous ancient works in which
the characters appear, but I have
endeavoured to include the main sources
and reference to any of the incidents
mentioned in the text. There is often no
single standard text or translation, and
space again prevents the listing of each
text I have used, so the line numbers
should not be taken as absolute but
rather as a rule of thumb.

References

For all biblical references, I have used
the book divisions and line numbers as
used in the *New English Bible*. While
trying to be as specific as possible, for
major figures it has naturally been
impossible to list all verse or chapter
references, in which case just the book
reference has been given. For most
Christian saints no reference is given but
I have been careful to preface any story
of doubtful authenticity with the word
'legendary' or some similar adjective. In
fact, the source for many saints' lives
and Church feasts is the medieval

		1700 AD	1800 AD	1900 AD	2000 AD
HISTORY			US Declaration of Independence 1776	Russian Revolution 1917	
				World War I	
			French	(1914–18)	
			Revolution		World War II
			1789		(1939–45)
ART		Rococo (c.1700–c.1800)			
			Neoclassicism	Impressionism (c.1860–c.1926)	
			(c.1750–c.1820)	Pre-Raphaelites (c.1848–c.1910)	
			Romanticism (c.1800–c.1850)	Symbolism (c.1885–c.1910)	

HOW TO USE THIS BOOK

This book is divided into two main sections of equal length, a Classical Characters section and a Biblical and Religious Characters section. The entry for each character or characters is composed of background text, a boxed panel, an icon and a representative painting in which the relevant character or characters appear in art.

The following icons are used in this book:

Text: The main text provides the background stories to the character(s) concerned, their symbols and attributes, and the way in which they are most frequently depicted in art. Cross references are denoted in bold.

Icon: The icon for each entry lets the reader know, at a glance, the broad category into which the character(s) fall. The categories are illustrated on the right.

Classical Characters

Gods

Mythical characters

Historical characters

Mythical creatures

Biblical and Religious Characters

Old Testament

New Testament

Post-biblical saints

Sample spread showing the St. Andrew and Angels and Archangels entries

References, Attributes and Major Paintings:
The boxed panel lists the main background textual references for the character(s) in question. This is followed by a list of attributes or symbols directly associated with the character(s). Finally, the panel lists a selection of paintings in which the characters appear. The painting depicted in the entry is indicated by a directional arrow before the painting's name. For each painting listed, the artist's name, the year(s) in which the painting was completed (if known), and the name and location of the gallery in which the painting is housed, are provided.

Abbreviations:
NYMet: Metropolitan Museum of Art, New York, USA.
NGL: National Gallery of London, England.
NGADC: National Gallery of Art, Washington DC, USA.

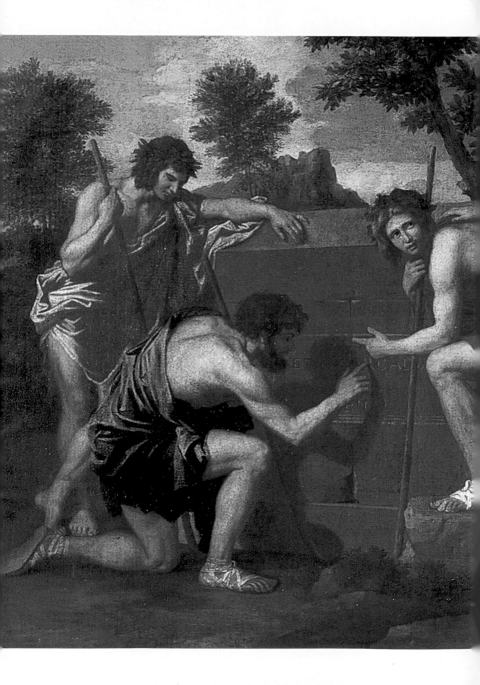

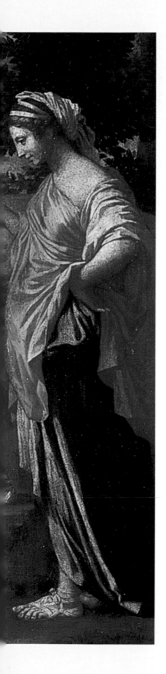

CLASSICAL CHARACTERS

The Olympian gods, legendary
humans, mythical creatures,
and historical figures from the
Greek and Roman civilizations.

Achilles

The greatest of the legendary Greek warriors

Achilles was the son of the sea **nymph** Thetis and the mortal Peleus. His mother tried to make him either immortal by holding him in a fire or invulnerable by dipping him into the River Styx in the Underworld whilst holding him by the ankle, which thus remained his only weak spot – his 'Achilles' heel'. Achilles was sent away to be brought up by Chiron, a wise and friendly **centaur** who taught him archery, music, medicine and other noble skills.

In a subsequent, rather strange episode – a favourite of post-classical artists – Thetis, aware that Achilles would die if he fought in the approaching Trojan War, disguised Achilles as a girl and sent him to live with the daughters of King Lycomedes of Scyros. This ruse was foiled by **Ulysses** who went to Scyros disguised as a merchant selling cloth. Among the cloth Ulysses had placed weapons and, as he had suspected, whilst the women were concerned with the pretty embroideries, Achilles instinctively picked up the weapons, thus giving himself away.

For ten years Achilles, along with the Greek forces, besieged the city of Troy to recover **Helen**, the wife of the King of Sparta, who had eloped with **Paris**, a Trojan prince. The final, tenth year is the subject of *The Iliad* of **Homer** whose first line and central theme is 'the wrath of Achilles'. This anger is directed at Agamemnon, the leader of the Greeks, who took for himself Achilles' beautiful girlfriend Briseis. Achilles retired to his tent sulking, refusing to fight. With increasing Greek losses, Agamemnon sent Ulysses, Ajax and the aged Phoenix to Achilles' tent to ask him to return, but to no avail.

The turning point in Achilles' attitude came when his great friend Patroclus, having borrowed Achilles' armour, was mistaken for him and killed by **Hector**. Grief-stricken, Achilles swore revenge and, after being brought a new set of armour by his mother Thetis, took to the battlefield. Achilles killed Hector and, tying the body to his chariot, dragged it round the walls of Troy and then round Patroclus' funeral pyre. Achilles only relented when Hector's father, King Priam of Troy, visited him and begged him to return his son's body; united in grief, the pair wept together.

Achilles was eventually shot in his vulnerable heel by Paris and died, his fame immortalized by poets and painters from Homer onwards.

Classical References:

Homer, *Iliad*; Apollodorus 3.13.8.

Attributes:

Arms and armour; chariot; pair of horses; bow; lyre.

Major Paintings:

▶ Regnault, Jean-Baptiste: **Education of Achilles in the Art of Hunting**, 1782, Louvre, Paris, France.

● Poussin, Nicolas: **Achilles and the Daughters of Lycomedes**, 1656, Museum of Fine Arts, Boston, Massachusetts, USA.

● Ingres, Jean-Auguste-Dominique: **The Ambassadors of Agamemnon in the Tent of Achilles**, 1801, Ecole des Beaux-Arts, Paris, France.

● West, Benjamin: **Thetis Bringing Armour to Achilles**, 1806, New Britain Museum of American Art, Connecticut, USA.

A youthful Achilles is instructed in archery by the wise centaur Chiron. The dead lion lying behind them symbolizes not only Achilles' prowess in hunting but also his daily diet of lion entrails designed to increase his courage and strength. Chiron also taught Achilles the more gentle, but no less important, art of music, as indicated by the lyre in the foreground.

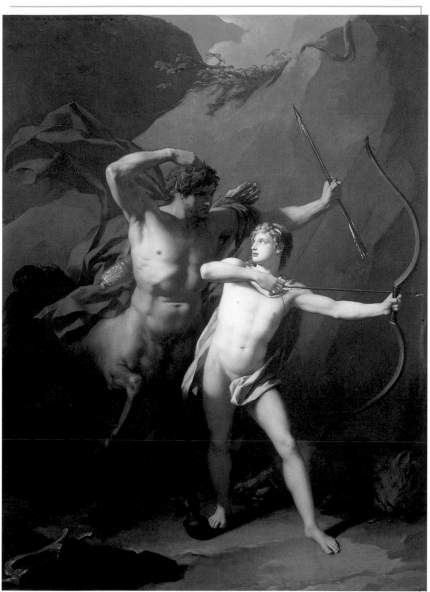

Actaeon
Greek mythological hunter

Actaeon was the grandson of Cadmus, King of Thebes, who, while out hunting with his hounds, unwittingly ventured into a wood sacred to **Diana**, goddess of the hunt. There he had the misfortune to come across Diana bathing in a spring, attended by her **nymphs**. The virgin goddess, ashamed and deeply offended at being seen naked by a man, threw water over Actaeon and changed him into a stag to ensure that he was unable to tell others that he had seen her in the flesh. Actaeon panicked and ran. Tragically, his own beloved dogs scented and chased him, finally dragging him down and savagely devouring him.

Although ancient poets give different reasons for Actaeon's transformation, this version, told by the celebrated Latin poet Ovid in his *Metamorphoses*, is the best-known, and is a popular subject in both ancient and post-classical art. There are two major artistic treatments of the story. Some show Actaeon at the moment when he surprises Diana bathing, and so concentrate

upon the nude goddess; others depict the final act of the tale when Actaeon is torn to pieces by his hounds. In this more dramatic situation, the terror and plight of Actaeon is foremost. The youth is often shown in the process of being transformed into a stag, his head either sprouting horns or even completely changed into that of a deer – a case of the hunter becoming the hunted.

Classical References:
Ovid, *Metamorphoses* 3.138–252.

Attributes:
Bow and arrow; hounds; metamorphosis into a stag.

Major Paintings:
- Cesari, Giuseppe: **Diana and Actaeon**, 1603–06, Museum of Fine Arts, Budapest, Hungary.
- Titian: **Diana and Actaeon**, 1556–58, National Gallery of Scotland, Edinburgh, Scotland.
- ▼ Titian: **Death of Actaeon**, *c*.1559, NGL.

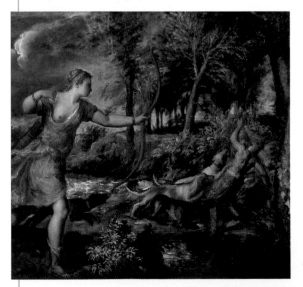

Diana, the virgin goddess of hunting, dominates Titian's dark and stormy treatment of the myth of Actaeon. Artistic licence sees Diana joining in the hunt, the viewer's eye being led along her arrow's flight – from her right hand, across her bow to Actaeon who, in the midst of being transformed into a stag, is ripped apart by his own hounds.

Adonis
Handsome youth loved by Venus

Adonis' mother Myrrha was tricked into sleeping with her own father, Cinyras, King of Cyprus, because she had neglected to worship **Venus**. Myrrha, pregnant with Adonis, was exiled, and wandered miserably until the gods took pity on her and changed her into a myrrh tree. Adonis was born from this tree and, according to some myths, the goddesses Proserpine (see **Pluto**) and Venus were given charge of Adonis' upbringing and both subsequently fell in love with the beautiful child and wished to keep him for themselves. **Jupiter** decreed that Adonis should spend a third of the year with each of the two, and the final third with whomever Adonis chose. Unsurprisingly, Adonis favoured Venus, goddess of love, over Proserpine, Queen of the Under-world. The time Adonis spent with Venus was equated to fertile spring and summer, while the time he was with Proserpine was the dead,

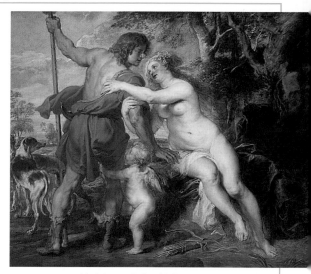

Adonis ignores the forceful pleas of both his lover Venus, her black cloak hinting at the forthcoming tragedy, and little Cupid whose bow and arrows symbolically lie unattended on the ground, and sets out on what will be his last, fateful hunt.

Classical References:
Ovid, *Metamorphoses* 10.300–739; Apollodorus 3.14.3–4.

Attributes:
Bow and arrows; hounds; boar; anemone.

Major Paintings:
- Titian: **Venus and Adonis**, 1553–54, Prado, Madrid, Spain (later versions by Titian in NGL and NGADC).
- Barry, James: **Death of Adonis**, *c.*1800?, National Gallery of Ireland, Dublin, Republic of Ireland.
- Mignard, Nicolas: **Venus and Adonis**, *c.*1650, Minneapolis Institute of Arts, Minnesota, USA.
- Rubens, Peter Paul: **Venus and Adonis**, *c.*1635, NYMet.

winter period. This alternation of birth and death formed the basis of Adonis' popular historical cult, which was linked with the Egyptian cult of Osiris. As an exceptionally handsome young man and a keen hunter, Adonis remained the object of Venus' affections. They spent time together in country pursuits, but despite Venus' pleas not to hunt dangerous animals, Adonis was fatally wounded by a wild boar. Venus rushed to his side as he died, and promising that he would be remembered, caused anemones or 'windflowers' to spring from where his blood fell; like Adonis, their flowers are short-lived, destroyed in their prime by the first breath of wind.

In art, Venus restraining Adonis from going hunting was made popular by Titian while the emotional subject of Adonis' death has been represented many times.

Aeneas

Trojan hero and legendary ancestor of the Romans

Aeneas, the son of Anchises and the goddess **Venus**, was the second-in-command of the Trojan forces during the Trojan War – but he is best remembered for being the founder of the Roman race, his tale being most famously told in the Roman poet Virgil's epic poem *The Aeneid*.

Unable to prevent the sack of Troy by the Greeks, Aeneas, at his mother's insistence, fled the city, taking with him his father whom he carried on his back, his young son Ascanius, his city's gods (the Penates) and a band of followers, although he lost his wife Creusa during his escape through the burning city.

With a fleet of twenty ships, Aeneas set sail not knowing where to settle. When the refugees landed on Delos, the sacred island of **Apollo**, the

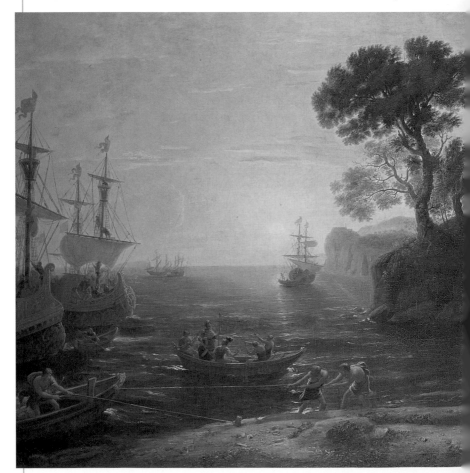

priest Anius told them to seek out their 'ancient mother', while on reaching Crete, the Penates revealed that they must journey to Italy, the land of their ancestor Dardanus. After being harassed (like **Jason**) by the Harpies, the wanderers met the seer Helenus who advised them to build their new city where they saw a white sow suckling piglets. Having sailed past the whirlpool

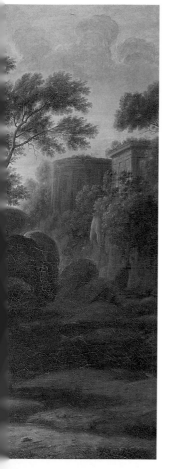

This expansive landscape is typical of Claude Gellée, better known as Lorraine after his French birthplace. The small figures of Aeneas and his men, placed below the eye-line, are only a minor part of the whole, dramatically lit scene which dissolves into the horizon.

Charybdis, the sea monster Scylla and the **Cyclopes**, all dangers encountered by **Ulysses**, they landed in Sicily, where Anchises died.

Aeneas was next driven by a storm to Tunisia where he had a love affair with **Dido**, Queen of Carthage. Prompted by the gods to continue his journey, Aeneas and his band finally reached Italy, landing at Cumae where he consulted the **Sibyl** and cut the Golden Bough from a tree on the sides of Lake Avernus, thus opening up the entrance to the Underworld. There he met his father who pointed out to him the souls of future famous Romans. Continuing up the Italian coast, Aeneas sailed up the River Tiber where he spotted the white sow and thirty piglets. Here Ascanius founded a city called Alba Longa ('Long White') after the sow, where the twins **Romulus and Remus** would be born. Aeneas also visited the nearby city of Pallanteum, ruled by Evander who showed him around the site where Rome would be founded 500 years later by the twins.

After a battle between the Trojans and the local Latins, the two peoples united under the rule of Aeneas, who received immortality on being anointed by Venus whilst he was bathing in a river.

Classical References:

Homer, *Iliad* 20.160–350; Virgil, *Aeneid*; Ovid, *Metamorphoses* 13.623–14.622; *Heroides* 7.

Attributes:

Helmet and sword.

Major Paintings:

- Vouet, Simon: **Aeneas and his Father Fleeing Troy**, *c.*1635, San Diego Museum of Art, California, USA.
- Claude Lorraine: **Coast View of Delos with Aeneas**, 1672, NGL.
- ◄ Claude Lorraine: **Arrival of Aeneas in Italy**, *c.*1600–82, Pushkin Museum, Moscow, Russia.
- Turner, Joseph Mallord William: **Aeneas and the Sibyl at Lake Avernus**, *c.*1798, Tate Britain, London, England.

Alexander the Great

Conqueror and creator of one of the world's largest empires

Alexander's military conquests took him from being King of Macedon in northern Greece to ruler of an empire that embraced the modern countries of Turkey, Syria, Israel, Egypt, Iran, Iraq, Afghanistan and Pakistan. His military genius, personal deeds, self-proclaimed divinity and short life ensured that a wealth of stories, both true and legendary, originated in his own lifetime and have inspired artists and writers until the present.

Alexander was born in 356 BC, the son of King Philip II of Macedon, and succeeded to the throne in 336 BC at the age of 20. He inherited a small kingdom which had just started to dominate the affairs of Greece, and after Alexander had secured Greece's allegiance, he set off in 334 BC on foreign conquests that would keep him away from Macedon until his death eleven years later.

Alexander's military objective was to conquer the Persians, who were at that time the pre-eminent power in the Middle East. Victory came swiftly in the major battles of the River Granicus, Issus and Gaugamela, the last resulting in the capture of the Persian capitals of Babylon, Susa and Persepolis in 331 BC. The Persian king, Darius, was soon killed and Alexander became ruler of the Persian Empire, adopting Persian dress and customs.

In the following four years Alexander expanded his empire eastwards into Afghanistan and Pakistan where he defeated the local king, Porus, in his last great battle at the Hydaspes (Jhelum) River, a tributary of the Indus. His army refusing to go further east into India, he returned to Babylon where he died of fever in 323 BC, aged 32. Alexander left not just the largest empire in the world, but thirty or so cities bearing his name, and the seeds of Greek culture spread from west to east.

In the Phrygian city of Gordium there was a chariot tied with such a complicated knot that it was said that whoever could untie it would rule the world. Characteristically, Alexander defied convention and cut the knot with his sword.

Classical References:

Plutarch, *Life of Alexander*; Quintus Curtius Rufus, *History of Alexander*; Arrian, *The Campaigns of Alexander*.

Attributes:

Helmet and sword; Gordian knot.

Major Paintings:

- ▶ Berthelemy, Jean Simon: **Alexander Cutting the Gordian Knot**, *c.*1775–1800, Ecole Nationale Supérieure des Beaux-Arts, Paris, France.
- ● Veronese, Paolo: **The Family of Darius before Alexander**, 1565–70, NGL.
- ● Altdorfer, Albrecht: **The Battle of Alexander**, 1529, Alte Pinakothek, Munich, Germany.

Representations of Alexander are numerous, many ancient and post-classical rulers wishing to equate themselves with the young military hero. The four great battles and subsequent triumphs are frequently represented. Other episodes include: ● Alexander taming his horse Bucephalus; ● with his tutor, the philosopher Aristotle; ● worshipping at the tomb of his hero Achilles; ● watching Apelles, his court painter, painting Campaspe, a concubine whom he gave to the artist; ● cutting the Gordian knot, a knot so complicated that it had never been undone until Alexander cut it in two; ● marrying the beautiful Roxana; ● with his trusted doctor, Philip, despite a letter besmirching him; ● showing mercy to Timoclea, a woman who had killed a Macedonian soldier after being raped by him; and ● showing mercy to the family of the defeated King Darius.

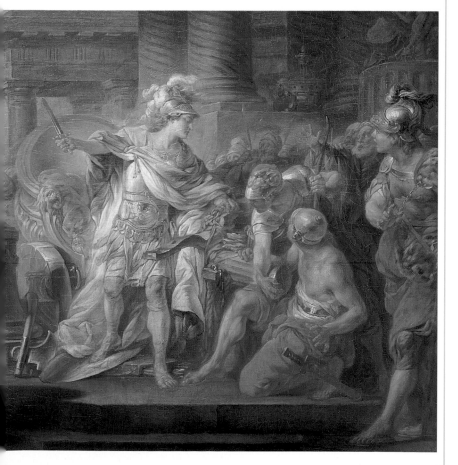

Apollo
God of archery, prophecy, healing, music and light

Known to both the Greeks and the Romans by the same name, Apollo – the embodiment of youthful, physical beauty – was a god who presided over various elements, in particular those aspects of human life which were intelligent, creative and civilized.

Apollo was the son of **Jupiter** and Leto, and the twin of **Diana**. He was born under a palm tree on the Aegean island of Delos, which became a major cult centre. He had the gift of prophecy and founded his main oracle at Delphi in Greece where people could seek advice and prophecies via his priestess, the **Sibyl**. Apollo was also known as *Pythian* since he had killed Python, a gigantic snake which had terrorized Delphi.

Although Apollo's arrows were thought to inflict illness, he was revered for being able to purify and heal, accomplishments which were assumed by his son Asclepius who became the main god of medicine. Apollo, as god of poetry and harmonious music, was regarded as the leader of the **Muses**, with whom he is often portrayed playing the lyre. This stringed instrument can be regarded as symbolic of man's rational, considered judgement in contrast to the wind instruments that symbolize passions and irrationality.

Apollo was also known as *Phoebus*, 'the Shining One', in his role as god of light and so Apollo became identified with

the Greek sun god Helios and the Roman sun god Sol. This identification was popular with post-classical artists who often depict Apollo with a shining halo around his head.

Apollo loved Hyacinthus, a beautiful youth, who was tragically killed when struck by a discus thrown by Apollo but deflected by **Zephyr**, the

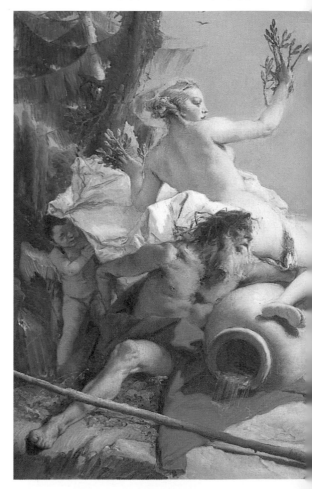

jealous West Wind. Apollo's most famous love affair was with the **nymph** Daphne. **Cupid**, wanting revenge on Apollo, who had insulted his archery skills, fired golden, love-kindling arrows at Apollo, while he pierced Daphne with cold, lead arrows. Apollo no sooner caught sight of Daphne than he fell in love with her and chased her. Daphne repulsed him and fled, but when she found her way blocked by the River Peneius, her very own father, she prayed to him for help. Just as Apollo grabbed her, Daphne was changed into a laurel (bay) tree. Apollo made the laurel his special tree, with all victors in sport and the arts crowned with a laurel wreath.

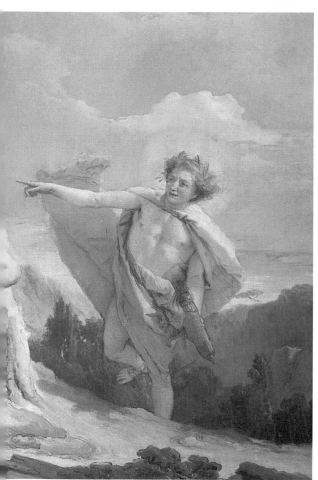

Radiant Apollo chases the nymph Daphne who, seeking the protection of her father, the river god Peneius (identifiable by his water jar and oar), begins to transform into a laurel tree. Tiepolo, the greatest Italian painter of the 18th century, also depicts Cupid hiding behind Daphne.

Classical References:

Hesiod, *Theogony* 94–95, 918–20; Ovid, *Metamorphoses* 1.452–567; 10.162–219.

Attributes:

Bow and arrow, lyre or other stringed instrument; laurel wreath; palm tree. As sun god – chariot of the sun; halo.

Major Paintings:

◄ Tiepolo, Giovanni Battista: **Apollo Pursuing Daphne**, *c.*1755–60, NGADC.

● Poussin, Nicolas: **Apollo and Muses**, 1631–32, Prado, Madrid, Spain.

● Cranach, Lucas the Elder: **Apollo and Diana**, *c.*1530, Musées Royaux des Beaux-Arts, Brussels, Belgium.

Arcadia
Region of Greece celebrated in art and poetry

Arcadia is the name of the central region of the Peloponnese in Greece. It is largely a mountainous area, once wild and unspoiled, inhabited only by sheep, goats and their herdsmen. It was noted for being the birthplace of **Mercury**, the messenger of the gods, as well as being the realm of the goat-god **Pan**.

Arcadia has played, and continues to play, an influential part in the poetry and art of Western culture. It was celebrated by the ancient poets, especially the poet Virgil, who made it the idealized setting for his pastoral poetry. In his *Eclogues*, Arcadia was inhabited by shepherds singing about their lives and loves, and from these poems, technically known as 'idylls', the word 'idyll' took on the meaning of a simple, rural life of leisure. The region was also often considered the haunt of the **nymphs** of the woods and rivers and the revelling **satyrs** and **centaurs**.

This idealized vision of Arcadia was taken up in the Renaissance by European poets and artists attracted to this vision of a classical, unsophisticated existence free from the constraints of Christian morality. Guercino and, more famously, Poussin painted Arcadian scenes where shepherds are shown deciphering the ambiguous Latin phrase *Et in Arcadia ego* inscribed on a tomb. This can mean 'I too once lived in Arcadia', referring to the occupant of the tomb, but is often more darkly thought to imply that Death is present even in an idyllic world, and in this sense has been used by authors, poets and artists up to the present day.

Classical References:
Virgil, *Eclogues*.

Major Paintings:
▼ Poussin, Nicolas: **The Shepherds of Arcadia**, 1638, Louvre, Paris, France.
● Guercino: ***Et in Arcadia Ego***, 1546–48, Borghese Gallery, Rome, Italy.
● Cole, Thomas: **Dream of Arcadia**, 1838, Denver Art Museum, Colorado, USA.

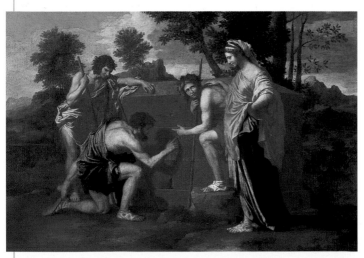

Arcadian shepherds, coming upon a tomb and its sombre inscription, realize that death has come to their idyllic paradise, a truth reflected in the woman's resigned yet noble expression and pose.

Atalanta
Greek mythological huntress and athlete

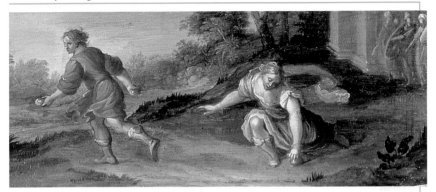

Van Balen, a Flemish painter and teacher of van Dyck, specialized in mythological subjects – here the deadly race between Atalanta and Hippomenes, the latter ensuring victory by dropping golden apples that were irresistible to Atalanta.

Atalanta was abandoned at birth in the wild and brought up by hunters. She became an accomplished huntress and swift runner, and in these capacities she appears in several Greek myths.

She is occasionally mentioned in the expedition of **Jason** and the Argonauts, but is commonly present with many other heroes at the great funeral games held for King Pelias, killed upon Jason's return; there she wrestled and beat the mighty Peleus, father of **Achilles**.

Atalanta famously took part in the Calydonian boar hunt, led by the hero Meleager. Her skill was proved when she was the first to wound the wild boar which had been terrorizing the region. When Meleager finally killed the beast, he presented Atalanta, with whom he had fallen in love, with the boar's head and pelt, a scene frequent in art due to its tragic overtones. For Meleager's actions aroused jealous resentment among the other hunters, which spilled over into fighting and the death of Meleager.

Atalanta, wishing never to marry, announced that she would only marry a man who could beat her in a race, while all losers would be killed. Despite many lovers going to their deaths, Hippomenes challenged her but asked **Venus** for help. Venus gave him three golden apples which Hippomenes, during the race, dropped one by

one. Atalanta kept pausing to pick them up, allowing Hippomenes to win the race and claim Atalanta's hand, a subject enjoyed by many post-classical artists.

Atalanta and Hippomenes' marriage was short-lived, however, for they were turned into lions when they dared to make love in the temple of the mother-goddess Cybele.

Classical References:
Ovid, *Metamorphoses* 8.270–525, 10.560–704, Apollodorus, 3.9.2.

Attributes:
Hunting weapons; boar; golden apples.

Major Paintings:
▲ Balen the Elder, Hendrick van: **Atalanta and the Golden Apples**, *c.*1619, Philadelphia Museum of Art, Pennsylvania, USA.

● Reni, Guido: **Hippomenes and Atalanta**, *c.*1612, Prado, Madrid, Spain.

● Rubens, Peter Paul: **Atalanta and Meleager**, *c.*1635, Alte Pinakothek, Munich, Germany.

Bacchus/Dionysus

God of wine and vitality

Bacchus, also known as Dionysus to the Greeks, was probably originally a fertility god who presided over the 'life force' or power in nature – that is, the blood in the veins, the sap in the tree. Such vitality is particularly evident in the fast-growing grapevine which, along with its produce, wine, became inextricably linked to Bacchus.

Part of Bacchus' Greek cult involved his followers, usually women known as Bacchantes or Maenads, entering trancelike, ecstatic states (possibly helped by wine) and then ripping apart animals, eating the raw flesh and drinking the warm blood, so symbolically devouring the god himself and becoming part of him. The details of Bacchus' cult, which seems to have offered blissful immortality, were shrouded in mystery to all but its initiates.

However, for most Greeks and Romans, the many religious festivals of Bacchus merely centred around drinking, dancing and sex. It is this decadent aspect of 'jolly' Bacchus and his riotous celebrations, Bacchanalia, that appealed to post-classical poets and artists.

Bacchus is usually depicted as a naked youth, his head crowned with a wreath of vine leaves or ivy – the latter, an evergreen plant, symbolizing the undying force of nature. Similarly fir and the fir cone were also his symbols. He is often accompanied by a band of merry followers, including Bacchants and **satyrs**, who may handle snakes, which were a symbol of death and rebirth since they shed their skin. Panthers or leopards, exotic animals to the Greeks, hint at the eastern origin of Bacchus, and are often depicted by his side or pulling his chariot.

Bacchus' mother was Semele, killed by **Jupiter** when he appeared to her in all his glory. Jupiter nurtured the unborn Bacchus in his thigh until his birth, when he was taken by **Mercury** to be raised by the **nymphs** on Mt. Nysa. When older, he travelled from the East into Greece, spreading the vine and his cult, often severely punishing those who resisted him – from pirates,

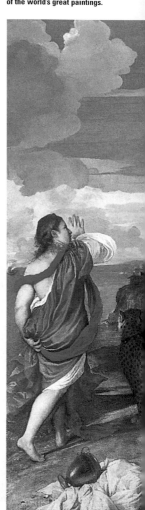

Titian's depiction of Bacchus, accompanied by his revelling retinue and leaping out of his chariot towards Ariadne, is one of the world's great paintings.

Classical References:

Euripides, *Bacchae*; Ovid, *Metamorphoses* 3.310–15, 597–691, 8.169–82; Catullus 64.50–264; Philostratus, *Imagines* 1.25.

Attributes:

Grapevine; ivy; fir cone; panther; wine jugs and cups.

Major Paintings:

▶ Titian: **Bacchus and Ariadne**, 1520–22, NGL.

● Caravaggio: **Bacchus**, 1590s, Uffizi, Florence, Italy.

● Bellini, Giovanni: **The Infant Bacchus**, 1505–10, NGADC.

● Poussin, Nicolas: **The Andrians or The Great Bacchanal**, 1628, Louvre, Paris, France.

whom he changed into dolphins, to Kings Lycurgus and Pentheus.

Reaching the island of Naxos, Bacchus came across the beautiful Ariadne who had been abandoned there by **Theseus** after she had helped him to escape from the **Minotaur**. Bacchus married Ariadne and made her immortal by transforming her into a crown of stars, the constellation Corona, while he became one of the twelve Olympian gods.

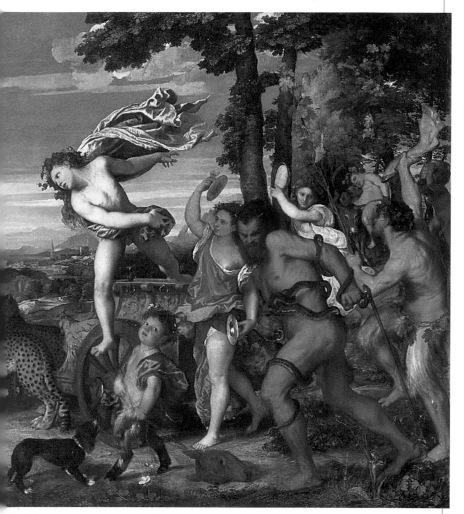

Caesar, Julius

Roman general and statesman

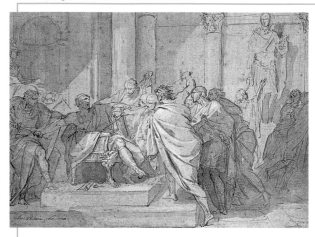

Julius Caesar was on his way to a meeting of the Senate in the Theatre of Pompey in Rome when twenty or more conspirators attacked him with daggers. He fell and died at the foot of the statue of his former arch-rival, Pompey.

Julius Caesar was one of the most influential political and military leaders in history. He was born in Rome on July 12, 100 BC into the aristocratic Julian family which believed it was divinely descended from **Venus** and **Aeneas**. Caesar, however, sided with the Popular or Plebeian party which represented the masses of Roman citizens of lower social status, so giving him a long-lasting and solid basis of support.

Caesar escaped the anti-Plebeian purges of the Roman dictator Sulla in 82 BC by going to Asia Minor where he started winning military honours. Returning to Rome in 73 BC he quickly climbed through the various senatorial offices, achieving a reputation as a military leader in Spain and then in Gaul, which he conquered in 51 BC, making a personal fortune from the booty. His enemies in the Senate declared him a public enemy. Caesar responded by marching with his legions over the Rubicon River, the boundary between his Gallic province and Italy, so symbolically declaring civil war on Rome. Defeating his rival Pompey in 48 BC, Caesar became dictator of Rome, and ruler of vast parts of the Mediterranean. Under him the Republic of Rome, ruled by two consuls and a Senate, was eroded and when he attempted to

be titled King, conspirators assassinated him by stabbing him to death on the Ides (15th) of March, 44 BC. Further battles between rival supporters ensued. Eventually in 31 BC, Caesar's great-nephew and heir, Octavian, was victorious, later assuming the title Augustus. As essentially the sole ruler of Rome and her Empire, Augustus became the first Emperor of Rome, and all subsequent Emperors were also known as Caesar.

Classical References:

Caesar, *The Conquest of Gaul, The Civil War*; Plutarch, *Life of Caesar*; Suetonius, *The Twelve Caesars*.

Attributes:

Purple-banded toga; laurel wreath.

Major Paintings:

● Camuccini, Vincenzo: **The Ides of March**, *c.*1800?, Galleria di Capodimonte, Naples, Italy.

● Mantegna, Andrea: **The Triumphs of Caesar**, 1486–94, Hampton Court, London, England.

▲ Pecheux, Laurent: **The Assassination of Julius Caesar**, 1760, Philadelphia Museum of Art, Pennsylvania, USA.

Callisto
A nymph raped by Jupiter

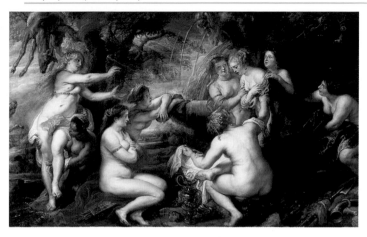

Surrounded by other nymphs, a reluctant Callisto is helped to undress at the fountain, so revealing her shameful pregnancy to a startled Diana.

Callisto, whose name means 'most beautiful', was a lovely **nymph** from the land of **Arcadia**. She was a favourite companion of **Diana**, virgin goddess of hunting, and like her, vowed to a life without men.

One day, **Jupiter**, king of the gods, spotted Callisto in the woods and immediately desired her. Knowing that the nymph would flee as soon as he approached, he disguised himself as Diana and approached her. They talked, laughed and embraced. When Callisto realized the true nature and intent of her companion, she tried to resist but Jupiter overpowered her.

Callisto found herself pregnant but, ashamed at her rape, kept it a secret from Diana and the other nymphs. However, nine months later, when she was compelled to undress and bathe with her companions, her figure revealed her secret. Diana, horrified that one of her nymphs was 'impure', chased Callisto away.

Ancient sources vary as to what happened next. Most agree that Callisto gave birth to a son named Arcas, and was then changed into a bear by either Diana, Jupiter or his jealous wife **Juno**. After years wandering alone in the forests Callisto bumped into her son who did not

Classical References:
Apollodorus 3.8.2; Ovid, *Metamorphoses* 2.401–508, *Fasti* 2.155–92.

Attributes:
Bow and arrows (as nymph of Diana); bear.

Major Paintings:
- Rubens, Peter Paul: **Diana and Callisto**, *c.*1638–40, Prado, Madrid, Spain.
- Boucher, François: **Jupiter and Callisto**, 1769, Wallace Collection, London, England.
- Titian: **Diana and Callisto**, 1556–59, National Gallery of Scotland, Edinburgh, Scotland.

recognize her as a bear. Arcas was on the point of killing her (or he or Diana did kill her) when mother and son were taken up to heaven by Jupiter and transformed into the constellation of Ursa Major ('Great Bear') and the nearby star Arcturus ('Bear Guardian').

Callisto's sad story has been enormously popular in post-classical art. Artists tend to focus either on Jupiter/Diana seducing Callisto, a scene infused with lesbian eroticism, or Diana's discovery of Callisto's secret while bathing.

Calypso
Island nymph, lover of Ulysses

Calypso was a **nymph** who lived on the beautiful island of Ogygia and detained the Greek hero **Ulysses** on his voyage home from the Trojan War. A great storm shipwrecked Ulysses on Ogygia, sometimes identified with the island of Ortygia in the Bay of Syracuse in Sicily. Calypso, a nymph and the immortal daughter of the Titan Atlas, found and fell in love with the hero. Calypso made Ulysses her lover, despite his reluctance and continual desire to return home to Ithaca and see his wife **Penelope**. Neither Calypso's charm nor her offer of bestowing immortality upon Ulysses enticed him to remain with her. So, after seven years, **Minerva**, Ulysses' protector, persuaded the gods to allow Ulysses to continue homewards. **Mercury**, the messenger of the gods, was sent to Calypso to bid her to release Ulysses. Complying, Calypso helped Ulysses construct a raft, supplying him with clothes, food and drink for his journey. She then sped Ulysses on his way with a favourable wind.

In a scene inspired by a French reworking of the classical tale, Calypso welcomes ashore Telemachus who, like his father Ulysses before him, is shipwrecked on Calypso's island and falls in love with the nymph.

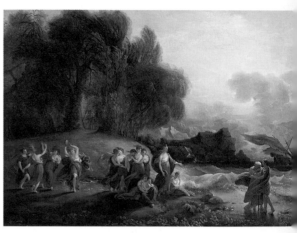

Calypso's sorrow over Ulysses' departure was intense – the Roman poet Propertius gives a moving account of the nymph, hair dishevelled, weeping day after day to the empty waves as she recalled her long years with Ulysses.

Homer's description of Calypso's fertile island and wondrous cave has provided artists with a rich background in which to set the pair of lovers. Ulysses' reaction to Calypso's advances can be variously portrayed – from ready acceptance to reluctant acquiescence. Painters have also been influenced by a French romance, *The Adventures of Telemachus,* written by Fénelon in 1699, which tells of Ulysses' son subsequently being shipwrecked on Calypso's island and falling in love with the nymph.

Classical References:

Homer, *Odyssey* 1.13–15, 48–59, 5.13–281, 7.244–69; Hesiod, *Theogony* 1017–18; Ovid, *Art of Love* 2.125–42; Propertius 1.15.9–16.

Attributes:

Cave.

Major Paintings:

- Beckmann, Max: **Odysseus and Calypso**, 1943, Kunsthalle, Hamburg, Germany.
- Böcklin, Arnold: **Odysseus and Calypso**, 1882, Kunstmuseum, Basle, Switzerland.
- West, Benjamin: **Telemachus and Calypso**, *c.*1890, Corcoran Gallery of Art, Washington DC, USA.

Centaur
Half-man, half-horse

The centaurs were a race of mythical beasts, infamous for their wild, drunken and lecherous ways. They were the offspring of Centaurus, the son of King Ixion of Thessaly who was notorious for being eternally punished on a revolving wheel. Centaurus, taken with a passion for the wild horses on Mt. Pelion in Greece, had mated with the mares who gave birth to a new race of creatures formed with the head and chest of a human above the body of a horse.

The centaurs, living in the forests and mountains of Thessaly and later **Arcadia**, largely kept to themselves but much of their notoriety stemmed from a battle they fought with the Lapiths, a Thessalian race of men. This fight originated when Perithous, brother of Centaurus, invited the centaurs to his wedding. The centaurs, unused to wine, became riotously drunk and started raping the Lapith women, including the bride. A violent battle ensued, with Perithous' friend, the Athenian hero **Theseus**, coming to his aid.

In a similar incident, the centaurs also fought with the hero **Hercules** after they had smelled the wine being offered to him by the friendly centaur Pholus. Hercules also had to fight on another occasion with the centaur Nessus after the creature tried to rape his wife, Deianeira, while offering her a ride across a river.

The most famous centaur, however, was the kindly, civilized Chiron, son of **Saturn** rather than Centaurus. He was skilled in archery, hunting, the arts and healing, and was the tutor of many Greek heroes, including **Achilles**, **Jason** and **Actaeon**, as well as the god of medicine, Asclepius. Chiron was accidentally shot with an arrow by Hercules; he became the constellation Sagittarius.

Classical References:
Plutarch, *Theseus* 30; Ovid, *Metamorphoses* 12.210–535.

Attributes:
Human torso and head, horse's back and legs.

Major Paintings:
- Altamura, Saverio: **The Centaur Chiron and Hermes**, c.1826–97, Galleria d'Arte Moderna, Rome, Italy.
- Böcklin, Arnold: **Battle of the Centaurs**, 1873, Kunstmuseum, Basle, Switzerland.
- Reni, Guido: **Abduction of Deianeira by the Centaur Nessus**, 1620, Louvre, Paris, France.
- Crespi, Giuseppe Maria: **Centaur Chiron Teaches Young Achilles Archery**, c.1700?, Kunsthistorisches Museum, Vienna, Austria.
- Lippi, Filippino: **The Wounded Centaur**, c.1500, Christ Church Picture Gallery, Oxford, England.

The wise centaur Chiron played the lyre, invented by Mercury, so skilfully that he taught many heroes how to play.

Cephalus and Procris

Faithful husband who killed his wife by accident

Cephalus, a handsome youth, attracted the eye of Aurora, goddess of the dawn, who fell in love with him. Despite Aurora's best efforts, Cephalus stayed faithful to his young wife Procris, his constant declarations of his love for his new bride so annoying Aurora that she gave up on trying to seduce him – but not before she had cast doubts in Cephalus' mind as to the faithfulness of Procris.

Returning to his wife, Cephalus tested her fidelity by trying to seduce her while he, with the help of Aurora, had taken the appearance of a beautiful stranger. Procris, staying loyal, declined his advances. However, when he offered her a vast fortune for one night of passion, Procris wavered. Cephalus revealed his true identity and denounced Procris who fled into the country. There she remained, devoting herself to **Diana** and the art of hunting, until Cephalus begged her to return. They then lived for many years in perfect happiness.

Cephalus often went out hunting with a dog, Laelaps, and a spear, both special gifts from Procris which had originally been given to her by Diana. Laelaps never failed to catch his prey and the spear never missed its mark. One day Cephalus was resting in shady undergrowth and

Classical References:
Ovid, *Metamorphoses* 7.661–866, *Art of Love* 3.687–746.

Attributes:
Dog; spear.

Major Paintings:
▼ Poussin, Nicolas: **Cephalus and Aurora**, 1627–30, NGL.
● Spencer-Stanhope, John Roddam: **Procris and Cephalus**, 1872, Barry Friedman Gallery, New York, USA.
● Piero di Cosimo: **The Death of Procris**, *c.*1500, NGL.
● Guérin, Pierre-Narcisse: **Aurora and Cephalus**, 1810, Louvre, Paris, France.

singing the praises of the cooling breezes of **Zephyr**. His cooing words were overheard by a **satyr** who thought he was making love to a **nymph** and rushed to inform Procris. The next day Procris secretly followed Cephalus. After hunting for a while, Cephalus sought shade and again praised the breezes; Procris thought the worst and moaned with despair. Cephalus, hearing the noise and thinking it an animal, threw his never-erring spear. The awful truth dawned on them both only when it was too late and Procris died in Cephalus' arms.

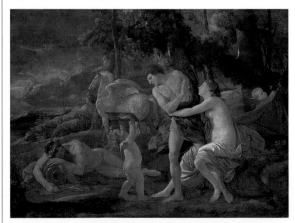

Cephalus tears himself away from Aurora, goddess of the dawn, prompted by Cupid who holds up a portrait of his wife Procris (a detail not in the classical myth). The sleeping river god is probably Ocean from where Aurora was thought to rise every morning, while the goddess next to the winged horse Pegasus may be Terra ('Earth') who watches the Sun's chariot rising in the sky.

Ceres/Demeter

Goddess of corn, agriculture and the harvest

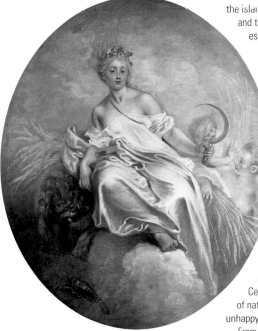

Ceres, goddess of harvest, is surrounded by the zodiacal signs of the summer – the Gemini twins, Leo the lion and Cancer the crab.

the island of Sicily (renowned for its fertility) and the Greek town of Eleusis being especially honoured.

At Eleusis, Ceres sat sobbing by a well until Metanira, Queen of Eleusis, enlisted her as a nurse to her baby son Demophon (or Triptolemus). In gratitude Ceres tried to make the baby immortal by holding him over a fire and burning away his mortality but she was stopped by the horrified queen. Revealing herself, Ceres commanded the Eleusinians to build her a temple into which she retreated, still mourning the loss of her daughter, and causing a worldwide famine.

Jupiter finally intervened and decreed that Proserpine should return from the Underworld for the spring and summer months. During these months, Ceres was happy and life returned to all of nature; conversely, in the winter she was unhappy and the land was barren.

From Ceres is derived the word 'cereal', a generic term for grain.

The Roman goddess Ceres was identified with the Greek goddess Demeter since both were deities of corn (wheat, barley and so on). She was one of the twelve great Olympian gods, not least because of the importance of wheat, in the form of bread, to ancient civilizations.

Ceres was usually worshipped in association with her daughter Proserpine (see **Pluto**), known to the Greeks as Persephone or Kore. Proserpine was famously abducted to Hades, causing Ceres to search far and wide for her daughter. Many legends tell how Ceres, usually disguised, received information or hospitality from individuals and towns on Earth during her search. In return she taught them the art of agriculture,

Classical References:

Homeric Hymn to Demeter; Hesiod, *Theogony* 453–506, 912–14, 969–74.

Attributes:

Wheat (in sheaves or a crown); cornucopia (horn of plenty); sickle; chariot; flaming torches; snakes.

Major Paintings:

- Rubens, Peter Paul and Snyders, Frans: **Ceres**, 1617, Prado, Madrid, Spain.
- Watteau, Jean-Antoine: **Ceres (Summer)**, 1715–16, NGADC.
- Veronese, Paolo: **Ceres Renders Homage to Venice**, 1575, Accademia, Venice, Italy.

Circe
Greek sorceress who enslaved Ulysses

Circe, daughter of the sun god Helios, was a sorceress notorious for turning humans into animals and featured in several Greek myths. She received **Jason** and her niece, **Medea**, on her island of Aeaea when they were sailing back in the *Argo* with the Golden Fleece, and purified them of murder. Circe's evil ways were more dramatically shown when she spitefully turned the beautiful **nymph** Scylla into a horrible monster after she had been rejected by Scylla's lover, Glaucus.

Circe is best known, however, for her meeting with **Ulysses** and his crew after they had landed on her island while returning from the Trojan War. Ulysses' scouting party came across Circe's home in a forest. Wolves, lions and other wild animals prowled around outside the house, while from within they heard sweet singing. All but one of Ulysses' men, Eurylochus, went inside and were offered drinks by Circe. Immediately upon drinking the poisoned concoction, the men turned into pigs, a terror compounded by the fact they had retained their minds and knew precisely what had happened to them.

Ulysses, warned by Eurylochus, made his way to Circe's home to confront her but was waylaid by **Mercury** who gave him the plant 'moly' as an antidote to Circe's drugged cup. Ulysses, able to resist Circe's potions, was then, however, unable to resist her seductions. Before sleeping with her, though, Ulysses made Circe promise to restore all his men to their former selves. Ulysses continued his love affair with Circe for a whole year while his companions enjoyed her unlimited food and wine, until the hero decided it was time to continue home to Ithaca.

Classical References:

Homer, *Odyssey* 10.133–574, 12.1–150; Hesiod, *Theogony* 956–57, 1011–14; Apollonius, *Argonautica* 3.311–13, 4.559–91, 659–752; Ovid, *Metamorphoses* 13.966–14.71, 14.248–440.

Attributes:

Wand; cup of poison; animals.

Major Paintings:

● Barker, Wright: **Circe**, *c.*1900, Bradford Art Galleries, Bradford, England.

▼ Dossi, Dosso: **Circe and her Lovers in a Landscape**, *c.*1525, NGADC.

● Waterhouse, John William: **Circe Offering the Cup to Ulysses**, 1891, Oldham Art Gallery, Oldham, England.

● Castiglione, Giovanni Benedetto: **Circe Changing Ulysses' Men into Animals**, 1650s, Museum of Fine Art, Houston, Texas, USA.

Circe, both naked seductress and clever sorceress, is surrounded by animals which were once her human lovers. Traces of other animals, painted later by inferior artists but now removed, can be seen in the enchanting, pastoral landscape that is an outstanding feature of Dossi.

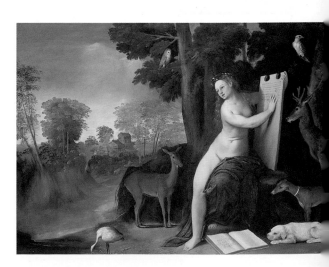

Cleopatra
Egypt's passionate and ill-fated queen

Cleopatra, born in 69 BC, became Queen Cleopatra VII of Egypt at the age of 17. Ruling jointly with her younger brother, Ptolemy XIII, she was expelled by him in 48 BC. Cleopatra appealed to the powerful Roman leader Julius **Caesar** who came and restored Cleopatra to the throne as co-ruler with her youngest brother Ptolemy XIV, as custom dictated. Cleopatra then travelled to Rome to be Caesar's mistress and there soon afterwards she gave birth to his son, Caesarion.

After Caesar's assassination in 44 BC, Cleopatra returned to Egypt and reputedly poisoned Ptolemy XIV so that she could rule jointly with her young son Caesarion, now titled Ptolemy XV. Refusing to take sides in the Roman civil war caused by Caesar's death, Cleopatra was

Tiepolo's use of perspective and classical architecture transports the viewer back to Cleopatra's famous banquet where she drops a pearl into her drink, dissolving it to prove her wealth and luxury to Mark Antony.

Classical References:

Pliny the Elder, *Natural History* 9.57.119–21; Plutarch, *Life of Antony* 78–86.

Attributes:

Egyptian/oriental robes; pearl earring; snake.

Major Paintings:

- Cabanel, Alexandre: **Cleopatra Testing Poison on Condemned Prisoners**, 1887, Musée Royal des Beaux-Arts, Antwerp, Belgium.
- Claude Lorraine: **Disembarkation of Cleopatra at Tarsus**, 1643, Louvre, Paris, France.
- Warhol, Andy: **Blue Liz as Cleopatra**, 1963, The Daros Collection, Zurich, Switzerland.
- Tiepolo, Giovanni Battista: **Banquet of Cleopatra**, 1743–44, National Gallery of Victoria, Melbourne, Australia.

summoned by the Roman general Mark Antony. They met in 41 BC at Tarsus where Cleopatra impressed her wealth upon Antony by hosting a lavish banquet at which she dissolved a pearl in her drink. The two became lovers.

Antony proposed that they share the rule of the East, a suggestion which caused Caesar's great-nephew Octavian (later Augustus, the first Roman emperor) to attack and defeat them at the Battle of Actium in 31 BC. Antony committed suicide, but Octavian met Cleopatra in Egypt where she symbolically gave him a list of her treasures.

Cleopatra, unable to live in defeat, concealed a cobra or asp in a basket of figs and took her own life by letting the snake bite her. A later version gives poison as her method of suicide. She died on August 10, 30 BC, and was the last ruler of an independent Egypt before its annexation to the Roman Empire.

Cupid/Eros and Psyche

God of love and the beautiful girl he adored

The classical god of sexual love was called Cupid ('Desire') or Amor ('Love') by the Romans, and Eros ('Sexual Love') by the Greeks. Cupid was generally regarded as the mischievous son of **Venus**, goddess of love, and **Mars**, god of war. Armed with golden arrows of desire and leaden arrows of repulsion, Cupid became the constant attendant of Venus, inflaming gods' and men's hearts.

Cupid himself was not immune to desire and fell in love with Psyche, a royal princess, who was the most beautiful girl in the world. Cupid arranged for Psyche to be taken to a mountaintop to be wed to a 'mischievous spirit' that even the gods feared. Psyche was lifted up by the wind, and gently blown to a wooded valley where she came upon a magnificent castle. Here she spent her days alone in leisure and her nights in the arms of her mysterious lover who demanded to be always unseen. One night, however, persuaded by her jealous sisters, curiosity got the better of Psyche and she lit an oil lamp and gazed upon the face of her partner – Cupid himself. A drop of hot oil fell on the god and, waking, he flew away from Psyche.

Psyche searched the world in vain for Cupid, and Venus set her near-impossible tasks as punishment for dishonouring her son. However **Jupiter**, moved by Cupid's lovesick pleas for Psyche, made the girl immortal and the couple were reunited and married at a heavenly banquet.

Since Psyche's name means 'Soul' in Greek, this tale may have been symbolic to classical philosophers, as it certainly was to later Christian commentators and artists, of the soul's struggle and eventual attainment of heaven and immortality through love.

Renaissance artists generally portrayed Cupid as a youth, like his early Greek depictions, but Baroque and Rococo artists followed the Romans by portraying him as a chubby, winged infant. All were attracted to showing various incidents, often amusing, from Cupid's youth, such as when he is educated by Venus and **Mercury**; sharpens his bow and arrows; is blindfolded; and is punished for his mischief – many of these episodes carry symbolic meanings regarding sex and morality. In many scenes of happiness and pleasure Cupid is multiplied into numerous cupids known by the Italian term *putti*.

Classical References:

Hesiod, *Theogony* 120–22, 192–202; Sappho 47, 130; Apuleius, *The Golden Ass* 4.28–6.24.

Attributes:

Bow and arrows; flaming torch.

Major Paintings:

- Dyck, Sir Anthony van: **Cupid and Psyche**, Royal Collection, Buckingham Palace, London, England.
- Gérard, Baron François : **Cupid and Psyche**, *c.*1798, Louvre, Paris, France.
- Claude Lorraine: **Landscape with Psyche at the Palace of Cupid (The Enchanted Castle)**, 1664, NGL.
- David, Jacques Louis: **Cupid and Psyche**, 1817, Cleveland Museum of Art, Ohio, USA.

The Italian-born French painter Gérard, a pupil of Jacques Louis David, portrays winged Cupid, ('Desire') giving his lover Psyche ('Soul') a tender, liberating kiss. The butterfly hovering over her head was the Roman symbol of the soul.

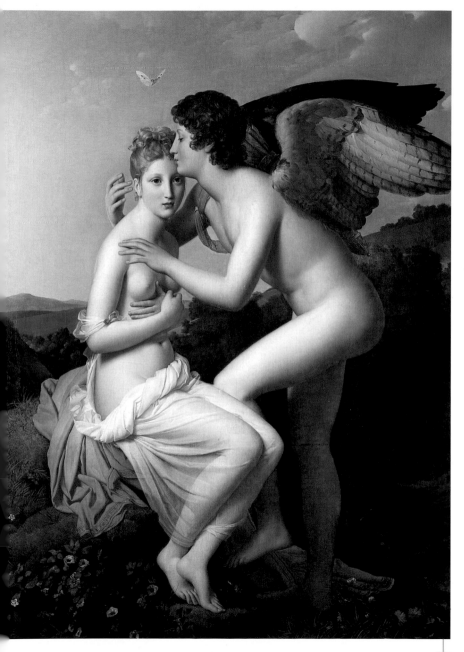

Cyclopes, The
One-eyed giants

The Cyclopes were a race of giants with one eye (although occasionally represented with three) in the centre of their foreheads. The early Greek poet Hesiod says that they were the sons of Uranus ('Sky') and Gaia ('Earth'), and were three in number called Brontes ('Thunderer'), Steropes ('Lightning') and Arges ('Flasher').

Along with their brothers, the Titans, the Cyclopes were imprisoned by their stepbrother **Saturn** who feared the wrath of these monsters. However, they were released by **Jupiter** to help in his overthrow of Saturn. In gratitude for their freedom, the Cyclopes made lightning bolts for Jupiter, a trident for **Neptune** and a cap of invisibility for **Pluto**.

Later ancient authors attributed differing lifestyles to the Cyclopes whose number also varied. Some thought they were the blacksmiths to the gods, their forges located under the volcano Mt. Etna in Sicily. Other sources described the Cyclopes as shepherds. It is this pastoral community that is chanced upon by the hero **Ulysses** in one of the most famous episodes in the epic poem *The Odyssey* by **Homer**. Ulysses and his crew had become trapped in the cave of a Cyclops called Polyphemus who had started eating the men. Ulysses devised a plan of escape. Getting Polyphemus drunk, he plunged a red-hot, sharpened log into the giant's single eye, blinding him. Ulysses then managed to sneak past the blinded monster by tying himself and his men

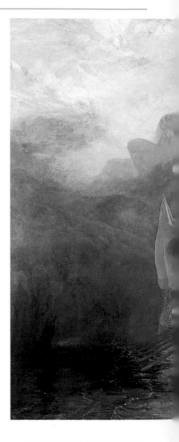

Classical References:

Homer, *Odyssey* 9.105–566; Hesiod, *Theogony* 139–46, 501–06; Callimachus, *Hymn* 3.46–86; Virgil, *Aeneid* 8.416–53.

Attributes:

One central eye (occasionally three eyes); gigantic stature.

Major Paintings:

- Jordaens, Jacob: **Odysseus**, 1660s?, Pushkin Museum, Moscow, Russia.
- Giulio Romano: **Polyphemus, Acis and Galatea**, *c.*1528, Palazzo del Te, Mantua, Italy.
- Redon, Odilon: **The Cyclops**, 1898–1900, Rijksmuseum Kröller-Müller, Otterlo, The Netherlands.
- ▶ Turner, Joseph Mallord William: **Ulysses Deriding Polyphemus**, 1829, NGL.

The gigantic presence of the Cyclops Polyphemus, shrouded in the dawn mist, looms menacingly over Ulysses' ship as the Greek hero sails away. Ulysses, having blinded Polyphemus and just escaped from his cave, taunts the monster from the deck of his ship.

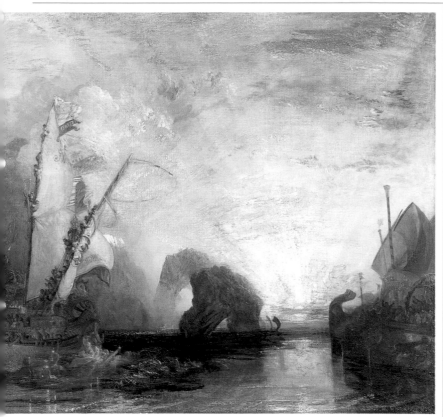

underneath the sheep which Polyphemus kept in his cave and let out to pasture each morning.

On realizing the escape, Polyphemus called out to his assailant, asking him what his name was, to which cunning Ulysses replied, 'No one.' Polyphemus then tried to stir up the rest of the Cyclopes by shouting, enigmatically, 'No one has blinded me.' This ruse gave Ulysses the extra time he needed to escape, sailing away as the

Cyclopes threw rocks at his ships from afar. Polyphemus' father, Neptune, punished Ulysses for blinding his son by delaying the hero's return home for many years.

The Cyclops Polyphemus also featured in the myth of **Galatea and Acis**. The original three Cyclopes were killed by **Apollo**, who was furious after they had forged the lightning bolt which had destroyed his son, Asclepius, god of medicine.

Daedalus and Icarus
Father and his son who flew too close to the sun

The mythical Daedalus was renowned as a great master craftsman and inventor. Originally from Athens, he fled to Crete after having murdered his nephew Perdix, and entered the service of King Minos. Daedalus constructed a hollow, wooden cow for Queen Pasiphae, in which she mated with a bull; the union produced the **Minotaur**. Daedalus then devised the maze known as the Labyrinth in which the creature was hidden away. Later, Daedalus helped the King's daughter, Ariadne, by providing her with a ball of thread to help her lover **Theseus** escape from the Labyrinth after killing the Minotaur.

Daedalus and his son Icarus were imprisoned in the Labyrinth by King Minos for helping Ariadne, but the ever-ingenious Daedalus created

Classical References:

Ovid, *Metamorphoses* 8.183–235;
Virgil, *Aeneid* 6.14–33.

Attributes:

Wings fashioned from feathers
and wax.

Major Paintings:

- Matisse, Henri: **Icarus**, 1947, NYMet.
- Saraceni, Carlo: **Fall of Icarus**, *c.*1600, Galleria di Capodimonte, Naples, Italy.
- Bruegel the Elder, Pieter: **Landscape with Fall of Icarus**, 1558, Musée Royal des Beaux-Arts, Brussels, Belgium.
- Draper, Herbert James: **The Lament for Icarus**, *c.*1898, Tate Britain, London, England.

Following Ovid's account, the ploughman, shepherd and fisherman are almost unaware of Icarus' fatal fall, his splash seen below the ship.

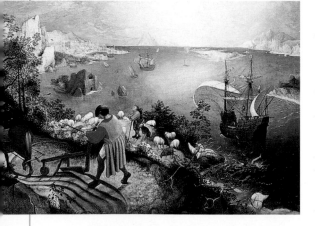

wings of feathers and wax. They flew out of the Labyrinth and away from Crete. Unfortunately, Icarus disregarded his father's warning about flying too close to the sun, with tragic consequences. The wax holding his wings together began to melt in the sun's heat and Icarus plunged headlong into the Aegean Sea. Daedalus buried his son on a nearby island which thereafter was called Icaria.

Daedalus continued to Sicily, but Minos cunningly discovered his whereabouts. Minos promised a reward to anyone who could pass a thread through a spiral seashell, confident that the person who overcame this difficult task would be none other than Daedalus. Minos was proved correct, for Daedalus threaded the shell by making a hole at one end and letting an ant, attached to the thread, walk through the shell. However, before Minos could apprehend Daedalus, Minos was killed in his bath by the Sicilian king's daughters, who did not wish Daedalus to be taken back to Crete.

Daedalus and Icarus have been represented numerous times in literature and in art, their flight a symbol of man's inventiveness and aspirations, Icarus' fall an allegory of folly or youth.

Danae

Greek princess who conceived in a shower of gold

Danae was the only daughter of King Acrisius of Argos in Greece. When the King was warned by an oracle that a future grandson of his would one day kill him, he kept Danae locked away from men, imprisoned either in a bronze, underground room, or according to later versions, in a bronze tower.

Despite being shut away, Danae caught the eye of **Jupiter**. He transformed himself into a shower of gold, slipped through a small opening in the roof of the prison and poured himself into Danae's lap, causing her to conceive. When the baby was born, Danae named her son **Perseus**. Danae's father, refusing to believe her story about Jupiter and the shower of gold, locked Danae and baby Perseus in a wooden chest and threw it out to sea.

Titian painted Danae conceiving amidst a shower of gold several times. In this version, a greedy servant tries to steal some of the gold while in more romantic versions Cupid takes the place of the servant.

Classical References:

Apollodorus 2.4.1–5; Virgil, *Aeneid* 7.371–72, 408–13; Horace, *Odes* 3.16; Ovid, *Metamorphoses* 4.611–13.

Attributes:

Chest; gold coins.

Major Paintings:

▲ Titian, **Danae with Nursemaid**, 1553–54, Prado, Madrid, Spain.

● Correggio, Antonio: **Danae**, 1531–32, Galleria Borghese, Rome, Italy.

● Gossaert, Jan: **Danae**, 1527, Alte Pinakothek, Munich, Germany.

The chest floated on the waves of the Aegean Sea until, near the island of Seriphos, it was washed into the fishing nets of Dictys, brother of Polydectes, King of Seriphos. Danae and Perseus lived with Dictys for many years. Then Polydectes fell in love with Danae and regarding Perseus as an obstacle in the path of his desire, sent him away on a mission to behead **Medusa**. When Perseus returned triumphant, he killed Polydectes and took Danae back to her home in Argos, although Roman tradition says Danae settled in Ardea in Italy and that one of her descendants was Turnus, the arch-rival of **Aeneas**.

Danae's conception via a shower of gold has been an extremely popular subject in post-classical art, not least because of an opportunity to paint the female nude. The shower is often depicted either as a fall of coins, droplets or a sunbeam. For many, Danae's acceptance of the shower of gold symbolized the immorality of greed.

Diana/Artemis
Virgin goddess of hunting

Diana was the Roman equivalent of the Greek goddess Artemis. The daughter of **Jupiter** and Leto, and twin sister of **Apollo**, she was one of the twelve great Olympian deities. Diana had many aspects. In the role of a virgin huntress she was primarily associated with hunting and women, especially pubescent girls and those in childbirth. She also became identified with the Moon, as well as with Hecate, a triple-faced goddess of black magic.

As the epitome of athletic, chaste femininity, Diana roamed wild mountains and woods, surrounded by her entourage of virgin **nymphs**, delighting in hunting and bathing whilst shunning all contact with men. Many myths, such as those of the hunter **Actaeon** and the nymph **Callisto**, show the fatal cost of violating this happy state.

Others, too, discovered that Diana, for all her apparent charm, was a goddess who brought death. Diana's gift of an unerring spear to Procris led accidentally to her being killed by her husband **Cephalus**. Diana's vengeance against Niobe, who had insulted her mother, was total – she shot all of Niobe's daughters. She was also responsible for the death of the giant hunter Orion, after Orion had tried to rape her, or had dared to challenge her at the discus, or because he had fallen in love with another, which uncharacter-istically aroused Diana's jealousy. Diana had also demanded the sacrifice of the young girl **Iphigenia**, but at the last moment substituted a deer on the altar.

A favorite, romantic myth with poets and artists involves Endymion with whom Diana – here equated with the Moon (Selene in Greek, or Luna in Latin) – fell in love. Endymion, a beautiful

Classical References:
Hesiod, *Theogony* 918–20; Ovid, *Metamorphoses* 6.146–312; Apollodorus 1.4.1–5, 1.7.4–6.

Attributes:
Bow and arrows; spear; hunting dogs; deer; crescent moon.

Major Paintings:
▶ Boucher, François: **Diana Bathing**, 1742, Louvre, Paris, France.
● Renoir, Pierre-Auguste: **Diana**, 1867, NGADC.
● Poussin, Nicolas: **Diana and Endymion**, c.1630, Detroit Institute of Arts, Michigan, USA.
● Poynter, Edward: **The Vision of Endymion**, 1901, Manchester City Art Gallery, Manchester, England.

Boucher, exponent of the Rococo style, depicts a sensual Diana, identified by the crescent moon on her head, preparing to bathe and attended by a nymph. The goddess' hunting trophies include doves (love) and a rabbit (lust), symbolizing Chastity's conquest of Venus.

youth, had been cast by Jupiter into an everlasting sleep whilst remaining forever young. Diana, as the Moon, gazed lovingly upon him each night, or else came to him in the evening or at dawn to fulfil her desires. Another theme frequently portrayed in art is the enduring contest between Chastity and Lust; the celibate Diana and alluring **Venus** are portrayed side by side in such allegories. An artistic variant of this theme depicts **satyrs** surprising and attempting to rape Diana and her nymphs.

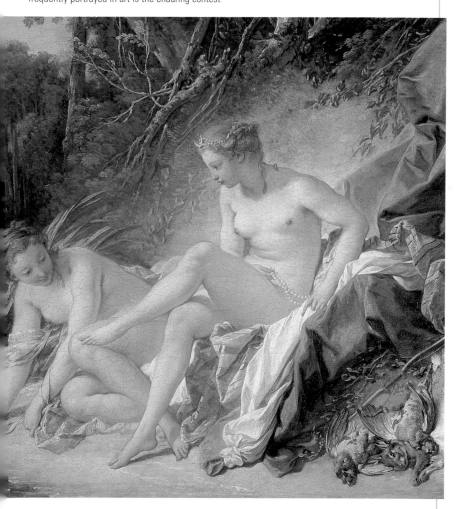

Dido

Legendary queen of Carthage

Dido (also known as Elissa) was a princess of Tyre in Phoenicia who married her wealthy uncle Sychaeus (or Sicharbas). When he was murdered by her brother Pygmalion, the King of Tyre, Dido fled with her followers to Tunisia in North Africa. There a local ruler, Iarbas, agreed to sell her only as much land as could be covered by an oxhide. Cleverly, Dido cut the hide into strips to encircle a large amount of land, where she founded the city of Carthage ('New Town')

which later became a great trading and military rival of Rome.

When Carthage began to prosper, Iarbas threatened Dido with war unless she married him. Rather than this, Dido constructed a funeral pyre on which she stabbed herself.

Another, more famous, version of Dido's death is told by the Roman poet Virgil in his mythological epic *The Aeneid*. According to Virgil, the Trojan prince **Aeneas** was shipwrecked at

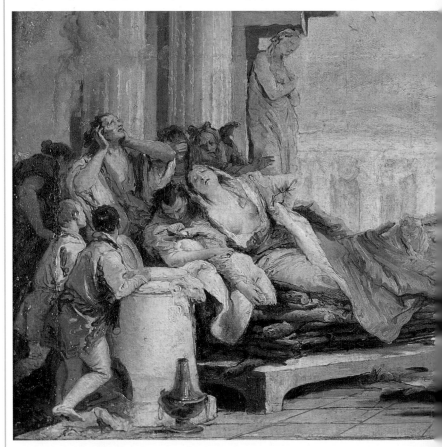

Carthage after escaping from the sack of Troy with family and companions, and was warmly received by Queen Dido who gave a magnificent banquet for the Trojans at which Aeneas recounted the fall of Troy and his subsequent wanderings. Although Dido had pledged herself to celibacy after the murder of her husband, she was visited by **Cupid** in the guise of Aeneas' son, Ascanius, and pierced by his arrows of desire. Dido and Aeneas realized their mutual love whilst

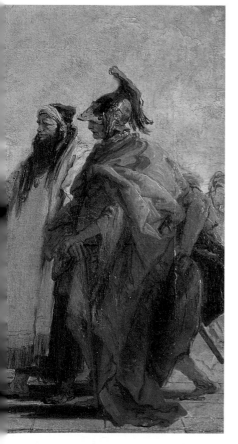

sheltering in a cave from a storm, its darkness and violence symbolic of Dido's ultimate fate.

Dido and Aeneas settled down, Aeneas having forgotten his mission to reach Italy and found a new city, the forerunner of Rome. Prompted by the gods to remember his duty, Aeneas left Dido, despite her heart-wrenching pleas, and sailed away from Carthage. In agony and despair, Dido persuaded her sister to build a pyre on which she was going to burn all Aeneas' remaining possessions, but then in a tragic climax, Dido saw Aeneas' ships sailing away, climbed on top of the pyre and killed herself with his sword. The smoke from her flaming pyre was seen by the Trojans out at sea.

For artists, poets, authors and composers, this story of passion, loss and death has been immensely influential, with Dido often being cast as the archetypal tragic heroine in a tale where love is sacrificed for duty.

Tiepolo gives Dido's death a greater emotional pathos by depicting, without literary authority, Aeneas looking on.

Classical References:

Virgil, *Aeneid* 1.335–756, 4.1–705, 6.450–76; Ovid, *Heroides* 7.

Attributes:

Oriental robes; sword; pyre.

Major Paintings:

- Turner, Joseph Mallord William: **Dido Building Carthage**, 1815, NGL.
- Solimena, Francesco: **Dido Receiving Aeneas and Cupid Disguised as Ascanius**, 1720s, NGL.
- Claude Lorraine: **Aeneas' Farewell to Dido and Carthage**, 1675–76, Kunsthalle, Hamburg, Germany.
- Tiepolo, Giovanni Battista: **Death of Dido**, *c*.1696–1770, Pushkin Museum, Moscow, Russia.
- Rubens, Peter Paul: **Death of Dido**, *c*.1635–38, Louvre, Paris, France.

Echo and Narcissus

Talkative nymph besotted with a youth in love with his own reflection

Echo was a **nymph** who used to distract the goddess **Juno** with an endless flow of chatter while other nymphs, who had been making love with Juno's husband, **Jupiter**, had time to scatter. When Juno realized that she was being tricked, she punished Echo by making her unable to say anything other than to repeat the last words spoken to her.

One day Echo came across a handsome boy wandering alone in the woods. He was Narcissus, the son of the river god Cephissus and the nymph Liriope, and Echo, like many others, fell desperately in love with him. However, Narcissus had never succumbed to anyone's charms and, in fact, treated his admirers with coldness and scorn – so much so that one of them, who remains anonymous, prayed that Narcissus would fall madly in love and be unable to obtain his desire.

Narcissus, true to character, repeatedly rejected Echo's advances. The poor, heartbroken nymph grew thinner and thinner until she wasted

away through unrequited love – the only part of her which remained was her voice which can still be heard in the woods and hills, 'echoing' the last words of anyone in the area.

Narcissus then came upon a crystal-clear, sparkling pool of water. Lying down next to it, he leaned over to take a drink. It was then he saw the most beautiful face he had ever seen staring back at him. Narcissus was enraptured and continued to gaze, besotted with what he saw. Not realizing that he was looking at his own

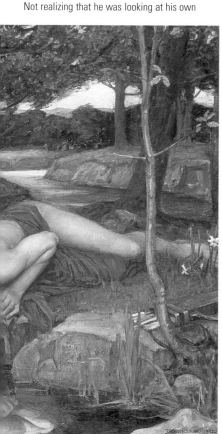

reflection, he repeatedly tried to reach out to the person he thought was below the water. Narcissus remained by his reflection day and night, not eating or drinking, and so he too wasted away. Where his body had been there was now a beautiful flower of white petals around a yellow centre – the narcissus.

The story of Echo and Narcissus has been one of the most popular of the ancient myths in both post-classical art and literature. The frequent subject of Narcissus gazing at his reflection provides an interesting, complex and skilful composition. Echo is sometimes shown – artistic necessity requiring her to have a body – sitting nearby, gazing upon her beloved, who may be asleep as he passes away. Symbolically, a narcissus flower or some daffodils (of the narcissus family) are usually present.

The English painter John William Waterhouse, influenced by the Pre-Raphaelites, remains popular for his dreamily romantic style applied with great success to his paintings of Greek, Roman and English legends. Here Echo gazes longingly over to Narcissus who is fatally falling in love with his own reflection.

Classical References:
Ovid, *Metamorphoses* 3.356–510.

Attributes:
Reflection in water; narcissus flower.

Major Paintings:
◄ Waterhouse, John William: **Echo and Narcissus**, 1903, Walker Art Gallery, Liverpool, England.
● Poussin, Nicolas: **Echo and Narcissus**, *c.*1629, Louvre, Paris, France.
● Claude Lorraine: **Landscape with Narcissus and Echo**, 1645, NGL.

Europa
Princess abducted to Europe by a bull

Europa was usually regarded as the daughter of Agenor, King of Tyre or Sidon in Phoenicia. One day while out playing with her friends by the seashore, she was spotted by **Jupiter** who was immediately taken with the princess' beauty. Jupiter, wishing to get closer to Europa, changed himself into a handsome, snowy-white bull. He mingled with the other cattle and his fine appearance and placid nature caught the eye of Europa. The princess overcame her initial hesitancy and held out flowers for the bull who excitedly licked Europa's hands.

With increasing fervour the bull gained Europa's trust and now frolicked with the girl on the green turf as well as on the sandy beach. Europa placed garlands on its horns and, oblivious of the bull's real identity, climbed on its back. Jupiter seized his chance. He leaped up and plunged into the sea, gradually drawing farther and farther away from the shore, with Europa left clinging helplessly on his back and watching her friends and country disappearing from sight.

Jupiter carried her from Asia to the island of Crete, part of the continent that was later to bear Europa's name – Europe. There, assuming his

Classical References:
Ovid, *Metamorphoses* 2.836–75.

Attributes:
Girl with bull.

Major Paintings:
▽ Hinderhout, Hendrick van: **Rape of Europa**, *c.*1680s?, Musée des-Beaux Arts, Rouen, France.
● Titian: **Rape of Europa**, *c.*1559–62, Isabella Stewart Gardner Museum, Boston, Massachusetts, USA.
● Veronese, Paolo: **Rape of Europa**, *c.*1570–80, Doges' Palace, Venice, Italy; *versions in* NGL and Capitoline Museum, Rome, Italy.

rightful shape, Jupiter made love to Europa and she bore three sons – Rhadamanthys, a famed lawgiver; Sarpedon, a Greek hero of the Trojan War; and Minos, ruler of Crete and husband of Pasiphae, who also coupled with a bull to produce the **Minotaur**. Europa's abduction is also commemorated in the constellation of Taurus, the bull.

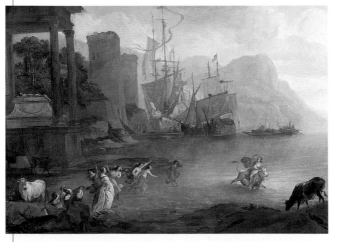

Jupiter, in the guise of a bull, makes off with Europa on his back, taking her to the continent that was to bear her name.

Fates, The
Goddesses of destiny

The three Fates were known to the Greeks as the *Moirai* and to the Romans as the *Parcae*. They were the daughters of **Jupiter**, king of the gods, and either Night or Themis, goddess of justice, law and order.

The Fates determined the lifespan of every human, and were regarded as physically spinning, measuring and cutting a woollen thread of life. The names of the three sisters reflect their tasks – Clotho the 'Spinner', Lachesis the 'Apportioner' who measures the thread, and Atropos the 'Inevitable' who finally cuts it. Their decrees over the lives of mortals were nearly always final and were respected even by the other gods.

In artistic representations the Fates are usually portrayed as old and decrepit. Not usually subjects in their own right, they are often included in larger allegorical compositions relating to life and death. They are often shown with the various attributes relating to spinning – the woollen thread, a distaff (or, anachronistically, a spinning wheel), spindles, and scissors or knife for the final cutting.

Despite their obvious importance, the Fates rarely play a leading role in any of the great

myths. However, in the tale of Meleager they appear to his mother to warn that the newborn Meleager would live for as long as the log on the fire was still unburned. Meleager's mother immediately pulled the log off and kept it safe until many years later, in a fit of rage after Meleager had killed his brothers, she threw it onto a fire, so ending Meleager's life.

Classical References:
Hesiod, *Theogony* 217–22, 904–06; Plato, *Republic* 10.617c.

Attributes:
Woollen thread; spindles; distaff or spinning wheel; scissors or knife.

Major Paintings:
▼ Goya, Francisco: **The Fates**, 1820–21, Prado, Madrid, Spain.
● Vedder, Elihu: **Fates Gathering in the Stars**, 1887, Art Institute of Chicago, Illinois, USA.
● Restout, Jean: *detail from* **Orpheus in the Underworld Reclaiming Eurydice** *or* **The Music**, 1763, Louvre, Paris, France.

Goya's idiosyncratic interpretation of the Fates who judge the span of one's life.

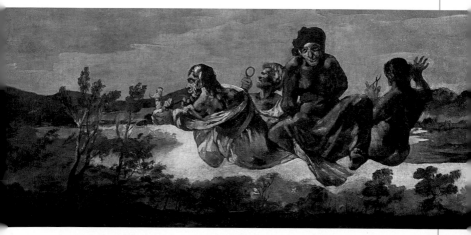

Flora
Goddess of flowers

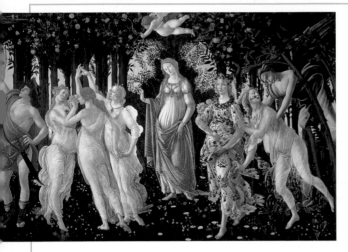

At the extreme right Zephyr abducts a startled Chloris who transforms into the beautiful Flora next to her who strews the ground with roses. The other figures in Botticelli's *La Primavera* are Venus, the Graces and Mercury.

Flora, literally meaning 'Flowers' in Latin, was an ancient goddess of flowering plants and crops – and thus spring – worshipped by the Romans, Sabines and other ancient Italian peoples. The Roman poet Ovid provides Flora with a Greek predecessor, Chloris, presumably as a way of lending authenticity and respectability to the Italian goddess. Flora was originally a countryside **nymph** named Chloris (meaning 'Fresh Green') whose home was in the Elysian Fields, the idyllic resting place of dead heroes. One day whilst wandering in the fields, Chloris was spotted by **Zephyr**, the West Wind, who immediately fell in love with her and pursued her. Zephyr overpowered Chloris and made her his wife, transforming her into Flora and bestowing upon her not only immortality in the form of perpetual springtime but also jurisdiction over flowers, fruits and ripening crops. Flora's transformation was equated with Zephyr warmly blowing his springtime breezes over the land and awakening nature. Similarly, when Flora breathed, she was thought to exhale fresh roses.

Flora had a temple in Rome and the festival of Floralia, established in 238 BC in response to a drought, was celebrated each year between April 28 and May 3. Festivities included chariot racing and theatrical mimes of a sexual nature as appropriate for a fertility cult. Reflecting the role of Flora, participants wore multicoloured clothes rather than white which was the customary colour for devotees in Roman religious festivals.

Flora is especially popular with post-classical artists who saw in her many allegories as well as opportunities for painting beautiful females – real or imaginary.

Classical References:
Varro, *Res Rusticae* 1, *De Lingua Latina* 5.74; Ovid, *Fasti* 5.193–375; Juvenal, *Satires* 6.251.

Attributes:
Flowers; bouquets; fruits.

Major Paintings:
- Botticelli, Sandro: *right-hand figure in* **La Primavera**, *c.*1477–78, Uffizi, Florence, Italy.
- Titian: **Flora**, 1515, Uffizi, Florence, Italy.
- De Morgan, Evelyn: **Flora**, 1894, The De Morgan Foundation, London, England.
- Poussin, Nicolas: **The Triumph of Flora**, 1628, Louvre, Paris, France.

Galatea and Acis
Beautiful sea nymph and her ill-fated lover

Galatea was a Sicilian sea **nymph**, the daughter of Nereus, an old sea deity whose many daughters were known as the Nereids. Galatea's fame arises from her love affair with Acis, a handsome youth who was the son of **Pan** and a river nymph. The two were very much in love and whiled away pleasant hours in each other's company.

However, Acis had a rival. Polyphemus, one of the monstrous **Cyclopes**, was also in love with Galatea but his feelings were not shared by the sea nymph. Polyphemus pined terribly for her, consoling himself by playing his pipes and composing love poetry – but all to no avail. Then one day he came upon Galatea and Acis in one another's arms. Polyphemus was overcome with despair, jealousy and rage. He tore up rocks and flung them at the lovers. Galatea escaped, but Acis was crushed to death. The sea nymph, distraught at her loss, transformed the body of Acis into a river which took his name.

The story of Acis and Galatea, which encapsulates the painful dichotomy between requited and unrequited love, has been a continual source of inspiration for painters and poets. Artists have been attracted to the contrast between an idyllic landscape setting with a pair of lovers and the looming, threatening presence of the Cyclops, focusing either on the pathos of the lovesick giant playing his pipes, or the tragic cruelty of the enraged Cyclops.

In complete contrast, Galatea is also often depicted at the centre of a great maritime celebration, The Triumph of Galatea, a subject with no basis in classical myth. Galatea, surrounded by a host of sea creatures and deities, rides the waves in a scene of love and joy.

Classical References:

Homer, *Iliad* 18.45; Hesiod, *Theogony* 250; Theocritus, *Idyll* 11; Ovid, *Metamorphoses* 13.738–897.

Attributes:

Lovers in idyllic setting; the Cyclops; dolphins and other marine beings (in Galatea's Triumph).

Major Paintings:

- Claude Lorraine: **Coast Scene with Acis and Galatea**, 1657, Gemäldegalerie, Dresden, Germany.
- Raphael: *detail from* **The Triumph of Galatea**, c.1511–12, Villa Farnese, Rome, Italy.
- Poussin, Nicolas: **Acis and Galatea**, 1626–28, National Gallery of Ireland, Dublin, Republic of Ireland.
- Corneille, Michel II: **Acis and Galatea**, c.1642–1708, The Trianon, Château de Versailles, Versailles, France.

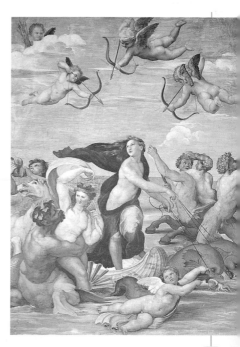

The Triumph of Galatea is one of Raphael's most famous works. Its figures and subject reflect the gentle humanity that characterized Raphael himself who, up until the late 19th century, was regarded by nearly all as the greatest painter ever.

Ganymede

Jupiter's cupbearer

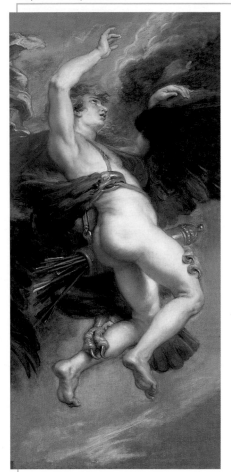

Jupiter, transformed into an eagle, carries off the young Ganymede into a thunderous sky to be his cupbearer.

she married **Hercules**, who had just become a demigod, or was dismissed after tripping up. A new cupbearer had to be found.

Jupiter's eye was immediately attracted to Ganymede, who was a beautiful Trojan prince and shepherd. He was the son of Tros, who had given his name to the city of Troy, and the grandson of the Trojan river gods Simoeis and Scamander. Jupiter's decision was now how to abduct (or 'rape') Ganymede. Early myths say that Jupiter sent a whirlwind to whisk the young boy up to Olympus; later ones claim that Jupiter sent an eagle – or that he himself transformed into an eagle – to fly down and grab Ganymede. Ganymede then became Jupiter's illustrious cupbearer, and was immortalized in the stars as the constellation Aquarius positioned near Aquila the Eagle.

Greek and Roman poets and artists focused on the homoerotic nature of the abduction, as did some post-classical painters. Other Renaissance artists saw a moral dimension to the myth – the innocent soul being rewarded and ascending to heaven to take its place at the side of the creator.

Classical References:

Homer, *Iliad* 20.231–35; Virgil, *Aeneid* 5.250–57; Ovid, *Metamorphoses* 10.152–61.

Attributes:

Eagle; jug; cup.

Major Paintings:

◀ Rubens, Peter Paul: **The Abduction of Ganymede**, *c.*1611–12, Prado, Madrid, Spain.

● Gabbiani, Anton Domenico: **Rape of Ganymede**, 1700, Uffizi, Florence, Italy.

● Correggio, Antonio: **Ganymede**, 1531–32, Kunsthistorisches Museum, Vienna, Austria.

On Mt. Olympus the twelve great gods were attended to and waited upon by minor deities and various other beings who served them ambrosia and nectar, the food and drink of the gods. Significant honour was bestowed upon **Jupiter**'s personal cupbearer. This task had been the responsibility of Hebe, the goddess of youth, but legends say that she either left her post when

Graces, The
Goddesses of beauty, charm and favour

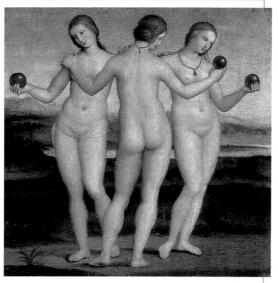

The three Graces, in their classic triple pose, hold the golden apples of the Hesperides which, according to a Roman myth, were the reward given to Scipio, a soldier who chose Virtue over Pleasure (depicted by Raphael in *The Knight's Dream*, a companion piece to this panel).

The Graces – also known as the Charities after their Greek name – were the daughters of **Jupiter** and, as minor goddesses, were the personifications of beauty, grace and favour. Most traditions follow the Greek poet Hesiod in specifying that they were three in number, called Aglaea ('Splendour'), Euphrosyne ('Mirth') and Thalia ('Festivity'), although **Homer** also names Pasithea ('Virtue') as the youngest of them.

They were often represented as living on Mt. Olympus along with the other gods, and were the especial attendants of **Venus**, goddess of love, and her son **Cupid**. They played no central role in any of the myths, but were often regarded as being present at wedding ceremonies and other festivities, since they delighted in joyous occasions. In this aspect, the Graces were also thought to accompany **Apollo** in his role as patron of the arts along with the **Muses**.

In ancient times they were represented in sculpture and painting, with their nudity and famous triple pose established by the fourth century BC. This pose shows the Graces in a group with their hands on each other's shoulders – the central figure usually has her back to the viewer while the flanking figures face forwards. One of the most celebrated ancient depictions of the Graces in this sensuous stance is a Roman fresco from Pompeii, now in the Naples Archaeological Museum. In the Renaissance, artists returned to the subject with enthusiasm since it enabled the

female form to be shown nude from differing viewpoints. Botticelli, Raphael and Rubens have all painted successful versions, while Canova sculpted a renowned masterpiece.

Classical References:
Homer, *Iliad* 14.263–76; Hesiod, *Theogony* 64–65, 907–11, 945–46; Seneca, *On Benefits* 1.3.2.

Attributes:
Apples; myrtle; roses.

Major Paintings:
- Raphael: **The Three Graces**, *c.*1503–04, Musée Condé, Chantilly, France.
- Burne-Jones, Edward: **The Three Graces**, *c.*1885, Tullie House Museum, Carlisle, Cumbria, England.
- Rubens, Peter Paul: **The Three Graces**, *c.*1636–38, Prado, Madrid, Spain.

Hector and Andromache

Trojan hero and his devoted wife

Hector was the eldest son of King Priam of Troy, and the husband of Andromache. He was the greatest of the Trojan warriors who battled against the Greeks who were besieging his city during the Trojan War. He thus plays a central role in **Homer**'s account of the war, *The Iliad*, in which he is shown as noble, compassionate, and as much loved by his comrades as feared and respected by his enemies.

In a scene from Racine's play Andromache (1667), the heroine lovingly holds her child Astyanax having just rejected the advances of her captor Neoptolemus, whose father Achilles had killed her beloved husband Hector.

One of the most moving episodes in *The Iliad* – frequently portrayed by artists – involves Hector's departure for battle. He meets his tearful wife Andromache and his young son Astyanax at the city gate and they say a loving goodbye. Portentously, Astyanax shrinks away from Hector, frightened by his father's plumed helmet. Hector consoles Andromache, telling her that no one could change one's fate. Andromache returns to her chamber to mourn for her husband.

Hector fought courageously in many battles during the war, but his killing of Patroclus, the great friend of **Achilles**, sealed his fate – for Achilles, the greatest Greek hero, re-entered the war to seek his revenge on Hector. When the two warriors finally met, Hector was killed and Achilles, in an act of indecent rage, fastened Hector's body to his chariot and dragged it round Troy's walls and Patroclus' funeral pyre. King Priam, distraught, paid Achilles a ransom for his son's body which was then cremated in a splendid ceremony.

In the ensuing sack of Troy by the victorious Greeks, Andromache was enslaved and married to Achilles' son, Neoptolemus (Pyrrhus), while Astyanax was killed.

Classical References:

Homer, *Iliad* 1.240–44, 6.369–502, 12.462–71, 22.395–515, 24.718.

Attributes:

Helmet and sword.

Major Paintings:

- David, Jacques Louis: **Andromache Mourning Hector**, 1783, Louvre, Paris, France.
- Prud'hon, Pierre Paul: **Andromache and Astyanax**, 1814–24, NYMet.
- Leighton, Lord Frederick: **Captive Andromache**, *c.*1888, Manchester City Art Gallery, Manchester, England.
- Coypel, Antoine: **The Farewell of Hector and Andromache**, *c.*1700, Louvre, Paris, France.

Helen

'The face that launched a thousand ships'

Helen of Troy was the most beautiful woman in the world, and it was her renowned beauty that was the cause of the famous Trojan War.

Helen was the daughter of **Jupiter**, and her mother is usually regarded as being **Leda**. She was raised by her step-father Tyndareus, King of Sparta. Whilst young she was abducted by the Athenian hero **Theseus**, but rescued by her brothers Castor and Pollux. When it was time for Helen to marry, numerous prospective husbands came from all over Greece, but it was Menelaus – later King of Sparta – who won her hand.

After many years of contented married life, Helen was influenced by **Venus**, the goddess of love, to fall in love with the Trojan prince, **Paris**, when he turned up at Sparta to claim Helen as his new wife – a prize he had been promised by Venus after judging her more beautiful than **Minerva** and **Juno**. Helen ran away with – or, according to some, was abducted by – Paris, the pair arriving at Troy where they were married.

Menelaus mustered a great force of Greek kings and heroes which sailed to Troy and besieged the city for ten years, the final year of action being recounted in *The Iliad* of **Homer** who says that Helen, although regretful at having caused so much bloodshed, was also still very much in love with Paris. With the Greeks finally triumphant, Menelaus' first reaction was to kill his wife, but Helen's beauty was such that he was overwhelmed and dropped his sword. Reunited, they returned to Sparta where they lived contentedly into old age. Helen was later worshipped as a goddess in many parts of Greece.

Standing symbolically in front of their bed, Helen leans on the shoulder of her lover Paris, the Trojan prince, who has hung up his bow and quiver to play the lyre.

Classical References:
Homer, *Iliad* 3.121–447, 6.313–58, 24.761–76, *Odyssey* 4.120–305, 15.56–181; Euripides, *Trojan Women* 860–1059; Virgil, *Aeneid* 2.567–603.

Attributes:
Beauty.

Major Paintings:
▼ David, Jacques Louis: **Paris and Helen**, 1788, Louvre, Paris, France.
● Fra Angelico, follower of: **Abduction of Helen**, c.1450, NGL.
● Rossetti, Dante Gabriel: **Helen of Troy**, 1863, Kunsthalle, Hamburg, Germany.
● West, Benjamin: **Helen Brought to Paris**, 1776, Smithsonian Institution, Washington DC, USA.

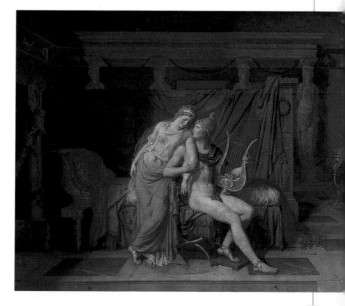

Hercules/Heracles
Superhuman hero and god

Hercules, known to the Greeks as Heracles, was the greatest of the legendary heroes. His life was filled with constant trials and hardships throughout which he demonstrated his superhuman strength, courage and endurance.

Hercules was the son of the mortal woman Alcmene and **Jupiter** – a union that caused Jupiter's wife, **Juno**, to persecute Hercules throughout his life. Hercules' divine powers were obvious from his birth, when he strangled two deadly snakes in his cradle.

As a young adult, Hercules faced a famous moral choice, widely represented in post-classical art, when he came to a crossroads and met two females personifying Virtue and Vice. Virtue's road was difficult and narrow but led to timeless fame, whilst Vice's road was easy, leading downwards to lazy, lustful pleasures. Hercules chose Virtue's path. But Hercules' trials had just begun, for after he married Megara and they had several children, Juno inflicted madness upon him and he killed them all. To purify himself he had to undertake whatever tasks King Eurystheus of the Argolid commanded. These became the famous Twelve Labours of Hercules, all of which he succeeded in performing.

The Twelve Labours of Hercules
1. to kill the Nemean Lion, whose skin Hercules then wore;
2. to kill the many-headed, snake-like Hydra of Lerna;
3. to capture the Ceryneian Hind, a stag with golden horns;
4. to capture the Erymanthian Boar;
5. to clean the filthy stables of King Augeas;
6. to kill the man-eating birds of Lake Stymphalus;
7. to capture the fire-breathing Cretan Bull;
8. to tame the man-eating horses of King Diomedes;
9. to capture the girdle of Hippolyta, Queen of the Amazons;
10. to capture the cattle of Geryon, a three-bodied monster;
11. to retrieve the Golden Apples growing in the garden of the Hesperides. This journey involved Hercules freeing **Prometheus**, wrestling with the giant Antaeus, and temporarily supporting the sky on his shoulders, so relieving Atlas who then fetched the apples;
12. to bring back Cerberus, the three-headed guard dog of the Underworld.

Hercules undertook other exploits, such as his wrestling match with the river god Achelous, his killing of the **centaur** Nessus and his retrieval of the beautiful Alcestis from the Underworld. A much-depicted episode involved Hercules' time spent with Omphale, Queen of Lydia, when the two lovers exchanged clothes.

Hercules' end came when he wore a poisoned cloak given to him by his second wife Deianeira, who had been given it by Nessus and who thought it was covered in love potion. Dying on his pyre, he was struck by lightning and taken up to heaven as a god.

Classical References:
Apollodorus 2.4.8–2.7.8; Euripides, *Alcestis*; Xenophon, *Memorabilia* 2.1.22; Ovid, *Fasti* 2.303–58, *Metamorphoses* 9.101–273.

Attributes:
Club; lion skin; bow and arrows.

Major Paintings:
▶ Reni, Guido: **Hercules and the Lernean Hydra**, 1620, Louvre, Paris, France.
● Ligare, David: **The Choice of Hercules between Pleasure and Virtue**, 1986, Koplin Gallery, Los Angeles, California, USA.
● Cézanne, Paul: **Abduction: Hercules and Alcestis**, *c.*1867, Fitzwilliam Museum, Cambridge, England.

Hercules, his dramatically lit, muscular body framed by his lion-skin cloak, swings his trademark
wooden club at the many-headed Hydra. Guido Reni was once considered second only to Raphael.

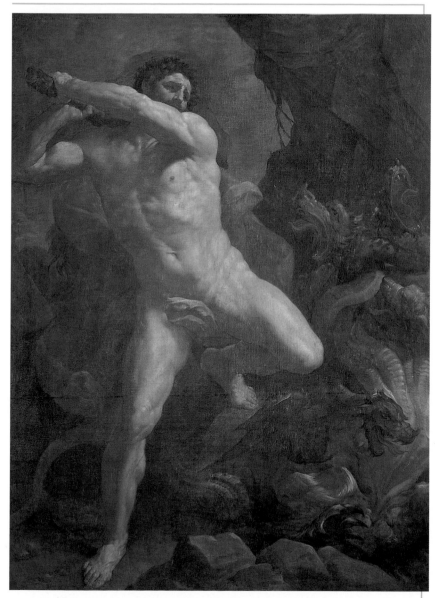

Hero and Leander

Tragic young lovers

Hero was a young priestess of **Venus** who lived in Sestos on the northern, European bank of the Hellespont (now known as the Dardanelles), the narrow straits at the entrance to the Black Sea. She fell in love with Leander, a handsome youth who lived across the water in Abydos on the southern, Asian shore.

Every night Leander would sneak away from his family and swim from Abydos to Sestos to be with Hero for the night. Leander was guided across the treacherous, fast-flowing water – some two miles wide – by a light which Hero would place at the top of a high tower. One stormy winter's night the wind blew out the lantern and, unguided, Leander lost his bearings and perished in the rough seas. At daybreak, Hero scanned the sea from the tower and saw her lover's lifeless body washed up on the shore. Utterly distraught, she threw herself off the tower and fell headlong to her death, her own body ending up next to Leander's.

This tragic tale has been extremely popular with artists, especially the Italian and Dutch painters of the seventeenth century. It has also

Classical References:

Virgil, *Georgics* 3.258–63; Ovid, *Heroides* 18, 19; Musaeus, *Hero and Leander.*

Attributes:

Tower; lantern.

Major Paintings:

- Feti, Domenico: **Hero and Leander**, 1622–23, Kunsthistorisches Museum, Vienna, Austria.
- Turner, Joseph Mallord William: **The Parting of Hero and Leander**, before 1837, NGL.
- Chassériau, Théodore: *detail from* **Hero and Leander**, *c.*1840–41, Louvre, Paris, France.

been celebrated by post-classical poets such as Byron, the great Romantic and philhellene, who in 1810 famously repeated the feat of swimming from Abydos to Sestos. Memory of the two young lovers is upheld by those who still attempt the challenge of swimming the Hellespont.

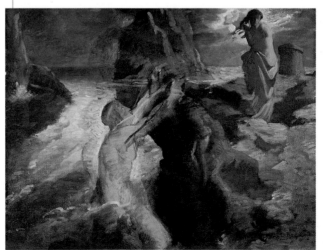

The French artist Chassériau, a pupil of Ingres, depicts Leander having swum the Hellespont and reaching the shore where his lover Hero awaits.

Hippolytus and Phaedra
Son of Theseus, and his stepmother

The tragic tale of Hippolytus, the son of the great Athenian hero **Theseus** by his mistress, the Amazon queen Antiope or Hippolyta, centres around his relationship with his stepmother Phaedra who fell in love with him.

There are two versions of the myth. The first characterizes Phaedra, the daughter of King Minos of Crete, as an immoral, manipulative woman. Having tried to seduce Hippolytus and been rejected, she then accused him of having attempted to rape her. Theseus, enraged at his son's behaviour, begged **Neptune** to punish him, and the god duly sent a monster from the sea causing Hippolytus' terrified horses to bolt, overturn his chariot and rip the entangled youth apart.

A second version sees Phaedra as the innocent victim. It is now Hippolytus who sins – his

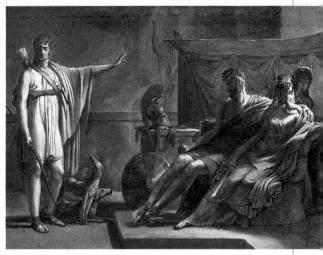

Hippolytus, devoted to Diana and a celibate life of hunting, rejected the advances of his stepmother Phaedra, whom Guérin depicts sword in hand in allusion to her later suicide. Phaedra's scheming nurse and King Theseus are also shown.

overwhelming devotion to **Diana**, the virgin goddess of the hunt, has led him to neglect the worship of **Venus**, goddess of love, who punishes Hippolytus by causing Phaedra to fall in love with him. Having struggled to overcome her passions, Phaedra confides in her nurse (called Ocnone by the French dramatist Racine in his 1677 influential play), who then tells a horrified Hippolytus. Phaedra, stung by his rejection, kills herself, leaving a letter accusing him of rape. Hippolytus, diplomatically remaining silent about his stepmother's true feelings, is cursed by his father. Consequently, the poignant ending is the same as in the first version – Hippolytus, thrown from his chariot, is dragged to his death.

This tragedy has attracted artists, its human passions contrasting with the unfeeling and manipulative role that the ancient gods were seen to play in the lives of mortals.

Classical References:

Euripides, *Hippolytus*; Seneca, *Phaedra*; Ovid, *Metamorphoses* 15.497–546, *Heroides* 4.

Attributes:

Hippolytus – hunting weapons and dog; chariot.
Phaedra – letter; knife.

Major Paintings:

▲ Guérin, Pierre-Narcisse: **Hippolytus before Phaedra and Theseus**, 1802, Louvre, Paris, France.
● Rubens, Peter Paul: **Hippolytus**, c.1611–12, Fitzwilliam Museum, Cambridge, England.
● Cabanel, Alexandre: **Phaedra**, 1880, Musée Fabre, Montpellier, France.

Homer
Greek epic poet

Homer is generally regarded as the earliest and greatest of all the Greek poets. Even in antiquity details of his life were disputed, but it is now thought that he lived sometime between 800 and 700 BC, born in the eastern Aegean perhaps on the island of Chios or at Miletus.

The ancient world attributed the monumental epic poems *The Iliad* and *The Odyssey* to Homer, although there is still a possibility that they were written by different poets. Some doubts remain as to whether Homer was the bard who composed and sang these poems from memory or was merely the scribe who first wrote down these undoubtedly oral poems.

The title of *The Iliad* derives from Ilion, an alternative name for the city of Troy which is the setting for the poem's story about the Greeks fighting the Trojans over the abduction of **Helen**, a Greek queen, by the Trojan prince **Paris**.

The sequel, *The Odyssey*, follows the ten-year trials and tribulations of the Greek hero Odysseus (**Ulysses**) as he tries to sail back home after the Trojan War.

Numerous tales, many obviously fabricated, were related about the life of Homer. Most famously, he was nearly always regarded as

Classical References:
Herodotus (attributed to), *Life of Homer*.

Attributes:
Blindness; laurel wreath or headband; musical instrument; books.

Major Paintings:
▽ Ingres, Jean-Auguste-Dominique: **The Apotheosis of Homer**, 1827, Louvre, Paris, France.
● Bouguereau, Adolphe William: **Homer and his Guide**, 1874, Milwaukee Art Museum, Wisconsin, USA.
● Rembrandt van Rijn: **Aristotle before the Bust of Homer**, 1653, NYMet.

being blind (uncannily like the bard Demodokos in Book 8 of *The Odyssey*), and many ancient and modern portraits of Homer focus on this trait. He is often shown wearing a laurel wreath, signifying artistic inspiration, or the simple philosopher's headband. Homer is also sometimes shown holding his two great books, or a lyre or, anachronistically, a violin, signifying the actual Greek practice of accompanying poetry with music. Other various fictional episodes from his life are also occasionally depicted by artists.

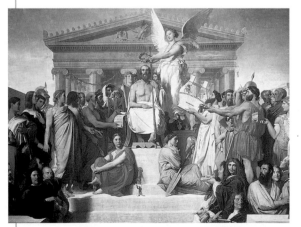

Winged Victory crowns Homer, seated above female personifications of *The Iliad* (with sword) and *The Odyssey* (with oar). The poet is surrounded by other great men of the arts, both ancient and modern, including Phidias, Apelles, Shakespeare, Michelangelo, Mozart and Poussin, the illustrious French neoclassical artist who points to Homer.

Horatii, The
Three patriotic Roman brothers

During the reign of King Tullus Hostilius of Rome (672–640 BC) a war broke out between Rome and her close neighbour Alba. To save lives on both sides it was decided that three Roman brothers, the Horatii, should fight three Alban brothers, the Curiatii. Two of the Horatii had been killed when the third brother, Publius Horatius, pretended to flee. The pursuing Curiatii became separated from one another at which point Horatius turned round and slew each in turn.

David's dramatic painting of the three Horatii brothers swearing an oath of loyalty to Rome upon their swords, which their father holds aloft while their sisters grieve, is widely regarded as the epitome of French neoclassicism.

Returning to Rome in triumph amid public acclaim, Horatius met his sister, who had been engaged to one of the Curiatii. She recognized the cloak over Horatius' shoulder as one she had made for her beloved and, realizing the awful truth, she was overcome with grief. Horatius was enraged by her tears for an enemy at the time of his triumph, and he promptly drew his sword and killed her. Horatius was put on trial and condemned to death for his actions, yet through the King's and his father's pleas, the people acquitted him. Horatius'

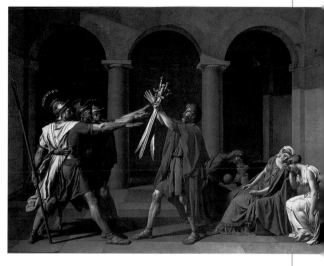

actions, whether real or legendary, became a symbol of Roman patriotism by which the State came before the individual.

Both the combat and Horatius' slaying of his unpatriotic sister have appealed to artists from the sixteenth century onwards. The Roman account was embellished in the seventeenth century by the French dramatist Corneille who gave the name Camille to Horatius' sister and had Horatius married to a sister of the Curiatii. In the eighteenth century the Frenchman C. Rollin's *Roman History* introduced the detail of the Horatii brothers swearing a loyalty oath in front of their father and sisters, an episode famously depicted by Jacques Louis David in his *Oath of the Horatii*.

Classical References:

Livy 1.23–26.

Attributes:

Battle, swords.

Major Paintings:

▲ David, Jacques Louis: **Oath of the Horatii**, 1784, Louvre, Paris, France.

● Lagrenée, Louis Jean François: **Horatius Killing his Sister**, 1753, Musée des Beaux-Arts, Rouen, France.

● Bordone, Paris: **The Battle of the Horatii**, c.1560?, Kunsthistorisches Museum, Vienna, Austria.

Io

Beautiful girl transformed into a cow by Jupiter

Io was the daughter of the river god Inachus, and her beauty was such that **Jupiter** fell in love with her. The Greek playwright Aeschylus says that Jupiter sent her sexually suggestive dreams that led to her being exiled and then turned into a cow by Jupiter or his wife **Juno**. The Roman poet Ovid tells the following better-known version.

Jupiter's passion for Io was so great that he pursued the frightened young girl across the countryside, bidding her to lie with him. Then covering the land with, or becoming, a dark cloud to conceal his subsequent actions from Juno, Jupiter accosted Io and made love to her. Sensing his wife's approach, Jupiter quickly turned Io into a beautiful white cow. Juno, suspicious of the heifer, requested her as a gift and then put her in the safe keeping of Argus, a hundred-eyed and ever-watchful guardian.

After a while, Jupiter could no longer bear for Io to suffer as a cow, so he sent his messenger **Mercury** to set her free. Disguised as a shepherd, Mercury lulled Argus to sleep by playing the panpipes and then cut off his head. However, Io was not free; before she could regain her former shape Juno, enraged at Argus' death and realizing the true identity of the cow,

immediately sent a gadfly or horsefly to constantly bite and torment her.

Io wandered far and wide over the Earth, driven wild by the gadfly. She even crossed the straits between Europe and Asia, later called the Bosphorus ('Cow's Ford'). When Io reached Egypt, Juno relented and Io was restored to her human form, and was thereafter worshipped as the Egyptian goddess Isis.

Classical References:

Aeschylus, *Prometheus Bound* 561–886; Ovid, *Metamorphoses* 1.583–663, 724–50.

Attributes:

Water jar (as daughter of a river god); cloud; horns; cow.

Major Paintings:

▼ Velázquez, Diego Rodriguez de Silva: **Mercury and Argus**, 1659, Prado, Madrid, Spain.

● Correggio, Antonio: **Io**, 1531–32, Kunsthistorisches Museum, Vienna, Austria.

● Gandolfi, Ubaldo: **Mercury Lulling Argus to Sleep**, *c*.1770–75, North Carolina Museum of Art, Raleigh, North Carolina, USA.

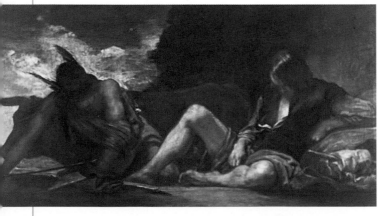

Mercury creeps up to kill sleeping Argus while, in the background, Io in the shape of a cow waits to be set free.

Iphigenia

Legendary princess sacrificed for the Trojan War

Iphigenia was the daughter of Clytemnestra and Agamemnon, King of Mycenae in Greece. She was only a young girl when, upon the advice of the prophet Calchas, her father agreed to sacrifice her to the goddess **Diana** to placate Diana's anger. The reason behind Diana's anger at Agamemnon is unclear, but the goddess was preventing the Greek fleet, led by Agamemnon, from sailing from the port of Aulis in Greece to Troy to begin the Trojan War.

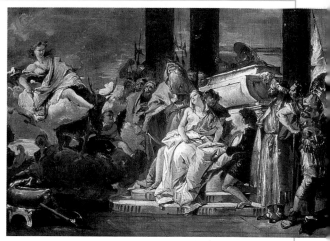

The human and divine drama of Iphigenia's sacrifice gives it a strong emotional appeal for artists and viewers alike.

Iphigenia was summoned to Aulis on the pretence that she was to be married to the great hero **Achilles**, but there found a sacrificial altar waiting for her. A few ancient sources say that

Classical References:

Homer, *Iliad* 9.145; Euripides, *Iphigenia in Aulis, Iphigenia in Tauris*; Ovid, *Metamorphoses* 12.24–38.

Attributes:

Altar; sacrificial instruments; deer.

Major Paintings:

- Tiepolo, Giovanni Battista, studio of. **Sacrifice of Iphigenia**, *c*.1735, University of Tucson, Arizona, USA.
- Steen, Jan: *detail from* **Sacrifice of Iphigenia**, 1671, Rijksmuseum, Amsterdam, Netherlands.
- West, Benjamin: **Pylades and Orestes Brought as Victims before Iphigenia**, 1766, Tate Britain, London, England.
- Leighton, Lord Frederick: **Cymon and Iphigenia**, *c*.1884, Art Gallery of New South Wales, Sydney, Australia.

she was actually killed but many state that at the very moment the priest drew his knife across her neck a deer, a symbol of Diana, was substituted in her place. Iphigenia found herself whisked away and set down in Tauris, the Crimean peninsula in the Black Sea, where she became a priestess of Diana.

Many years later, Iphigenia recognized two strangers who had landed on Tauris. They were her long-lost brother, Orestes, and his friend Pylades, but instead of sacrificing them as the savage king Thoas demanded, she fled with them across the sea to Greece taking the cult statue of Diana with her.

Another Iphigenia, frequently painted from the Renaissance onwards, is a non-classical character from Boccaccio's *Decameron*, a medieval collection of tales. She was spied sleeping in a meadow by Cymon, a coarse, uneducated youth, but through their love he became a refined gentleman.

Jason
Leader of the Argonauts searching for the Golden Fleece

The story of Jason and his sea voyage with the Argonauts to find the Golden Fleece is one of the most famous of all ancient myths.

When Jason was a baby, his father Aeson, the rightful King of Iolcus in Greece, was deposed by his half-brother Pelias. Aeson, fearing for Jason's life, sent him away to be brought up by the wise **centaur** Chiron. Years later Jason returned to claim the throne from his uncle. He entered the city with just one sandal on his foot, so identifying himself to Pelias who had been warned that a person wearing one shoe would be his downfall.

Pelias, realizing his precarious position, set Jason a challenge from which he thought his rival would never return – to bring back the Golden Fleece from the land of Colchis on the Black Sea. This was the fleece of a golden, flying ram which had rescued the young twins Phrixus and Helle from their murderous stepmother and had flown them over the sea to Colchis (although Helle had tragically fallen into the straits later called the Hellespont, 'Helle's Sea'). The Golden Fleece was hung in a sacred grove in Colchis where it was guarded by a dragon.

Jason assembled a crew of Greek heroes, including **Hercules** and **Theseus**, and in the

ship *Argo* the Argonauts set sail on their quest. They encountered many adventures en route such as ridding the blind prophet Phineus of the Harpies ('Snatchers'), winged monsters which continually stole his food, and sailing through the treacherous Clashing Rocks.

When the Argonauts arrived in Colchis, King Aeetes agreed to let Jason take the Fleece if he succeeded in another challenge – to yoke two bronze-hoofed, fire-breathing bulls, plough and

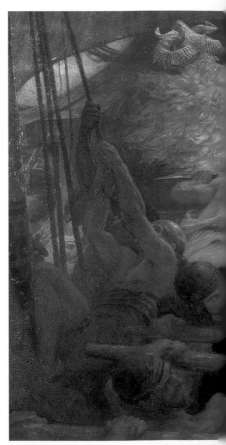

Classical References:
Pindar, *Pythian Ode* 4; Apollonius of Rhodes, *Argonautica*.

Attributes:
Golden Fleece; helmet and sword.

Major Paintings:
▶ Draper, Herbert James: **The Golden Fleece**, 1904, Bradford Art Galleries, Bradford, England.
● Moreau, Gustave: **The Return of the Argonauts**, 1890–97, Musée Gustave Moreau, Paris, France.
● Toutain, Pierre: **Jason Presenting the Golden Fleece in the Temple of Jupiter**, 1681, Louvre, Paris, France.
● Beckmann, Max: **The Argonauts**, 1949–50, NGADC.

sow the ground with dragon's teeth, and fight the men that would spring up. With the help of the king's daughter, **Medea**, who had fallen in love with him, Jason triumphed by using a protective ointment. Then, killing (or drugging) the guardian dragon, Jason took the Golden Fleece and sailed for home with Medea. She delayed her father's pursuing fleet by cutting up her brother, Apsyrtus, and throwing pieces of his body overboard.

After running the gauntlet of the Sirens and the giant bronze man, Talus, they reached home. Medea killed Pelias, and Jason fled with her to Corinth where Jason left her for another. Jason eventually met his death when he was struck by a beam falling from the *Argo*.

Jason, clutching the Golden Fleece, urges the Argonauts forward while Medea orders her brother to be thrown overboard to delay her father's pursuing fleet.

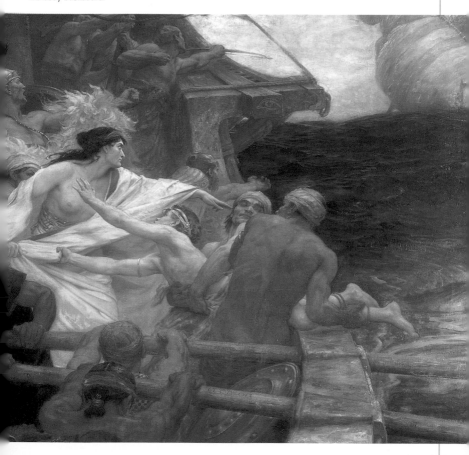

Juno/Hera
Queen of heaven

Juno, the Roman equivalent of the Greek goddess Hera, was both the sister and the wife of **Jupiter**, king of the gods, and was considered the Queen of heaven. Given her role as Jupiter's wife, she was worshipped as the goddess of marriage and childbirth.

In myth, Juno's main characteristic is one of jealousy and vindictiveness; she was a constant victim of her husband's infidelities, and persecuted not just his lovers but also his children from those relationships. Thus she punished **Callisto** by changing her into a bear, **Echo** by robbing her of speech, and Semele, the mother of **Bacchus**, by suggesting she ask to see Jupiter in his full, but lethal, glory as a bolt of lightning. Juno's fury at Bacchus even stretched to those who reared him, Ino and Athamas, driving

the couple mad so that they killed their own children.

Juno reserved special hatred for **Hercules**, born of Alcmene by Jupiter. One legend tells of how Juno was tricked into suckling the newborn Hercules. When the baby revealed its superhuman strength and real identity by his violent sucking, Juno tore him away from her breast, splashes of milk flying up into the sky and forming our galaxy, the Milky Way. Juno continued to afflict Hercules throughout his life, until Jupiter punished her by suspending her from Mt. Olympus, her hands tied by golden chains and her feet weighed down by anvils – Juno, in allegories, thus representing Air.

Juno's main attributes were a crown and sceptre designating her position among the gods, a magic belt or girdle given to her by **Venus** to make her more seductive, and peacocks relating to the tale of Argus. Argus was a hundred-eyed, ever-vigilant monster to whom Juno gave the task of guarding **Io**, another of her husband's lovers but now in the shape of a cow. Jupiter, however, commanded **Mercury** to kill Argus and release Io. Juno was so saddened by his death that she put all his eyes on the tails of peacocks which then pulled her chariot through the heavens.

In retaliation for losing the divine beauty contest judged by the Trojan prince **Paris**, Juno fought against the Trojans in the Trojan War. In a famous episode, she helped the Greeks by diverting Jupiter's attention from the fighting by seducing him on Mt. Ida.

Classical References:

Hesiod, *Theogony* 921–29; Homer, *Iliad* 14.153–351, 15.18–21; Ovid, *Metamorphoses* 1.722–23; Diodorus Siculus 4.9.

Attributes:

Crown; sceptre; chariot; peacocks.

Major Paintings:

- Veronese, Paolo: **Juno Pouring Gifts over Venice**, 1553, Palazzo Ducale, Venice, Italy.
- Tintoretto, Jacopo: **Origin of the Milky Way**, *c.*1575–80, NGL.
- Barry, James: **Jupiter and Juno on Mt. Ida**, *c.*1790?, City Art Galleries, Sheffield, England.
- Rubens, Peter Paul: **Argus and Juno**, *c.*1610–11, Wallraf-Richartz Museum, Cologne, Germany.

Juno recoils at the strength of the baby Hercules, held by Jupiter, drops of her milk splashing up to form the Milky Way.

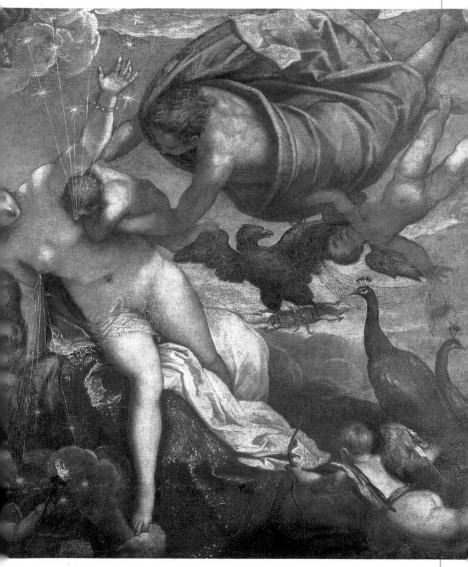

Jupiter/Zeus

The king of the classical gods

Jupiter or Jove, the Roman equivalent of the Greek Zeus, was the mighty king of all the classical gods. He and the other major gods ruled from Mt. Olympus in northern Greece and so were known as the Olympians. According to the influential Greek poet Hesiod the Olympians were twelve in number: Jupiter, the supreme being; his siblings **Juno**, **Neptune** and **Ceres**; his children **Apollo**, **Bacchus**, **Diana**, **Mars**, **Mercury**, **Minerva** and **Vulcan**; and sea-born **Venus**. However, other ancient sources add or substitute other deities to the Olympian dynasty including Jupiter's brother, **Pluto** and sister, Vesta.

Jupiter became the ruler of gods and men after overthrowing his tyrannical father, **Saturn**, who had swallowed Jupiter's five elder brothers and sisters in an attempt to avoid being overthrown. Jupiter himself had been swapped at birth, by his mother Rhea, for a stone wrapped in blankets, which his father promptly swallowed believing it to be Jupiter. Jupiter was raised by the **nymphs** on Mt. Ida or Mt. Dicte on Crete, nourished by the she-goat Amalthea. When grown, he made his father vomit up all the children he had devoured – Vesta, Juno, Ceres, Pluto and Neptune – and, with their help, overthrew Saturn. Jupiter was now acknowledged as the king of the gods and the major realms of the Earth were

Classical References:

Hesiod, *Theogony*; Ovid, *Fasti* 5.111–28.

Attributes:

Throne; scepter; lightning-bolt; eagle.

Major Paintings:

▶ Ingres, Jean-Auguste-Dominique: **Jupiter and Thetis**, 1811, Musée Granet, Aix-en-Provence, France.

● Giulio Romano: **Gods of Olympus**, *c.*1527–30, Palazzo del Te, Mantua, Italy.

● Poussin, Nicolas: **The Infant Jupiter Nurtured by the Goat Amalthea**, *c.*1638, Dulwich Picture Gallery, London, England.

divided among them. Jupiter presided over the heavens; Juno became his queen; Ceres was goddess of the land and crops; Neptune ruled over the seas; Pluto was king of the Underworld; and Vesta, the quietest and most stable of the gods, ruled over people's hearth and home. Jupiter, as ruler of the heavens, controlled the weather and was particularly associated with rainstorms, thunder and lightning. His power and authority were expressed both by the lightning bolt, which only he could wield, and by the eagle, a great and noble bird which soars close to heaven. These two attributes were not just Jupiter's symbols but were at times thought to personify him. Jupiter (his name related to the Latin *deus-pater* or 'father-god') was also regarded as the 'father' of mortals and protector of law and justice. However, even Jupiter was subject to the decrees of the **Fates**.

Jupiter's love affairs with gods, nymphs and mortals were numerous and often deceptive. Jupiter sometimes changed shape either to hide from Juno or get close to his lovers. Thus, he ravished **Callisto** in the guise of the goddess Diana, **Danae** as a shower of gold, **Europa** as a bull, **Io** as a cloud, **Leda** as a swan and Antiope as a **satyr**; and carried off **Ganymede** while in the form of an eagle.

Jupiter's power and majesty reverberate throughout Ingres' magnificent painting of the king of the gods. Jupiter, his enthroned pose modelled on that of the statue of Zeus at Olympia, one of the seven wonders of the ancient world, is begged by Thetis to help her son Achilles in the Trojan War.

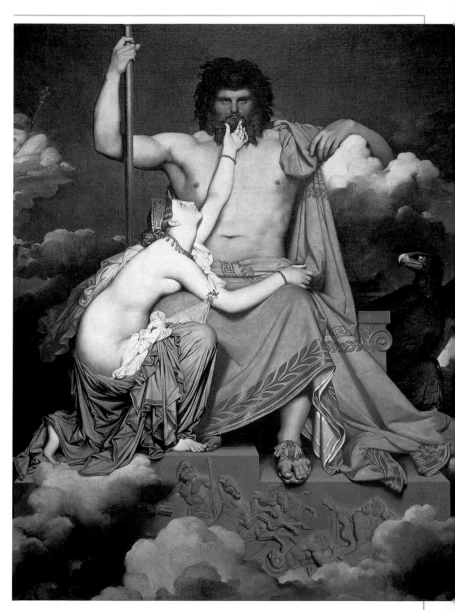

Leda and her sons Castor and Pollux

Legendary queen beloved of a swan, and her heavenly twins

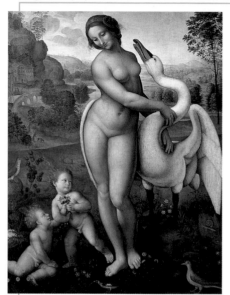

One of several copies of Leonardo's lost original, this painting shows Leda and her beloved swan standing over their children Castor and Pollux, who were hatched from an egg.

Castor and Pollux, Leda's sons, also known as the Dioscuri or Heavenly Twins, were famed horsemen, and took part in many Greek myths. They also reputedly appeared to, and helped, the Romans at the Battle of Lake Regulus in 496 BC after which a famous temple was dedicated to them in the Roman Forum.

Their most infamous adventure, well represented in post-classical art, involved their rape of their cousins, Hilaeira and Phoebe, the daughters of Leucippus. Castor and Pollux died in the ensuing battle, but Jupiter transformed them into the constellation of Gemini. They were also the patrons of ancient sailors to whom they appeared as the flickers of light which play around ships' masts in storms, an electrical atmospheric phenomenon now known as St. Elmo's Fire.

Leda was the wife of the Spartan King Tyndareus. One day she was seen bathing in the River Eurotas by **Jupiter** who was struck by her beauty. Jupiter devised a plan to win Leda's affections. He changed himself into a swan while **Venus**, goddess of love, changed herself into an eagle. Both birds began to swoop and dive around Leda, the eagle chasing the swan. Jupiter finally sought refuge in the arms of Leda who hugged and caressed the frightened white swan, and so Jupiter was able to avail himself of naked Leda's charms.

Nine months later Leda gave birth to two eggs. From these hatched four children – **Helen**, whose beauty caused the Trojan War; Clytemnestra, who married and murdered Agamemnon, the leader of the Trojan expedition; and Castor and Pollux. Castor and Clytemnestra were usually said to be the mortal children of Leda's husband Tyndareus, while Helen and Pollux were the immortal children of Jupiter.

Classical References:

Homer, *Odyssey* 11.298–304; Euripides, *Helen* 6–21, 213–16, 256–59; Ovid, *Fasti* 5.699–720; Apollodorus 1.8, 3.10–13; Pliny, *Natural History* 2.101.

Attributes:

Leda – swan. Castor and Pollux – horses; star.

Major Paintings:

▲ after Leonardo da Vinci: **Leda and the Swan**, 16th century, Galleria Borghese, Rome, Italy.

● Correggio, Antonio: **Leda**, c.1525, Gemäldegalerie, Berlin, Germany.

● Daingerfield, Elliot: **Leda and the Swan**, c.1900, The Parthenon, Nashville, Tennessee, USA.

● Rubens, Peter Paul: **The Rape of the Leucippidae**, c.1616, Alte Pinakothek, Munich, Germany.

Lucretia
Tragic Roman heroine

The story of the rape of Lucretia, a virtuous Roman wife, and her subsequent suicide was not just a personal tragedy but also the spark that led to the overthrow of the Roman kings and the foundation of the Roman Republic in 510 BC.

During the reign of King Tarquinius Superbus, the Romans were besieging the nearby city of Ardea. During a lull the King's son, Sextus, and his companions discussed the merits of their wives. Collatinus was so certain of his wife's virtue, that he proposed they all ride back to Rome immediately and see what their wives were up to in their absence. All the other men found their wives enjoying a banquet but Collatinus found his wife, Lucretia, hard at work spinning wool. Sextus was impressed not only with her industriousness but also with her beauty. Some days later when Collatinus was away, Sextus broke into Lucretia's bedroom and raped her, threatening that if she resisted he would kill her and a male servant, and claim that he had caught them together and avenged her husband's honour.

The next day, Lucretia revealed all to her father, her husband, and his friend Brutus before plunging a dagger into her heart and falling dead. Brutus led the Roman people to expel the King and his family from Rome; Sextus was subsequently killed. The Roman Republic, presided over by two elected consuls, was then established in the place of monarchy. Lucretia was thereafter regarded as a model of Roman industry and virtue, popular with poets and artists alike.

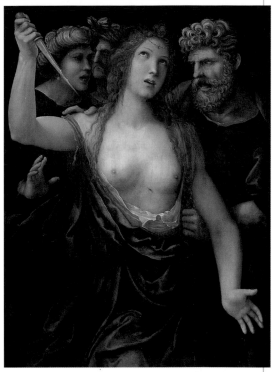

Lucretia's suicide, prompted by her rape, is witnessed by Brutus who swears revenge on the kings of Rome.

Classical References:
Ovid, *Fasti* 2.725–852; Livy 1.57–59.

Attributes:
Sword or dagger.

Major Paintings:
▲ Sodoma: **Death of Lucretia**, *c.*1513, Galleria Sabauda, Turin, Italy.
● Titian: **Suicide of Lucretia**, 1515, Kunsthistorisches Museum, Vienna, Austria.
● Rembrandt van Rijn: **Lucretia**, 1664, NGADC.

Mars/Ares
God of war

Mars was the Roman equivalent of the Greek war god Ares. He was aggressive and cruel, delighting in blood and slaughter, and so, although one of the twelve major Olympian gods, he was little worshipped in Greece. In contrast, the Romans held Mars in high regard, not just because they were constantly expanding their empire through war, but also since Mars was the father of Rome's legendary founders, **Romulus and Remus**. These divergences in Mars' cult also extended to his parentage; whereas the Greeks believed Mars was the son of **Jupiter** and **Juno**, the Romans thought Juno conceived him through the touch of a magic herb given to her by **Flora**.

Mars' belligerent nature meant he played a prominent role in the Trojan War, as famously told in *The Iliad* by **Homer**. Mars fought on the side of the Trojans, who were eventually beaten by the

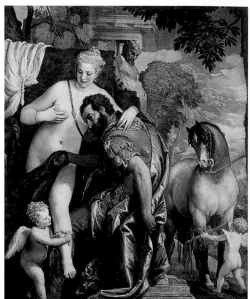

Mars' war horse is kept at bay so Mars and Venus, assisted by their children, can indulge their passion.

Classical References:

Homer, *Iliad* especially 5.825–909, 21.391–433; Hesiod, *Theogony* 933–37; Ovid, *Metamorphoses* 4.171–89.

Attributes:

Weapons and armour; chariot.

Major Paintings:

▲ Veronese, Paolo: **Mars and Venus United by Love**, c.1570–80, NYMet.

● Poussin, Nicolas: **Mars and Venus**, 1626–28, Museum of Fine Arts, Boston, Massachusetts, USA.

● Botticelli, Sandro: **Mars and Venus**, 1483–85, NGL.

● Rubens, Peter Paul: **The Horrors of War**, 1637–38, Palazzo Pitti, Florence, Italy.

Greeks. During the war, he was also beaten in two duels with **Minerva**, goddess of wisdom, a symbolic victory that is often emphasized in post-classical painting, where the joint depiction of Minerva and Mars is an allegory of Civilization and Arts overcoming Barbarity and War.

Mars had many love affairs, the most notable with **Venus**, wife of **Vulcan**. Although eventually both were caught in a snare by Vulcan, their union produced four children – **Cupid**, Harmony, Fear and Terror. This affair has inspired the majority of paintings depicting Mars; his armaments are often shown being cast aside in favour of the gentler charms of Venus – Aggression vanquished by Love.

Marsyas and Midas

Musical satyr and a king who turned all to gold

Marsyas was a **satyr** from Phrygia who was renowned for his skill in playing the double pipes, a type of flute. He had learned to play them when **Minerva**, their inventor, threw them away because they made her cheeks puff out. Marsyas was so confident of his musical talent that he challenged the god of music, **Apollo**, to a contest.

They agreed that the winner could choose the loser's forfeit, and they chose the **Muses** as judges. Apollo finally triumphed since he could play his lyre upside down. Marsyas, as a punishment for his arrogance in daring to challenge a god, was then hung from a tree and skinned alive. The tears of the other satyrs and **nymphs** flowed together to form the River Marsyas, a tributary of the River Meander.

Frequently depicted in ancient art, this myth was revived by Renaissance painters for whom the rivalry between wind and stringed instruments symbolized that between sensual and intellectual forms of music.

This musical contest between Apollo and Marsyas is sometimes confused with another between Apollo and the god **Pan**. In this, Apollo was again the winner but Midas, the King of Phrygia, doubted the decision and as a punishment Apollo transformed his ears into those of an ass; thus depicted, Midas is sometimes included in post-classical paintings of Apollo and Marsyas.

Midas is, of course, best known for the myth that everything he touched turned to gold. This apparent blessing was bestowed on Midas by **Bacchus** after he helped one of the wine god's followers, but Midas found it a curse when his

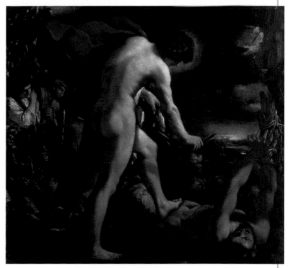

Apollo skins the satyr Marsyas for daring to challenge him to a musical contest.

food and drink turned into metal. He rid himself of this 'gift' by bathing in the Pactolus, a river renowned for bearing gold.

Classical References:

Ovid, *Metamorphoses* 6.382–400, 11.85–193, *Fasti* 6.695–710.

Attributes:

Marsyas – flute; panpipes. Midas – crown; ears of an ass.

Major Paintings:

▲ Guercino: **Apollo Flaying Marsyas**, *c.*1591–1666, Palazzo Pitti, Florence, Italy.

● Titian: **The Flaying of Marsyas**, 1575–56, State Museum, Kromeriz, Czech Republic.

● Raphael: **Apollo and Marsyas**, 1509–11, Stanza della Segnatura, Vatican, Italy.

● Poussin, Nicolas: **Midas Washing at the Source of the Pactolus**, 1624, NYMet.

Medea
Sorceress and lover of Jason

Medea was the daughter of King Aeetes of Colchis and, like her aunt **Circe**, was a sorceress. She fell in love with and helped **Jason** in his quest to gain the Golden Fleece. Medea not only provided an ointment to prevent him being hurt by two fire-breathing bulls, but also cast an enchanted sleep over the dragon guarding the Fleece. As promised, Jason took her with him on his return voyage, on which she notoriously cut up her brother Apsyrtus and scattered his pieces in their wake to slow down her pursuing father.

In Jason's home of Iolcus, Medea applied her magic arts to help Jason try and reclaim his throne from his uncle Pelias. In front of Pelias' daughters she killed and boiled a ram (or, in some versions, Jason's father) with magical herbs; the ram then emerged from the pot rejuvenated. Promising she would do the same for Pelias, she persuaded his daughters to kill and boil their father – but Medea substituted powerless herbs, spelling the end for Pelias.

Medea fled with Jason to Corinth where they spent many years and had two or three children. Jason then left Medea to marry Glauce (also known as Creusa), the daughter of Creon, King of Corinth. Medea exacted a terrible revenge, powerfully dramatized by the Greek playwright Euripides. She sent Glauce a robe as a wedding present, but it was poisoned, and killed both Glauce and her father Creon. Then Medea, after agonizing over what to do next, killed her children so as to make Jason suffer the ultimate grief.

Some tales end with Medea returning home to Colchis, but in Euripides' famous climax Medea's grandfather, the sun god Helios, sends a serpent-drawn chariot to rescue Medea.

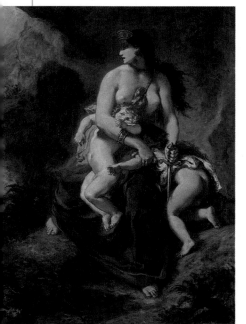

A distraught Medea prepares to murder her children to exact revenge on her husband Jason.

Classical References:
Euripides, *Medea*; Ovid, *Metamorphoses* 7.1–452.

Attributes:
Potions; cup; cauldron; ram; knife; chariot.

Major Paintings:
◁ Delacroix, Eugène: **The Fury of Medea**, 1862, Louvre, Paris, France.

● Sandys, Frederick: **Medea**, *c.*1890?, Birmingham Museum and Art Gallery, Birmingham, England.

● Draper, Herbert James: **The Golden Fleece**, 1904, Bradford Art Galleries, Bradford, England.

● Turner, Joseph Mallord William: **Vision of Medea**, 1828, Tate Britain, London, England.

● Vassallo, Antonio Maria: **Medea**, 1637, Uffizi, Florence, Italy.

Medusa

Monstrous Gorgon whose looks turned people to stone

Caravaggio's frightful depiction of Medusa is
painted upon Cosimo II de Medici's tournament
shield so as to terrify the prince's opponents.

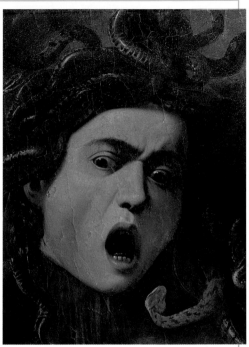

Medusa was one of the three Gorgons
and, like her sisters Stheno and Euryale,
was of terrible appearance. In place of
their hair grew writhing snakes, from
their mouths grew tusks, and they had
hands of bronze and wings of gold. So
terrifying were they, that anyone who
looked at them was instantly 'petrified' –
literally 'turned to stone'.

The Gorgons' dreadful appearance
resulted in models of them being placed
on ancient Greek temples, shields and so
on, to act as charms for scaring away
evil. Medusa's fame, however, is derived
from her central, albeit unwitting, part
in the myth of **Perseus**. In this tale
Perseus' mission was to behead
Medusa, which he achieved by not
looking directly at the Gorgon but looking
at her reflection in a shield given to him
by **Minerva**. From Medusa's severed
neck sprang the winged horse **Pegasus**
and Chrysaor, a being of unspecified
appearance. Medusa's head was taken by
Perseus and as he flew across Libya drops of
her blood fell onto the sands below, creating the
many snakes that live in that region. Perseus later
used her grisly head to turn his enemies Phineus
and Polydectes to stone.

Finally, Medusa's head was given by Perseus
to Minerva, who placed it either on her shield or
on her *aegis*, a goatskin cloak or breastplate, to
scare off enemies. Minerva also gave Asclepius,
god of healing, some of Medusa's blood – drops
from her left side (traditionally equated with bad
luck and all things 'sinister' – Latin for 'left')
causing harm, and drops from her right side
restoring life.

Classical References:

Hesiod, *Theogony* 270–81; Pindar, *Pythian Ode* 12.6–27; Ovid,
Metamorphoses 4.614–20, 772–804.

Attributes:

Terrifying face; head entwined with snakes; occasionally wings.

Major Paintings:

▲ Caravaggio: **Medusa**, 1598–99, Uffizi, Florence, Italy.

● Maffei, Francesco: **Perseus Cuts off Medusa's Head**,
 *c.*1650, Accademia, Venice, Italy.

● Vedder, Elihu: **Head of Medusa**, 1878, San Diego
 Museum of Art, California, USA.

● Burne-Jones, Edward: **Birth of Pegasus and Chrysaor
 from the Blood of Medusa**, 1876–85, Southampton City
 Art Gallery, Southampton, England.

Mercury/Hermes
Messenger of the gods

Mercury, one of the twelve main Olympian gods, was identified by the Romans with the Greek god Hermes and his chief role was to act as the messenger of the gods. The son of **Jupiter** and Maia, Mercury was born in a cave in **Arcadia** in Greece. His inherent crafty nature was revealed on the day of his birth when he stole fifty cattle belonging to **Apollo** and hid their tracks by driving them backwards. When finally detected, Mercury pacified Apollo by giving him a lyre

The crafty messenger-god Mercury, in his characteristic winged sandals and helmet, instructs Cupid in the art of mischief, whilst the infant's mother Venus stands by.

which he had just created from a tortoiseshell, and he became the keeper of the divine herds.

Consequently, Mercury became the god of flocks and herds on Earth (a function shared with **Pan**), and was closely linked with their fertility and hence their owners' prosperity. Thus, to bring good luck, Greeks and Romans put up pillars, known as 'herms' (after Hermes), which were sculpted just with Mercury's head and a phallus.

Mercury was the patron god of traders, thieves, travellers and athletes, and conducted dead souls to the Underworld. He was also the god of eloquence, since his speech was cunning and skilful.

With his herald's staff (caduceus), winged helmet and sandals, Mercury is immediately recognizable in art. He was involved in parts of many myths, but artists have been particularly attracted to his role in the following: the Judgement of **Paris**; killing Argus, the guardian of **Io**; falling in love with Herse and turning her jealous sister, Aglauros, to stone; being welcomed into the humble house of pious **Philemon and Baucis** when in disguise with Jupiter; and teaching **Cupid** the art of eloquence.

Classical References:

Homer, *Odyssey* 5.42–149; *Homeric Hymn to Hermes*; Ovid, *Fasti* 5.665–91, *Metamorphoses* 2.708–832.

Attributes:

Herald's staff twined with snakes; winged hat; winged shoes.

Major Paintings:

◄ Correggio, Antonio: *detail from* **Mercury with Venus and Cupid (The School of Love)**, *c.*1525, NGL.

● Tiepolo, Giovanni Battista: **The Olympus**, *c.*1661–64, Prado, Madrid, Spain.

● Carracci, Annibale: **Mercury and Paris**, 1597–1600, Galleria Farnese, Rome, Italy.

● Boucher, François: **Mercury Confiding the Infant Bacchus to the Nymphs**, *c.*1732–34, Wallace Collection, London, England.

Minerva/Athena
Goddess of wisdom, crafts, arts and rational warfare

Minerva was the Roman equivalent of the Greek goddess Athena. Minerva, one of the twelve major Olympian deities, was the daughter of **Jupiter** and his first wife Metis ('Intelligence'). Minerva's birth was unusual since Jupiter had swallowed his pregnant wife after being warned that he would be overthrown by her second child; however, when it was time for the first child, Minerva, to be born, the god **Vulcan** struck Jupiter's head with an axe and out sprang an adult Minerva, fully armed.

As a goddess of warfare, Minerva distinguished herself from **Mars**, the god of war, by only sanctioning force when it was a necessary protection. Thus, she was the patron goddess of many cities, including Athens,

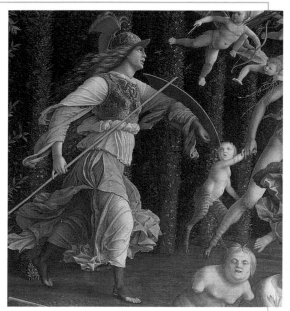

An armed Minerva, in her role as patroness of wisdom and the arts, chases the uncouth Vices from the Garden of Virtue.

where the Parthenon was her temple. Athens was named after her in honour of her victory over **Neptune** in a contest or dispute over the patronage of the city – Athena offered the olive, Neptune offered sea water, and the citizens of Athens chose Athena as her gift was more beneficial. Minerva was also the protector of many heroes, including **Ulysses**, **Jason**, **Hercules** and **Perseus**, the latter giving her the head of the Gorgon **Medusa** to place upon her *aegis*, a goatskin cloak or breastplate.

Minerva was also the patron of many crafts and arts, from spinning and weaving to carpentry and pottery. Her jealousy of Arachne's skill in weaving drove her to punish the girl and finally change her into a spider, a natural weaver.

Minerva was also the personification of Wisdom, her symbols being the owl and books. Thus she often accompanied the **Muses** and was a guardian against vice.

Classical References:
Hesiod, *Theogony* 886–900; Homer, *Odyssey* 13.221–310; Ovid, *Metamorphoses* 6.4–145.

Attributes:
Helmet and weapons; breastplate with Gorgon's head; owl; olive tree.

Major Paintings:
- Klimt, Gustav: **Pallas Athena**, 1898, Kunsthistorisches Museum, Vienna, Austria.
- Mantegna, Andrea: *detail from* **Minerva Expelling the Vices**, 1504, Louvre, Paris, France.
- Hallé, Noël: **The Dispute over Athens**, 1748, Louvre, Paris, France.
- Velázquez, Diego Rodriguez de Silva: **The Spinners (the Fable of Arachne)**, 1657, Prado, Madrid, Spain.

Minotaur, The
Half-man, half-bull

The Minotaur was a mythical hybrid creature with the body of a man but the head, horns and tail of a bull. He was the product of the unusual union between Pasiphae, wife of King Minos of Crete, and a bull sent by **Neptune**. Pasiphae's lust for the bull was caused by Neptune, who was angry at Minos for not sacrificing the fine beast, as he had promised, in return for the sea god's help in securing the Cretan throne.

Pasiphae persuaded the skilled craftsman **Daedalus** to build her a hollow wooden cow in which the queen then placed herself to be mated with Neptune's bull. Pasiphae gave birth to a half-human, half-bull creature known as the Minotaur ('Minos' bull'). The creature was shut away in a dark underground maze known as the Labyrinth, built by Daedalus.

Each year the Minotaur was fed seven young men and seven girls brought from Athens as a tribute to King Minos. One year, the human sacrifices included the Athenian prince **Theseus**, who killed the Minotaur and escaped the Labyrinth with the help of Minos' daughter Ariadne.

The word 'labyrinth' derives from *labrys*, an ancient Greek word meaning a double-headed axe. This axe and the bull were important religious symbols to the Bronze Age peoples of Crete, known as Minoans after their legendary king. It is also intriguing that many Minoan palaces on Crete have many twisting and turning passages. A mix of all these elements would seem to be present in the legend of the Minotaur.

The Minotaur has given great scope for artists and sculptors, especially in the twentieth century. The tortured mind of the beast is superbly represented in works by Picasso and Ayrton.

The celebrated English painter and sculptor George Watts imbues the Minotaur with a sense of sadness, as he gazes out over the sea – perhaps longing for his liberation from both his monstrous shape and his prison, the Labyrinth.

Classical References:
Ovid, *Metamorphoses* 8.169–73, *Heroides* 10.101–02; Plutarch, *Life of Theseus* 1.15–19; Virgil, *Aeneid* 5.588–91.

Attributes:
Human body with bull's head; labyrinth.

Major Paintings:
▲ Watts, George Frederick: **The Minotaur**, 1885, Tate Britain, London, England.
● Loo, Carle van: **Death of the Minotaur**, 1746, Musée des Beaux-Arts, Nice, France.
● Picasso, Pablo: **Minotaur Caressing a Sleeping Woman**, 1933, San Diego Museum of Art, California, USA.

Muses, The

Goddesses of creative inspiration

The nine Muses gave inspiration to all poets, artists and thinkers. They were traditionally the daughters of **Jupiter** and his nine consecutive nights of passion with the Titan Mnemosyne ('Memory'). Originally **nymphs** of sacred springs in Greece whose waters gave inspiration, such as Hippocrene on Mt. Helicon and the Castalian spring on Mt. Parnassus, the Muses assimilated these creative powers. They became the attendants of **Apollo** in his role as god of music and the arts. They presided over particular spheres of influence and had attributes which were not always consistent in antiquity. However, since the Renaissance, artists have generally given the Muses the attributes as listed by Cesare Ripa in his influential *Iconologia* (1593), an alphabetical directory of signs and symbols.

The nine Muses, their functions and attributes are:

Calliope ('Beautiful Voice'): Muse of epic poetry and eloquence – trumpet; tablet and stylus; books; laurel crown in hand.

Clio ('Renown'): Muse of history – books; scroll; tablet and stylus; swan; trumpet; laurel crown in hand.

Polyhymnia or Polymnia ('Many Songs'): Muse of hymns and mimes – small organ or other instruments.

Classical References:

Hesiod, *Theogony* 1–115, 915–17.

Attributes:

See main text.

Major Paintings:

- Vouet, Simon: **Parnassus or Apollo and the Muses**, 1635–40, Museum of Fine Arts, Budapest, Hungary.
- Le Sueur, Eustache: **The Muses**, 1652–55, Louvre, Paris, France.
- Denis, Maurice: **The Muses in the Sacred Wood**, 1893, Musée d'Orsay, Paris, France.

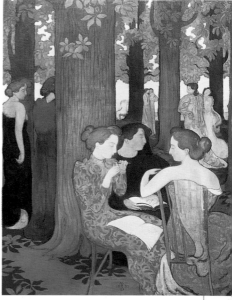

The Muses seen in a late nineteenth-century context by the French Symbolist painter Denis, whose early work emphasized the flat surface of the canvas.

Euterpe ('Gladness'): Muse of music and lyric poetry – flute, trumpet, and so on.

Terpsichore ('Delighting in Dance'): Muse of dance and lyric poetry – viol, lyre, harp, or other instruments.

Erato ('Loveliness'): Muse of lyric and love poetry – tambourine, lyre, viol; swan.

Melpomene ('Singer'): Muse of tragedy – tragic mask; horn; sword; sceptre; crown in hand.

Thalia ('Good Cheer'): Muse of comedy and pastoral poetry – comic mask; scroll; viol or other instruments.

Urania ('Heavenly One'): Muse of astronomy – globe and compass; crown of stars.

The Muses gave their name to any place of arts and learning – a Museum.

Neptune/Poseidon

God of the sea

The Roman god Neptune was equated with the Greek Poseidon. Neptune became the ruler of the seas after he helped his brother **Jupiter** overthrow their all-powerful father, **Saturn**.

Neptune not only held sway over the oceans and seas, over which he could summon up great storms, but he could also command earthquakes and tame horses (giving rise to a theory that the Trojan Horse was a symbolic representation of an earthquake which seems to have actually destroyed Troy). However, he was not the only sea deity. Nereus, Proteus and Phorcys, all known as the Old Men of the Sea, were more ancient sea gods with the power to foretell the future and change shape, but were subordinate to Neptune.

Neptune married Amphitrite, one of the fifty Nereids, sea **nymphs**, who were the daughters of Nereus. Their son was Triton, a merman famed for his skill at blowing on the conch shell; later myths record numerous Tritons. Neptune also fathered many other children by different mistresses, the most famous of which were the ram with the Golden Fleece sought by **Jason**, **Pegasus**, and the **Cyclops** Polyphemus.

In art, Neptune is naturally suited for sculptural fountains, and in painting he often symbolizes the maritime power of states. Although occasionally shown competing with **Minerva** for patronage over Athens, it is his triumphs and love affairs that are most often depicted, especially those with Amphitrite, Amymone and Coronis. Amymone, one of the fifty daughters of Danaus, was out looking for water when a **satyr** tried to rape her, but she was saved, and loved, by Neptune. Coronis, on the other hand, fled from Neptune's advances, and, crying out for help, was changed by Minerva into a crow.

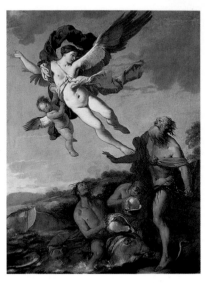

Coronis, in the midst of being transformed into a bird, escapes the clutches of Neptune, whom the Venetian artist Carpioni depicts in the traditional manner as an old man with a trident.

Classical References:

Homer, *Odyssey* 1.19–27, 5.282–381; Hesiod, *Theogony* 927–32; Virgil, *Aeneid* 1.124–56, 5.1015–80.

Attributes:

Trident; sea creatures; chariot.

Major Paintings:

- Crane, Walter: **Horses of Neptune**, 1892, Neue Pinakothek, Munich, Germany.
- Poussin, Nicolas: **Triumph of Neptune and Amphitrite**, 1634, Philadelphia Museum of Art, Pennsylvania, USA.
- Carpioni, Giulio: **Neptune Pursuing Coronis**, 1665–70, Uffizi, Florence, Italy.

Nymphs
Female spirits of nature

Nymphs were quasi-divine, female spirits of nature, only some of whom were immortal. They were usually regarded as beautiful young girls with playful, amorous personalities – the Greek word *numphe* meaning a bride or a girl of marriageable age.

Nymphs inhabited various parts of the natural world. On land there were mountain nymphs (Oreads), freshwater nymphs (Naiads) and tree nymphs (Dryads, originally of oak trees; Meliads, of ash trees; and Hamadryads who died with their tree). At sea, the Nereids were the daughters of the old sea deity Nereus, and the Oceanids were the daughters of the Ocean.

Nymphs formed the entourage of many gods and goddesses, especially those whose roles embraced the countryside or sea such as **Diana**, **Pan** or **Neptune**. Unsurprisingly, their beauty and charm meant that they were amorously involved with gods (e.g. **Callisto** with **Jupiter**, Daphne with **Apollo**) and even men (**Calypso** with **Ulysses**). Their nature could also be fatal to mortals, as in the tale of Hylas, one of the Argonauts who accompanied **Jason** on his quest for the Golden Fleece. Going ashore, Hylas leaned over a pool to draw water when the nymph of the pool was so taken by his beauty that she pulled him under and drowned him.

Another well-known group of nymphs were the Hesperides, the daughters of the Evening. They, along with a serpent, guarded the Golden Apples which Earth gave to Jupiter and **Juno** as a wedding present. One of **Hercules'** labours was to steal these apples. A frequent subject in ancient art, the apples of the Hesperides may have been the source of the supposition that the 'forbidden fruit' of **Adam and Eve** was an apple.

Classical References:

Homer, *Iliad* 20.8–9; *Homeric Hymn to Aphrodite* 259–72; Hesiod, *Theogony* 129–30; Ovid, *Fasti* 4.231–32; Apollonius, *Argonautica* 1.1207–357.

Attributes:

Naked or near-naked young women.

Major Paintings:

▼ Waterhouse, John William: **Hylas and the Nymphs**, 1896, Manchester City Art Gallery, Manchester, England.

● Bouguereau, Adolphe William: **Nymphs and Satyr**, 1873, Sterling and Francine Clark Art Institute, Williamstown, Massachusetts, USA.

● Leighton, Lord Frederick: **Garden of the Hesperides**, *c.*1892, Lady Lever Art Gallery, Cheshire, England.

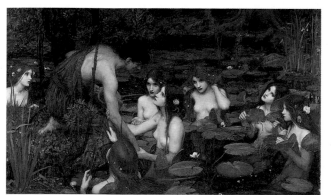

The beautiful young nymphs of a pool entice the Argonaut Hylas towards them, drawing him to his death. A masterpiece of English Victorian painting.

Oedipus
Tragic, self-deceiving Greek hero

Oedipus is one of the most tragic figures in Greek myth. The son of Laius and Jocasta, King and Queen of Thebes in Greece, Oedipus was abandoned at birth by his father, who had been warned by an oracle that he would be killed by his own son. The baby, his feet pierced with a spike, was left on the slopes of a mountain to die but was rescued by a shepherd and taken to the King of Corinth, Polybus. The King named the child Oedipus ('Swollen Foot') and raised him as his own. The boy grew up unaware that he was adopted, and when the Delphic oracle proclaimed that he would kill his father and marry his mother, he vowed never to return home to his supposed parents in Corinth.

A voluntary exile now from Corinth, Oedipus headed to Thebes. On his way he met his true father, King Laius, on a narrow road; a quarrel over the right of passage ensued, and Oedipus killed the King, thus unwittingly fulfilling the first part of the prophecy. Continuing to Thebes he encountered the Sphinx, a terrible monster that had been terrorizing the city. This creature frequented the roads to the city, killing and devouring travellers who could not answer the riddle she put to them. Oedipus alone confronted the Sphinx and solved the riddle. In despair the Sphinx dashed her head on the rocks and killed herself.

In gratitude, the citizens of Thebes gave Oedipus the throne and also the hand of widowed Queen Jocasta in marriage, unaware that she was his mother. For many years the couple lived in happiness; they had two sons, Eteocles and Polynices, and two daughters, Antigone and Ismene.

When the devastating truth about Oedipus' identity and inadvertent actions was discovered,

Classical References:
Aeschylus, *Seven against Thebes*;
Sophocles, *Oedipus Rex.*

Major Paintings:
▶ Ingres, Jean-Auguste-Dominique: **Oedipus and the Sphinx**, 1808, Louvre, Paris, France.
● Fuseli, Henry: **Oedipus Cursing his Son, Polynices**, 1786, NGADC.
● Moreau, Gustave: **Oedipus and the Sphinx**, 1864, NYMet.

Jocasta hanged herself and Oedipus blinded himself. He relinquished the throne and went into exile, accompanied by his daughter Antigone. However, he cursed his sons for their ill-treatment of him or because they were polluted; this led to their deaths fighting over the throne in an episode known as the Seven against Thebes.

The terrible tale of Oedipus was most famously told by the Greek tragedian Sophocles in *Oedipus Rex*, often considered the greatest of all Greek plays. The legacy of his fate has occupied many writers and thinkers since and is the basis for Sigmund Freud's celebrated psychological identification of an 'Oedipus complex'.

In Greek art and literature the Sphinx (meaning 'strangler') is normally female, with the head of a human and a lion's body. Some artists depict additional features such as the wings of a bird. The Sphinx was regarded as a terrifying man-eating creature, and was also often associated with death and funerary rites.

Although the Sphinx occurs in several myths, by far the most famous tale is that involving Oedipus, whose solution of her enigmatic riddle caused her to kill herself.

The Riddle of the Sphinx

Q: What walks on four legs in the morning, on two legs at noon, and on three legs in the evening?

A: Man – in infancy he crawls on all fours, in adulthood he walks upright on two legs, and in old age he uses a cane.

The murderous Sphinx, poised over her dark, bone-strewn lair, challenges a heroically nude
Oedipus – his victory over her is representative of the triumph of human accomplishment over barbarity.

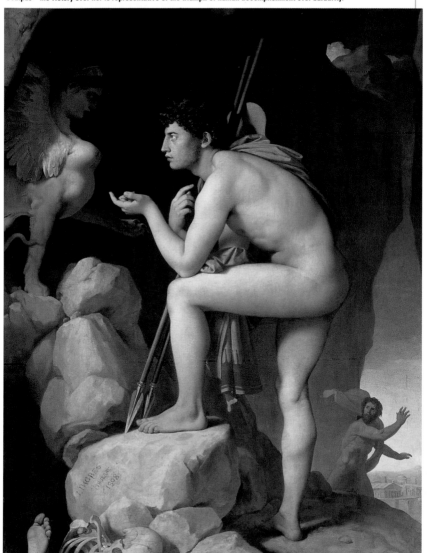

Orpheus and Eurydice
Legendary musician and his ill-fated wife

Orpheus was a renowned mythical poet and musician who came from Thrace in northern Greece. His singing and playing of the lyre was so beautiful that it not only charmed men and animals but caused trees and rocks to gather around him.

Orpheus was the son of one of the **Muses**, usually said to be Calliope, by either **Apollo** or the Thracian king Oeagrus. He joined **Jason** and the Argonauts on the search for the Golden Fleece, calming the waves with his music, and drowning out the fatally alluring songs of the Sirens (see **Ulysses**).

One of the saddest tales in ancient myth involved Orpheus' wife, the **nymph** Eurydice. When the new bride was out playing in the meadows she was bitten by a snake on the ankle – some say she was fleeing at the time from the advances of a certain Aristaeus. Eurydice died from the bite and joined all the other dead souls in the Underworld. Orpheus, heartbroken, decided to try and bring her back from the land of the dead, a feat unheard of. Playing his lyre, he charmed his way past the guardians of the Underworld, Cerberus, the three-headed dog, and Charon, the ferryman

across the River Styx. He so entranced **Pluto and Proserpine**, the King and Queen of the Underworld, that they agreed to let Eurydice return to the upper world, but only on the condition that Orpheus did not look back as they left.

Orpheus led Eurydice out of the dark Underworld, but, in sight of daylight, Orpheus, desperate to see his wife, glanced back. Eurydice melted away before his eyes, dying a second death. Orpheus tried to return, but this time his way was barred. Grieving, Orpheus returned to Thrace, where he roamed the land mournfully singing of his loss.

For many years Orpheus disregarded the advances of other women. Finally, a group of Maenads, followers of the god **Bacchus**, became so outraged at Orpheus' rejection of them that in a frenzy they ripped him apart. While the whole of nature wept for Orpheus, his head was thrown into the River Hebrus and floated, still singing, into the sea to be washed ashore on Lesbos, where it continued to sing and utter prophecies. In many Renaissance pictures, Orpheus' Greek lyre is replaced by the *lira da bracchio*, an early type of violin.

Classical References:
Apollonius, *Argonautica*; Virgil, *Georgics* 4.453–503; Ovid, *Metamorphoses* 10.1–105, 11.1–43.

Attributes:
Lyre; violin; trees and animals.

Major Paintings:
- Bellini, Giovanni: **Orpheus**, *c.*1515, NGADC.
- Rubens, Peter Paul: **Death of Eurydice**, 1636–38, Prado, Madrid, Spain.
- Savery, Roelandt: **Orpheus**, 1628, NGL.
- ▶ Moreau, Gustave: **Prophetic Head and Lyre of Orpheus**, 1866, Louvre, Paris, France.
- Poussin, Nicolas: **Landscape with Orpheus and Eurydice**, 1648–50, Louvre, Paris, France.

Moreau's poetic yet haunting imagination was naturally drawn to the myth of Orpheus, whose violent death exemplified woman's destructive power over man, a recurring theme with French Symbolist painters. A woman from Lesbos gazes sorrowfully upon Orpheus' head and tortoiseshell lyre washed ashore on her island.

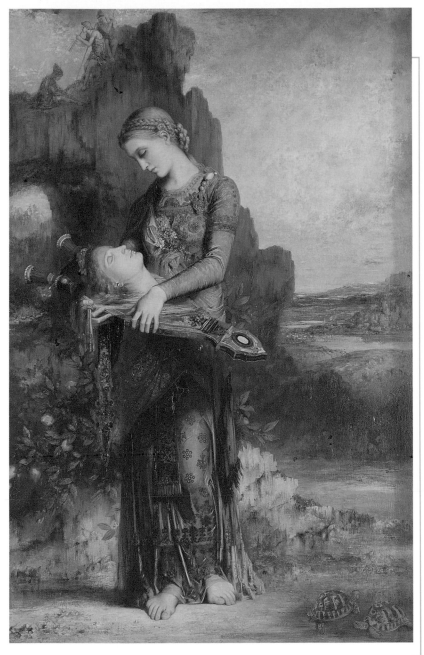

Pan/Faunus

Half-man, half-goat, god of flocks and herds

Pan was the Greek god of fields, mountains, flocks, herds and wild places in general. Born in **Arcadia**, a rugged region of Greece, Pan had the head and torso of a man, goat legs, horns and pointed ears. His father was usually given as **Mercury**, another Arcadian god, and his mother a **nymph**. Pan's name was popularly thought to derive from the Greek word *pan* meaning 'all' (because, according to an early myth, he delighted all the gods) but his name is in fact derived from *paon* meaning 'guardian of the flocks'.

Pan was renowned for his lustful nature, a characteristic he shared with goats, and he often pursued nymphs. One day he spied Syrinx, a young nymph, and called to her to lie with him. Syrinx, not sharing his desires, fled, and Pan chased after her. Syrinx reached a river she could not cross, and, realizing her fate if Pan caught her, she prayed that the river nymphs rescue her. Just as Pan grabbed her, Syrinx was transformed into reeds. Sighing with disappointment, Pan's breath through the hollow reed stems produced a thin plaintive sound. Enchanted by the sound, he cut the reeds to different lengths and joined them together, so creating the panpipes, which he called, in Greek, *syrinx* after his lost love.

Pan spent his time wandering through the wild countryside, playing sweet melodies on his pipes, watching over shepherds and their flocks and indulging in amorous pursuits. He even seduced the Moon (Selene or **Diana**), enticing her down from the sky by offering her a fleece of pure white wool. His musical skill on the pipes was no less daring, challenging **Apollo** to a contest judged by Midas (see **Marsyas and Midas**).

The sudden, often inexplicable fear that causes herds of animals to stampede was attributed to Pan wandering amongst them – an affliction which was thus known as 'panic'.

In post-classical painting, Pan is often shown in idyllic, Arcadian landscapes, sometimes part of a drunken, lustful revel surrounded by men, women, nymphs and **satyrs**. His presence may be substituted by his statue or pillar. Pan is often depicted chasing Syrinx, and also wrestling **Cupid**. Pan (Lust) is subdued by Cupid (Love), indicating not only 'Love conquers Lust' but also, in an allegory of the well-known Latin phrase *Amor vincit omnia*, 'Love conquers all'.

Classical References:

Homeric Hymn to Pan; Ovid, Metamorphoses 1.689–712.

Attributes:

Horns; pointed ears; goat legs; panpipes.

Major Paintings:

▶ Burne-Jones, Edward: **Pan and Psyche**, 1869–74, Fogg Art Museum, Cambridge, Massachusetts, USA.

● Jordaens, Jacob: **Pan and Syrinx**, *c.*1630–35, Rijksmuseum, Amsterdam, Netherlands.

● Poussin, Nicolas: **Triumph of Pan**, 1636, NGL.

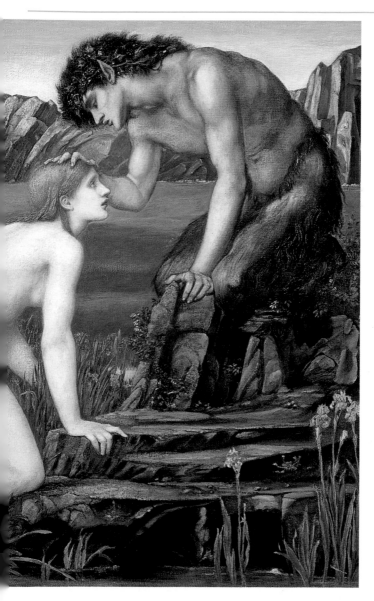

Pan comforts Psyche, washed up on the river bank after trying to drown herself in despair at losing her lover Cupid. Burne-Jones derived many of his paintings from his unpublished drawings that were to illustrate William Morris' *The Earthly Paradise*, an epic poem based on European myths.

Pandora

The first woman and cause of all trouble

In Greek mythology, Pandora was the first human woman. She was created by the god **Vulcan** out of earth and water on the orders of **Jupiter**, the king of the gods. Jupiter's gift was not intended to be a comfort to men – just the opposite, for he was enraged that men had been given, against his will, the gift of fire by the Titan **Prometheus**.

The woman was fashioned in the shape of a goddess. **Minerva** taught her domestic crafts such as weaving, **Venus** gave her beauty, charm and desire, but **Mercury** bestowed upon her cunning and deceit. She was then named Pandora, meaning 'All Gifts'.

Pandora was sent to Prometheus' brother, Epimetheus ('Afterthought') who was so smitten with her that he forgot his brother's warnings about accepting anything from Jupiter, and took Pandora as his wife. Trouble was bound to ensue, and this came in the form of a sealed jar in which was every type of misfortune. Pandora either brought this jar with her as a marriage gift or discovered

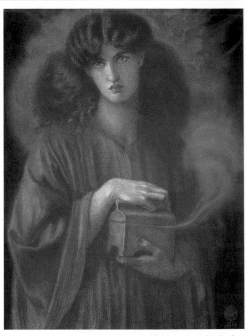

Pandora's haunting face is highlighted against the cloud of 'ills' streaming out of the box she opens. The painting's luminosity is characteristic of the Pre-Raphaelites of whom Rossetti was a founder member.

Classical References:

Hesiod, *Works and Days* 57–101, *Theogony* 570–90;
Apollodorus 1.2.3, 1.7.2.

Attributes:

Jar; box.

Major Paintings:

▲ Rossetti, Dante Gabriel: **Pandora**, 1869, Faringdon Collection Trust, Faringdon, England.

● Barry, James: **Pandora**, 1791, Manchester City Art Gallery, Manchester, England.

● Redon, Odilon: **Pandora**, 1910–12, NGADC.

● Cousin, Jean: **Eva Prima Pandora**, 1549, Louvre, Paris, France.

it in Epimetheus' house – but she was curious to look inside. As soon as she lifted the lid, all the ills flew out and began to afflict mankind. Only hope remained at the bottom of the jar as an ambiguous comfort for men.

Naturally Pandora was seen as a classical parallel of biblical Eve, and this is sometimes emphasized by artists. Pandora's story was especially popular with English neoclassical artists from the mid-eighteenth century onwards. However, Pandora's jar is often replaced by a box.

Paris

Trojan prince whose judgement started the Trojan War

Paris, a son of King Priam of Troy, was abandoned at birth after it was foretold that he would be the ruin of Troy. Rescued by a farmer, Paris grew up as a shepherd and married the **nymph** Oenone. Later, his real identity was revealed and he was welcomed back into the royal family.

However, Paris was soon at the centre of a tragic chain of events, not of his own making, for he was chosen by **Jupiter** to judge a beauty contest between three goddesses – **Juno**, **Minerva** and **Venus**. The prize was a golden apple (the 'Apple of Discord') inscribed 'to the fairest' which Eris, the goddess of strife, had cast among the guests at the wedding of Peleus and Thetis to which she had not been invited. Each goddess offered Paris bribes. Juno offered him power, land and wealth; Minerva, victory in battle; and Venus promised him the most beautiful woman in the world, **Helen** of Sparta. Paris awarded the golden apple to Venus.

Paris sailed to Sparta to claim his reward and when Helen's husband, Menelaus, the King of Sparta, was away, he eloped with Helen who readily journeyed to Troy with him. As soon as Menelaus discovered Helen's 'abduction', he

sailed to Troy with a vast force of Greeks, led by his brother Agamemnon, to recover Helen. The Greeks besieged Troy for ten years. Paris was not a major hero in the war as told in **Homer**'s *The Iliad*, but fought with his bow from a distance, killing the mighty **Achilles** by shooting him in his weak heel. Soon after, Paris was fatally wounded by Philoctetes using the great bow of **Hercules**.

Classical References:

Homer, *Iliad* 3.15–447, 6.313–58, 503–29, 7.347–64, 11.369–83; Apollodorus 3.12.5–6.

Attributes:

Shepherd's crook; bow; golden apple.

Major Paintings:

▼ Claude Lorraine: **Landscape with the Judgement of Paris**, 1645–46, NGADC.

● Rubens, Peter Paul: **The Judgement of Paris**, 1635–38, NGL and *c*.1639, Prado, Madrid, Spain.

● Wtewael, Joachim: **The Judgement of Paris**, *c*.1615, NGL.

● Cranach, Lucas the Elder: **The Judgement of Paris**, 1530, Staatliche Kunsthalle, Karlsruhe, Germany.

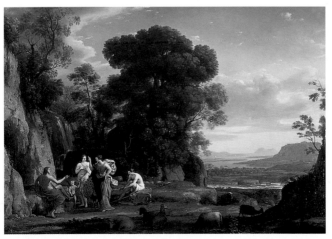

In post-classical painting the Judgement of Paris is one of the most common mythological subjects. The shepherd-prince Paris chooses which of the three goddesses, identifiable by their attributes, is the most beautiful.

Pegasus
Mythical winged horse

Pegasus was the winged horse who sprang from the neck of the Gorgon **Medusa** after she had been beheaded by **Perseus**. Pegasus' father was **Neptune**, god of the sea, and appropriately enough, Pegasus was also associated with water. His name was said to derive from *pegae*, the Greek word for 'springs', since he was born near the springs of the world-encircling Ocean. Pegasus also created two springs, both called Hippocrene or 'Horse spring', at spots in Greece where he stamped his hoof. One was at Troezen and the other was on Mt. Helicon, the latter being especially renowned because of its associations with the **Muses** and its powers of poetic inspiration. Pegasus formed this spring to cool the lyrical atmosphere during a musical contest between the Muses and the Pierides, the daughters of Pierus, who, in defeat, hurled abuse at the Muses and so were changed into magpies.

Pegasus also helped Bellerophon who had been set three life-threatening tasks by Iobates, King of Lycia, after the King's daughter had falsely accused Bellerophon of trying to rape her. The winged horse, discovered by Bellerophon at the spring of Peirene in Corinth, was tamed by being harnessed with a divine, golden bridle. Then, flying on Pegasus' back, Bellerophon first killed the Chimaera, a monstrous fire-breathing beast with three heads – a lion's, a goat's and a snake's; next he fought the Solymi tribe and finally battled with the Amazons, a race of female warriors.

Bellerophon also tried to fly up to Mt. Olympus but a gadfly, sent by **Jupiter**, stung Pegasus who threw Bellerophon off. Thereafter Pegasus lived on Mt. Olympus, bringing Jupiter's thunderbolt to him.

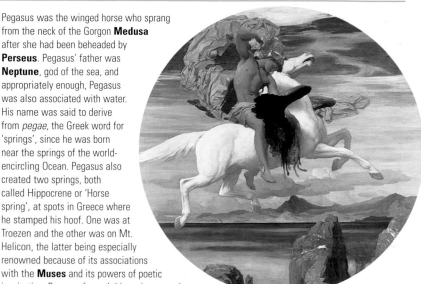

The engaging nature of a winged horse has appealed to artists ancient and modern. Here Perseus rides upon Pegasus, a feat with no basis in myth.

Classical References:
Hesiod, *Theogony* 274–86; Pindar, *Olympian Ode* 13.60–92; Apollodorus 2.4.2.

Attributes:
Wings; golden bridle.

Major Paintings:
- Redon, Odilon: **Pegasus**, 1900, Hiroshima Museum of Art, Hiroshima, Japan.
- Leighton, Lord Frederick: **Perseus on Pegasus Hastening to the Rescue of Andromeda**, *c.*1895–96, Museum and Art Gallery, Leicester, England.
- Mantegna, Andrea: *detail in* **Parnassus**, 1497, Louvre, Paris, France.
- Rubens, Peter Paul: **Bellerophon on Pegasus Slaying the Chimaera**, 1635, Musée Bonnat, Bayonne, France.

Penelope
Faithful wife of Ulysses

Penelope was the wife of the Greek hero **Ulysses**, and her unswerving, twenty-year wait for his return from the Trojan War has made her one of the best-loved Greek mythical heroines. Penelope, the daughter of Icarius, a Spartan prince, had only been married to Ulysses for one year when he left their home on Ithaca to join the Greek expedition to Troy. Penelope and their young son Telemachus had to endure ten years

Penelope, beset by suitors, weaves a tapestry while faithfully awaiting the return of her husband Ulysses.

knowing that Ulysses was risking his life fighting at Troy, but unlike the wives of other Greek heroes, she remained faithful to her husband in his absence. When the war ended, Penelope then had to wait another ten years alone, not knowing whether Ulysses was alive or dead, during which time the hero was trying to sail home but

encountering the many trials and tribulations recounted in **Homer**'s *The Odyssey*.

Penelope's wait for her dear husband was also not without incident, for many local nobles – the Suitors – had taken over Ulysses' palace, feasting at his expense and continually persuading Penelope to admit that her husband was dead and that she needed to marry one of them. Penelope had craftily kept them at bay for a time by promising that she would choose one of them when she had finished weaving her tapestry – which she then unpicked at night. Finally, prompted by **Minerva**, she agreed to marry whichever Suitor was able to shoot an arrow through the handle holes of twelve axes with Ulysses' great bow. The only man to succeed in the challenge was none other than Ulysses himself, who had recently returned home in disguise. After Ulysses had killed the Suitors, Penelope was reunited at last with her husband, her love and faithfulness finally rewarded. A rare happy ending in Greek myth!

Classical References:

Homer, *Odyssey* 19, 21, 23; Ovid, *Heroides* 1.

Attributes:

Loom.

Major Paintings:

 Waterhouse, John William: **Penelope and her Suitors**, 1906, Aberdeen Art Gallery, Aberdeen, Scotland.

● Padovanino: **Penelope Brings the Bow of Odysseus to her Suitors**, 1620s, National Gallery of Ireland, Dublin, Republic of Ireland.

● Pintoricchio, Bernardino: **Penelope with the Suitors**, c.1509, NGL.

Perseus and Andromeda

Greek hero and rescued bride

Perseus was born from the union of **Jupiter**, in the form of a shower of gold, and **Danae**. The newborn Perseus and his mother were set adrift in a chest by his grandfather, Acrisius, who had been warned by an oracle that he would be killed by a grandson. Eventually rescued, they lived happily on the island of Seriphos until Polydectes, the King of Seriphos, fell in love with Danae. The King believed that Perseus was an obstacle in the path of his desire, so he set him the near-impossible challenge of finding and beheading the Gorgon **Medusa** whose gaze turned people to stone.

Perseus first visited the three Graeae, the blind and toothless sisters of Medusa who shared a single eye and tooth which they passed around. Perseus stole their eye, thus forcing them to reveal the whereabouts of a group of **nymphs** who would help him further. These nymphs gave Perseus winged sandals enabling him to fly, a cap of invisibility belonging to **Pluto**, and a bag for keeping Medusa's head in once he had severed it with the curved scimitar given to him by **Mercury**.

Perseus then flew beyond the known world to the land of the three Gorgons. To avoid being 'petrified' (literally meaning 'turned to stone'), he avoided looking directly at the snaky-haired Medusa's reflection in the goddess' shiny, bronze shield and so succeeded in beheading the Gorgon.

On Perseus' return journey he flew over Ethiopia and caught sight of a girl chained to a rock and about to be devoured by a sea monster. Perseus learned that the girl was Andromeda, daughter of King Cepheus and Queen Cassiopeia, and that she was being sacrificed to satisfy **Neptune**, the god of the sea. Neptune had been angered by Cassiopeia's boast that she was prettier than the Nereid sea nymphs, and was destroying the

Classical References:

Hesiod, *Theogony* 274–83; Pindar, *Pythian Ode* 12; Ovid, *Metamorphoses* 4.605–5.249; Apollodorus 2.4.1–5.

Attributes:

Head of Medusa; winged sandals; scimitar; bag.

Major Paintings:

▶ Piero di Cosimo: **Perseus Freeing Andromeda**, *c.*1462–1521, Uffizi, Florence, Italy.

● Leighton, Lord Frederick: **Perseus and Andromeda**, 1891, Walker Art Gallery, Liverpool, England.

● Wtewael, Joachim: **Perseus Rescuing Andromeda**, 1611, Louvre, Paris, France.

● Giordano, Luca: **Perseus Turning Phineas and his Followers to Stone**, *c.*1680s, NGL.

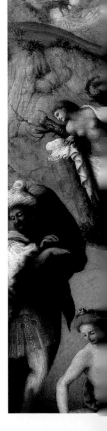

Perseus heroically attacks the sea monster that is advancing upon chained Andromeda. Sometimes artists, to impart further drama, depart from the ancient myth and depict Perseus flying to Andromeda's aid on the back of the winged horse Pegasus.

country with floods which would only cease with Andromeda's sacrifice.

For Perseus it was love at first sight, and when Andromeda agreed to marry him, he flew into the air, killed the sea monster and set Andromeda free. His problems were not over, however, as Andromeda was engaged to her uncle Phineus, who, with his supporters, now set upon Perseus. The hero pulled Medusa's head from his bag and so turned his enemies to stone the instant they saw the terrifying face of the Gorgon.

Perseus and Andromeda returned to Seriphos where again he used Medusa's head, this time to turn Polydectes to stone, so freeing Danae from his advances. Perseus then went to Argos to try to be reconciled with his grandfather but while throwing the discus he accidentally struck and killed Acrisius, thus fulfilling the prophecy.

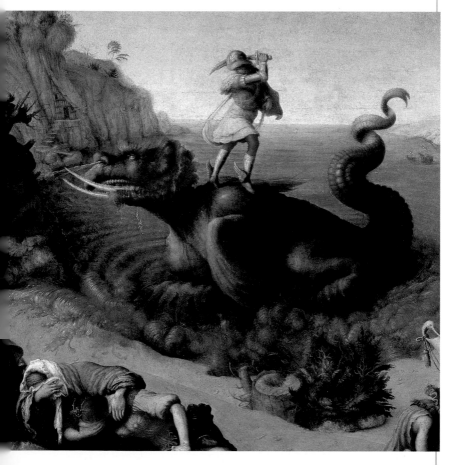

Phaethon (Phaeton)

Youth who crashed the chariot of the sun

Phaethon was the mortal son of Helios, the sun god who was responsible for driving the sun chariot across the sky each day and lighting up the world. In later myth and art Helios was often identified with **Apollo**, the 'Shining One'.

When the young Phaethon doubted his parentage, his mother Clymene sent him from his home in Ethiopia to the palace of Helios at the ends of the Earth. The radiantly shining Helios, surrounded by the Hours, Days, Months, Seasons and Years, acknowledged Phaethon as his son, and promised Phaethon anything he wished. Phaethon immediately asked to drive his father's four-horse sun chariot for one day.

Helios imploringly warned Phaethon of the difficulties and dangers in attempting such a ride across the sky, but to no avail. The fire-breathing steeds were yoked to the golden chariot and Phaethon took the reins, Helios urging him to keep to the middle course of the sky. The horses hurtled forward and upwards into the sky but the chariot, lighter than normal, tipped and rolled on its course. Phaethon was unable to control the horses and, terrified at the menacing sight of the constellation Scorpio, dropped the reins, and the horses ran wild, dragging the sun chariot towards the ground. The Earth began to burn in the heat – forests burst into flames, seas dried up, cities were destroyed and some races received blackened skins.

Classical References:

Ovid, *Metamorphoses* 1.750–2.366; Virgil, *Aeneid* 10.187–93.

Attributes:

Chariot of the sun.

Major Paintings:

- Redon, Odilon: **Chariot of Apollo**, 1905–14, Musée d'Orsay, Paris, France.
- Rubens, Peter Paul: **Fall of Phaethon**, *c.*1605, NGADC.
- Poussin, Nicolas: **Helios and Phaethon with Saturn and the Four Seasons**, *c.*1630, Gemäldegalerie, Berlin, Germany.
- Le Sueur, Eustache: **Phaethon asks Apollo to Drive the Chariot of the Sun**, 1646, Louvre, Paris, France.

Jupiter was unable to stand by and see the world completely destroyed and so he struck Phaethon with a lightning bolt. The young boy, flaming, fell to his death into the River Po. His sisters, the Heliades, wept inconsolably by its banks until they were turned into poplar trees, and his friend Cygnus sang his farewells in the form of a swan.

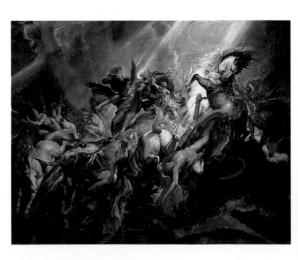

With the Earth already aflame and the heavens in chaos, Phaethon is struck by Jupiter's blinding lightning bolt and falls headlong from the Sun's careering chariot.

Philemon and Baucis

Peasant couple who played host to the gods

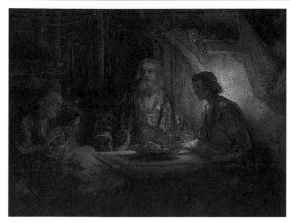

Jupiter and Mercury, bathed in lantern-light, share a meal with Philemon and Baucis sitting opposite. Jupiter prevents the elderly couple killing their goose which they intend to sacrifice to their divine guests.

The gods **Jupiter** and **Mercury**, disguised as humans, had been travelling through Phrygia in Asia Minor. Exhausted, they knocked on the doors of a thousand houses seeking somewhere to rest their tired limbs – but they were always turned away. Finally, they came to a lowly, mountainside cottage which belonged to Philemon and Baucis, a poor, elderly couple who had spent all their married lives in their small dwelling.

Classical References:

Ovid, *Metamorphoses* 8.618–724.

Attributes:

Humble house; goose.

Major Paintings:

▲ Rembrandt van Rijn: *detail from* **Philemon and Baucis**, 1658, NGADC.

● Rubens, Peter Paul: **Philemon and Baucis**, c.1625, Kunsthistorisches Museum, Vienna, Austria.

● Elsheimer, Adam: **Jupiter and Mercury in the House of Philemon and Baucis**, c.1600, Gemäldegalerie, Dresden, Germany.

The couple welcomed the strangers into their home and began preparing a wholesome meal, ungrudgingly sharing all their food. During the dinner, Philemon and Baucis noticed that the wine flagon never emptied but kept refilling of its own accord. They immediately realized that they were in the presence of the gods, and set about trying to catch their only goose to offer it as a sacrifice to their divine guests. However, the goose took refuge with Jupiter and Mercury, who stopped the bird being killed.

The gods declared that all their neighbours were to be punished for their wicked inhospitality and led Philemon and Baucis up the mountain. From the top they saw that all the people were drowned, and the land and all the houses were completely flooded except for their cottage which transformed into a magnificent temple. Jupiter granted the couple any favour, and they asked to serve in the temple as priests and that, when their end came, they should die together.

This was granted: upon dying, they turned simultaneously into an oak and a linden tree with a single trunk.

Pluto/Hades and Proserpine/Persephone

God of the Underworld and his queen

Pluto, also known as Dis, was the Roman god of the Underworld. Both his names, paradoxically for a deity associated with death, mean 'Wealthy', alluding to the fact that earth is the valuable source of all life. The Greek god of the Underworld was Hades, from whom the Romans took most of Pluto's mythology. Hades was also the name for the Underworld itself.

Pluto became the lord of the dead and ruler of the Underworld after he helped his brother **Jupiter** overthrow their all-powerful father, **Saturn**. Thereafter, Pluto was chiefly infamous for his abduction (or rape) of Proserpine, his niece, the daughter of **Ceres**. Myths tell how Pluto fell in love with the young Proserpine and, knowing that her mother would be against the match, decided to snatch her away. So while Proserpine was out picking flowers in the meadows – at either Eleusis in Greece or Enna in Sicily – the ground suddenly opened and Pluto, riding in his chariot pulled by four black horses, rushed out, grabbed the girl and sped back to the Underworld.

Classical References:

Homeric Hymn to Demeter, Hesiod, *Theogony* 453–506, 767–74, 850, 912–14; Ovid, *Metamorphoses* 5.346–571; *Fasti* 4.417–620.

Attributes:

Pluto – sceptre; chariot; black horses; cap of darkness.
Proserpine – pomegranate.

Major Paintings:

▷ Schwartz, Christoph: **Rape of Proserpine**, *c.*1570,
 Fitzwilliam Museum, Cambridge, England.

◉ Rembrandt van Rijn: **The Abduction of Proserpine**,
 1631, Gemäldegalerie, Berlin, Germany.

◉ Leighton, Lord Frederick: **Return of Persephone**, 1891,
 Leeds City Art Gallery, Leeds, England.

◉ Blake, William: **Cerberus**, 1824–27, Tate Britain,
 London, England.

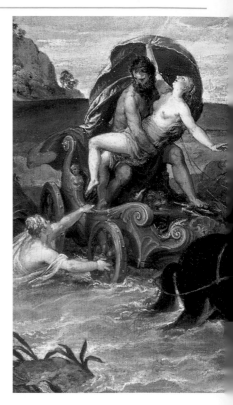

Pluto made Proserpine his queen but Ceres, the goddess of crops and grain, was so distressed at the loss of her daughter that the Earth's crops did not grow and there was worldwide famine. Eventually, Jupiter ordered Pluto to surrender Proserpine – but only if she had never eaten during her time in the Underworld. Unfortunately, Proserpine had tasted a pomegranate – either cunningly given to her by Pluto or of her own accord – and swallowed some of its seeds. So Jupiter decreed that she had to remain with Pluto for the same number of months each year as the seeds she had swallowed. So for four or six months (ancient

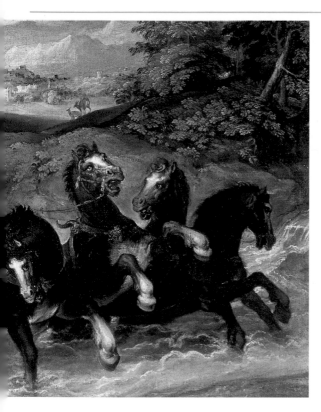

Pluto, clutching a distraught Proserpine, sweeps past the Sicilian water nymph, Cyane, who unsuccessfully implores the god of the Underworld to stop his abduction of the young girl.

sources vary) out of the twelve, Proserpine remained with Pluto, renewing Ceres' sadness and causing the barren winter months; conversely, the summer months were a time of happiness and growth.

Pluto is rarely depicted alone in ancient or post-classical art. Artists have nearly always placed Proserpine by his side, either as the regal Queen of the Underworld or, more commonly, as the victim of his abduction.

In Greek and Roman literature the Underworld (Hades) is regarded as a dark, cold, subterranean place inhabited by helpless dead, shadowy souls. When a person died **Mercury** escorted their soul

down to the boundary of the Underworld, which was thought of as either the River Styx or River Acheron. Then those who had received a proper burial paid the ferryman Charon to be taken across to the gates of Hades, which were guarded by Cerberus, a three-headed dog who ate all who tried to leave. Later writers placed Elysium, the happy abode of a few heroic mortals, within Hades rather than at the edge of the world. Tartarus, a terrible place for the few really wicked sinners, was also sometimes thought to be part of Hades.

Prometheus
Giant punished for giving fire to mankind

Prometheus was one of the Titans, the race of giants that according to Greek mythology dominated the Earth in its early history. He was renowned for the sympathy he showed towards humankind – an early legend even accredited Prometheus with creating man from clay. His nature was also cunning, as his name (which means 'Forethought') indicates, and this was demonstrated when he divided an ox between the gods and the men who were at the same feast. Prometheus surreptitiously gave the best meat to the humans, while to the gods he gave – disguised under a juicy wrapping of fat – just the hard bones. **Jupiter**, the king of the gods, realizing he had been deceived, punished not Prometheus but man by denying him the use of fire.

Prometheus again came to the aid of mankind, stealing fire from the Sun's chariot or **Vulcan**'s forge, and taking it to Earth concealed in a stalk of fennel (whose slow-burning nature was ideal for transporting flame). This time Jupiter vented his wrath on Prometheus, ordering him to be chained to the Caucasus mountains which separate Europe and Asia, with his liver being pecked at each day by an eagle. Man's punishment for receiving fire was the creation of woman in the form of **Pandora**.

Prometheus was eventually released by **Hercules** on condition that he told him how to obtain the golden apples of the Hesperides.

Prometheus' son, Deucalion, and his wife Pyrrha also helped humans. The sole survivors on Earth after Jupiter sent a great flood to wipe out dissolute mankind, they emerged from their ark to repopulate the Earth by throwing over their shoulders rocks which then turned into humans.

Classical References:

Hesiod, *Theogony* 507–616, *Works and Days* 41–105; Aeschylus *Prometheus Bound*; Ovid, *Metamorphoses* 1.76–88, 125–415.

Attributes:

Fire; eagle; gigantic figure chained to rock.

Major Paintings:

- Moreau, Gustave: **Torture of Prometheus**, *c.*1869, Musée Gustave Moreau, Paris, France.
- Rubens, Peter Paul: **Chained Prometheus**. 1611–12. Philadelphia Museum of Art, Pennsylvania, USA.
- Puvis de Chavannes, Pierre: *detail from* **Prometheus**, *c.*1896, Barnes Foundation, Merion, Pennsylvania, USA.

Prometheus' sufferings on behalf of mankind and his gift of creative fire, the spark of which has been equated with the spark of human intelligence, have always had great symbolic value to artists.

Pygmalion

Sculptor whose statue came to life

Pygmalion was a Cypriot sculptor who was so horrified at the disreputable behaviour of the women on the island that he vowed never to marry. Instead, he spent his time carving an ivory statue of his ideal woman. Pygmalion's skill was such that the statue was more beautiful than any living woman, the white ivory imitating young flesh. The sculptor became infatuated with the statue, talking to it, bringing it gifts and even embracing it.

At a festival of **Venus**, Pygmalion prayed to the goddess of love and beauty to be given a wife as lovely as his creation. Venus, however, understood Pygmalion's heart and granted his secret desire. So, when Pygmalion returned home and took the statue in his arms, he found that the ivory was becoming softer and softer, like melting wax, and that the body was becoming real. Pygmalion, delighting in his new girl, married her. They had a son called Paphos, from whom was derived the name of the town in Cyprus, an important centre of Venus' cult in ancient times.

This story, which reflects man's desire for the ideal, has become popular in post-classical times, as reflected in the many depictions of the myth in painting, sculpture, theatre and cinema (George Bernard Shaw's 1914 play *Pygmalion* was adapted into the film musical *My Fair Lady*). Artists have usually concentrated on the

Classical References:

Ovid, *Metamorphoses* 10.243–97.

Attributes:

Sculptor's tools; female statue.

Major Paintings:

- Gérôme, Jean-Léon: **Pygmalion and Galatea**, after 1881, NYMet.
- Burne-Jones, Edward: **The Soul Attains (Pygmalion and the Image Series)**, 1875–78, Birmingham Museum and Art Gallery, Birmingham, England.
- Bargellini, Giulio: **Pygmalion**, 1896, Galleria d'Arte Moderna, Rome, Italy.

life-giving moment of transformation from statue to girl, who is often called Galatea. The scene is usually placed in the sculptor's workshop or in a palace, reflecting a less well-known classical version where Pygmalion was the King of Cyprus.

The young sculptor Pygmalion shrinks back in astonishment as his beloved ivory statue of a girl comes to life.

Romulus and Remus and the Sabines

Legendary founders of Rome, and their neighbours

Ancient Roman tradition credited the foundation of Rome in 753 BC to the twins Romulus and Remus, their divine origins lending a mystique and sanctity to the city.

The twins' grandfather Numitor, a mythical descendant of the Trojan hero **Aeneas**, had been the King of Alba Longa, a city 15 miles from the site of future Rome, until his brother Amulius deposed him. To safeguard his position, Amulius killed Numitor's son and forced his daughter, Rhea Silvia, to become a vestal virgin to prevent her marrying and having children. However, after an affair with the god **Mars**, she gave birth to twin sons, Romulus and Remus.

On Amulius' orders, the twins were set adrift in a basket on the River Tiber to die of exposure. However, they ran aground under a fig tree at the foot of the Palatine Hill, where the babies were protected and suckled by a she-wolf until a shepherd, Faustulus, rescued them. He and his wife Acca Larentia brought up Romulus and Remus as their own, keeping their identities secret until they were young men, when Amulius realized who they were and moved against them. The twins, leading a band of rebels, deposed

Amulius and restored their grandfather to the throne of Alba Longa.

Romulus and Remus then decided to build a new city at the spot where they had been suckled by the wolf. Unable to decide who should be King and what the city should be called, they looked for a signal from the gods through augury, watching and interpreting the flight pattern of birds. Romulus saw six birds first but then Remus

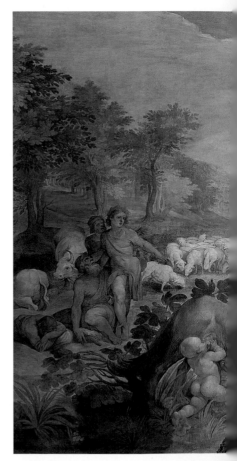

Classical References:

Livy 1.4–13; Ovid, *Fasti* 2.381–422; Plutarch, *Life of Romulus.*

Attributes:

She-wolf; helmets and swords.

Major Paintings:

▶ Arpino, Knight of (Giuseppe Cesari): **Romulus and Remus Suckled by the Wolf**, *c.*1600, Capitoline Museum, Rome, Italy.

● Rubens, Peter Paul: **Romulus and Remus**, 1618, Capitoline Museum, Rome, Italy.

● David, Jacques-Louis: **The Sabine Women**, 1799, Louvre, Paris, France.

● Poussin, Nicolas: **Rape of the Sabines**, *c.*1637–38, Louvre, Paris, France.

spotted twelve. A dispute arose as to who the gods favoured, with each named King by their supporters. According to a popular legend, Remus arrogantly jumped over the new city's boundary ditch or wall that Romulus was in the process of making, angering Romulus who struck his brother and killed him. The city was therefore called Rome after Romulus.

Shortly afterwards, Romulus invited their neighbours, the Sabines, to a festival during which the Romans carried off the Sabine women to make them their wives. Three years later the Sabine men, led by Tatius, retaliated, but the Sabine women intervened to stop war between their Sabine fathers and their now beloved Roman husbands, whereupon the two peoples united.

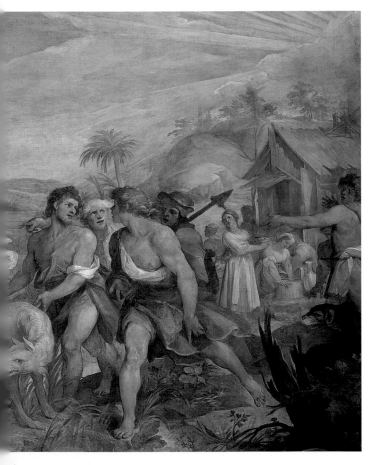

The site of future Rome – the baby twins Romulus and Remus, being suckled by a she-wolf, are discovered by kindly shepherds.

Saturn/Cronus
Father of the Olympian gods

The Roman god Saturn was identified with the Greek Cronus (Kronos).

Saturn was the son of Uranus ('Sky') and Gaia ('Earth') and belonged to the race of gigantic Titans. His father couldn't bear the sight of his monstrous children, which included the **Cyclopes**, and so forced them back inside Gaia. When Uranus and Gaia next lay together, Saturn came to his mother's rescue by cutting off his father's genitals with a sickle and flinging them into the sea (so giving birth to **Venus**). From the drops of blood that fell on Gaia arose the Giants and the Furies. Saturn released his brothers and overthrew his now powerless father to rule over all the universe.

Saturn, however, became as tyrannical as his father, imprisoning all his brothers in the dark region far below Earth called Tartarus. More cruelly still, having learned from his mother that he would one day be overthrown by one of his sons, he swallowed all his children at their birth. Saturn had swallowed five – Vesta, **Ceres**, **Juno**, **Pluto** and **Neptune** – when his wife Rhea begged Gaia for help to preserve her sixth child, **Jupiter**. Gaia hid the newborn child and gave Saturn a stone wrapped like a baby to swallow. Jupiter was brought up in secret in a cave on Crete and later led a revolt against Saturn and the other Titans. He forced his father to regurgitate his siblings and then cast him into Tartarus.

In contrast to this brutal tale, another legend – more popular with the Romans – tells that Saturn, when ruler of the universe, presided over a Golden Age on Earth. Men lived in complete peace and freedom, with no cares or worries; days were spent in leisure, the earth producing food spontaneously; rivers flowed with milk and

nectar, and honey dripped from the trees. In this gentle version, when Saturn was replaced by Jupiter he was sent to rule over Elysium, or the Isles of the Blessed, a place at the ends of the Earth where deserving dead souls rested in bliss. In the Roman world, Saturn's annual festival, the Saturnalia, was one of the most widely celebrated of all holidays. It took place at the winter solstice, December 21, and was characterized by feasting, jollity and the giving of presents. The Christian festival of Christmas was largely grafted on to the pagan Saturnalia. Through the close resemblance of the Greek name for Saturn (Cronus) to the Greek word for 'time' (*chronos*), Saturn was also identified with Father Time, a suitable identification for one of the oldest of the gods.

Classical References:

Hesiod, *Theogony* 155–82, 453–506, 617–735, *Works and Days* 109–20, 169–73; Virgil, *Aeneid* 6.792–94, 7.48–49, 8.314–27, 355–58; Ovid, *Metamorphoses* 1.89–150.

Attributes:

Sickle; scythe; armillary sphere (symbolizing the universe); crutch (for old age). As Father Time – scythe; crutch; wings; hourglass; snake (symbolizing rejuvenation and eternity).

Major Paintings:

▶ Goya, Francisco: **Saturn**, 1821–23, Prado, Madrid, Spain.

● Poussin, Nicolas: **Time Revealing Truth with Envy and Discord**, 1640–42, Louvre, Paris, France.

● Poussin, Nicolas: **Helios and Phaethon with Saturn and the Four Seasons**, c.1630, Gemäldegalerie, Berlin, Germany.

The subject matter of Saturn devouring one of his children was particularly suited to Goya, who became drawn to the sinister and the morbid.

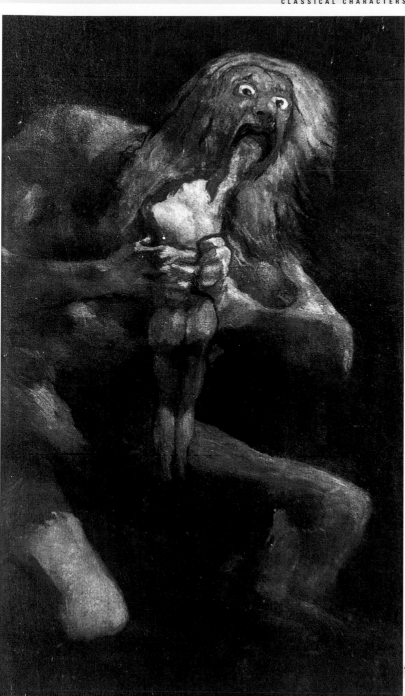

Satyrs, The
Mythical goatlike creatures

Satyrs were hybrid creatures – half-man, half-animal. In early Greek times they were depicted as men with horses' tails and ears but in later Greek and Roman times satyrs took on the features of the god **Pan**, with goat legs, horns and pointed ears, an imagery that continued in post-classical art.

Satyrs were the followers of the wine god **Bacchus** and delighted in constant drunken revelry and sexual pursuits with **nymphs** and other female revellers. Thus, in medieval and Renaissance allegory satyrs personify Lust and Evil, resulting in their horns and hooves being used for the

Jupiter, disguised as a satyr, creeps up on Antiope, the beautiful nymph whom he ravishes.

Classical References:

Pausanias 1.23.6–7; Ovid, *Metamorphoses* 6.111, 11.89–105.

Attributes:

Goat or horse legs; pointed ears; wine jars and cups; flutes; horns of plenty; snakes.

Major Paintings:

- Correggio, Antonio: **Venus and Cupid with a Satyr**, *c.*1525, Louvre, Paris, France.
- Bouguereau, Adolphe William: **Nymphs and Satyr**, 1873, Sterling and Francine Clark Art Institute, Williamstown, Massachusetts, USA.
- Jordaens, Jacob: **Satyr and Peasant**, 1620s, Pushkin Museum, Moscow, Russia.
- Rubens, Peter Paul: **Silenus**, 1616–17, Kassel Museum, Kassel, Germany.
- Watteau, Antoine: **Jupiter and Antiope**, 1715, Louvre, Paris, France.

Renaissance image of Satan, the Christian embodiment of evil. However, for many Baroque and later artists, the lusts of satyrs provide valid opportunities to portray erotic scenes.

Two prominent satyrs were **Marsyas** and Silenus. Silenus, the tutor of Bacchus, was the oldest and most drunken of the satyrs, and characteristically lolled on the back of a donkey. His drunken stupor empowered him with wisdom and prophecy, and he was once captured by King Midas who wished to share his wisdom. Silenus revealed that for man, it was best never to be born at all and, if born, to die as soon as possible! In post-classical art, Silenus, although a satyr, is usually depicted as a fat, old man.

An unusual classical tale, retold by La Fontaine, a French teller of fables, and popular with seventeenth-century Flemish painters, tells how a family of satyrs invited a human traveller into their house one cold night. When the guest blew both on his hands to warm them up and also on his soup to cool it down, the satyrs were amazed at such a feat.

Sibyl
Prophetess

Sibyl was the name given to a prophetess who under divine guidance, usually from **Apollo**, uttered oracles which foretold future events. From mythical beginnings, when the original Sibyl, called Herophile, prophesied that **Helen** of Sparta would cause the Trojan War, the number of Sibyls in the classical world grew.

One of the most famous was the Delphic Sibyl, also known as the Pythia, who served in the Temple of Apollo at Delphi in Greece. Ancient sources say that she had to be a woman over the age of 50 and that she sat upon a tripod (a bronze three-legged cauldron), which was Apollo's throne, and went into a trancelike state – perhaps from chewing laurel leaves or inhaling vapours emanating from cracks in the ground. Although she answered questions in ambiguous riddles, she became so famous that even kings came to consult her.

The Sibyl at Cumae in Italy was equally renowned. Consulted by **Aeneas** when he first landed in Italy, she instructed him how to enter the Underworld at Lake Avernus by cutting the Golden Bough with a sickle. She was said to have sold three books of oracular utterances – the Sibylline Books – to the Roman king Tarquinius Superbus, which were still consulted by the Romans over 400 years later until they were destroyed in a fire in 83 BC. The Cumaean Sibyl had also once been loved by **Apollo** who promised her anything. She asked to live for as many years as there were grains in a handful of sand – but she forgot to ask also for perpetual youth, and so she became shrivelled with age. Her wish and utterance was now 'I want to die!'

In the Christian era, twelve of the Sibyls were seen as prophets foretelling the coming of **Jesus**, and artists have portrayed them in both their classical and Christian roles.

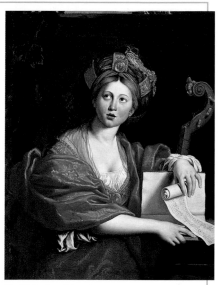

The Sibyl's close link with Apollo, god of oracles and the arts, is shown by her book of prophecies, a musical scroll, the viola, and laurel. The vine alludes to the blood of Christ whose coming the Sibyl was believed to have foretold.

Classical References:
Ovid, *Metamorphoses* 14.101–53; Virgil, *Aeneid* 6; Petronius, *Satyricon* 48.

Attributes:
Book or scroll; turban.

Major Paintings:
- Collier, John: **Priestess of Delphi**, 1891, Art Gallery of South Australia, Adelaide, Australia.
- Michelangelo: **The Five Sibyls**, 1508–12, Sistine Chapel, Vatican, Italy.
- Guercino: **Cumaean Sibyl with a Putto**, 1651, NGL.
- Turner, Joseph Mallord William: **Aeneas and the Sibyl at Lake Avernus**, *c.*1798, Tate Britain, London, England.
- Domenichino: **The Cumaean Sibyl**, *c.*1581–1641, Galleria Borghese, Rome, Italy.

Theseus
Great Athenian hero

Theseus was the son of Aegeus, King of Athens, and Aethra, a princess of Troezen, a city near Athens. Aegeus had been tricked into sleeping with Aethra and before leaving Troezen, he placed his sword and a pair of sandals beneath a great rock, telling Aethra that any future son would only succeed him as King of Athens if he could lift the rock and retrieve the items. Some legends say that Theseus was fathered by **Neptune** who had lain with Aethra after Aegeus.

When Theseus was a young man, he was able to lift the heavy boulder and, taking the sword and sandals, set off to Athens to claim his royal inheritance. On his way Theseus overcame many fearsome beasts and savage men who tried to kill him. On arriving in Athens, he was recognized only by Aegeus' new wife, the sorceress **Medea** who, wishing her own son to become King, sent Theseus to capture the dangerous Bull of Marathon. After successfully completing the task, Theseus dined with Aegeus, and when Theseus drew his sword to cut the meat, Aegeus immediately recognized it as his own and made Theseus his heir.

Soon afterwards, Theseus sailed to Crete as part of the human tribute required by King Minos in recompense for the death of his son in Athens. The Athenian youngsters were to be fed to the **Minotaur**, a beast hidden in the maze-like Labyrinth. Theseus was helped by Ariadne, Minos' daughter, who had fallen in love with him. She gave Theseus a ball of thread which he tied to the Labyrinth's entrance and unwound as he

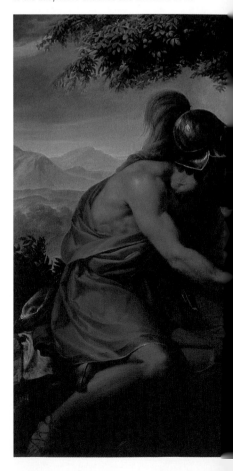

Classical References:

Plutarch, *Life of Theseus*; Ovid, *Metamorphoses* 7.404–52, 8.155–82.

Attributes:

Helmet; sword; club.

Major Paintings:

- Poussin, Nicolas: **Theseus Finding his Father's Arms**, *c.*1633–34, Uffizi, Florence, Italy.
- Flandrin, Hippolyte: **Theseus Recognized by his Father**, 1832, Ecole Nationale Supérieure des Beaux-Arts, Paris, France.
- Rubens, Peter Paul: **Battle of the Amazons**, *c.*1615, Alte Pinakothek, Munich, Germany.
- Politi, Odorcio: **Theseus and Perithous Playing Dice with Helen of Troy**, 1831, Museo Civico, Treviso, Italy.

went in; having killed the Minotaur, he followed the thread back to the exit. The pair sailed to Naxos where Theseus callously deserted Ariadne (see **Bacchus**).

As Theseus sailed into Athens, he forgot to hoist up the white victory sails. Aegeus, seeing black sails, believed Theseus was dead and threw himself into the sea, thereafter named the Aegean. Theseus then became King of Athens.

His further exploits included helping his friend Perithous in a battle against the **centaurs** and briefly abducting young **Helen** of Troy. Theseus also fought against the Amazons, fearsome warrior women, carrying off their queen, Antiope or Hippolyta, as his mistress. She bore him a son, **Hippolytus**.

Theseus was eventually killed, ingloriously, by being pushed off a cliff on the island of Scyros.

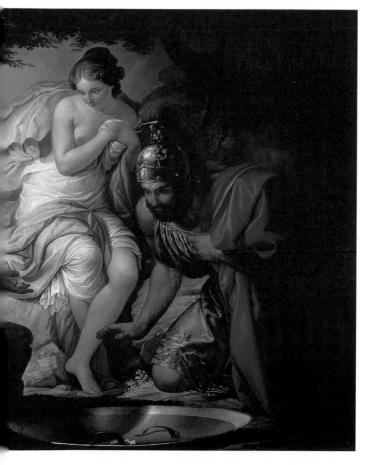

Theseus and his friend Perithous, having abducted Helen of Troy, play dice to see who should win her as a bride. Theseus wins but Helen is rescued by Castor and Pollux while Theseus and Perithous are in the Underworld attempting to abduct Proserpine as a bride for Perithous.

Ulysses/Odysseus
Greek hero and adventurer

Ulysses – perhaps better known by his Greek name Odysseus – is one of the best known of the mythical heroes largely due to his exciting and fantastical adventures on his way home from the Trojan War. His journey is related by the poet **Homer** in his epic poem, *The Odyssey*. Ulysses was King of Ithaca, an island off the west coast of Greece. He was married to the faithful **Penelope**, with whom he had a son, Telemachus. Renowned for being resourceful and cunning, he played a prominent part in the Trojan War, famously conceiving the idea of the Wooden Horse. This was a trick by which Greek warriors hid inside a massive wooden horse which was

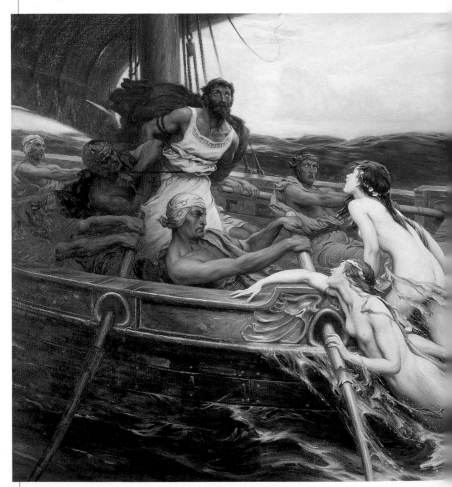

Enchanted by the Sirens' singing, Ulysses strains at the ropes binding him to the mast, while his crew, ears plugged with wax, row hard to pass the danger.

left outside the city of Troy. As Ulysses forecast, the Trojans took the horse into their city believing it to be a peace offering from their enemies, whereupon the Greeks broke out from the horse and destroyed the city, so winning the ten-year war.

Ulysses' voyage back to Ithaca was beset with great difficulties and delays due mainly to the anger of **Neptune**, who wished to punish him for blinding his son, Polyphemus (see **Cyclops**). Ulysses' return home took ten years and has given rise to the term 'an odyssey'. His adventures included being waylaid in the land of the lotus-eaters where his crew ate the fruit of forgetfulness; blinding the Cyclops; opening the bag of winds given to him by Aeolus; losing most of his crew to the Laestrygonians, man-eating giants; his comrades being turned into animals by the sorceress **Circe**; and his journey to the Underworld where he was warned of further dangers, including his brush with the Sirens.

The Sirens are one of the more popular artistic subjects relating to Ulysses because of their erotic nature. They were young girls who sang alluringly to passing sailors from rocks. No one could resist their charms, and yet death met all who went to them. These ultimate *femmes fatales* were evaded by Ulysses who made his men tie him to the ship's mast so he couldn't rush to the Sirens on hearing their songs, while his crew blocked their ears with wax.

After other trials that included losing the rest of his crew when they ate the forbidden cattle belonging to the Sun, Ulysses was shipwrecked on the island of **Calypso** for seven years. Finally, Ulysses was able to reach Ithaca and slay a band of men who were trying to seize his kingdom and wife in his absence. According to Homer, Ulysses was to die a gentle death after all his trials.

Classical References:
Homer, *Odyssey, Iliad* 2.631–37, 9.182–306.

Attributes:
Arms and armour; bow; beard.

Major Paintings:
- Waterhouse, John William: **Ulysses and the Sirens,** 1891, National Gallery of Victoria, Melbourne, Australia.
- Draper, Herbert James: **Ulysses and the Sirens**, 1909, Ferens Art Gallery, Kingston-upon-Hull, England.
- Claude Lorraine: **Seaport with Return of Ulysses**, 1644, Louvre, Paris, France.

Venus/Aphrodite

Goddess of love and beauty

Venus, the Roman version of the Greek Aphrodite, was one of the twelve great Olympian deities. The loveliest of all the gods, she presided over erotic love and feminine beauty.

According to **Homer**, Venus was the daughter of **Jupiter** and the obscure goddess Dione. More popularly, Venus was born from the sea foam (*aphros* in Greek, thus Aphrodite) after Uranus' genitals were cut off by **Saturn** and cast into the sea. Venus came ashore either at Paphos on Cyprus or on the small Aegean island of Cythera.

Venus was married to **Vulcan**, god of metal-working, but she had many love affairs, most famously with **Mars**, god of war, by whom she had **Cupid**. She also loved the mortal **Adonis**, a beautiful young hunter, with whom she was so enraptured that she spent all her time with him. His death left her distraught; while rushing to his side as he lay dying she trod on a thorn of a white rose, the drops of her blood creating the first red roses. Venus was especially worshipped at Rome since she was the mother of the Trojan

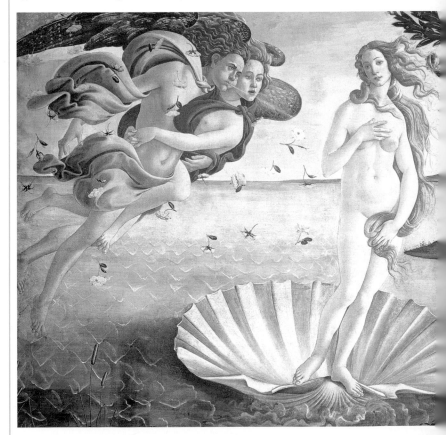

Aeneas, the legendary ancestor of the Roman race. Venus was inextricably linked with Troy after being judged the most beautiful goddess by the Trojan prince, **Paris**, which ultimately precipitated the Trojan War.

Venus, with her associations of erotic beauty, has been an extremely popular subject with sculptors and painters in both classical and modern times. Venus' birth is frequently portrayed, the goddess shown rising (*anadyomene*) from the waves, wringing her wet hair, and floating ashore on a seashell. Her relationship with Mars has also inspired numerous allegorical paintings where Venus (Love) disarms Mars (Hate).

In the Renaissance, a picture-type known as the 'Toilet of Venus' developed where a reclining Venus, or a lady of the day, was portrayed stretched out on a couch, often looking in a mirror or being adorned. This depiction was, originally, merely an excuse to paint seductive female nudes, but it has since had an illustrious and continuous history.

Another subject popular during the Renaissance depicted two Venuses side by side, representing Sacred and Profane Love. Sacred Love, also known as Celestial Venus, naked in her purity, symbolized love aroused through contemplation of God, while Profane Love, or Earthly Venus, clothed in material fashions, symbolized worldly beauty and procreation. The message was that one had to be open to Profane Love to achieve Sacred Love.

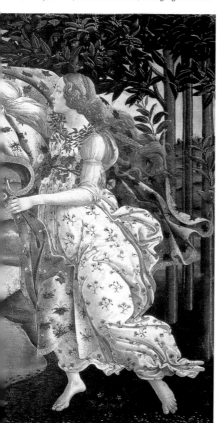

Venus, her modest pose copying that of an ancient statue-type, is wafted ashore by the fresh, energizing breaths of Zephyr and Flora, and offered a cloak by one of the Seasons.

Classical References:

Homer, *Iliad* 5.311–13, 370–81; Hesiod, *Theogony* 188–200.

Attributes:

Doves, swans; scallop shell; flaming torch; rose; myrtle; mirror.

Major Paintings:

◄ Botticelli, Sandro: **The Birth of Venus**, *c.*1490, Uffizi, Florence, Italy.

● Cabanal, Alexandre: **Birth of Venus**, 1863, Louvre, Paris, France.

● Velázquez, Diego Rodriguez de Silva: **The Toilet of Venus ('Rokeby Venus')**, 1647–51, NGL.

● Titian: **Sacred and Profane Love**, 1514, Galleria Borghese, Rome, Italy.

Vulcan/Hephaestus

God of fire, metalworking and artisans

Vulcan, the Roman equivalent of the Greek god Hephaestus, was the blacksmith god who forged not only the weapons of many gods and heroes but also wondrous items of gold and silver. He was also the god of fire and, together with **Minerva**, the patron of craftsmen.

Vulcan, the son of **Jupiter** and **Juno**, or Juno alone, was born with a crippled foot or leg, and was lame. This decline from the divine ideal underscored his status among the gods as an 'outsider' – Vulcan toiled and sweated in his forge, was treated as an amusing rustic at feasts of the gods, and yet was admired for his craftsmanship.

Vulcan, once if not twice, was thrown out of Olympus, the home of the gods. Juno flung him into the sea (from where he was rescued by the **nymph** Thetis) because she was ashamed about his deformity; and/or Jupiter cast him out for trying to defend Juno from his anger, with Vulcan falling (some say cripplingly) onto the island of Lemnos, which became his main cult centre.

Vulcan famously took revenge on his unfaithful wife, **Venus**, by trapping her and her lover, **Mars**, in an invisible net while they were

Classical References:

Homer, *Iliad* 1.578, 590–94, 18.368–616; Hesiod, *Theogony* 927–29; Virgil, *Aeneid* 8.370–85, 416–54.

Attributes:

Craftsman's cap; hammer and anvil; crutch.

Major Paintings:

▼ Velázquez, Diego Rodriguez de Silva: **The Forge of Vulcan**, 1630, Prado, Madrid, Spain.

● Le Nain, Louis: **Venus at the Forge of Vulcan**, 1641, Musée Saint-Denis, Reims, France.

● Tintoretto, Jacopo: **Mars and Venus Surprised by Vulcan**, *c*.1555, Alte Pinakothek, Munich, Germany.

sleeping together, a humiliation which he invited all the gods to witness.

Vulcan's forges were believed to be beneath volcanoes, named after him, especially Mt. Etna on Sicily. The **Cyclopes**, one-eyed giants, were his assistants. Numerous paintings show Vulcan being visited in his forge by Thetis begging arms for her son **Achilles**; or Venus, accompanied by **Cupid**, asking for weapons for her son **Aeneas**.

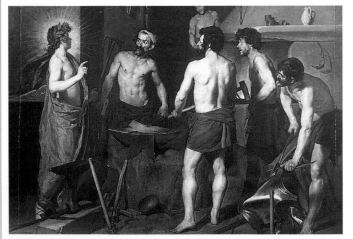

Vulcan, working in his forge, stares at Apollo who tells the smith god of his wife Venus' affair with Mars.

Zephyr
God of the West Wind

Zephyr was considered to be both the West Wind and the god of the West Wind. He was the son of Astraeus, one of the giant Titans, and of Eos, the Dawn.

In the early Greek mythology of **Homer**, Zephyr is portrayed as a stormy and ill-blowing wind, like his brothers, Boreas and Notus, the North and South Winds respectively. However, Homer's near contemporary, Hesiod, describes Zephyr as a bright, cleansing and refreshing wind, and in later classical literature Zephyr is always regarded as a warm and gentle breeze.

Zephyr is often portrayed with **Flora**, the goddess of flowers, who was the **nymph** Chloris until touched by the West Wind's spring-like breath. Despite this close relationship, Zephyr was sometimes considered to be married to Iris, the rainbow, who, as a link between heaven and earth, was an occasional messenger of the gods.

Zephyr was the father of Xanthus and Balius, the immortal horses that ran like the wind and belonged to the great warrior **Achilles**. He fathered them with Podarge, one of the Harpies, winged creatures which were famously put to flight by **Jason**.

Zephyr also fell in love with Hyacinthus, a handsome youth, but his love was unrequited since Hyacinthus was the lover of the god **Apollo**. Zephyr watched jealously as the two threw a discus to each other, until, unable to bear it any longer, he blew and deflected the discus so that it hit Hyacinthus, killing him.

In art Zephyr and the other Winds are usually portrayed as accompanying figures, although Zephyr, popular because of his sweet, gentle nature which announces spring, is occasionally the main subject.

Zephyr and his consort Flora exhale the warming, fragrant breezes that herald spring.

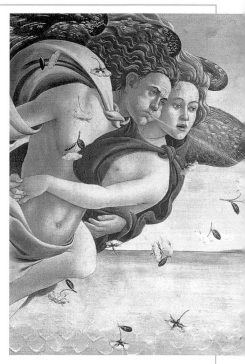

Classical References:
Homer, *Iliad* 16.148–51, 23.198–230; Hesiod, *Theogony* 378–80, 869–71; Ovid, *Fasti* 201–06.

Attributes:
Puffed cheeks; wings.

Major Paintings:
- Botticelli, Sandro: *detail from* **The Birth of Venus**, *c.*1490, Uffizi, Florence, Italy.
- Prud'hon, Pierre-Paul: **The Zephyr**, before 1814, Wallace Collection, London, England.
- Tiepolo, Giovanni Battista: **The Triumph of Zephyr and Flora**, 1734–35, Museo del Settecento Veneziano di Ca' Rezzonico, Venice, Italy.

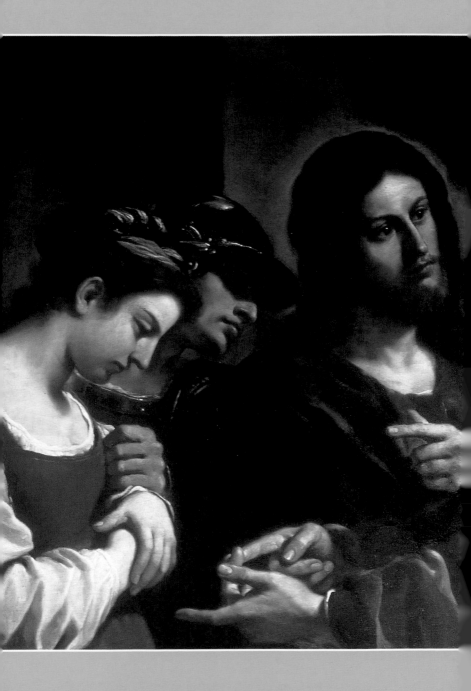

BIBLICAL AND
RELIGIOUS CHARACTERS

Famous figures from the Bible's
Old and New Testaments as
well as early and medieval
Christian saints.

Abraham

Father of the Jewish people

Abraham, thought to have lived sometime between 2000 and 1650 BC, was originally called Abram ('High Father'). He is regarded as the founder of the Hebrew nation and the ancestor of other Semitic peoples such as the Arabs. Abram came from the city of Ur 'of the Chaldees' in modern Iraq but left there when he was commanded by God to go to a new land.

Abram journeyed to Canaan in modern Israel with his wife, Sarai, and his nephew, **Lot**, but after a quarrel, Lot moved away and settled in the city of Sodom. After Lot and the flocks, herds and provisions of Sodom were captured during a local war, Abram and his followers freed Lot and the city. The victorious Abram was met by Melchizedek, the priest-king of Salem (later Jerusalem) who offered Abram bread and wine and blessed him, an episode that has been seen as a prefiguration of the Christian Holy Communion.

God promised Abram that he would have many descendants even though he and Sarai did not have any children. Since Sarai was past child-bearing age, she gave her servant **Hagar** to Abram so he could father children. However, after Hagar's new son Ishmael was born, God again confirmed his promise of many descendants, and changed Abram's name to Abraham ('Father of a Multitude') and Sarai's to Sarah ('Princess'). When God promised that Sarah would have a son, Abraham laughed in disbelief, and God commanded that the son be called Isaac ('He laughed').

Abraham was then visited by three messengers or **angels** who foretold the birth of Isaac. Sarah, aged 90, was listening from her tent and laughed at this announcement which is sometimes compared to the Annunciation of **Jesus**' birth to the Virgin **Mary**. After Isaac was weaned, Hagar and Ishmael were sent away at Sarah's insistence.

The most famous episode in Abraham's story was when God put Abraham's faith to the

ultimate test by commanding that he sacrifice his son Isaac. Despite the terrible order, Abraham demonstrated his unswerving obedience to God and made preparations. As Abraham was wielding the knife above Isaac, an angel

Abraham, portrayed as a general in armour, returns in triumph and receives bread and wine from the robe-clad Melchizedek, the king and high priest of Salem.

Biblical Reference:
Genesis: 11–22.

Attributes:
Knife.

Major Paintings:
- Caravaggio: **Sacrifice of Isaac**, 1603, Uffizi, Florence, Italy.
- Rembrandt van Rijn: **Abraham and Isaac**, 1635, Hermitage, St. Petersburg, Russia.
- Rubens, Peter Paul: **Meeting of Abraham and Melchizedek**, 1625–30, Musée des Beaux-Arts, Caen, France.
- Domenichino: **Sacrifice of Isaac**, c.1630, Prado, Madrid, Spain.

appeared and restrained him, declaring his faith proved true. A ram caught in some nearby bushes was then sacrificed instead.

Isaac grew up to marry **Rebecca** and have twin sons, **Jacob** and Esau.

Adam and Eve

The first man and woman

According to the first book of the Bible's Old Testament, Adam and Eve were the first humans, created by God in his own image. God formed man from the dust of the ground and gave him life by breathing the 'breath of life' into his nostrils. Wishing to give him a companion, God then formed woman from a rib taken from the sleeping man.

The names Adam and Eve are thought to derive from the Hebrew for 'earth' and 'life', the former due to the substance of Adam's birth and the latter because Eve was the mother of all humankind.

God placed Adam and Eve in the Garden of Eden (Hebrew for 'delight'), an earthly paradise, where the only stipulation was that they were not to eat the fruit of the Tree of Knowledge of Good and Evil that stood in the middle of the Garden. Eve, however, tempted by a serpent, ate some of the 'forbidden fruit' and then gave some to Adam. Suddenly realizing they were naked, they covered themselves with fig leaves, a symbolic act indicating their shame at their disobedience to God.

God punished Adam and Eve by taking away their immortality and expelling them from the Garden of Eden. After this 'Fall' from paradise man had to earn his living by hard work and 'the sweat of his brow'.

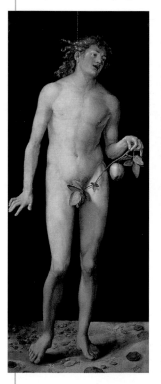

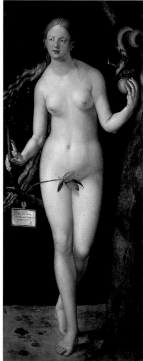

Biblical References:
Genesis 1–4.

Attributes:
Nakedness; fig leaves; fruit; serpent.

Major Paintings:

◄ Dürer, Albrecht: **Adam and Eve**, 1507, Prado, Madrid, Spain.

● Michelangelo: **The Creation of Man** *et al*, 1511–12, *ceiling of* Sistine Chapel, Vatican, Italy.

● Masaccio: **Adam and Eve Expelled from Paradise**, *c.*1427, Brancacci Chapel, S. Maria del Carmine, Florence, Italy.

The vivid imagery and technical finesse so characteristic of Dürer's work are evident in these early 16th-century wood panels of Adam and Eve.

St. Agatha
Virgin martyr

Agatha was an early Christian saint of the third century, although many details of her story are probably legendary. Born in Catania in Sicily, Agatha decided to remain a virgin and dedicated her life to **Jesus**. The Roman governor of Sicily tried to seduce her, but Agatha rejected his advances. He sent her into a brothel (like **St. Agnes** and **St. Lucy**) where she miraculously retained her virginity.

Agatha was then subjected to a singularly cruel torture when she was martyred by having her breasts torn off with pincers. The next day, the spirit of **St. Peter** reputedly visited her in a dungeon where he healed her wounds. Agatha was then brought before a court and hauled over hot coals until she died, her death accompanied by earthquakes.

Agatha's cult flourished in Sicily where she was invoked against earthquakes, lightning and eruptions of Mt. Etna, which towers over Catania. Her veil, still in Catania's cathedral, has allegedly helped the town survive numerous lava flows. Agatha's cult quickly spread from Sicily to the Italian mainland, France, Germany and Spain, where it protects against these natural phenomena and also against fire. The manner of her torture means that she is invoked against diseases of the breast.

Medieval pictures often show Agatha carrying her severed breasts on a dish, or holding pincers or shears – the instruments of her torture. She may carry a flaming building representing her protection against fire. The Renaissance and later artists tend to depict Agatha's actual moment of torture or the immediate aftermath.

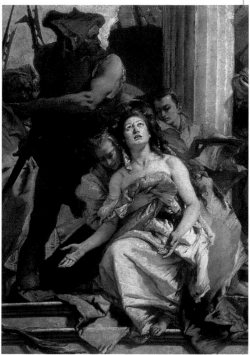

Tiepolo's portrayal of Agatha modestly, yet still shockingly, covering herself with her bloodied dress is typical of the saint's post-medieval depictions.

Attributes:

Severed breasts; pincers or shears; flaming tower; bloodied dress held to her chest.

Major Paintings:

- Tiepolo, Giovanni Battista: **Martyrdom of St. Agatha**, c.1750, Gemäldegalerie, Berlin, Germany.
- Zurbarán, Francisco de: **St. Agatha**, 1630–33, Musée Fabre, Montpellier, France.
- Rossi, Mariano: **Martyrdom of St. Agatha**, c.1760–1800, Louvre, Paris, France.

St. Agnes
Early Christian virgin martyr

St. Agnes lived and died in Rome during the time of the Christian persecutions by the Emperor Diocletian (284–305 AD), and is thus one of the oldest and most venerated of the saints.

At the age of 13 Agnes refused a number of lovers to remain faithful to her vow of chastity. The father of one of these prospective lovers was a senior Roman magistrate, who came to hear of the rebuff to his son and so condemned Agnes to a brothel (like **St. Agatha** and **St. Lucy**).

Legends recount that either on her way to the brothel or inside it, Agnes was stripped naked, but her hair miraculously grew to hide her body from view or else an angel appeared and covered her with a shining white robe which blinded onlookers. Whilst inside the brothel, Agnes' virginity was miraculously preserved. She then survived being burned alive (her executioners being burned instead), but was finally executed by being stabbed in the neck or beheaded. After her death, Agnes appeared to her parents accompanied by a lamb.

Agnes' main emblem is a lamb, either derived from a pun on her name – which actually comes from a Greek word meaning 'pure' but was later related to the Latin *agnus* meaning lamb – or representing her youth, innocence and self-sacrifice to God (a lamb being the usual sacrifice to God in Judaism). Agnes is also often shown on her pyre, extinguished or alight. She often figures alongside other virgin martyrs.

This detail from the altarpiece shows St. Agnes, identifiable by the lamb at her feet, with St. Bartholomew and the kneeling donor of the triptych, originally made for St. Columba's church in Colgone.

Attributes:

Lamb; olive branch; olive crown; long hair; white robe; burning pyre; sword or dagger; book.

Major Paintings:

▲ Master of St. Bartholomew Altarpiece: *detail from* **St. Bartholomew Altarpiece**, *c.*1500, Alte Pinakothek, Munich, Germany.

● Cowper, Frank: **St. Agnes in Prison Receiving from Heaven the 'Shining White Garment'**, 1905, Tate Britain, London, England.

St. Ambrose
Doctor of the Church

Ambrose (c.339–397 AD) is one of the four great theologians or 'Doctors' of the early Church. His rise to this prominence began in 374 AD when, as Governor of Milan, he intervened in a riot between two Church factions over the choice of a new bishop. One wished to elect a follower of the doctrine of Arius, arguing against the divinity of Jesus and the idea of the Holy Trinity, while the other wished for a traditionalist Catholic bishop. Ambrose quelled the trouble by making a passionate plea for calm and understanding. A child's voice then cried out, 'Ambrose, become our Bishop!'

Ambrose became a stout defender of the Church against Arianism, which brought him into conflict with the Emperor. During a siege of his church by Roman troops, he soothed the congregation by persuading them to sing hymns – the first known instance of communal church singing. Later, Ambrose imposed his authority on the great Emperor Theodosius, whom he excommunicated and forced to do public penance for permitting a massacre, thereby asserting the authority of the Church over the State.

In art, Ambrose is usually depicted in his bishop's robes with his crozier (crook) and mitre (hat). He often carries a whip, which may have three knots in it representing his adherence to the idea of the Holy Trinity. As a theologian he can carry a book or pen. His abilities as a preacher are also alluded to when he is pictured either as a baby with a swarm of bees about to settle on his lips or with a beehive, both illustrating the sweetness of his eloquence. He is often pictured with the three other Doctors – **Augustine**, **Gregory** and **Jerome**.

St. Ambrose depicted in his role as Bishop of Milan, a book indicating his status as a theologian and a Doctor of the Church.

Attributes:
Bishop's mitre and crozier; bees or beehive; book or pen; whip.

Major Paintings:
▸ Justus van Ghent: **St. Ambrose**, c.1468, Palazzo Ducale, Urbino, Italy.
● Vivarini, Alvise: **Altarpiece of St. Ambrose**, 1503, S. Maria Gloriosa de Frari, Venice, Italy.
● Dyck, Sir Anthony van: **St. Ambrose Repulsing Emperor Theodosius from his Church in Milan**, c.1620, NGL.

St. Andrew
The first disciple of Christ

The fact that St. Andrew, brother of Simon Peter (**St. Peter**) and like him a fisherman on the Sea of Galilee, was the very first apostle to follow Christ (see **Jesus**), has earned him immense veneration. He was originally a disciple of **John the Baptist,** but, convinced about Jesus' true identity, said to his brother, 'We have found the Messiah'. Much of his subsequent life story comes from the thirteenth-century *Golden Legend*.

Andrew's missionary work of preaching and healing took him to Asia Minor, Russia and finally Greece where he was crucified at Patras for healing and converting the Roman governor's wife. He was traditionally tied, not nailed, to an X-shaped cross, also known as a saltire and subsequently 'St. Andrew's Cross', although he is shown on a normal cross before the fourteenth century.

In the fourth century, the Bishop of Patras fled with St. Andrew's body to Scotland and was shipwrecked at a place which later became the town of St. Andrew's. The saint's head was stolen from Byzantium by crusaders and ended up in Rome. It was returned to the Patriarch of Constantinople in 1965 as a gesture of reconciliation.

St. Andrew's cult was extremely popular in the Middle Ages, especially in eastern and northern Europe, and he is the patron saint of many countries including Greece, Russia and Scotland, as well as the patron saint of fishermen.

St. Andrew is usually shown as an old man, with white hair and beard, carrying his X-shaped cross, a fisherman's net, or fish. Depictions of his crucifixion are also common.

Biblical References:
John 1:40.

Attributes:
X-shaped cross; fishing net; fish; rope (he was bound, not nailed, to the cross).

Major Paintings:
◀ El Greco: **St. Andrew and St. Francis**, 1595, Prado, Madrid, Spain.
● Caravaggio: **The Crucifixion of St. Andrew**, 1607–10, Cincinnati Art Museum, Ohio, USA.
● Murillo, Bartolomé Esteban: **The Martyrdom of St. Andrew**, 1675–82, Prado, Madrid, Spain.

The elongated figures and the exaggerated, unusual colours in the works of El Greco ('The Greek') are typical of his style and that of other painters in the Mannerist period (*c*.1520–1580).

Angels and Archangels
God's messengers

Angels, the Greek word for 'messengers', are
heavenly beings who act as God's intermediaries
with humans. According to *The Celestial
Hierarchy*, a work codifying the nature of angels
written *c.*500 AD, an angel is actually the lowest
of nine ranks of celestial beings. These ranks, or
choirs, of angels are arranged in three divisions:

 1: Seraphim, Cherubim and Thrones – who
 encircle and praise God;

 2: Dominations, Virtues and Powers – who
 rule the stars and elements;

 3: Princedoms, Archangels and Angels – the
 final two of which act as God's messengers.

Early Christian art shows wingless angels,
distinguished from men only by their halos. By the
sixth century angels are commonly depicted with
wings, taking their inspiration from Greek and
Roman personifications of Victory. From the
medieval period, the influence of *The Celestial
Hierarchy* is felt, with separate classes of angels
now depicted, of which the Seraphim (Seraphs)
and Cherubim (Cherubs) are generally shown just
as winged heads – the Seraphs traditionally red,
the Cherubs blue or yellow. Baroque paintings
portray angels as winged children, akin to the
classical **Cupid**. Of the seven Archangels, the

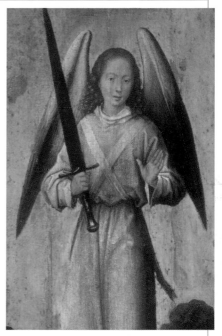

The angel's calm and restrained pose, so typical of
Memling's art, is all the more striking since the angel,
identified by his sword, is the Archangel Michael,
heaven's warrior.

Biblical References:
Bible and Apocrypha.

Attributes:
Wings; messenger's staff; orbs; musical instruments.

Major Paintings:
▷ Memling, Hans: **Angel with Sword**, 1465–94, Wallace
 Collection, London, England.
● Melozzo da Forlì: **The Dome of the St. Mark's
 Sacristy**, 1480s, Basilica of the Santa Casa, Loreto, Italy.
● Burne-Jones, Edward: **An Angel**, 1878, Sudley Art
 Gallery, Liverpool, England.
● Raphael: *cherubs in* **The Sistine Madonna**, *c.*1513,
 Gemäldegalerie, Dresden, Germany.

best known are: Gabriel – God's chief messenger,
commonly shown carrying a lily for purity in the
Annunciation to the Virgin **Mary**; Michael
leader of the heavenly army of angels, usually a
warrior slaying a dragon (Satan); and Raphael –
the angel of healing, and shown as accompany-
ing **Tobias** with his fish; with this story the idea
of guardian angels became popular from the
sixteenth century. Angels singing or playing
musical instruments signify celestial harmony and
glory, and have a visual charm which appealed to
many artists. The Hebrew and Christian traditions
of angels owe much to Mesopotamian, Persian,
Greek and Roman beliefs.

St. Anne
Mother of the Virgin Mary

The New Testament nowhere mentions the name of Anne, traditionally the mother of the Virgin **Mary**, and she only appears for the first time in the early apocryphal gospels dating from the first few centuries after Christ (see **Jesus**).

Depictions of Anne concentrate upon two distinct and separate types. In the first, very popular in the Middle Ages, Anne is often shown meeting and embracing her husband, Joachim, at the Golden Gate of Jerusalem, after his expulsion from the Temple since he was childless. The **angel** Gabriel, who foretold the birth of the Virgin Mary to both Anne and Joachim, is also usually shown present. The circumstances of Anne's surprisingly late motherhood are probably adapted from the story of a similarly named Hannah, the mother of **Samuel**.

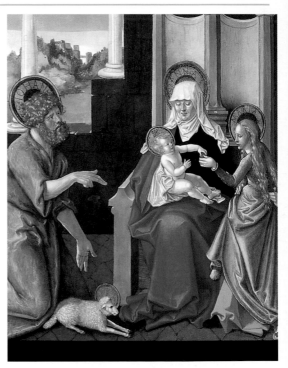

The Christ Child, seated on the knee of Anne, receives an apple from the young Virgin Mary, symbolizing that Jesus was the second Adam and a new beginning for mankind.

In the second type of representation, Anne is shown together with the Holy Family. Anne is sometimes standing or sitting next to Mary and Jesus; sometimes Anne has Mary on her knee in a parallel to the more usual image of Mary with the baby Jesus. However, somewhat confusingly, Jesus is sometimes shown seated on Anne's knee, with a young Mary standing by their sides. In the fourteenth century, a popular variant depicts Anne educating the young Mary by teaching her either to sew or, more usually, to read.

Anne is often dressed in green and red clothes – green symbolizing springtime, rebirth and thus immortality; red symbolizing love.

Attributes:

Lily (for purity); an open book (the education of Mary); green and red robes.

Major Paintings:

▲ Baldung, Hans: **St. Anne with Christ Child, the Virgin and St. John Baptist**, c.1511, NGADC.

● Masaccio: **The Virgin and Child with St. Anne**, 1420–25, Uffizi, Florence, Italy.

● Giotto: **Meeting at the Golden Gate**, 1304–06, Scrovegni Chapel, Padua, Italy.

St. Anthony Abbot of Egypt

Hermit and founder of monasticism

St. Anthony Abbot, also known as Anthony the Great, was born around 250 AD in Egypt. He retired to the desert to follow an austere, solitary life and contemplate God, and is thus considered the founder of monasticism, although he never actually founded an order.

Anthony was repeatedly tempted by the Devil in the desert, giving artists great scope for portraying horrible creatures assaulting Anthony, or women (sometimes revealing their true nature with their cloven hooves or little horns) tempting him with carnal pleasures.

Another frequently depicted episode of Anthony's life revolves around his fantastical visit to St. Paul the Hermit, who also lived alone in the desert. Anthony was guided by a **centaur** and a **satyr** to Paul; both men were fed by a raven; and when Paul died, lions helped Anthony to bury him.

More factually secure is the establishment in the eleventh century of the Hospitallers of St. Anthony or Antonites, a monastic order that cared for sufferers of skin diseases, including that known as St. Anthony's Fire.

St. Anthony is generally depicted as an old man with a T-shaped crutch, dressed in the black habit and small cowl of his Antonite Order. He sometimes has a bell and a pig; the bell was rung by the Antonites seeking alms and possibly to drive off temptation, and pig fat was perhaps used as a cure for St. Anthony's Fire, the latter occasionally represented by flames.

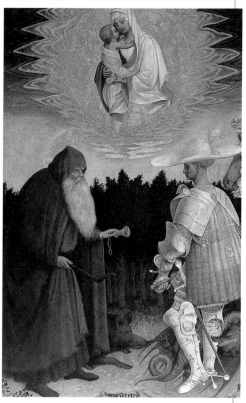

The hog behind the roughly dressed St. Anthony stares down the snarling dragon at the feet of a finely armoured St. George.

Attributes:

T-shaped cross or crutch; black habit; bell; pig; fire.

Major Paintings:

- Pisanello, Antonio: **Virgin and Child with St. George and St. Anthony Abbot**, mid-15th century, NGL.
- Piero di Cosimo: **Visitation with St. Nicholas and St. Anthony Abbot**, c.1490, NGADC.
- Cézanne, Paul: **Temptation of St. Anthony**, 1867–70, E.G. Bührle Collection, Zurich, Switzerland.

St. Anthony of Padua

Preacher and orator

Born around 1195 in Lisbon, Portugal, Anthony first joined the Augustinian Order of monks and then transferred to join the Franciscan Order established by **Francis of Assisi**. Anthony showed such a talent for preaching that this became his main duty for the Franciscan Order. For the rest of his life he travelled widely, sermonizing to huge crowds and becoming the greatest preacher of the medieval period. He practised poverty and penitence, calling people to a life of evangelical holiness and comforting the lowly while lambasting the dissolute and the rich. He spent his final years in Padua in Italy preaching from a walnut tree; he died in 1231.

Anthony became the patron saint of Portugal and so his cult was exported with Portuguese sailors all over the known world. He is especially invoked by the Christian poor, and can be called upon to find things that are lost.

His representations in art feature the many miracles attributed to him including: restoring a boy's severed leg; causing a mule to kneel in front of the Eucharist; and preaching to the fishes (derived from St. Francis preaching to the birds). A common depiction is of Anthony's vision of the Virgin **Mary** and Child, which show Anthony holding baby **Jesus**. Anthony is usually dressed in the brown habit and the three-knotted belt of the Franciscan Order. Although he can be shown with numerous attributes relating to his miracles (e.g. fish, mule), he is most often shown with a flaming heart (derived from Augustine) for religious ardour, a lily for purity, or a Christ Child seated on a book.

Attributes:

Franciscan habit; three-knotted belt; mule; lily; fish; a flowered cross; flaming heart; Christ Child on a book.

Major Paintings:

▶ David, Gerard, and workshop: *detail from* **St. Anne Altarpiece**, c.1500–20, NGADC.

● Titian: **Scenes from the Life of St. Anthony of Padua**, 1510–11, Scuola del Santo, Padua, Italy.

● Foppa, Vincenzo: **St. Anthony of Padua**, before 1500, NGADC.

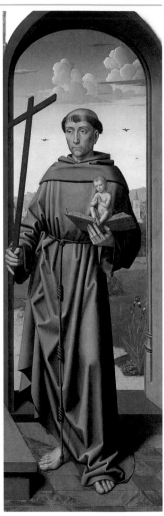

St. Anthony, the Franciscan friar, holds his main personal attribute – a Christ Child seated on a book – alluding to both his vision of the Madonna and Child, and his Christian teachings.

St. Augustine of Hippo
The Western Church's greatest theologian

Born in Algeria in 354 AD, Augustine was educated in the North African city of Carthage. After enjoying its attractions, and having fathered a son, Augustine went to Milan to teach oratory. There he discovered Christianity. Hearing a child's voice saying, 'Take, read' (*'Tolle, lege'*), and, opening randomly the Epistles of **St. Paul**, he read, 'Let us walk . . . not in rioting and drunkenness, not in chambering and wantonness . . . but put ye on the Lord **Jesus Christ**.' Augustine was baptized by Ambrose, and returned to Africa, becoming Bishop of Hippo in 396 AD.

Augustine died in 430 AD having written many theological works, including his *Confessions* and *The City of God*. Augustine is one of the four Doctors of the Church, along with **Ambrose**, **Gregory** and **Jerome**. Augustine is predominantly depicted as a bishop, with mitre and crozier, and is often engaged in study or holds a book or even a model of a city – his 'City of God'. He is sometimes dressed as an Augustinian canon in a black habit with leather belt, since these canons or monks later adapted his ideas on communal living. He may hold a

Attributes:

Bishop's robes; monk's black robes; model of a city; flaming heart; heart pierced by arrows; child or angel with shell.

Major Paintings:

▼ Carpaccio, Vittore: **Vision of St. Augustine**, 1502–07, Scuola di San Giorgio degli Schiavoni, Venice, Italy.

● Lippi, Fra Filippo: **Vision of St. Augustine**, mid 15th century, Hermitage, St. Petersburg, Russia.

● Master of the Life of the Virgin, workshop of: **St. Augustine** (*and other saints*), probably 1485–90, NGL.

flaming heart indicating his religious fervour, or a heart pierced by three arrows highlighting his meditations upon the Holy Trinity. He often stands with the three other Doctors of the Church, or his mother, St. Monica. The Visions of St. Augustine are frequently depicted. The most popular is Augustine's visionary encounter with a child whilst walking on a beach. When Augustine pointed out the futility of the child trying to bail out the sea with a shell, the child replied it was no less futile than Augustine attempting to understand the mystery of the Holy Trinity.

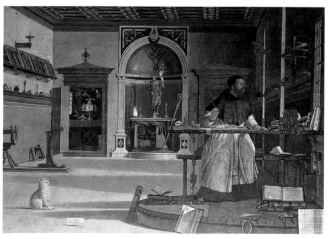

Carpaccio depicts the moment when Augustine, writing in his study, is struck by a vision of St. Jerome, indicated by a shaft of light through the window, who tells him that his death is imminent.

St. Barbara

Virgin martyr imprisoned in a tower

Barbara's story has no historical basis, but her cult was extremely popular in the medieval period. She is reputed to have been born in Nicomedia on the Sea of Marmara, her father being a pagan ruler called Dioscuros. He shut her up in a tower – in one version so that no man could cast eyes upon her, and in another to preserve her from Christianity. In her father's absence Barbara became a Christian and added a third window to the tower in honour of the Holy Trinity.

Furious with Barbara, her father commanded her death, but she escaped the tower and fled, hiding in a crack which mysteriously opened in a rock before her. She was betrayed by a shepherd, tortured, paraded naked (but an angel shielded her from view), and finally dragged up a mountain and beheaded by her own father, who was himself immediately struck by lightning and killed.

As a result, Barbara was invoked against sudden death, especially by fire, lightning or storm. She is thus the patron saint of those involved in dangerous occupations.

In art, Barbara's execution is the common set-piece scene; otherwise she stands with one of her attributes, normally a tower either in the background or in her hands. She became the patron saint of gunners, by association with lightning, and can also carry either a chalice and wafer of the Last Rites, or a peacock's feather signifying immortality. She may also hold a book alluding to her Christian studies.

Attributes:

Tower; cannon; lightning; axe or sword; book; chalice and wafer.

Major Paintings:

● Eyck, Jan van: **St. Barbara**, 1437, Koninklijk Museum voor Schone Kunsten, Antwerp, Belgium.

● Memling, Hans: **Virgin and Child with Sts. Catherine of Alexandria and Barbara**, 1479, NYMet.

▼ Cranach, Lucas the Elder: **Madonna and Child with Sts. Catherine, Dorothy and Barbara**, first half of 16th century, Museum of Fine Arts, Budapest, Hungary.

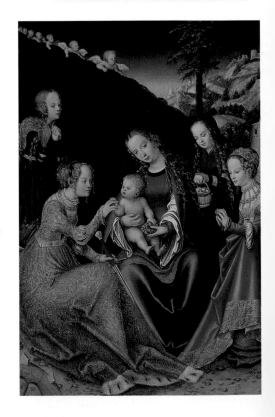

The tower in which Barbara was imprisoned can be seen behind her in Cranach's painting, which also includes St. Catherine with broken wheel and St. Dorothy with a basket of apples and roses.

St. Bartholomew
Apostle who was skinned alive

Bartholomew, one of **Jesus**' twelve disciples, is mentioned in the Gospels of **Matthew**, **Mark** and **Luke**, and is probably the person known as Nathaniel in **John**'s Gospel. Although Bartholomew played no active role in either the Gospels or Acts, after Jesus' death he and St. Philip reputedly spread Jesus' message to Arabia and Mesopotamia and they may have travelled as far as India. He was martyred in Armenia where he was first flayed (skinned alive) and then crucified and beheaded.

The nature of his death has resulted in Bartholomew becoming the patron of all who work with animal skins, especially leather, including butchers, tanners, curriers, glovemakers and bookbinders. In many towns, members of these wealthy and powerful trades commissioned depictions of him in churches, and the founding and naming of St. Bartholomew's Hospital in Smithfield meat market in London is an example of this patronage.

In art, Bartholomew is very often depicted having been flayed. He may appear reddened, indicating that his skin has been stripped off, and he may even carry his skin on his shoulder or over his arm. By far the best-known representation of this is Michelangelo's 'Last Judgement' in the Sistine Chapel, where he is shown holding his own skin and with the features of the artist Michelangelo himself. Baroque painters, in keeping with their tendency for heightened realism, sometimes gruesomely show Bartholomew in the process of being skinned.

The punishment of being skinned alive, while by no means uncommon in Roman times, has a mythological parallel in the story of **Marsyas**.

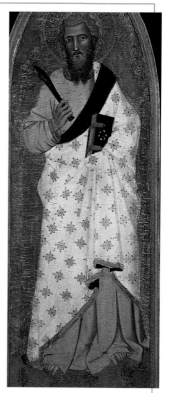

The old-fashioned styles of Byzantine icons continued to influence the early Gothic art of the Florentine painter Andrea Bonaiuti, popularly known as Andrea da Firenze, as exemplified in this devotional image of St. Bartholomew.

Biblical References:
Matthew 10:3; Mark 3:18; Luke 6:15; John 1:45–51, 21:2.

Attributes:
Reddened body; flaying knife; skin (over his arm or shoulder).

Major Paintings:
- Master of St. Bartholomew Altarpiece: *detail from* **St. Bartholomew Altarpiece**, c.1500, Alte Pinakothek, Munich, Germany.
- Andrea da Firenze: **St. Bartholomew**, c.1360–65, Museum of Fine Arts, Houston, Texas, USA.
- Michelangelo: **Last Judgement**, 1537–41, Sistine Chapel, Vatican, Italy.

Bathsheba
Beautiful woman seduced by a king

The Old Testament story of Bathsheba has been a favourite subject for artists, not least because it gave a valid excuse to portray a female nude.

Bathsheba, a model of beauty, was bathing one evening when she was spotted by King **David** of Israel who happened to be walking on the roof of his palace in Jerusalem. David immediately fell in love with Bathsheba, despite having many wives already, and made enquiries as to her identity. He was informed that she was the wife of Uriah the Hittite, a soldier in David's army which, at that time, was besieging a hostile city. In spite of this, David summoned Bathsheba to his palace where he seduced her and she conceived.

David, wishing to disguise the paternity of the child, ordered Uriah to go home and sleep with Bathsheba. Uriah refused, however, saying that he could not do so whilst the King's army was fighting, and so David then callously gave Uriah a letter to deliver to the army commander. Unbeknown to Uriah, the letter ordered that Uriah should be placed in the forefront of the battle in the hope that he would be killed – which is what happened.

Bathsheba, having mourned for Uriah, married David and bore him a son. But what David had done was 'wrong in the eyes of the Lord' and God sent the prophet Nathan to David to admonish him for his sins. Although David repented, he was punished by the death of his baby son. Subsequently he and Bathsheba had another son called **Solomon**.

Biblical References:
2 Samuel 11.

Attributes:
Nakedness; bath; letter.

Major Paintings:
- Memling, Hans: **David and Bathsheba**, c.1482, Staatsgalerie, Stuttgart, Germany.
- Rembrandt van Rijn: **Bathsheba**, 1654, Louvre, Paris, France.
- Rubens, Peter Paul: **Bathsheba at the Fountain**, c.1635, Gemäldegalerie, Dresden, Germany.
- Brülloff, Karl: **Bathsheba**, 1832, Tretyakov Gallery, Moscow, Russia.

The seductiveness of Bathsheba is emphasized by her pose and expression as she unties her hair while gazing directly at the viewer. Her illuminated pale skin contrasts with that of her kneeling servant.

Belshazzar
King of Babylon

The Old Testament Book of Daniel states that Belshazzar was the son of Nebuchadnezzar II. However, Babylonian inscriptions indicate that he was the eldest son of Nabonidus (King of Babylon, 555–539 BC) and Nitocris, who was perhaps a daughter of Nebuchadnezzar. Belshazzar ruled Babylon jointly with his exiled father from 550 DC until the fall of Babylon in 539 BC.

According to the Book of Daniel, Belshazzar held a great feast for a thousand of his courtiers. He attended with his wives and concubines, and ordered the wine to be served in the golden vessels which had been looted from the great Temple of **Solomon** in Jerusalem when that city had been captured by the Babylonians. Amidst the carousing, as the Babylonian gold and silver idols

Biblical References:
Daniel 5.

Attributes:
Crown; luxurious robes; feast; writing on the wall.

Major Paintings:
● Martin, John: **Belshazzar's Feast**, 1826, NGADC.
▼ Rembrandt van Rijn: **Belshazzar's Feast**, c.1635, NGL.

were being praised, a hand suddenly appeared out of thin air and wrote on a wall the following words in Hebrew, '*Mene, mene, tekel, upharsin.*'

None of Belshazzar's astrologers or wise men knew the meaning of the words and so the Hebrew prophet **Daniel**, who had once interpreted one of Nebuchadnezzar's dreams, was summoned. Daniel explained that because of Belshazzar's sacrilegious ways the words were a warning from God, '*mene*: God has numbered your kingdom and finished it; *tekel*: You have been weighed in the balance and found wanting; *upharsin*: Your kingdom is divided and given to the Persians.' For Belshazzar, the 'writing was on the wall'.

That same night Babylon was attacked by the Persians and Belshazzar was killed.

Rembrandt's version of the feast is notable since he apparently provides an excuse as to why Belshazzar's men could not read the 'writing on the wall' – the Hebrew script must be read downwards rather than right to left, for any meaning to emerge.

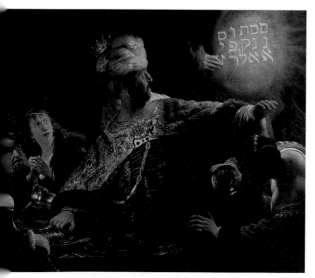

Belshazzar's Feast with its sumptuous, pagan setting and startling climax appealed especially to 17th-century tastes. Rembrandt's is perhaps the finest depiction.

St. Benedict
Father of Western monasticism

Benedict (Benedetto in Italian) was born in the Italian province of Nursia in Umbria *c.*480 AD. Educated in Rome, he was shocked by the excesses of the city and he withdrew to lead a solitary, contemplative life in a cave at Subiaco. Benedict's secluded lifestyle attracted followers, and after three years he was invited to become the head or 'Abbot' of a group of monks. When Benedict's strict rules caused the monks to offer him poisoned bread (snatched in time by a raven), he left and started a monastery at Monte Cassino, northwest of Naples.

Benedict's Rule for the communal lives of monks became the basis for all monastic life in the Western Church, with emphasis on a daily routine of prayer, private study and manual labour. No property could be owned, meals were taken together and conversation was kept to a minimum. A hugely successful order, the number of Benedictine monasteries grew throughout Europe, although rules relaxed and the monks devoted more time to teaching.

Many legends about Benedict are represented in art. Some of the most common show Benedict accepting food being lowered on a rope into his cave; rolling in a thorn bush to purge himself of temptation; meeting Totila, King of the

Attributes:
Black or white habit; raven; bread and cup (poisoned); water sprinkler; tray; crozier; book.

Major Paintings:
- Peregino, Pietro: **St. Benedict**, 1495–98, Vatican, Italy.
- Angelico, Fra: **St. Benedict**, *c.*1440, Minneapolis Institute of Arts, Minnesota, USA.
- ▼ Lippi, Fra Filippo: **St. Benedict Orders St. Maurus to the Rescue of St. Placidus**, *c.*1445, NGADC.
- Lorenzo Monaco: **Scenes of St. Benedict**, probably 1407–09, NGL.

Ostrogoths; exorcizing demons from people, sometimes with the aid of a holy-water sprinkler; and miraculously mending a broken tray which his nurse had dropped.

Benedict himself is often depicted in the black robes worn later by Benedictine monks, or sometimes the white habit of variant orders. He sometimes holds the tray or the brush-like sprinkler, and more often his 'Book of Rules' and an abbot's crozier.

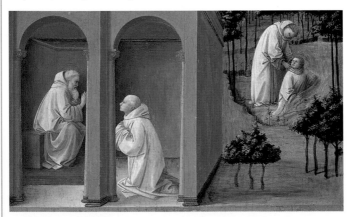

Benedict, having had a vision that one of his early followers, Placidus, had fallen into a lake, blessed and sent another, Maurus, to rescue him. Maurus miraculously walked on the water to pull Placidus out.

Cain and Abel

Sons of Adam and Eve

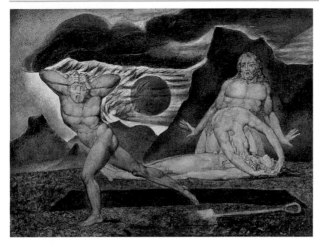

Blake shows not just the horror of Adam and Eve finding Abel's body, but also the flames of divine wrath upon Cain, all set against a blood-red setting sun and lowering clouds.

Cain and Abel were the sons of **Adam and Eve** according to the Old Testament. The elder brother, Cain, was a farmer while Abel was a shepherd.

In the course of time they both offered a sacrifice to God – Cain gave his produce from the land and Abel gave his best lambs. For reasons not made clear in the Bible, Abel's offering was accepted while Cain's offering was rejected. The implication is that Cain's offering was inferior or Cain himself was unworthy. Out of jealousy Cain lured Abel into open country and murdered him.

When asked by God about the whereabouts of Abel, Cain replied, 'Am I my brother's keeper?' God cursed Cain, saying that Abel's blood was 'crying out from the ground', and banished Cain to be a wanderer on Earth. Cain feared he could be killed wherever he went but God relented and put the 'mark upon Cain' so that anyone finding him should not kill him. Cain eventually settled in the land of Nod, east of Eden, where he had a son named Enoch.

In art, Cain is often shown murdering Abel. Cain usually wields a weapon such as a stone, club, a hoe or spade (as befits a farmer), or, due to a conflation with **Samson**, the jawbone of an

ass, although there is no biblical testimony for these implements. Sometimes the soul of Abel is shown 'crying out from the ground'.

Biblical Reference:

Genesis 4:1–16.

Attributes:

Club, stone, spade, jawbone of an ass; sacrificial pyre; the soul of Abel crying out.

Major Paintings:

△ Blake, William: **Body of Abel Discovered by Adam and Eve**, c.1825, Tate Britain, London, England.

● Rubens, Peter Paul: **Cain Slaying Abel**, c.1600?, Courtauld Institute, London, England.

● Tintoretto, Jacopo: **Cain and Abel,** 1550–53, Accademia, Venice, Italy.

St. Catherine of Alexandria
Virgin martyr tortured on a wheel

Catherine is one of the most popular saints, although no longer actually considered one by the Catholic Church due to her doubtful history.

According to the *Golden Legend*, Catherine was born in Alexandria in Egypt around 290 AD into a noble or royal family. She was well educated and an avid learner who achieved great wisdom. As a young girl she dedicated her life to God and took a vow of chastity, considering herself married to **Jesus.**

The Roman Emperor Maxentius wished to marry Catherine but she refused him due to her 'mystic marriage' to Christ. Maxentius engaged fifty pagan philosophers to try to show Catherine the illogical nature of her views, but Catherine converted them instead. Maxentius had the philosophers executed, and devised a novel torture instrument for Catherine, consisting of a set of revolving, spiked wheels. However, before Catherine was subjected to this, the machine was struck by a bolt of lightning sent from God. Catherine was then martyred in a more traditional manner by being beheaded. Her body

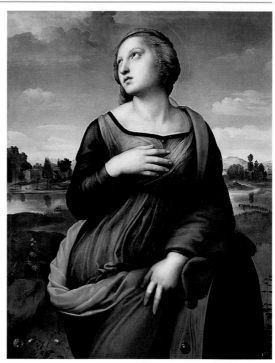

St. Catherine, resting on her wheel, typifies Raphael's genius at portraying human expression; her heavenward gaze reveals dignity and spiritual strength.

was allegedly carried to Mt. Sinai where a monastery was later re-named in her memory.

Catherine is nearly always shown with her wheel of torture, which may be broken in allusion to its fate, and she may also hold the sword that was used to behead her. Books and other technical instruments allude to her wisdom and learning, of which she is the patron saint. She may also hold a ring to symbolize her 'mystic marriage'. This marriage is often an artistic subject itself, comprising the baby Jesus, seated on his mother's knee, placing a ring on Catherine's finger.

Attributes:

Wheel; sword; royal crown; book; ring.

Major Paintings:

▲ Raphael: **St. Catherine**, *c.*1507–08, NGL.

● Lotto, Lorenzo: **St. Catherine**, *c.*1522, NGADC.

● Parmigianino, Francesco Mazzola: **The Mystic Marriage of St. Catherine**, *c.*1530, NGL.

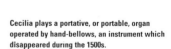

St. Cecilia
Patron saint of musicians

Cecilia's life is thought to be purely legendary. She was supposed to have been a Christian girl who married a pagan Roman called Valerius. He agreed to sexual abstinence if Cecilia's guardian **angel** appeared to him; whereupon the angel descended and placed crowns of roses and lilies upon their heads. Cecilia then converted Valerius to Christianity.

During a persecution of Christians by the Romans, Valerius and his brother were executed, and Cecilia was arrested. She refused to reject her faith and was condemned to suffocation in a boiler or steam bath, or, according to some, to be boiled alive in a vat of oil. She survived these tortures and was taken to be beheaded, but the executioner failed, and she lingered on for three days before dying.

Cecilia is sometimes represented either at her wedding, where the angel heralds the conversion of Valerius, or being tortured in the boiler, steam bath or vat of oil. However, a very different representation emerges at the end of the fifteenth century when Cecilia is sometimes pictured with a musical instrument. This musical Cecilia arose from a series of misunderstandings of her legend which recounts that at her wedding she sang 'in her heart' to drown out the pagan 'instruments' – *organa* in Latin. Some artists not only mistakenly portrayed Cecilia herself with instruments, but also gave her a small, handheld organ. Others, more accurately, depict Cecilia rejecting the pagan instruments, often associated with erotic pursuits, by holding the organ upside down or with broken instruments at her feet.

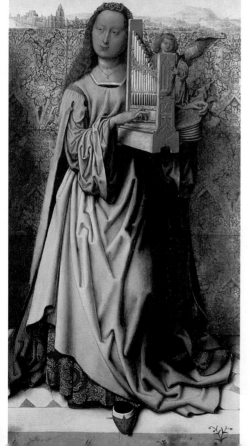

Cecilia plays a portative, or portable, organ operated by hand-bellows, an instrument which disappeared during the 1500s.

Attributes:
Musical instruments; angel; wreath of flowers; roses and lilies.

Major Paintings:
◄ Master of St. Bartholomew Altarpiece: *detail from* **St. Bartholomew Altarpiece**, *c.*1500, Alte Pinakothek, Munich, Germany.
● Raphael: **St. Cecilia with Saints**, *c.*1513–16, Pinacoteca, Bologna, Italy.
● Domenichino: **St. Cecilia**, 1617–18, Louvre, Paris, France.

St. Christopher
Protector of travellers

The legends surrounding Christopher, of which the most popular are recounted in the *Golden Legend*, seem purely fictional, which accounts for his demotion from saintly status by the Catholic Church in 1969. His cult was extremely popular from the thirteenth century onwards, and the popularity of St. Christopher medallions as a protection while travelling is still current.

Christopher was reputedly born in Canaan in the third century and named Offero, meaning 'I carry'. He was a huge man, possibly a giant, and wished to serve the greatest king in the world. After serving various mortal kings with no joy, Offero dedicated his life to **Jesus**. A hermit told him to live by a deep and powerful river, using his strength to carry pilgrims and travellers across. One day a child asked Offero for his assistance, but as he crossed, guided by the hermit with a lantern, the load grew heavier and, even with the aid of his staff – a palm tree – he only just managed to get across. The child then revealed himself to be Christ, explaining that the burden that Christopher had carried was that of the world and its creator. As proof, the child told him to plant his staff in the ground, saying that it would flower and bear fruit the next day. This prediction came true.

Offero was renamed Christopher, 'Christ-bearer', and preached the gospel in Asia Minor. Around 250 AD he was condemned to death for refusing to worship pagan gods, and, after surviving being shot with arrows, he was beheaded.

St. Christopher is invariably shown, staff in hand, crossing the river with the Christ Child on his shoulders.

Attributes:
Giant; staff or palm tree; river; Christ Child on shoulders.

Major Paintings:
- Lotto, Lorenzo: **St. Sebastian and St. Christopher**, 1531, Gemäldegalerie, Berlin, Germany.
- Witz, Conrad: **St. Christopher**, *c*.1435, Öffentliche Kunstsammlung, Basle, Switzerland.
- Bellini, Giovanni: **St. Christopher Carrying the Christ Child**, *c*.1464–68, Church of SS. Giovanni e Paolo, Venice, Italy.

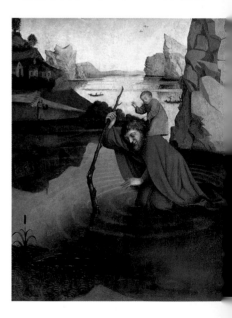

The advanced naturalism that characterizes the few known paintings by Conrad Witz, a German-born Swiss artist, is seen in the ripples and reflections in the water in this picture of St. Christopher.

Daniel
Old Testament prophet and interpreter

Daniel is considered one of the five major prophets of the Old Testament, although the stories about him, related in various books of the Bible, are probably mythical.

During the exile of the Jewish people in Babylon (586–539 BC), Daniel was admitted to be trained as a court official at the court of King Nebuchadnezzar where he prospered and was promoted to provincial governor due to his unique ability to interpret the King's dreams. One of these involved a huge tree that reached to heaven and which was cut down to a stump by an angel. Daniel interpreted this as a direct warning of a threat to the King's power. Indeed, as Daniel had forecast, Nebuchadnezzar fell from power, and was succeeded by **Belshazzar** (whom Daniel helped by interpreting the 'writing on the wall') and in turn by Darius.

Those jealous of Daniel's success prevailed upon King Darius to issue a decree forbidding prayer to anyone but Darius for thirty days on pain of being eaten by lions. Daniel, with his unshakeable faith, continued praying three times a day to his God. Darius, bound to honour his decree, sorrowfully had Daniel thrown into the lions' den. Miraculously, Daniel was unharmed by the lions, and upon release said, 'My God has sent his angel to shut the lions' mouths.'

Three episodes from Daniel's life are usually portrayed by artists – the lions' den, the writing on the wall and the story of **Susanna**. The first episode has been painted from the earliest times down to the present day, not least because of the dramatic potential of a scene with lions.

Attributes:

Lions.

Biblical References:

Daniel; Apocrypha: The Song of the Three, Daniel and Susanna, Daniel, Bel, and the Snake.

Major Paintings:

▼ Riviere, Briton: **Daniel in the Lions' Den**, 1883, Walker Art Gallery, Liverpool, England.

● Rubens, Peter Paul: **Daniel in the Lions' Den**, 1615, NGADC.

● Blake, William: **Nebuchadnezzar**, 1795, Tate Britain, London, England.

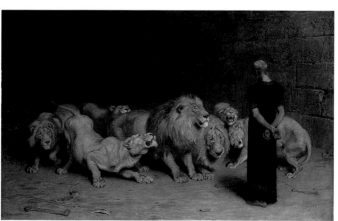

Daniel, strengthened by his faith in God, stands calmly and resolutely before the lions, which maintain a distance from the prophet. Briton Riviere, following in the tradition of the renowned animal artist, Edwin Landseer, humanizes the lions, giving them varying expressions ranging from bravado to wonder and fear.

David
Israel's greatest king

David, the second King of Israel, reigned for forty years from around 1000–960 BC. He was the youngest son of Jesse, and descended from the tribe of Judah. He grew up in Bethlehem where he looked after his father's sheep. From being a young shepherd boy he became Israel's greatest king, extending and strengthening his kingdom and making Jerusalem its capital. David was also a skilled harpist, a writer of psalms, a great warrior and a wise, though sometimes treacherous and immoral, ruler.

Because the first King of Israel, **Saul**, had lost God's favour, the prophet Samuel was sent by God to anoint David as king-in-waiting without Saul's knowledge. Saul suffered from bouts of depression and, on the recommendation of a servant, David was sent for to become the King's harpist.

Saul was often at war with the Philistines who had a formidable champion in Goliath of Gath, a giant in height and a heavily armed warrior. Goliath repeatedly challenged anyone to single combat and David begged to be allowed to fight him, telling Saul how he had killed both a lion and a bear while keeping his father's sheep. He rejected Saul's heavy armour and, taking only his sling and five carefully chosen stones, he advanced towards Goliath. David hit him on the forehead with a stone and, as Goliath lay stunned on the ground, he cut off his head with the Philistine's own sword. The Philistine army fled. David was given a triumphant reception and his popularity increased.

Saul's son, Jonathan, became David's closest friend and David married Michal, Saul's daughter. However, Saul became extremely jealous of David and twice threw a javelin at him while he was playing the harp. Jonathan tried to reconcile his father to David, but failed and so the two friends tearfully parted company. Finally Saul and Jonathan met their deaths fighting the Philistines on Mt. Gilboa. Saul, being severely wounded, killed himself with his own sword. David was now King of Israel and made Jerusalem his capital, to which he brought back the Ark of the Covenant.

The story of David has provided numerous incidents that are portrayed in art, but the most popular depict David playing the harp, watching **Bathsheba** bathing, and, above all, his encounter with Goliath where he is featured either in action or contemplating the head of the giant.

Biblical References:
1 & 2 Samuel; 1 Kings.

Attributes:
Crown; sling; stone; harp; head of Goliath.

Major Paintings:
- Castagno, Andrea del: **The Young David**, c.1450, NGADC.
- Degas, Edgar: **David and Goliath**, 1864, Fitzwilliam Museum, Cambridge, England.
- Caravaggio: **David with the Head of Goliath**, 1605–06, Galleria Borghese, Rome, Italy.
- Cima da Conegliano: **David and Jonathan**, c.1505–10, NGL.
- ▶ Hendrick van Somer: **David Holding the Head of Goliath,** 1625–85, Musée des Beaux-Arts, Nice, France.

The young David, standing next to the giant head of Goliath, engages the viewer with his thoughtful gaze. The weapons of David's victory are also portrayed – the sling with which Goliath was stoned and stunned, and the sword with which he was beheaded.

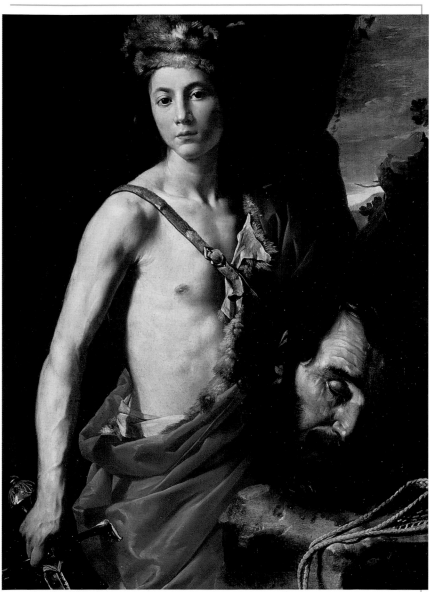

St. Dominic
Founder of the Dominican Order ('Black Friars')

Domingo Guzman was born in Spain in 1170 and became a lifelong preacher against heresy, notably trying to convert the Albigensians of southern France. In 1217 in Toulouse he founded an order of friars who set up centres of learning and preaching based in cities on the model of the Franciscans (see **St. Francis**). Their white robes and black cloaks meant they were known as 'Black Friars'. Dominic died in 1221 in Bologna, but the Dominican Order spread rapidly through Europe, with many houses established in university towns adding to the friars' reputation as theologians.

Legends abound about Dominic's life, a major one telling of his mother's dream in which she saw her unborn son with a star on his forehead, accompanied by a black-and-white dog holding a flaming torch in its jaws. Dominic's association with a dog is based on a pun linking his name to the Latin *Domini Canis,* i.e. the 'watchdog of God'.

Dominic was credited with numerous miracles, many of which feature in art. These include: bringing a young man back to life who had died after a fall from his horse; burning heretical books of the Albigensians while the Bible bounces out of the fire; saving pilgrims from drowning in a river; and Dominic and his friars being brought bread by angels.

Dominic himself is nearly always depicted in the black-and-white robes of his order, a star on his head or on his robes, and holding a lily (for chastity), a Bible, or a rosary which he was formerly thought to have invented.

Attributes:
Black-and-white robes; dog; lily; star; book; torch; loaf of bread; rosary.

Major Paintings:
◄ Lippi, Filippino: **Virgin and Child and Sts. Jerome and Dominic**, *c.*1485, NGL.

● Berruguete, Pedro: **St. Dominic and the Albigenses**, *c.*1480, Prado, Madrid, Spain.

● Tura, Cosimo: **St. Dominic**, 1475, Uffizi, Florence, Italy.

Filippino Lippi, son of the notorious Fra Filippo Lippi and pupil of Botticelli, demonstrates his typical artistic gentleness in this altarpiece depicting the Virgin with St. Jerome (with his lion) and St. Dominic dressed in his Black Friar robes (with Bible and lily).

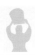

Elijah

Old Testament prophet taken up in a chariot of fire

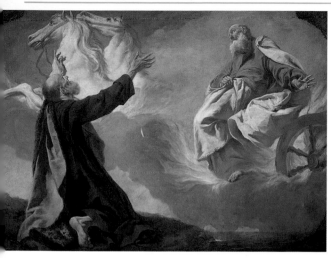

The prophet Elijah is taken heavenwards in a chariot of fire while his successor Elisha falls to his knees in astonishment.

Elijah, one of the five major Old Testament prophets, lived in the ninth century BC. He preached relentlessly against the worship of Baal and other 'false gods'.

When King Ahab of Israel was incited by his wife Queen Jezebel to build an altar to the worship of Baal, Elijah prophesied three years of drought. He then withdrew to the brook of Cherith where he was fed by ravens, a subject popular among artists. When the brook dried up, Elijah moved on to Zarephath, where he was fed by a widow who believed his prophecy that 'her barrel of meal and her cruse of oil' would not run out during the drought. When the widow's son died, Elijah prayed over the body and the boy was resuscitated.

Later, Elijah challenged 450 priests of Baal to invoke their god to conjure up fire upon the altars. When they failed, Elijah prayed to his God who duly sent fire. Queen Jezebel's priests were killed by their disillusioned followers, and in turn Jezebel tried to kill Elijah, who fled to Mt. Horeb for forty days and nights sustained only by an angel. After earthquake, wind and fire, Elijah was instructed by God to anoint Jehu as the new God-fearing King of Israel and Elisha to be his successor as prophet.

The most commonly represented episode from Elijah's life is, paradoxically, that of his final moments on Earth. For, while out walking with Elisha, he was suddenly taken up to heaven in a chariot of fire, and as he rose his mantle symbolically fell onto the shoulders of Elisha.

Biblical References:

1 & 2 Kings.

Attributes:

Raven; fiery sword; altars; chariot of fire; chariot's wheel; dogs attacking Jezebel.

Major Paintings:

▲ Angeli, Giuseppe (formerly attributed to Piazetta, Giovanni Battista): **Elijah Taken Up in Chariot of Fire**, c.1740–55, NGADC.

● Savoldo, Giovanni Girolamo: **Elijah Fed by the Raven**, c.1510, NGADC.

● Guercino: **Elijah Fed by Ravens**, 1620, NGL.

Esther

Jewish Queen of Persia and heroine

In the fifth century BC, Esther, a beautiful and charming girl, was chosen by King Ahasuerus (Xerxes I) of Persia as his new Queen after he banished his former wife, Vashti. Esther's foster father Mordecai, a Jewish official at the royal palace at Susa, told Esther not to disclose her true race or family to the King, for they were the descendants of Jewish captives taken to Babylon by Nebuchadnezzar.

Mordecai offended Haman, the King's proud chief minister, by refusing to bow down to him and, in revenge, Haman plotted to have all the Jews in the Persian empire killed by persuading the King to issue an order against them. Esther risked her life by appearing unannounced before King Ahasuerus, throwing herself at his feet, and directly appealing to him to spare the Jews, admitting they were her own people. The King, because he loved Esther, consented. Esther then invited the King and Haman to a banquet at which she exposed Haman's plot and denounced him. Haman was hanged on the gallows which he had himself erected for Mordecai.

Previously Haman had decided on the day for the intended Jewish massacre by casting lots (*pur* in Persian) from which derives the name Purim ('Feast of Lots'), the Jewish festival commemorating the day Esther saved her people.

Esther's story, essentially a secular historical romance, was popular in art, especially during the Baroque period, since the oriental setting allowed artists to indulge in sumptuous dress and detail. In addition, the subjects of Esther begging the King on behalf of her people and her denunciation of Haman provided an immediate emotional appeal.

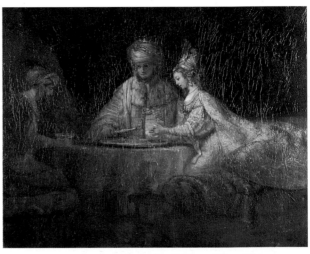

The Persian King sits between Esther and the plotting Haman, symbolically cast in shadow, in the psychologically intense moments (typical of Rembrandt) before the Jewish heroine's brave intercession to save her people.

Biblical References:

Esther; Apocrypha: Additions to Esther.

Attributes:

Crown; oriental royal robes.

Major Paintings:

- ▲ Rembrandt van Rijn: **Ahasuerus, Esther and Haman**, 1660, Pushkin Museum, Moscow, Russia.
- ● Ricci, Sebastiano: **Esther before Ahasuerus**, 1730–34, NGL.

St. Eustace and St. Hubert
Patron saints of hunters

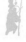

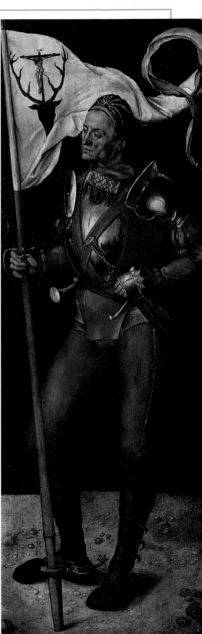

The history of St. Eustace is probably legendary and it is doubtful if he ever existed, although a church in Rome dedicated to him dates from the eighth century.

Eustace's legend claims that he was a Roman general called Placidus, serving under the Roman Emperor Trajan. One day while out hunting, Placidus spotted a stag and saw a crucifix appear between its antlers. The stag then spoke to him and told him to convert to Christianity and to remain firm throughout subsequent hardships with which the Devil would afflict him. Placidus and his family were baptized, and he changed his name to Eustace, meaning 'firm'

As warned, Eustace gradually lost all his property. His wife was seized during a sea voyage, and his children were taken by wild animals, but all were miraculously reunited. As Christians, Eustace and his family were thrown to the lions by Trajan, but as they were unharmed (see **Daniel**) they were placed in a hollow bronze bull and roasted alive over a fire.

Eustace had a widespread cult in France and Germany in the medieval period. During the Renaissance, however, St. Hubert – whose legend contains the same basic element of a stag with a cross between its antlers – became the more popular patron saint of hunters, especially in northern Europe.

Eustace and Hubert can be confused in art. However, Eustace is often dressed as a Roman soldier whereas Hubert is nearly always depicted as a medieval knight, nobleman or bishop.

In Dürer's painting, the banner emblazoned with a stag and crucifix immediately identifies the saint as either Eustace or Hubert.

Attributes:
Eustace – Roman dress; stag; antlers with crucifix; bronze bull. Hubert – medieval dress; bishop's robes; stag; antlers with crucifix; hunting horn.

Major Paintings:
▶ Dürer, Albrecht: **St. Eustace**, 1502–04, Alte Pinakothek, Munich, Germany.
● Pisanello, Antonio: **Vision of St. Eustace**, 1436–38, NGL.
● Master of the Life of the Virgin: **Conversion of St. Hubert**, probably 1480–85, NGL.

St. Francis of Assisi

Founder of the Franciscan Order and lover of animals

Francis was born in 1181 at Assisi in Italy into a wealthy cloth-merchant family. Aged about 28, and already compassionate towards the poor and sick, he was praying in a local church when he heard a voice telling him to repair the church. He sold some of his father's cloth to raise money, leading to a split with his father, which finally culminated in Francis discarding his fine clothes (and accepting the bishop's cloak), renouncing his inheritance and 'marrying' Lady Poverty. As an itinerant preacher, Francis' mission was to save the souls of the poor and share their life of hardship. Disciples began to join him and in 1209 they founded the beginnings of the Franciscan Order, whose members or 'friars', unlike monks who lived in self-sufficient seclusion in the countryside, lived in towns begging food and preaching. Their original grey robes caused them to be known as 'Grey Friars'.

Francis' love of nature was well known, and he reputedly preached to the animals. He also recreated the scene of **Jesus**' birth in a stable with live animals, thus inventing the popular Christmas Crib. In 1224, an **angel** (or in some versions, Jesus himself) with six wings appeared to Francis resulting in him receiving the stigmata – the nail wounds Jesus received on his hands and feet, and the spear wound on his side, when he was crucified. Francis died in 1226 and was made a saint only two years later. Venerated in his own lifetime, Francis rapidly became the most revered saint in all Christendom.

In the three centuries following his death artists commonly painted scenes from St. Francis' life, featuring real or legendary incidents. These include: Francis giving his cloak to a beggar; Francis' vision of a heavenly palace; Francis casting aside his clothes; Francis holding up the Lateran church in Rome in the Pope's dream; the 'marriage' of Francis and Lady Poverty; trial by fire in front of the sultan; the Crib; Francis preaching to the animals; Francis receiving the stigmata.

St. Francis, while in retreat on Mt. Alverna (or La Verna) in the Tuscan hills, receives the stigmata – the wounds Christ received on the cross – from heaven. The Spanish artist Ribera follows tradition by including a witness, Friar Leon, who continues reading oblivious of Francis' ecstasy.

The most celebrated example of these is the twenty-eight scenes from the life of St. Francis, painted along the walls of the nave of the Upper Church of Assisi, probably under the direction of Giotto in the 1290s.

From the sixteenth century, when devotional subjects became popular, St. Francis is often shown either at prayer or embracing the body of Christ; he is sometimes accompanied by a skull representing the mortality of man.

St. Francis is always shown wearing the grey or brown habit of his order with a three-knotted cord tied round the waist, the knots representing the vows of poverty, chastity and obedience. The stigmata are shown on his hands and feet, and his habit sometimes has a hole in its side to reveal the stigma corresponding to Christ's spear wound.

Attributes:

Brown or grey habit; three-knotted cord; stigmata; slit in side of habit; crucifix; lily (for chastity); skull (man's mortality).

Major Paintings:

▶ Ribera, Jusepe (or José) de: **St. Francis of Assisi**, c.1642, Monasterio de El Escorial, Madrid, Spain.

● El Greco: **St. Francis Receiving the Stigmata**, 1590–95, National Gallery of Ireland, Dublin, Ireland.

● Giotto: **St. Francis Receiving the Stigmata**, c.1295, Louvre, Paris, France.

● Caravaggio: **Ecstasy of St. Francis**, c.1596, Wadsworth Atheneum, Hartford, Connecticut, USA.

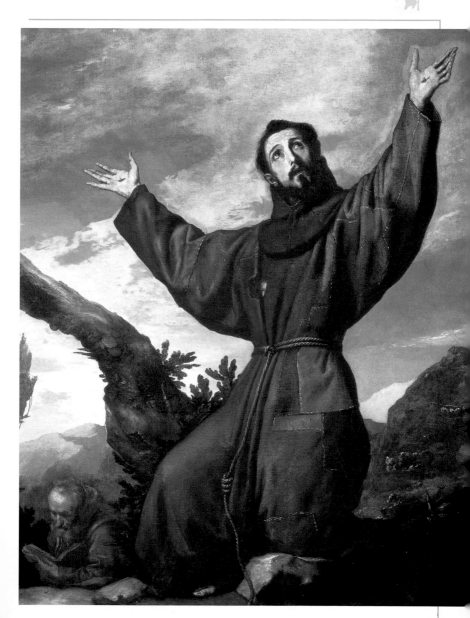

St. George
Slayer of the dragon

St. George is a totally legendary saint whose existence has been in doubt since the fifth century. The main elements in the life of St. George were related in the highly influential *Golden Legend*.

Born in Cappadocia in central Turkey of Christian parents, George became an officer in the Roman army. While travelling in Libya (or Lebanon), George came upon a fierce dragon that was terrorizing a city. The animal not only devoured all the cattle in the surrounding countryside but also insisted upon a daily tribute of two sheep. All the animals in the town having been eaten, a young person had then to be sacrificed. The victims' names were drawn by lot, with no family exempt. On the day that George arrived, the King's only daughter was the intended victim. George fought the dragon and, with **Jesus**' help, overcame the beast and set the Princess free. In one version of the legend the dragon was not killed immediately but merely wounded, and then led back to the city on a lead made from the Princess' girdle.

The combat with the dragon – an early Christian symbol of evil and paganism and perhaps conflated with the serpent in the Garden of Eden – symbolizes not just the straightforward triumph of good over evil, but also the triumph of Christianity over heathen lands. However, the tale seems certainly to have its origins in the Greek myth of **Perseus and Andromeda**.

Whatever its origins, the subject of St. George and the Dragon is an extremely common one in Christian and secular art. George is depicted as a Roman soldier or, especially in northern Europe, in the armour of a medieval knight. Other visual elements can include a white horse (symbolizing purity), a broken lance (indicating the ferocity of the dragon), and his banner or shield emblazoned with a red cross on a white background.

St. George was supposedly martyred at Lydda in Palestine during the reign of the Roman Emperor Diocletian (303–312 AD). Despite miraculously surviving various tortures – drinking a poisoned cup, being stretched on a wheel, being boiled alive – he was finally beheaded.

Due to George's chivalrous behaviour – protecting women, fighting evil, dependence on faith, and might of arms – the cult of St. George became widespread and popular, firstly in Greece, the Middle East and Russia, and subsequently in the West during the Crusades. He was the archetypal warrior saint, and was adopted as the patron saint of all Christian knights, of several European cities, of Portugal, and of England where his red cross was adopted as the national flag.

Attributes:

Dragon; white banner with red cross; broken lance.

Major Paintings:

▶ Raphael: **St. George and the Dragon**, *c.*1506, NGADC.

● Uccello, Paolo: **St. George and the Dragon**, *c.*1460, NGL.

● Burne-Jones, Edward: **St. George and the Dragon**, 1866–93, Gallery of New South Wales, Sydney, Australia.

Raphael shows St. George, traditionally a Roman soldier, anachronistically dressed in the metal plate-armour of the medieval period. On his leg is tied a blue ribbon inscribed *Honi*, the first word of the motto of the Order of the Garter of which St. George is the patron. This version in Washington DC is a virtual mirror-image of Raphael's version in Paris where the dragon, horse, and rider charge towards the viewer.

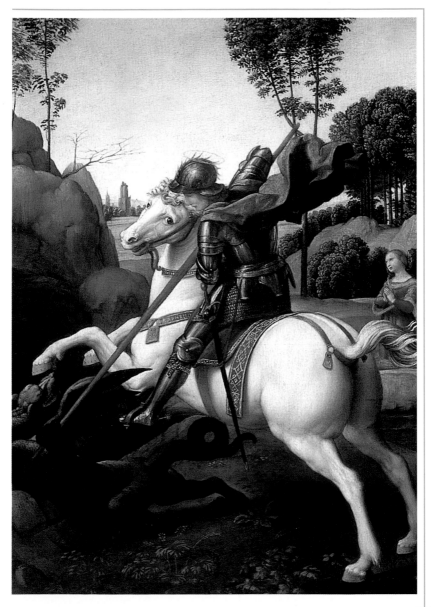

St. Gregory the Great
Pope and Doctor of the Church

St. Gregory the Great is the most important of the numerous saints called Gregory. Born c.540 AD, the son of a Roman senator and great grandson of a former Pope, he rose quickly in the government of Rome. He established a Benedictine (see **St. Benedict**) monastery on his own estate, and he later used his great wealth to found monasteries and relieve poverty.

Gregory was elected Pope in 590 AD. He demonstrated diplomatic skills by preventing an invasion of Italy by the Germanic Lombards, and showed himself to be an able administrator by providing food and money for Rome's poor from church land. These actions enhanced the prestige of the papal institution and ensured that it assumed a role of political leadership that it was not to relinquish until the twentieth century. Gregory also upheld Rome's claim to be the leading Christian centre over that of Constantinople, the capital of the Church in the East.

Gregory sent a mission to England in 597 AD to spread Christianity, reputedly prompted by seeing fair-haired Anglo-Saxon children in a Roman slave market whom he described as 'not Angles but **Angels**'. The leader of the mission was Augustine (not to be confused with **St. Augustine of Hippo**) who became the first Archbishop of Canterbury.

Gregory was a great philosopher and theologian as well as a prolific author, his major works being consulted through the ages. He revised the Church liturgy and established the Gregorian Chant ('plainsong'). Accordingly, he is one of the four Doctors of the Church, along with Augustine of Hippo, **Ambrose** and **Jerome**.

Attributes:
Pope's tiara and crozier; dove.

Major Paintings:
▷ Saraceni, Carlo: **St. Gregory the Great Writing his Gospel**, c.1579–1620, Palazzo Barberini, Rome, Italy.
● Pacher, Michael: **Church Fathers St. Augustine and St. Gregory**, c.1483, Alte Pinakothek, Munich, Germany.
● Guercino: **St. Gregory the Great with Saints**, c.1625–26, NGL.

Gregory was made a saint by popular acclaim immediately after his death in 604 AD.

Gregory is usually shown in his Pope's robes with his papal tiara – a cone-shaped hat with three horizontal decorations. His main attribute is a dove, which was seen by his secretary hovering near Gregory's ear and regarded as being the Holy Spirit inspiring his writings. Many wonders associated with Gregory are also depicted, including **Jesus** sitting down to supper with Gregory and twelve paupers; the vestment of **John the Evangelist** bleeding when Gregory cut it to prove its authenticity; and Gregory releasing the soul of the benevolent Roman Emperor Trajan from purgatory through power of prayer. The most common scene, however, is the Mass of St. Gregory. A medieval legend tells of how when Gregory was celebrating Mass, one of the congregation doubted that the bread and the wine were really the body and blood of Christ. Gregory prayed for a sign and Jesus appeared above the altar surrounded by objects associated with his Crucifixion.

The Italian baroque painter, Carlo Saraceni, depicts Gregory, his papal tiara to one side, writing under the inspiration of the Holy Spirit in the form of a dove.

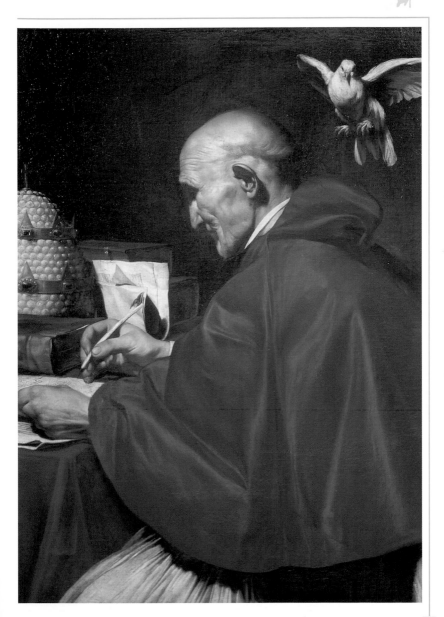

Hagar

Concubine of Abraham and mother of Ishmael

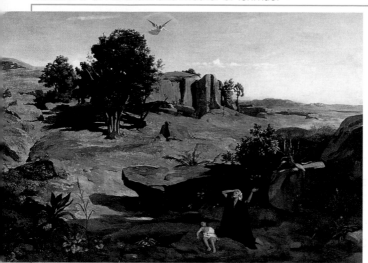

Alone in the wilderness, Hagar appeals to God to help her son, Ishmael, who is dying of thirst, while in the distance an angel flies towards them bringing relief. The French artist Corot was renowned for his landscapes, realistic yet tempered with slight romanticism, many of which were painted in situ – still a novelty at this time.

God had promised **Abraham** a son, who would become the father of a great nation. However, since Abraham and his wife Sarah were growing old, and they still had no son, Sarah gave Hagar – her Egyptian slave girl – to Abraham so that they might have a child.

Once Hagar was pregnant she despised Sarah, who then ill-treated her; so Hagar ran away into the wilderness. She was found by an angel by a spring of water and persuaded to return to Sarah. Hagar bore Abraham a son whom he named Ishmael, Hebrew for 'May God hear'.

Later, by a miracle, Sarah herself became pregnant in her old age and Isaac was born. Sarah then became jealous of Hagar's son, whom she did not want to share in Abraham's inheritance, so she persuaded Abraham to send Hagar and Ishmael away. The next morning Abraham gave food and water to Hagar and sent her to wander in the wilderness of Beersheba. When they ran out of water she put the child under a bush and sat some way off, weeping bitterly, as she did not want to see him die. God heard the child crying and sent an angel who opened Hagar's eyes and showed her a well of water which saved their lives.

Ishmael married an Egyptian woman and became the ancestor of twelve tribes of desert nomads – the Ishmaelites. They settled in Arabia, and the Arabs regard themselves as being the descendants of Ishmael.

Biblical References:
Genesis 16 & 21.

Attributes:
Mother and young son; angel; well.

Major Paintings:

▲ Corot, Jean Baptiste Camille: **Hagar in the Wilderness**, 1835, NYMet.

● Guercino: **The Angel Appears to Hagar and Ishmael**, 1652–53, NGL.

● Claude Lorraine: **Landscape with Hagar and the Angel**, 1646, NGL.

● Tissot, James: **Hagar and the Angel in the Desert**, 1896–1900, Jewish Museum, New York, USA.

St. Helena

Discoverer of the cross of Jesus

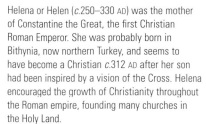

Helena or Helen (*c*.250–330 AD) was the mother of Constantine the Great, the first Christian Roman Emperor. She was probably born in Bithynia, now northern Turkey, and seems to have become a Christian *c*.312 AD after her son had been inspired by a vision of the Cross. Helena encouraged the growth of Christianity throughout the Roman empire, founding many churches in the Holy Land.

However, Helena owes her fame to her alleged discovery of the 'true' cross, on which **Jesus** was crucified, found during her journey to Jerusalem in 326 AD. She apparently discovered not just Jesus' cross and the nails and inscription, but also the crosses of the two criminals crucified either side of him. The finds were made on a site over which the Church of the Holy Sepulchre was built.

The story of the discovery, or 'Invention', of the True Cross was elaborated extensively during the Middle Ages in the *Golden Legend*. This gave explanations of how Helena was able to differentiate the True Cross from the other two, and of miracles which were performed on the spot – such as corpses brought to life when touched by the True Cross.

The most frequent depiction of Helena is at the moment of her discovery of the True Cross together with scenes of associated miracles. She is often represented in imperial costume holding the rest of her attributes, although the cross can sometimes appear to her, borne aloft by **angels**.

In another tale relating to the history of the True Cross, St. Helena accompanies the much-later Emperor Heraclius (7th century) who recovered the Cross after it had been captured by the Persians led by King Chosroes. As Heraclius triumphantly enters Jerusalem, an angel halts the procession and bids Heraclius humble himself before the cross.

Attributes:

Large cross; hammer; nails; imperial dress; crown; model church.

Major Paintings:

- Cima da Conegliano: **St. Helena**, *c*.1495, NGADC.
- Veronese, Paolo: **Vision of St. Helena**, *c*.1560–65, NGL.
- Bernat, Martin and Jimenez, Miguel: **St. Helena and Heraclius take Holy Cross to Jersualem,** *c*.1485–87, Saragossa Museum, Saragossa, Spain.

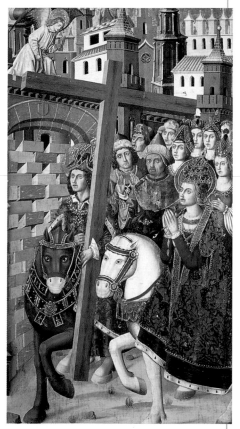

Jacob
Ancestor of the twelve tribes of Israel

Jacob and Esau were the twin sons of Isaac and the grandsons of **Abraham**. Esau, the elder twin, was a hairy man who became a hunter, while Jacob, the younger twin, had smooth skin and preferred to stay at home. Their father Isaac favoured Esau while their mother, **Rebecca**, loved Jacob more dearly.

One day Esau returned from hunting exhausted and asked his brother Jacob for some of the 'pottage' (stew) he had prepared. Jacob shared his meal but only after he had made Esau swear an oath to give up his birthright in return, for Esau, being the elder, was to inherit their father's goods.

Years later, when Isaac was old and blind he asked Esau to go hunting and prepare a meal so that he could bless Esau before he died. Rebecca, overhearing Isaac's words, determined that her favourite Jacob should be blessed instead and instructed Jacob to kill two kid goats which she then cooked. To disguise Jacob as hairy Esau, she covered his neck and hands with the goatskins and Jacob took the meal to his blind father. Isaac was puzzled that the voice was that of Jacob but the hands were those of Esau; nevertheless he gave Jacob his blessing. When Esau realized that Jacob had cheated him again, he threatened to kill his brother. Rebecca urged Jacob to seek refuge with her brother Laban who lived in Haran in Mesopotamia.

One night on his journey, at a place near Jerusalem, Jacob used a stone for a pillow and in a dream saw a ladder between earth and heaven with the **angels** of God ascending and descending. God promised Jacob to give the land to him and his descendants. Near Haran, Jacob met Laban's daughter Rachel at a well and

Biblical References:
Genesis 25–35.

Attributes:
Goatskins on arms; stone pillow; ladder to heaven; wrestling an angel.

Major Paintings:
- Gauguin, Paul: **Vision after the Sermon: Jacob Wrestling the Angel**, 1888, National Gallery of Scotland, Edinburgh, Scotland.
- Rembrandt van Rijn: **Jacob Wrestling with the Angel**, c.1660, Gamalda Kulturforum, Berlin, Germany.
- Rossetti, Dante Gabriel: **Dante's Vision of Rachel and Leah**, 1855, Tate Britain, London, England.

fell in love with her. Laban stipulated that Jacob had to work for him for seven years before he could marry Rachel. On their wedding night Laban substituted his older daughter Leah, claiming it was customary for the elder daughter to be married first. Jacob worked another seven years in order also to marry his true love Rachel.

Jacob returned to Canaan to be reconciled with Esau. The night before their meeting, however, Jacob wrestled with a stranger – usually represented in art as an angel – who finally blessed him and renamed him 'Israel', for he had 'power with God'. Jacob realized he had 'seen God face to face'.

Jacob had twelve sons who became the patriarchs of the twelve tribes of Israel. Leah bore Issachar, Judah, Levi, Reuben, Simeon and Zebulun; Rachel bore **Joseph** and Benjamin; the handmaiden Zilpah bore Gad and Asher; and the handmaiden Bilhah bore Dan and Naphtali.

Rembrandt's fascination with the human face and inner mind is evident in his representation of Jacob grappling with an angel, which focuses on the psychological rather than physical aspects of the encounter.

St. James the Great
The saint of pilgrims

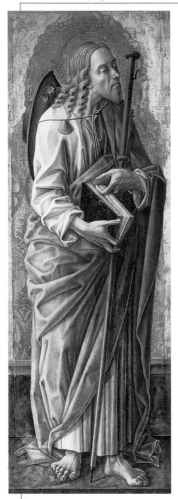

The Venetian artist Carlo Crivelli continued to paint brilliantly coloured, religious panel-paintings, which harked back to the Gothic style, during a time when the Italian Renaissance was approaching its height. His figure of St. James is identified by the shell on his shoulder and other attributes of a pilgrim and apostle.

James, the son of Zebedee, was one of **Jesus**' twelve disciples. He was a fisherman on the Sea of Galilee like his younger brother, **John the Evangelist**. As the two brothers were in their boat overhauling their nets Jesus saw them and summoned them to follow him. James was in the group of friends closest to Jesus, being present with Jesus at personal moments of his life such as his Transfiguration and the Agony in the Garden.

James' missionary work after Jesus' death is more unclear than that of most of the apostles, but he left Palestine to be a preacher in Syria and, on his return, was the first apostle to be martyred, beheaded by sword in 44 AD.

Medieval legends account for most of the colourful tales and representations of James. They tell of James' mission to Spain (historically unlikely) and the discovery and burial of his body at Compostela in northwest Spain. Renamed Santiago (i.e. St. James) de Compostela, his shrine became a major centre of pilgrimage. By 1000 AD a journey to his tomb became the most important pilgrimage in Christendom, next to Jerusalem and Rome. James thus became the medieval patron of pilgrims. As a pilgrim, James is depicted in a pilgrim's cloak decorated with scallop shells, which have become the symbol of pilgrimage; he also carries a staff and wallet (scrip). As an apostle, James is often shown barefoot, holding a book or scroll and a sword of martyrdom. In Spanish paintings especially, James can be shown as a mounted knight in his role as patron of Spain and leader of the Christian struggle to expel the Moors from the country.

Biblical References:
Matthew 4:18–22, 10:2; Acts 12:2.

Attributes:
Scallop shell(s); pilgrim's wide-brimmed hat, staff, and wallet; book or scroll; sword; crozier (he was reputedly the first archbishop of Spain).

Major Paintings:
- Dürer, Albrecht: **St. James the Apostle**, 1516, Uffizi, Florence, Italy.
- Veneziano, Lorenzo: **Annunciation with Saints** (*including St. James*), 1371, Accademia, Venice, Italy.
- Crivelli, Carlo: **St. James the Greater**, *c.*1457–93, Brooklyn Museum of Art, New York, USA.

St. James the Less
Disciple/First Bishop of Jerusalem

In addition to James the Great, there are five other Jameses mentioned in the New Testament – James the son of Alphaeus, James the Less (or Younger), James the brother of **Jesus**, James the Bishop of Jerusalem and James the writer of the Epistle. Early sources, including the influential *Golden Legend*, identified these as one and the same person under the name of James the Less, an interpretation largely followed by artists. Current thinking, however, regards the various Jameses as two different people. James, the son of Alphaeus, was the same James who was called the Less (or Younger) by **Mark**. He was one of the original twelve disciples.

The other James was Jesus' brother (thought by the majority of scholars to be Jesus' blood brother), who became the leader of the early Church in Jerusalem and the city's first bishop. Although there is no record of James following Jesus during his ministry, he was one of those to whom Jesus appeared after his Resurrection. He is also the most likely candidate to have written the Epistle of James. In 62 AD, James was allegedly condemned to death by the Jewish authorities for refusing to denounce Jesus, and thrown from the roof of the Temple of **Solomon**. He was then stoned and beaten to death with a fuller's club.

James' reputed facial similarity to Jesus was a trait adopted by many artists. Although James may be included in scenes with the Holy Family, his martyrdom is a more common theme. James' usual attribute is a fuller's club which was used in cloth-treatment although in some paintings this is substituted by a bow used in making felt hats.

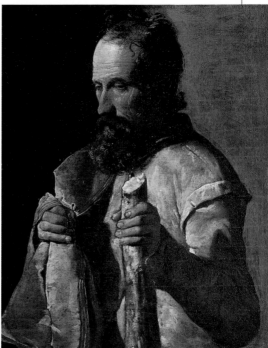

Influenced by Caravaggio's use of light and shade, Georges de La Tour depicts a sombre St. James with his club.

Biblical References:
Matthew 10:4, 13:55; Mark 3:18, 6:3, 15:40; Luke 6:15; Acts 1:13, 12:17, 15:13; Galatians 1:20, 2:9; 1 Corinthians 15:7; Epistle of James.

Attributes:
Bishop's robes; crozier; fuller's club or bat; occasionally a dragon and cross when conflated with St. Philip.

Major Paintings:
- Master of St. Francis: **St. James Minor**, *c.*1270–80, NGADC.
- La Tour, Georges de: **St. James the Less**, *c.*1615–20, Musée Toulouse-Lautrec, Albi, France.

St. Jerome
Translator of the Bible into Latin

Jerome (Hieronymus in Latin; Geronimo or Girolamo in Italian) was born in Croatia about 342 AD. He was a literary scholar with knowledge of Hebrew, Greek and Latin. Baptized as a Christian, he initially retired into the Syrian desert to lead a life of austerity and penitence as a hermit.

Jerome returned to Rome in 382 AD to become secretary to Pope Damasus who requested him to translate the Greek versions of the Old and New Testaments into Latin. This task, which took him over twenty years, was his great achievement. Jerome's Latin Bible was known as the Vulgate because it was in the common (*vulgus*) language of Latin – the language of the Western Church – as opposed to the scholarly language of Greek – the language of the Eastern Church.

He died in 420 AD and was buried in the Basilica of the Nativity in Bethlehem; his remains are now in the church of Santa Maria Maggiore in Rome. His theological work elevated him to the status of one of the four Doctors of the Western Church along with **Ambrose**, **Augustine** and **Gregory**.

Jerome's cult dates mainly from the thirteenth century, when various legends embroidered his life as a hermit and scholar. These are reflected in many of the depictions of Jerome's life in which Jerome himself is portrayed in one of three distinct ways – as a hermit, scholar or Doctor of the Church. In all of these he is normally shown with a cardinal's red, wide-brimmed hat and a lion. The lion alludes to the tale that when in the desert, Jerome removed a thorn from the foot of a lion (reminiscent of the Roman story of Androcles), which then remained faithfully with him for many years.

As a hermit in the desert, Jerome is often shown partly clothed and dishevelled. He may have a stone in his hand with which he is beating himself to rid himself of his sexual fantasies. An hourglass or skull can be shown – a vivid reminder of man's mortality. Artists also depict Jerome's vision of **angels** trumpeting the Last Judgement.

As a Doctor of the Church, Jerome is shown standing holding a model of a church. He wears the red robes and hat of a cardinal even though the post did not exist in his time. In this guise, he may also be shown as a scholar in his study, busy translating the Bible – the reason for his fame and the most common depiction of Jerome.

Attributes:
Cardinal's red robes and hat; lion; skull and hourglass; model of a church; desert landscape; stone; study; Bible.

Major Paintings:
- Bellini, Giovanni: **St. Jerome Reading**, 1480–90, NGADC.
- Antonello da Messina: **St. Jerome in his Study**, 1475, NGL.
- Masaccio: **St. Jerome and St. John the Baptist**, *c.*1428, NGL.
- Veronese, Paolo: **Penitent St. Jerome**, *c.*1578, Accademia, Venice, Italy.
- Pacher, Michael: **Church Fathers – St. Jerome**, *c.*1480, Alte Pinakothek, Munich, Germany.
- Crivelli, Carlo: **St. Jerome**, *c.*1476, NGL.

St. Jerome is depicted by Crivelli as a Doctor of the Church, dressed anachronistically in cardinal's robes, and holding both his Latin Bible and a model of a church, signifying his contributions to the Christian Church.

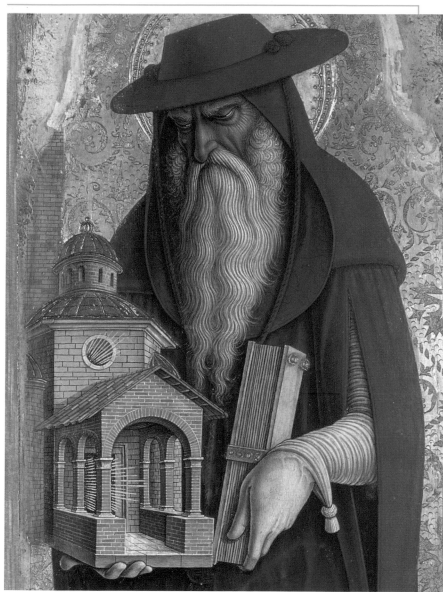

Jesus Christ—Early Life and Ministry
The 'Son of God' and central figure of Christianity

Jesus was born around 4 BC and died around 30 AD. According to the Christian faith, Jesus is the eternal Son of God. Jesus' mother was the Virgin **Mary** who conceived him miraculously through the Holy Spirit of God. Jesus is thus both human, 'the Son of Man', and divine, 'the Son of God'. Jesus is also known as *Christ*, Greek for the Hebrew word *Messiah* – 'the anointed one' – standing for the future (non-divine) leader of the Jewish people, and later used by the Church, to mean the saviour of humankind.

Jesus' birth, the Nativity, was in a humble stable in Bethlehem, near Jerusalem. There, the baby Jesus was visited by the **Magi** and local shepherds who wished to pay respects to the 'King of the Jews'. King Herod, hearing of a potential rival, tried to destroy Jesus by ordering the Massacre of the Innocents in which all male Jewish babies around Bethlehem were killed. Jesus was saved when Mary and her husband Joseph, a carpenter, fled with him to Egypt after Joseph was warned in a dream of Herod's intentions. Following Herod's death, the Holy

Family returned and settled in Nazareth where Jesus grew up. When Jesus was about 30, he was symbolically purified by being baptized in the River Jordan by **John the Baptist**. He then went into the desert to fast for forty days and nights at the end of which he proved his devotion to God by resisting three temptations offered to him by Satan. For the next three years, Jesus preached throughout ancient Palestine and gathered around him a band of followers – the

Biblical Reference:
Matthew; Mark; Luke; John.

Attributes:
Halo.

Major Paintings:
- Michelangelo: **The Holy Family**, c.1504, Uffizi, Florence, Italy.
- Elsheimer, Adam: **The Flight into Egypt**, 1609, Alte Pinakothek, Munich, Germany.
- Tintoretto, Jacopo: **Christ at the Sea of Galilee**, c.1575–80, NGADC.
- Duccio di Buoninsegna: **The Temptation of Christ**, c.1310, Frick Collection, New York, USA.
- Bassano, Jacopo: **The Good Samaritan**, c.1550–70, NGL.
- Rembrandt van Rijn: **Return of the Prodigal Son**, c.1668, Hermitage, St. Petersburg, Russia.

disciples ('students'). Jesus' main message was for people to repent of their sins and turn to God so as to enter the Kingdom of Heaven. His teaching was often through parables – simple, earthly stories with a heavenly meaning, such as 'The Prodigal Son' and the 'Good Samaritan'. Jesus presented the essence of his teachings in his Sermon on the Mount when he expounded the Lord's Prayer.

Early representations in art of Jesus seem to have been inspired by the Greek 'bearded philosopher' statue-type depicting an older man with long hair and beard, a tradition that has continued in Western art. Many of the events and miracles in his life have been depicted, although the most frequently represented are not always the most important theologically.

Amidst the storm, a majestically serene Jesus first summons his disciples Peter and Andrew.

Jesus Christ—Miracles and Final Days

The 'Son of God' and central figure of Christianity

Jesus performed numerous miracles that proved to his many followers that he was more than just another religious teacher. His first miracle was to turn water into wine during a wedding feast at Cana. Later Jesus not only healed the sick and the blind, but also brought three dead people back to life, most famously Lazarus who had been dead for four days. Jesus also calmed a storm, walked on water, and fed 5,000 people with only five loaves of bread and two fish.

After people realized Jesus was not a political leader who would overthrow Roman domination, many turned away from him. However, the disciples **Peter**, **James** and **John** had their conviction strengthened when they witnessed Jesus' Transfiguration during which his face shone like the sun and his clothes dazzled with blinding whiteness. **Moses** and **Elijah** also appeared either side of him, while a voice spoke from a cloud saying, 'This is my son in whom I am well pleased. Listen to him.'

Jesus' emphasis on moral sincerity rather than strict adherence to religious ritual and his claim to be the Messiah incurred the anger of the Pharisees, the religious 'interpreters' and upholders of the Jewish scriptures or Torah. His final clash with the Jewish authorities occurred in Jerusalem, during which time he symbolically expelled the moneylenders from the Temple. After scrutinizing Jesus' responses to various issues, the Pharisees presented to him a woman caught in adultery, a sin punishable by stoning to death. Jesus, showing his compassion for human weakness and disdain of hypocrisy, told them, 'Let him that is without sin cast the first stone.' When the accusers left silently, Jesus said to her, 'Neither do I condemn you. Go, and sin no more.'

With the full knowledge that his execution was imminent, Jesus held a Passover meal with his twelve closest disciples. At this Last Supper Jesus offered them bread and wine,

Biblical Reference:

Matthew; Mark; Luke; John.

Attributes:

Halo.

Major Paintings:

- Sebastiano del Piombo: **Raising of Lazarus**, c.1517–19, NGL.
- Guercino: **The Woman Taken in Adultery**, c.1621, Dulwich Picture Gallery, London, England.
- Leonardo da Vinci: **The Last Supper**, c.1497, S. Maria delle Grazie, Milan, Italy.
- Raphael: **The Transfiguration**, 1518–20, Vatican, Italy.
- Bellini, Giovanni: **Agony in the Garden**, c.1465, NGL.

Jesus, asked by a Pharisee to give judgement on an adulterous woman, replies that the person without sin should cast the first stone. Jesus' expression is a tour de force of compassion, forgiveness and love, an embodiment of his message.

representing his body and blood, a thanksgiving or 'Eucharist' which still forms the focus of Christian celebration and communion with God. Jesus foretold that one of them would betray him.

After the meal, Jesus went to the Garden of Gethsemane where, while Peter, James and John slept, he underwent the so-called Agony in the Garden as he prayed to God for strength to endure his imminent sufferings. Armed guards approached and, at **Judas**' signal, arrested Jesus.

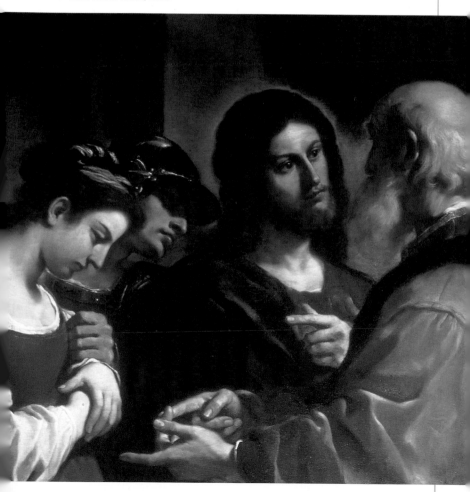

Jesus Christ—Crucifixion and Resurrection

The 'Son of God' and central figure of Christianity

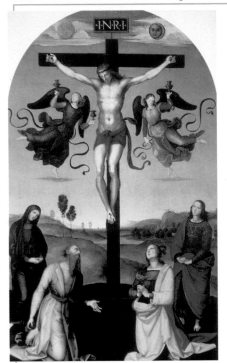

Following tradition, St. John the Evangelist and the Virgin Mary, standing to either side of the cross, witness Christ's Crucifixion. Raphael also includes, kneeling, Mary Magdalene and St. Jerome, to whom the altarpiece was dedicated.

criminals. A sign placed above his head read: 'Jesus of Nazareth, King of the Jews' – later often abbreviated to the Latin initials INRI.

That same evening, before the Sabbath, Jesus' body was taken down and laid by Joseph of Arimathea, with the help of Nicodemus, in Joseph's own tomb. On the morning after the Sabbath, **Mary Magdalene** and other women discovered the tomb empty, and while Mary wept, Jesus appeared to her proclaiming his Resurrection from the dead. Jesus later revealed himself to two disciples when he broke the bread during a supper they were sharing with him at Emmaus – until then they thought him a stranger they had just met on the road.

Over the next forty days, Jesus appeared among his other followers, confirming his divinity. On the fortieth day Jesus left the earth and ascended into heaven to take his place next to God, his message from then on to be spread by his disciples who were now his apostles, or messengers.

Jesus, under arrest, was questioned by the High Priest, Caiaphas, who accused him of blasphemy, the Sanhedrin (council), who condemned him to death, and Pontius Pilate, the Roman governor of Judea. Pilate, unable to see Jesus' guilt, presented Jesus to an assembled crowd, saying, 'Behold the Man' ('*Ecce Homo*'), allowing the people to decide his fate. They demanded Jesus' death and Pilate, washing his hands of the verdict, ordered Jesus' Crucifixion – that he be nailed to a cross and left to die.

Jesus was whipped and mocked by soldiers who placed a crown of thorns on his head. Jesus then carried his cross through Jerusalem to a place outside the city walls called Golgotha or Calvary, where he was crucified between two

Biblical References:

Matthew; Mark; Luke; John; Acts.

Attributes:

Halo; crown of thorns; cross.

Major Paintings:

▲ Raphael: Altarpiece: **'The Mond Crucifixion'**, *c.*1503, NGL.

● Rubens, Peter Paul: **Descent from the Cross**, 1612–14, Antwerp Cathedral, Antwerp, Belgium.

● Titian: **The Entombment**, 1559, Prado, Madrid, Spain.

● Caravaggio: **The Supper at Emmaus**, 1600–01, NGL.

Job

The model of piety and strength in adversity

Job was 'the greatest man in all the East', being extremely rich as well as pious. Satan argued with God that anyone with Job's wealth and fortune would find it easy to be righteous – but that in adversity he would curse God. So with God's acquiescence, Satan cast afflictions of increasing severity upon Job. He lost all his herds and flocks, his house collapsed, and his ten children were killed.

Job refused to be bowed by these calamities – indeed, he bore them so patiently that Satan finally struck him with sore boils and Job ended up sitting in ashes or on a dunghill scraping himself with a potsherd, abject and destitute. Friends consoled him, but they made matters worse by saying that he must have brought the afflictions upon himself – giving rise to the expression 'Job's comforters'. When Job refused to curse God despite his wife's attempts, God intervened and put an end to Job's trials. With Satan defeated, the 'patience of Job' was rewarded by God who provided him with another ten children and twice as much wealth.

Job is the supreme Old Testament example of faith and fortitude in adversity, yet at the heart of his story are questions about the mystery of God and the suffering of mankind.

Job is sometimes represented as a happy man with his family, but artists also depict his afflictions, including the non-biblical episodes of him being beaten or drenched with water by his wife. Satan, not usually represented in art, occasionally appears as the agent of the afflictions.

Biblical References:
Job.

Attributes:
Satan; dunghill; sores; bucket of water; musicians.

Major Paintings:

- Bonnat, Leon: **Job**, *c*.1900, Louvre, Paris, France.
- Dürer, Albrecht: **Job and His Wife**, *c*.1504, Staatliches Kunstinstitut, Frankfurt, Germany.
- Lievens, Jan: **Job on the Dungheap**, 1631, National Gallery of Ottawa, Canada.
- Blake, William: **Satan Smiting Job with Sore Boils**, *c*.1826, Tate Britain, London, England.
- Blake, William: **Job and his Daughters**, 1799–1800, NGADC.

William Blake, the English artist, philosopher and poet, gave idiosyncratic interpretations, imbued with his own visionary symbolism, of biblical stories.

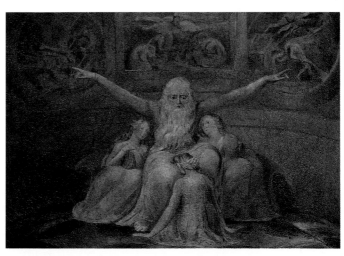

St. John the Baptist
The forerunner of Jesus

John the Baptist is regarded as the last of the prophets before **Jesus** and the first saint of the New Testament. He predicted the coming of the Messiah and recognized this Messiah in Jesus. John was six months older than Jesus and their mothers were cousins. All that is known about him is contained in the Gospels, all four Evangelists giving the same main facts.

John's birth was foretold by the **angel** Gabriel to his father **Zacharias** who was struck dumb in disbelief. In fact, it was considered miraculous since both his parents Zacharias and Elizabeth were elderly and childless. As a young man John retired to the Judean desert to live a simple life and collected a number of followers. He ate only locusts and wild honey and wore a garment of

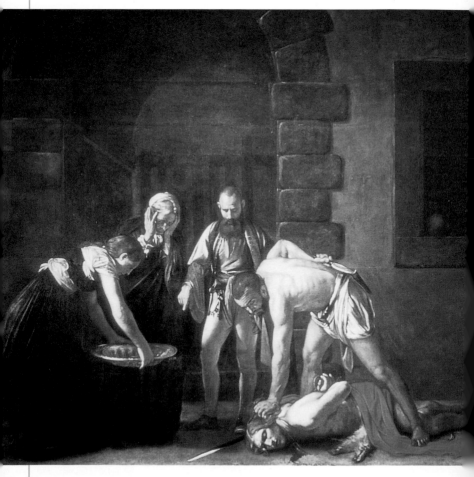

camel hair with a leather girdle. He claimed to be a messenger and a voice sent to bring the good news of the coming of a Messiah, for whom preparation must be made by repentance.

According to **Luke**, John left the desert and began to preach and baptize in the River Jordan. Those who wanted to change their way of life were baptized by immersion in water as a symbol

of purification and rebirth. This culminated in the major event in John's life when Jesus came to him asking for baptism. John recognized that Jesus was the Messiah when the Holy Spirit came to him in the form of a dove and a voice from heaven was heard saying, 'This is my beloved Son in whom I am well pleased.'

John became the first New Testament martyr when he was beheaded at the request of **Salome**.

Representations of St. John are ubiquitous.
The following episodes are especially common:

- John's infancy: he is often portrayed with the young Jesus and his family, despite lack of a biblical basis.
- John in the wilderness: he is shown as an unkempt young man dressed in animal skins.
- John baptizing Jesus: accompanied by the Holy Spirit in the form of a dove.
- John's death: the beheading is sometimes shown, most famously in Caravaggio's canvas in Malta, or more usually John's head upon a platter.

John's words upon seeing Jesus, 'Behold the Lamb of God' ('*Ecce Agnus Dei*') (John 1:29), widely accompany John's depiction, featured on a scroll or flag; it results in John's main symbol being a lamb, itself often carrying a crucifix or a flag with a red cross.

Biblical References:
Matthew 3:1–17, 11:1–19; Mark 1:1–11; Luke 1:5–80, 3:1–22; John 1:6–39.

Attributes:
Lamb (often with flag); animal-skin tunic; reed cross with long slender stem; honeycomb; baptismal cup.

Major Paintings:
- Titian: **St. John the Baptist**, *c.*1540, Accademia, Venice, Italy.
- Raphael: **The Boy Baptist in the Desert**, *c.*1517, Uffizi, Florence, Italy.
- Caravaggio: **Beheading of St. John the Baptist**, 1608, Cathedral of St. John, Valletta, Malta.

Caravaggio's famous masterpiece – the only work he signed (eerily traced in the blood from John's neck) – emphasizes the chilling atmosphere of the execution by the dark expanse of the prison wall, the curiosity of the prisoners, and the waiting woman's readiness with her platter on which the head will be placed.

St. John the Evangelist

Apostle – traditional author of the fourth Gospel and Book of Revelation

John the Evangelist is the traditional name given to the anonymous author of the fourth Gospel in the New Testament since the repeated reference in the work to the 'beloved disciple' has led many people to identify this as John, son of Zebedee, one of the original twelve disciples of **Jesus**. John the Evangelist has also traditionally been regarded as the author of the Book of Revelation, the final book of the Christian Bible, although this is no longer thought to be the case.

John and his brother **James the Great** were called by Jesus to be disciples when they were in their boat mending their nets. John was present at many critical moments in Jesus' adult life – his Transfiguration, his arrest in the Garden of Gethsemane and his trial before Caiaphas. In addition, the 'beloved disciple' (presumably John) sat next to Jesus or rested his head on Jesus' chest during the Last Supper, and he was present at the Crucifixion, supporting the Virgin **Mary** at the foot of the cross – so John's account of the life of Christ is very much an eye-witness one.

After the apostles scattered, according to legend, John settled in Ephesus with the Virgin Mary. Here numerous miracles were ascribed to him. At one point he is said to have been exiled to the Greek island of Patmos by the Roman Emperor Domitian (81–96 AD) where he wrote the Book of Revelation. Revelation describes symbolic visions of the heavens and the end of time, but it is now thought unlikely to be the work of the John who wrote the fourth Gospel, because of differences in style and language. John is then said to have returned to Ephesus and, at the

Biblical References:
Matthew; Mark; Luke; John; Acts.

Attributes:
Eagle; chalice, sometimes with emerging snake; vat of oil; book or scroll.

Major Paintings:
- ▶ Cano, Alonso: **St. John the Evangelist with Poisoned Cup**, 1636, Louvre, Paris, France.
- ● El Greco: **Apostle St. John the Evangelist**, 1606, Museo del Greco, Toledo, Spain.
- ● Memling, Hans: **St. John the Evangelist at Patmos**, c.1479, Museum van het Sint-Jans-Hospitaal, Bruges, Belgium.

request of a local bishop, composed his Gospel to counter heresy. John reputedly died in Ephesus c.96–104 AD.

Later apocryphal stories provide some of the commonest artistic depictions of St. John. These include John raising from the dead Drusiana, a woman with whom he had lodged at Ephesus, and turning sticks and stones into rods of gold and jewels. John's familiar attribute – the chalice – stems from his challenge by the priest of Diana at Ephesus to drink from a poisoned cup. John made the sign of the cross over the cup causing the poison to emerge as a snake or little dragon. Another story tells of John being thrown into a cauldron of burning oil, which he survived unhurt. In these depictions he is portrayed either as a young man with long curly hair, or as a grey, bearded old man usually writing his Revelation on Patmos. As one of the four Evangelists, his winged emblem is the eagle since, as the king of birds, it flies near to heaven and so parallels John's close and personal vision of God inherent in his Gospel. John is the patron saint of writers, printers, booksellers and theologians.

Following an apocryphal tale, Cano, a Spanish painter, sculptor and architect, has painted John, the 'beloved disciple', turning a poisoned drink into a three-headed snake.

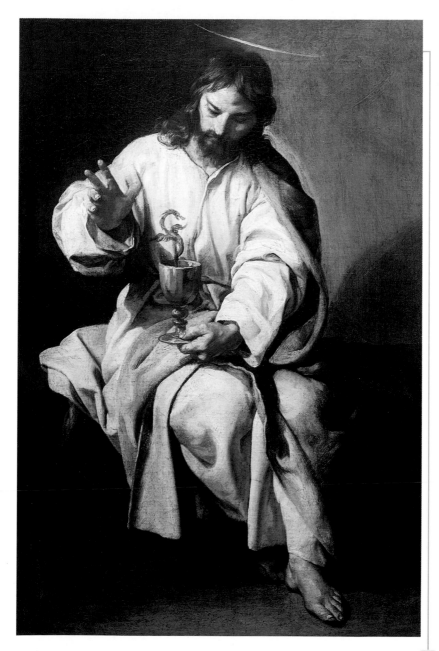

Joseph

Wearer of the Coat of Many Colours and interpreter of dreams

Joseph, the eleventh son of **Jacob**, was his father's favourite because he was the elder son of Rachel, Jacob's much-loved wife, who had died giving birth to Benjamin, Joseph's younger brother. His stepbrothers had become jealous of Joseph because he told them his dreams which indicated that he would rule over them. They threw him in a pit while deciding what to do with him. In the meantime, Joseph was rescued by passing traders and sold as a slave to other merchants travelling to Egypt.

Discovering his disappearance, the brothers wondered what they would tell their father. So they tore apart Joseph's special 'coat of many colours', dipped it in the blood of a goat and took it to Jacob who, believing that Joseph must have been killed by a wild beast, was inconsolable.

In Egypt, Joseph was sold to Potiphar, captain of Pharaoh's guard, and eventually was put in charge of Potiphar's household. Potiphar's wife fell in love with Joseph and tried to seduce him, but Joseph turned her away. Resentful, Potiphar's wife falsely accused Joseph of trying to rape her, and Potiphar threw him into prison.

There, after correctly interpreting the dreams of Pharaoh's butler and baker, Joseph interpreted Pharaoh's own dreams, foretelling that Egypt would enjoy seven years of bountiful harvests followed by seven years of famine. Pharaoh, recognizing Joseph's divine inspiration, appointed him Governor of Egypt. Joseph organized the storage of grain during the bountiful years that followed in readiness for the famine which he had predicted.

When the famine arrived, it was so severe in Canaan that Jacob sent his sons, excluding his beloved Benjamin, to Egypt to buy grain. Joseph recognized his brothers who, not recognizing Joseph, bowed down to him as predicted in his dream; and he ordered them to bring Benjamin to Egypt when they next came for grain. When the brothers returned, Joseph hid his own silver cup in the sack belonging to Benjamin, who was then arrested. The other brothers promised they would become slaves if they were found to have stolen the cup, and one of the brothers, Judah, offered himself as a slave if only Joseph would release Benjamin and send him back to his father. Overcome by his feelings, Joseph revealed his identity and arranged for his aged father, Jacob, to come to Egypt where, after an emotional reunion, the family settled.

On his deathbed Jacob blessed Joseph's sons, Manasseh and Ephraim, although, breaking with tradition, he gave his chief blessing to the younger Ephraim, whom he foretold would be the greater.

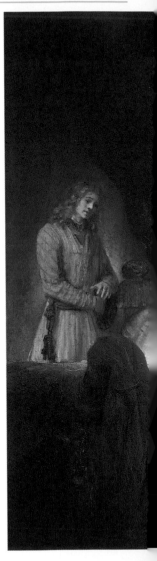

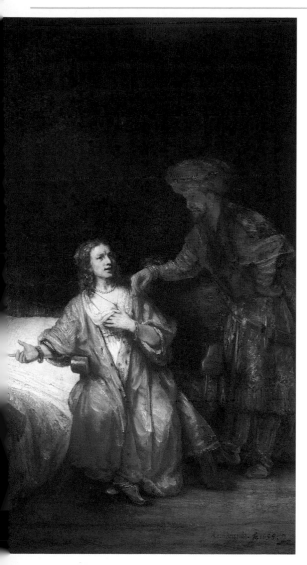

Biblical References:
Genesis: 30, 37, 39–48.

Attributes:
Coat of many colours; silver cup.

Major Paintings:
- Brown, Ford Madox: **The Coat of Many Colours**, c.1860–80, Walker Art Gallery, Liverpool, England.
- Guercino: **Joseph and Potiphar's Wife**, c.1649, John and Mable Ringling Museum of Art, Sarasota, Florida, USA.
- ◄ Rembrandt van Rijn: *detail from* **Joseph Accused by Potiphar's Wife**, 1655, NGADC.
- Velázquez, Diego Rodriguez de Silva: **Joseph's Bloody Coat Brought to Jacob**, 1630, Monasterio de San Lorenzo, The Escorial, Madrid, Spain.

Joseph stands quietly by as Potiphar's wife turns to her husband and falsely accuses Joseph of trying to rape her, pointing to his red robe on the bedpost as evidence. Rembrandt has departed from the biblical account by showing Joseph present when accused, so adding to the drama of the scene.

Judas Iscariot

The betrayer of Jesus

Judas Iscariot is the archetypal betrayer. His betrayal of **Jesus** – and the manner in which he did it – was the ultimate act of treachery.

Although Judas was one of the disciples, he is hardly mentioned in the gospels, presumably because of his subsequent deed. The Jewish chief priests and elders were plotting to have Jesus arrested and put to death. Judas asked what they would give him to betray Jesus, and they offered thirty pieces of silver. On the night of the Passover supper (The Last Supper) Jesus told his disciples that one of them would betray him; they all, including Judas, asked, 'Lord, is it I?' After supper Jesus went to the Garden of Gethsemane where he prayed. Judas arrived with an armed crowd and, as arranged, identified Jesus by giving him a kiss – the kiss of death. Jesus was seized and led away to trial and eventual crucifixion.

Judas, full of remorse, tried to return the thirty pieces of silver to the priests; unsuccessful, he threw the money down and hanged himself from a tree. But he meets an alternate death in the Acts of the Apostles which say that 'he fell forward on the ground, and burst open, so that his entrails poured out'.

Artists tend to show Judas in an unsympathetic light. He is often portrayed with an ugly face or posture; clutching a money bag (either full of the disciples' money, of which he was the treasurer, or the thirty pieces of silver); dressed in yellow, the colour of treachery; spurred on by the devil; or hanging from a tree. The 'Kiss', with its dual symbolism of love turned to hatred, is a favourite motif.

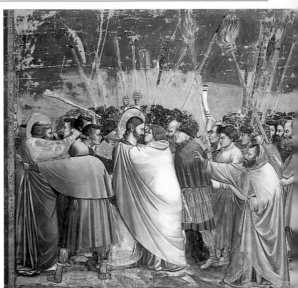

Christ's arrest is superbly conveyed by Giotto – against the tumultuous background of spears and firebrands, the serene figure of Jesus is enveloped in Judas' sinister embrace.

Biblical References:

Matthew 26:21–36, 47–50; Mark 14:10–21, 47–50; Luke 22:1–23, 47–51; John 13:21–30, 18:1–11; Acts 1:18.

Attributes:

Money bag; coins; kiss; demon on his shoulder; yellow cloak; noose hanging from a tree.

Major Paintings:

- Giotto: **The Kiss of Judas**, c.1305–06, Scrovegni Chapel, Padua, Italy.
- Caravaggio: **The Taking of Christ**, 1602, National Gallery of Ireland, Dublin, Republic of Ireland.
- Dyck, Sir Anthony van: **The Betrayal of Christ**, c.1618, Minneapolis Institute of Arts, Minnesota, USA.

Judith
Jewish heroine

Judith was a beautiful young woman whose courage and daring became a symbol of the Jews' struggle against their ancient enemies. She was living in the Jewish city of Bethulia (probably fictitious) when, in the sixth century BC, it was besieged by the Assyrians under Holofernes, a general of the Assyrian king Nebuchadnezzar.

The Israelites were on the point of surrender when Judith rebuked her people for losing faith in God and she volunteered to save the city. Judith went over to the Assyrian camp with her maid, pretending to be an informer, and charmed Holofernes with her beauty. After a few days Holofernes invited Judith to a banquet in his tent with the intention of seducing her, but he became drunk and fell asleep. Judith seized a sword and cut off Holofernes' head. Placing it in a bag provided by her maid, they returned to the city without being detected.

Her deed and her rousing words spurred the Israelites into action. They displayed Holofernes' head from the top of the city walls and pursued the Assyrians, who fled at the realization of what had happened to their general.

Several episodes from Judith's story have been depicted by artists, but all of them involve Holofernes. Early paintings show Judith carrying Holofernes' head in a sack or triumphantly displaying it, in a symbolic gesture of Virtue victorious over Vice, or humility and faith overcoming pride and doubt. Baroque and later artists tend to depict the bloody drama of the awful beheading itself.

In this painting by Giorgione, renowned for infusing his landscapes with atmosphere and mood, Judith stands over the head of her enemy Holofernes.

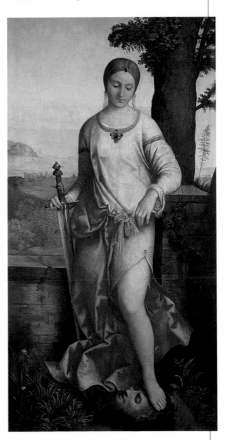

Biblical References:
Apocrypha: Judith.

Attributes:
Sword; head of Holofernes.

Major Paintings:
- Caravaggio: **Judith Beheading Holofernes**, c.1598, Galleria Nazionale dell'Arte Antica, Rome, Italy.
- Mantegna, Andrea: **Judith and Holofernes**, c.1495, NGADC.
- Gentileschi, Artemisia: **Judith Slaying Holofernes**, c.1612–21, Uffizi, Florence, Italy.
- Giorgione: **Judith with the Head of Holofernes**, c.1504, Hermitage, St. Petersburg, Russia.

St. Lawrence
Martyr and patron of the poor

St. Lawrence (Lorenzo in Italian), born in Spain and martyred in 258 AD in Rome, is one of the most venerated saints. His generosity in giving to the poor has won him many followers.

Lawrence was ordained as a deacon by Pope Sixtus II in 257 AD, a time of renewed persecution of Christians by the Roman Emperor Valerian. Lawrence was instructed upon the Pope's arrest to give away the Church's vessels and money to the poor. When Lawrence himself was arrested by the Roman authorities and asked to hand over the Church's wealth he pointed to the poor and declared that they were the Church's jewels.

Lawrence was reputedly martyred by being roasted alive on a metal rack (gridiron), upon which it is said he suffered with such spirit that he turned himself over to be on his other side. However, this graphic manner of death is certainly legendary, since as a Roman citizen he would have been beheaded with a sword, like many other Roman martyrs including **St. Paul**. A later scribe may have written in Latin *assus est* ('he was roasted') instead of *passus est* ('he died').

St. Lawrence is sometimes portrayed with Pope Sixtus II, but usually he is shown distributing the Church's vessels and money to the poor and afflicted, or being martyred on the rack, or standing with it. To aid identification, he sometimes wears the deacon's 'dalmatic', a robe with deep splits up the side. St. Lawrence may be paired with **St. Stephen** as both are patrons of deacons.

Attributes:

Gridiron (latticed metal roasting-rack); deacon's robes (dalmatic), sometimes embroidered with flames; dish or chalice of coins; deacon's cross.

Major Paintings:

 Angelico, Fra: **Scenes from the Life of St. Lawrence**, *c*.1447–49, *fresco in* Chapel of Nicholas V, Vatican, Italy.

● Titian: **The Martyrdom of St. Lawrence**, 1548–59, Chiesa dei Gesuiti, Venice, Italy.

● Zurbarán, Francisco de: **St. Lawrence**, 1636, Hermitage, St. Petersburg, Russia.

In this scene from Fra Angelico's fresco cycle in the Vatican, Pope Sixtus II confers the deaconship upon Lawrence, identified by his robes emblazoned with flames.

Lot
Escaped amidst the destruction of Sodom and Gomorrah

Lot was **Abraham**'s nephew who accompanied Abraham on his journey from Ur in Mesopotamia to Canaan and then chose to live in the fertile valley of the Jordan, settling in the city of Sodom.

The inhabitants of Sodom and nearby Gomorrah offended God by their sinful and licentious practices. So God sent two messengers in the guise of **angels** to Lot's house to warn him that God intended to destroy the city.

After being threatened by the inhabitants who wanted to violate them, the angel messengers led Lot, his wife and his two daughters out of the city, telling them not to look back. Then God rained down 'fire and brimstone' (sulphur) and destroyed everyone living in Sodom and Gomorrah. Unable to control her curiosity, Lot's wife looked back and was turned into a pillar of salt.

This episode is common in art since, like **Noah** and the flood, it warns about the ultimate consequences of man's sin. Lot's wife is often shown either transforming into a pillar of salt or wraithlike in the background, an iconographic symbol of the penalty for immorality.

Less widely depicted is the subsequent event when Lot went to live with his two daughters in a cave. Believing that no one else remained alive on Earth and wishing to give their father descendants, Lot's daughters made him drunk and then slept with him. Subsequently both daughters gave birth to sons, Moab and Ben-Ammi, whose descendants were the Moabites and Ammonites with territory in modern Jordan and who were related to, yet enemies of, the Hebrews.

Biblical References:
Genesis 19.

Attributes:
Destruction of cities; pillar of salt; drunkenness.

Major Paintings:
▼ Dürer, Albrecht: **Lot and his Daughters**, 1496–99, NGADC.
● Furini, Francesco: **Lot and his Daughters**, c.1630–40, Prado, Madrid, Spain.
● Lucas van Leyden. **Lot and his Daughters**, c.1520, Louvre, Paris, France.

Lot leads his daughters to safety, but his wife – in the distance – is turned into a pillar of salt for disobeying God.

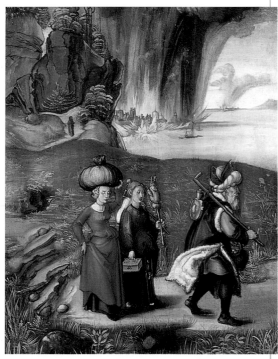

St. Lucy
Virgin martyr condemned to a brothel

St. Lucy (Lucia) was martyred *c.*304 AD during the Roman Emperor Diocletian's persecution of Christians. She was one of the earliest saints to achieve popularity, having a widespread following prior to the fifth century.

Various legends are attached to this historical figure from Syracuse in Sicily. The first relates to her distribution of her wealth to the poor which so angered her future husband that he reported her Christianity to the Roman authorities. Lucy was sentenced to a brothel (like **St. Agnes**) and was to be dragged there by oxen – except that she was able to stand her ground.

She was then also tortured by having her teeth pulled out, and her breasts cut off like

St. Agatha; and although she was condemned to death by boiling oil and fire, she proved impervious to both. She was eventually killed by being stabbed through the neck with a sword or dagger.

Because of later medieval and Renaissance traditions associating her name with *lux* (Latin for 'light'), she became the patron saint of sight, and so her attributes include lamps, or a pair of eyes on a stalk or plate. A later legend explains this symbolism more graphically. It tells that Lucy, determined to dedicate her life to **Jesus**, had plucked out her eyes and sent them to an admirer who was aroused by their beauty. Astounded by Lucy's devotion to her faith, this admirer converted to Christianity and Lucy later found her eyesight miraculously restored one day during prayer.

Attributes:
Eyes on a stalk or plate; lamp; ox; dagger.

Major Paintings:
◀ Zurbarán, Francisco de: **St. Lucy**, *c.*1625–30, NGADC.
● Cossa, Francesco del: **St. Lucy**, after 1470, NGADC.
● Tiepolo, Giovanni Battista: **Last Communion of St. Lucy**, 1747–48, Santi Apostoli, Venice, Italy.

The Spanish artist Zurbarán often portrayed female saints luxuriously attired in contemporary dress. Here St. Lucy holds the palm, signifying martyrdom, and startlingly, a dish holding her attribute – a pair of eyes.

St. Luke
Author of the third Gospel and Acts of the Apostles

Luke, one of the four Evangelists, is the author of the third Gospel in the New Testament as well as the Acts of the Apostles, which relates the first thirty years of the early Christian Church after **Jesus**' death.

Luke, a non-Jewish (Gentile) doctor, apparently came from the Syrian city of Antioch where followers of Jesus were first called Christians. Luke, not having known Jesus personally, was one of the earliest converts to Christianity. He compiled his Gospel from earlier collections of Jesus' sayings and stressed **St. Paul**'s doctrine that to become Christians, Gentiles did not need first to become Jews, so broadening the appeal of Jesus' message.

Luke accompanied St. Paul on his various missionary journeys, and after Paul's execution Luke possibly travelled to Egypt and then to Greece, where in Thebes he wrote his Gospel and the Acts around 70 AD. Luke's death is a mystery, although varying traditions tell of his being hanged from an olive tree, being crucified with **St. Andrew**, or dying a natural death.

Luke, due to his own profession, is the patron saint of doctors. He is also the patron saint of painters, his association stemming from an early eastern tradition that he had painted a number of icons of the Virgin **Mary** and Child. Painters, especially from the Netherlands during the fifteenth and sixteenth centuries, depicted Luke either actually painting the Virgin and Child or holding up a picture of them. Luke's evangelical attribute is a winged ox, the wings referring to his role as a messenger, and the ox – a sacrifical beast – alluding to the sacrifice mentioned at the start of his Gospel.

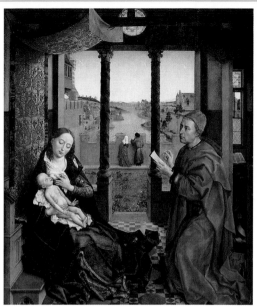

St. Luke, the patron saint of painters, is depicted by Rogier van der Weyden, the leading Netherlandish artist of the 15th century, painting the Virgin and Child, a popular motif.

Biblical References:

Luke; Acts.

Attributes:

Winged ox; Gospel; painter's palette.

Major Paintings:

- Carracci, Annibale: **Virgin Appearing to Sts. Luke and Catherine**, 1592, Louvre, Paris, France.
- Guercino: **St. Luke Displaying a Picture of the Virgin**, 1652–53, Nelson-Atkins Museum of Art, Kansas City, Missouri, USA.
- Weyden, Rogier van der: **St. Luke Drawing a Portrait of the Virgin Mary**, c.1435, Museum of Fine Arts, Boston, Massachusetts, USA.

Magi, The

The three wise men who visited the baby Jesus

The Gospel of **Matthew** tells how wise men from the East, known as Magi, learned of the birth of a king by the appearance of a star. They journeyed to Jerusalem to search for the child king, where King Herod the Great made them promise to tell him the child's whereabouts so that he could go and worship also.

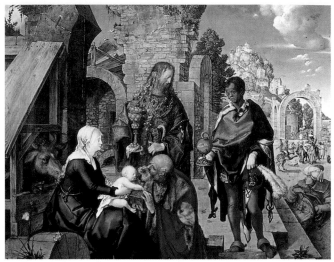

Gold, frankincense and myrrh – gifts from the three 'kings'. Dürer has ensured that the triangular composition of the Magi and the Virgin Mary is reflected in their architectural setting.

Guided by the star, they found the baby **Jesus** in Bethlehem with his mother the Virgin **Mary**. At this 'adoration' the Magi worshipped Jesus and presented to him their gifts of gold, frankincense and myrrh. Then, warned in a dream not to return to Herod, they returned to the East.

This basic story has been enriched by apocryphal additions and, although Matthew never gives the number of wise men, three becomes accepted by the third century. The prophecies of the Old Testament were invoked to identify the Magi – probably Persian priest astrologers – as kings to distinguish them from magicians. The names Caspar, Melchior and Balthasar do not appear until the sixth century.

Although all these episodes are depicted in art, usually in cycles, the most popular theme is the Adoration by the Magi which can be traced back to second-century drawings in Roman catacombs. The imagery developed over the centuries, with the eastern origin of the Magi providing scope for depicting luxurious robes, turbans, camels and other exotic animals. From late medieval times, the three kings can be depicted as of different races representing the three parts of the known world – Europe, Asia and Africa.

Biblical Reference:
Matthew 2.

Attributes:
Oriental robes; crowns; gifts; camels; star or comet.

Major Paintings:
- Giotto: **Adoration of the Magi**, 1304–06, Scrovegni Chapel, Padua, Italy.
- Gentile da Fabriano: **Adoration of the Magi**, 1423, Uffizi, Florence, Italy.
- Dürer, Albrecht: **Adoration of the Magi**, 1504, Uffizi, Florence, Italy.

St. Margaret (or Marina) of Antioch

Shepherdess swallowed by a dragon

The story of St. Margaret (also called Marina) is purely legendary and so, despite being an extremely popular saint in the past, she is no longer considered a saint by the Catholic Church. Margaret's tale, found in the *Golden Legend*, tells that she lived in the third century AD and was a shepherdess in Antioch, Syria. The daughter of a pagan priest, she converted to Christianity and vowed to remain a virgin. Her beauty attracted the advances of the Roman governor, but Margaret rejected him.

For this, Margaret was thrown into prison where, while at prayer, she was attacked and swallowed by the Devil in the form of a dragon. With the divine aid of a crucifix, however, she escaped from the inside of the monster. But Margaret's trials were not over, for she was then tortured; after whipping, burning and mutilation, Margaret was finally beheaded.

Margaret's escape from the dragon's insides meant that her aid was sought by women for a painless childbirth. This naturally made her one of the most popular saints, featuring in many pictures. A medieval mystery play based on Margaret's story also helped spread her cult far and wide.

In art Margaret is nearly always shown with a dragon. She sometimes has it underfoot or on a lead; she may even be shown emerging from the monster. Similarity with the princess in the legend of **St. George** has led to mingling of attributes, with Margaret occasionally wearing a crown. She can also be confused with St. Martha who expelled a dragon by sprinkling it with holy water. Margaret is often portrayed along with other virgin martyrs such as **St. Catherine of Alexandria** and **St. Barbara**.

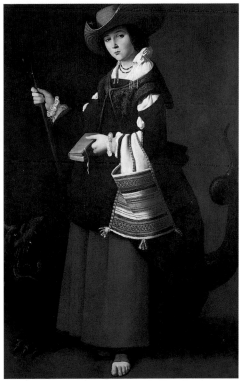

Dressed as a Spanish shepherdess, St. Margaret stands over the dragon which had attacked her.

Attributes:

Dragon; sheep; shepherd's crook; crucifix; pearls.

Major Paintings:

▲ Zurbarán, Francisco de: **St. Margaret**, *c.*1630–35, NGL.

● Guercino: **St. Margaret**, probably 1620s, S. Pietro, Rome, Italy.

● Titian: **St. Margaret and the Dragon**, *c.*1565, Prado, Madrid, Spain.

St. Mark

Interpreter of St. Peter

Mark, although not one of the original twelve disciples chosen to spread **Jesus**' message, wrote one of the four Gospels relating the life and teachings of Jesus.

Mark became involved with the early followers of Jesus since his mother had a house in Jerusalem where a group of Christians regularly met. Mark accompanied **Paul** on his earliest missionary journey, although Mark deserted him, causing a temporary rift. Mark, together with Barnabas, took his mission to Cyprus and, later, Mark was in Rome with **Peter** where early sources say that he was Peter's scribe, writing down as much as Peter could remember of the things said and done by Jesus. It is now generally accepted that Mark's Gospel was the first to be written, probably only about thirty years after Jesus' Crucifixion.

Very little is known of Mark's life after he was in Rome, but he is said to have been the first Bishop of Alexandria in Egypt, where he was reputedly seized at the altar, dragged through the streets on a rope and beaten to death. A thunderstorm occurred upon Mark's death, scattering the pagans and allowing local Christians to bury his body.

Subsequently, in 828 AD, some Venetian merchants claimed to have stolen Mark's body from his shrine in Alexandria and brought it back to Venice. A chapel was built over his new tomb, and Venice adopted Mark as its patron saint. In 1063 a splendid basilica, which still stands today, replaced the original chapel. Venice also adopted as its coat of arms Mark's evangelist symbol – the winged lion. The winged lion (the wings referring to its role as messenger and

distinguishing it from the lion of **St. Jerome**) was thought to allude to an opening passage in Mark's Gospel, which likens **John the Baptist** to one crying, or roaring, in the wilderness.

St. Mark is usually represented as a bearded man holding his Gospel and accompanied by his winged lion which, standing alone over a book, can even represent Mark himself. Paintings often show Mark writing his Gospel, being dictated to by either Peter, an angel, the Holy Spirit in the form of a dove, or even Christ himself. Various legends surrounding Mark have also been illustrated, especially by Venetian artists, notably Tintoretto.

Biblical References:

Mark; Acts.

Attributes:

Winged lion; book or scroll; quill or pen; bishop's robes.

Major Paintings:

- Carpaccio, Vittore: **Lion of St. Mark**, 1516, Palazzo Ducale, Venice, Italy.
- Tintoretto, Jacopo: **Removal of the Body of St. Mark**, 1562–66, Accademia, Venice, Italy.
- Titian: **St. Mark Enthroned with Saints**, c.1510, S. Maria della Salute, Venice, Italy.
- Palma Giovane: **St. Mark**, c.1580–1628, Hatton Gallery, University of Newcastle-upon-Tyne, Newcastle-upon-Tyne, England.

The subject of St. Mark, patron saint of Venice, was an appropriate subject for the Venetian artist Palma Giovane, who pictured Mark not only with his lion and gospel, but also in front of St. Mark's Square in Venice.

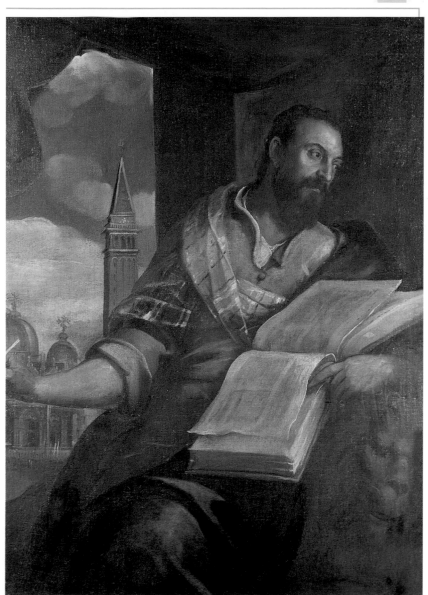

The Virgin Mary—The Annunciation
Mother of Jesus – 'Madonna'

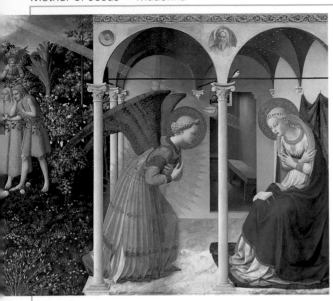

Biblical References:
Luke 1:26–38; Matthew 1:18–25.

Attributes:
Lily; book; crown (Queen of Heaven).

Major Paintings:

◄ Fra Angelico: *detail from* **The Annunciation**, *c.*1430, Prado, Madrid, Spain.

● Rossetti, Dante Gabriel: **Ecce Ancilla Domini**, 1849–50, Tate Britain, London, England.

● Leonardo da Vinci: **The Annunciation**, *c.*1472, Uffizi, Florence, Italy.

According to Christian faith, Mary conceived through the Holy Spirit of God and gave birth to **Jesus**.

Little is known of Mary's life. She is mentioned in only a few episodes in the New Testament, most significantly **St. Luke**'s account of the Annunciation and the Nativity. Apocryphal tales, many retold in the *Golden Legend*, are the source of much of her life-story.

Non-biblical stories relate that Mary's parents were **Anne** and Joachim, and that aged 3, Mary was 'presented' to the service of the Temple of Jerusalem, walking alone up the steps to the High Priest **Zacharias**. Mary's betrothal to Joseph, a carpenter, and their residence in Nazareth, a village in Galilee, is, however, recounted in the Gospels.

It is at this point that St. Luke's Gospel tells of the Annunciation or announcement of the impending birth of Jesus to Mary. God sent the **angel** Gabriel to Mary with the message that

The Dominican monk, Giovanni da Fiesole, better known as Fra Angelico, is renowned for the luminosity and colour with which he suffused his works; his angels, often painted with dazzling, multi-coloured wings, are always sublime.

she, a virgin, would give birth to a son by the power of the Holy Spirit, and that he was to be named Jesus. Mary replied, 'Behold the handmaid of the Lord' ('*Ecce Ancilla Domini*').

The Annunciation is widely represented in art from the medieval period onwards. Along with Mary and the angel, a dove representing the Holy Spirit is often shown, symbolizing the Incarnation where God becomes man in the person of Jesus. The angel may hold a white lily signifying Mary's virginity, and Mary herself often holds a book, alluding to an Old Testament prophecy of a virgin birth. The expulsion of **Adam and Eve** can be depicted in the background, symbolizing the Fall of Man and, with Jesus' birth, man's redemption.

The Virgin Mary—Madonna and Child
Mother of Jesus – 'Madonna'

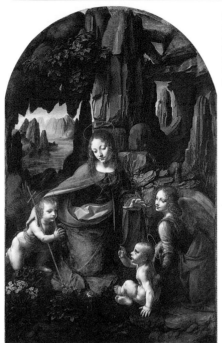

Set in an other-worldly landscape the Virgin Mary stretches out her hand in blessing over the baby Jesus, supported by an angel, who in turn blesses the young John the Baptist. This painting is thought to be a replacement for Leonardo's altarpiece (now in the Louvre) for the Oratory of San Francesco in Milan, although the issue of which version came first is still a contentious one.

throughout the Christian Church, despite vigorous debates as to the validity of Mary's title as the 'Mother of God'.

Mary's veneration grew especially in the medieval period when she is shown either by herself, symbolizing the Mother Church, or, more often, with Child in a variety of poses – standing, seated on a throne, facing front or sideways, holding the Child in her lap or in her arms, or even suckling the Child. During the Renaissance, stiffer compositions gave way to softer, more maternal ones.

A popular variant on the Virgin and Child image is to show the couple surrounded by saints and even the donors of the church or painting. Mary's usual dress is a red robe and blue cloak, red signifying love and blue, the heavens.

The birth of **Jesus** (Nativity) provides an emotive artistic theme, where Mary, Joseph and the newly born Jesus can be shown in the midst of a lowly stable. The visits of the shepherds and the **Magi** are also often illustrated in this setting.

However, probably the most widespread image of Mary is where she and the baby Jesus, usually held in her arms, form the sole or main subject of a painting. The earliest example is in a third-century Christian catacomb at Rome, reflecting that Mary's cult and iconography have probable origins in the many ancient beliefs about an earth- or mother-goddess, notably the Egyptian Isis and her son Horus. The image of the Virgin and Child, whether painted or sculpted, has subsequently had a long and popular history

Attributes:

Red robe and blue cloak; lily; star (deriving from her title Star of the Sea, the meaning of her Jewish name Miriam); roses (blood of the martyr); apple (for Christ as Redeemer after the Fall of Man); pomegranate (symbol of the Church).

Major Paintings:

- Raphael: **The Sistine Virgin**, c.1513, Gemäldegalerie, Dresden, Germany.
- Leonardo da Vinci: **Virgin of the Rocks**, 1503–06, NGL.
- Lippi, Fra Filippo: **Madonna and Child**, c.1440–45, NGADC.
- Michelangelo: **Holy Family ('Doni Tondo')**, c.1504, Uffizi, Florence, Italy.
- Bellini, Giovanni: **Madonna of the Meadow**, 1500–10, NGL.

The Virgin Mary—The Assumption
Mother of Jesus – 'Madonna'

According to the New Testament, Mary is present at just a few key moments in **Jesus'** adult life and ministry, including his Crucifixion where she is nearly always pictured at the foot of the cross. Afterwards, according to apocryphal sources, Mary accompanied **St. John the Evangelist** to Ephesus in Turkey where she remained for the rest of her life.

Events surrounding Mary's death, known as the 'Dormition' (from the Latin 'to sleep'), are related in the *Golden Legend* which was highly influential upon medieval and Renaissance artists. Painted episodes include the Annunciation, the announcement of her own imminent death by an **angel**. This is a scene distinguishable from the Annunciation of Jesus' birth by the fact that the angel – traditionally Michael rather than Gabriel – holds a palm (for martyrdom) instead of a lily (for purity). Mary's actual death is attended by the apostles who were miraculously transported to her side upon clouds, and even sometimes by Jesus.

The final part in Mary's story is one of the most commonly portrayed. Three days after her death, Mary's body and soul were taken up into heaven – an event known as the Assumption of the Virgin. Although this tradition has no biblical basis, the Assumption was declared a true occurrence by the Catholic Church in 1950.

In works of art, attempts have been made to illustrate the bodily assumption of the Virgin Mary. This usually takes the form of Mary, seated or standing, being borne aloft by angels. The apostles standing on the ground are usually present looking up in awe, and sometimes God is shown above waiting to receive Mary. Perhaps the greatest example of this scene is Titian's huge altarpiece in Santa Maria dei Frari in Venice, where the rich red colours and the upward-spiralling composition create a truly memorable and moving image.

From the sixteenth century, artists began to show the apostles around Mary's tomb which is filled with lilies (for purity) or roses (for martyrdom), while Mary herself rises to heaven unaided. **Thomas** is sometimes singled out as catching Mary's girdle, which falls to Earth in a symbolic confirmation for his traditional doubts about the Resurrection of Jesus.

Mary's Assumption is followed by her Coronation as Queen of Heaven. This was another popular subject for artists, appealing especially to those from Florence.

Attributes:
Open tomb; borne aloft by angels; lilies; roses; crown.

Major Paintings:
▶ Titian: **The Assumption of the Virgin**, 1516–18, S. Maria dei Frari, Venice, Italy.
● Correggio, Antonio: **The Assumption of the Virgin**, c.1526–28, Duomo, Parma, Italy.
● Carracci, Annibale: **Assumption of the Virgin**, c.1600, Cerasi Chapel, S. Maria del Popolo, Rome, Italy.

Tiziano Vecellio, known as Titian, the most famous of all Venetian painters, astounded all with his revolutionary altarpiece depicting the Assumption of the Virgin, one of the greatest works of art ever. The painting is saturated with the rich colours of red and gold. The anxiety of the apostles on Earth is tangible while the Virgin Mary, lifted heavenwards by throngs of cherubs, opens her arms out adoringly to be received by God.

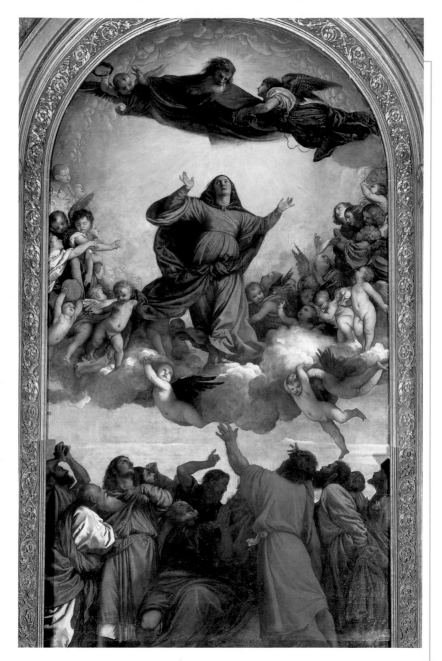

Mary Magdalene

One of Jesus' followers

Mary Magdalene received her name from the village of Magdala, now in modern Israel. She became a faithful follower of **Jesus** after he cleansed her of demons which had possessed her.

Mary Magdalene was present at several key events which are all widely represented in art. She stood with the Virgin **Mary** at the foot of the cross when Jesus was crucified, she helped with Jesus' burial and was among the 'holy women' who on going to Jesus' tomb to anoint his body, discovered that it was empty.

The Gospel of **John** records that Mary stayed at the tomb weeping while her companions returned home. After seeing two **angels**, she turned round and saw Jesus. Initially, she mistook him for the gardener but when she realized who he was, Jesus forestalled her embrace, saying, 'Do not touch me' (*'Noli Me Tangere'*) for he had not yet ascended into heaven. Jesus then told Mary to go to his disciples and tell them that he had risen from the dead.

Artists, following one-time Western Church opinion, have often regarded Mary Magdalene as the same person as Mary, the sister of Martha. Mary was criticized by Martha for merely sitting and listening to Jesus when he visited their house instead of busying herself with housework. Jesus, however, defended Mary saying that she 'played the better part'. Mary also appears in representations of her brother Lazarus' resurrection from the dead, one of Jesus' most famous miracles.

Similarly, Mary Magdalene was traditionally identified with the unnamed, 'immoral' woman who, in one account, on learning that Jesus was

Biblical References:
Matthew 28:1–10; Mark 16:1–11; Luke 7:36–50, 8:1–3, 10:38–42, 24:1–11; John 11:2, 12:1–8, 20:1–18.

Attributes:
Long hair; perfume or ointment jar; mirror; crucifix; skull.

Major Paintings:
▶ Titian: *detail from* **Christ Appearing to the Magdalene** (***Noli me tangere***), *c.*1512, NGL.
● Caravaggio: **Penitent Mary Magdalene**, *c.*1596–97, Galleria Doria-Pamphilj, Rome, Italy.
● La Tour, Georges de: **Repenting Magdalene** (**Magdalene in a Flickering Light**), *c.*1635–37, County Museum of Art, Los Angeles, California, USA.

in Simon the Pharisee's house, went to him and fell in repentance at his feet. She washed Jesus' hair with her tears, wiped them with her long hair and then anointed them with ointment from an alabaster jar. Jesus forgave her sins, saying that her love and faith had saved her.

This particular episode has provided the core attributes for images of Mary Magdalene – her long, flowing hair and jar of ointment. In addition, artists have often portrayed Mary as bejewelled and dressed in fine clothes, symbols of earthly vanities and pleasures. Mary may also be depicted either discarding these trappings or, as a penitent, simply dressed or even naked whilst meditating upon a crucifix, a crown of thorns, or even a skull indicating the transience of human life.

Mary Magdalene, with her trademark long hair, tries to embrace Jesus who withdraws from her touch. Jesus holds a hoe in reference to Mary's initially mistaking him for a gardener.

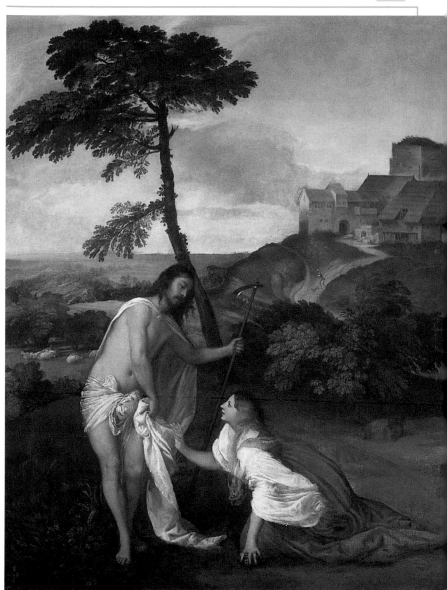

St. Matthew

Tax collector and Evangelist – author of the first Gospel

Matthew's original name was Levi and he may have been renamed Matthew ('Gift of God') by **Jesus**. He was a Jewish tax collector on behalf of the Roman rulers, and so was despised by the Jewish people, and especially the Pharisees who equated tax collectors with sinners. While sitting in a tax booth Matthew was summoned, or 'called', by Jesus; he got up and followed him.

Matthew became one of Jesus' twelve disciples. He would have had personal knowledge of Jesus and his teaching, which is reflected in the first Gospel of the New Testament, traditionally ascribed to Matthew, although its actual date of authorship is still uncertain. The Gospel reveals a strongly Jewish background and a concern with Old Testament law, presenting Christ as the fulfillment of the promises made by God to Israel. Matthew's Gospel contains the most scathing criticism of the hypocrisy of the Pharisees and embodies the Pauline belief that the Christian faith is not just for Jews but for everyone. Matthew narrates at length Jesus' Sermon on the Mount, which includes the Lord's Prayer and sets out his teaching on love, mercy, forgiveness, tolerance, kindness and generosity. According to Matthew, the people were astonished at Jesus' doctrine for he instructed

with '[divine] authority'. Matthew also relates the parables and the care taken by Jesus to explain their meaning.

Little is known of Matthew after the Crucifixion but according to the *Golden Legend* he journeyed to the Black Sea, Macedonia, Syria and Ethiopia where he was beheaded while preaching, possibly on account of his opposition to the Ethiopian King's marriage to the King's niece. His body is allegedly enshrined in Salerno cathedral in Italy.

As an Evangelist, Matthew's winged emblem (wings being representative of a messenger) is an **angel** or winged man.

In art, Matthew is often shown writing his Gospel with his emblematic angel dictating, or merely holding a pen or quill. He is also shown with a purse as a reminder of his being a former tax collector; or an ax or sword signifying his beheading.

Undoubtedly, the most famous representations of St. Matthew are the three canvases painted by Caravaggio in the church of San Luigi dei Francesi in Rome. Matthew is the patron saint of bankers and tax officials.

Biblical References:

Matthew.

Attributes:

Winged angel; purse; book; scroll; pen; quill; sword; axe.

Major Paintings:

- Rembrandt van Rijn: **Evangelist Matthew**, 1661, Louvre, Paris, France.
- Cantarini, Simone: **St. Matthew and Angel**, *c.*1645–48, NGADC.
- Caravaggio: **The Calling, The Inspiration and The Martyrdom of St. Matthew**, 1602, Contarelli Chapel, S. Luigi dei Francesi, Rome, Italy.

In Caravaggio's *Inspiration of St. Matthew* the striking intensity of the gaze between the saint and the angel dictating the Gospel is forceful and direct; it stands in contrast to the relaxed pose of Matthew resting his knee on the stool. Caravaggio, characteristically, portrayed Matthew in an even more workmanlike pose in his first version of this painting (now destroyed), but it was taken down by the priests who thought it lacked decorum.

Moses

Greatest leader and lawgiver of the Jews

The Israelites, or Hebrews, had settled in Egypt in the time of **Joseph**, but after several generations, perhaps around 1300 BC, they had been enslaved by the Egyptians. To restrict their numbers, the Egyptian Pharaoh (possibly Rameses II) had ordered all Israelite male babies to be killed, but when Moses was born his mother put him in a basket of bulrushes at the edge of the River Nile.

Pharaoh's daughter found the baby and immediately adopted him. Moses' sister Miriam, who was watching nearby, arranged for a nurse – Moses' mother – to help rear the baby. Moses grew up in Pharaoh's court, but as a young man he killed an Egyptian who was beating a Hebrew slave; he fled to Midian, where he married Zipporah and tended her father's flocks.

One day God spoke to Moses from a burning bush and commanded both him and his brother, Aaron, to lead the Israelites out of slavery to the 'Promised Land' of Canaan, the 'land of milk and honey'.

Moses pleaded before Pharaoh, and Aaron performed various miracles, to persuade him to let their people go, but only after God inflicted ten plagues upon the Egyptians did Pharaoh submit. The night of the final plague became known as the Passover since God brought death to the firstborn of Egypt but passed over the houses of the Israelites.

The Israelites immediately began their Exodus from Egypt to Canaan guided by a pillar of cloud and fire. Moses parted the waters of the Red Sea to let the Israelites pass through and led the Hebrews for forty years through the Sinai Desert. When they complained about lack of food and water, manna fell from heaven and water gushed from a rock which Moses struck.

Moses communed with God on Mt. Sinai, and came down with the two stone tablets of the Law on which were engraved by God his Ten Commandments. Meanwhile, the Israelites had made a golden calf and were worshipping it as their idol. Angrily Moses smashed the two tablets and destroyed the golden calf. Later Moses brought down two new tablets with the Commandments which were kept in a wooden chest – the Ark of the Covenant.

After forty years the Israelites reached Canaan. Moses did not enter but looked down on it from Mt. Nebo, where he died.

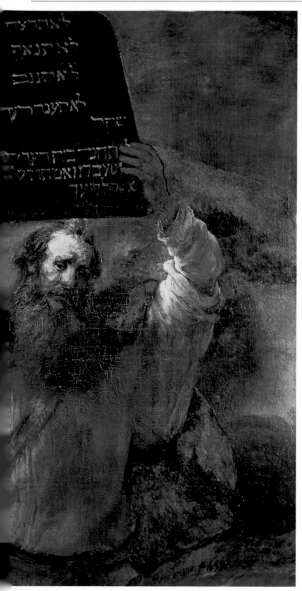

It is difficult to tell whether Moses is holding aloft the tablets bearing the Ten Commandments, in triumph, or whether he is about to smash them to pieces when he sees the Israelites idolatrously worshipping the golden calf.

Biblical References:

Exodus; Leviticus; Numbers; Deuteronomy.

Attributes:

Baby in basket; burning bush; stone tablets; golden calf.

Major Paintings:

- Gentileschi, Orazio: **The Finding of Moses**, 1633, Prado, Madrid, Spain.
- Poussin, Nicolas: **Adoration of the Golden Calf**, c.1635, NGL.
- Tintoretto, Jacopo: **Worship of the Golden Calf**, c.1560, NGADC.
- Rembrandt van Rijn: **Moses with the Tablets of the Law**, 1659, Gemäldegalerie, Berlin, Germany.

St. Nicholas
The original Santa Claus

The story of Nicholas is a mixture of fact and legend. The known facts about Nicholas are few. He was born *c*.270 AD and was consecrated Bishop of Myra, in southwest Turkey, while still a young man. He died in December around 343 AD, and in 1087 his body was stolen and enshrined at Bari in Italy.

There are many representations of the various legends surrounding Nicholas. The most notable concerns the 'Charity of St Nicholas'. When a poor nobleman could not afford dowries for his three daughters and was about to prostitute them, Nicholas came to the rescue by throwing a bag of gold to each of them through their window. Hence Nicholas' main attribute is three moneybags or golden balls which became the symbol of pawnbrokers. Another story is that of three boys who were slaughtered by a butcher and thrown into a tub of brine. Nicholas, by making the sign of the Cross, managed to resurrect them. Other miracles involve Nicholas relieving famine by replenishing stocks of grain and his appearance at sea to calm storms, for which he has become the patron saint of seafarers.

Nicholas' death in the month of December, and the fusion of the ancient custom of giving presents around midwinter with the story of Nicholas' charity, has led to his association with Christmas. In this capacity he has also become known as Santa Claus (a corruption of St. Nicholas), the semi-legendary figure who popularly gives presents at Christmas.

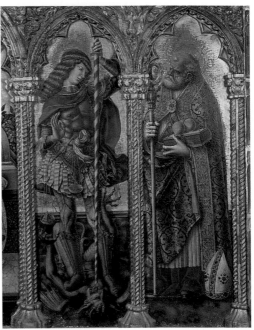

St. Nicholas, Bishop of Myra, crozier in hand and mitre at his feet, clutches a Bible on top of which balance his particular symbol, three golden balls. Next to him is the archangel St. Michael who tramples and slays Satan.

Attributes:
Bishop's robes and crozier; three moneybags or golden balls; ship's anchor.

Major Paintings:
● Tintoretto, Jacopo: **St. Nicholas**, *c*.1580–90, Kunsthistorisches Museum, Vienna, Austria.
● Raphael: **'Ansidei' Madonna and Child** (*with St. Nicholas*), *c*.1505, NGL.
● Veneziano, Paolo: **Charity of St. Nicholas**, 1346, Uffizi, Florence, Italy.
▲ Crivelli, Carlo: **Polyptych with St. Nicholas**, *c*.1457–93, San Martino, Monte San Martino, Italy.

Noah
Builder of the Ark and survivor of the Flood

Noah was favoured by God because he was a good, honest man living in a world so corrupted by wickedness that God regretted creating it. So God instructed Noah to build a large boat – the Ark – into which he was to take his wife, his three sons Shem, Ham and Japheth, and their wives. He was also to take two of every living creature, male and female. Then rain fell for forty days and nights until water covered all the Earth and every living thing died.

Eventually the flood receded and the Ark came to rest on Mt. Ararat. After sending out a raven and a dove to test for dry land, without success, Noah sent out the dove a second time and it came back carrying an olive leaf. The dove was sent out again and, as it did not return, Noah knew that it was safe to leave the Ark. God then sent a rainbow as a covenant between himself and mankind that never again would a flood destroy the Earth. The Ark, a symbol of salvation, is found on early Christian tombs. In post-classical art, the story of Noah and the Ark has remained popular, as has the subsequent episode of Noah's drunkenness. Noah was the first to cultivate the vine and after the first harvest, he became drunk on the wine and fell asleep naked. Ham made fun of his father whereas Shem and Japheth covered him with a cloak, an origin myth explaining why Ham's descendants (the Canaanites) became the traditional enemies of Shem's and Japheth's offspring (the Israelites).

Biblical References:

Genesis 6–9.

Attributes:

Ark; dove and olive leaf; raven; vine; wine cup; being covered up by his sons.

Major Paintings:

▼ Bellini, Giovanni: **Drunkenness of Noah**, *c.*1515, Musée des Beaux-Arts, Besançon, France.

● Hicks, Edward: **Noah's Ark**, 1846, Philadelphia Museum of Art, Pennsylvania, USA.

● Raphael: **Building the Ark**, 1518–19, Loggia, Vatican, Italy.

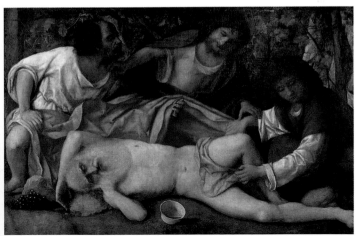

Noah lies next to a bunch of grapes and a cup indicating his drunkenness while Ham, amused by his father's condition, tries to stop his brothers covering him.

St. Paul

Apostle who spread early Christianity to non-Jews

Paul, originally named Saul, was born a Jew in Tarsus, Cilicia, now southern Turkey, and trained in Jerusalem as a Pharisee. He was a tent maker by trade and a Roman citizen.

As a devout Jew, he initially persecuted Christians and consented to the death of **Stephen**, the first Christian martyr. However, while on his way to Damascus in Syria, he experienced a dramatic and miraculous conversion. Blinded by a flashing light from heaven, he fell to the ground, and heard a voice saying, 'Saul, Saul, why do you persecute me?' It was the voice of **Jesus**, who told him to go on to Damascus where he would be told what to do. Saul was blind for three days until a Christian named Ananias restored his sight and baptized him a Christian. Saul now took the name of Paul and proceeded to teach that Jesus was the Messiah, the Son of God, with enthusiastic zeal.

More than any of the Evangelists, Paul was responsible for the early spread of Christianity through his three missionary journeys which covered the non-Jewish peoples of Syria, Asia Minor, Cyprus and Greece, for he felt that he had been personally chosen by God to take the Gospel to the gentiles. On these journeys Paul laid the foundations of the first Christian communities. His

Biblical References:
Acts; Paul's Epistles.

Attributes:
Book; sword (of martyrdom).

Major Paintings:
- Caravaggio: **Conversion of St. Paul**, 1601, Cerasi Chapel, S. Maria del Popolo, Rome, Italy.
- El Greco: **Apostles Peter and Paul**, 1592, Hermitage, St. Petersburg, Russia.
- Michelangelo: **Conversion of St. Paul**, 1542–50, Capella Paolina, Vatican, Italy.

work is detailed in the Acts of the Apostles and in his Epistles (letters), the earliest dating from c.48 AD.

Eventually, Paul was accused by Jewish leaders of causing trouble in Jerusalem. He appealed to the Roman Emperor Nero and, according to a Roman citizen's rights, was sent to Rome for trial. Under house arrest for two years, he wrote many letters. His fate is not certain but traditionally he was beheaded around 64 AD during Nero's persecution of Christians.

Early representations show Paul as small (*paulus* in Latin), bearded and bald, characteristics which many later artists followed. Scenes from Paul's life and missions are varied and numerous. However, Paul's conversion on the road to Damascus is the best-known and most widely illustrated episode, often showing Paul thrown from his horse. Depictions of Paul's execution often follow apocryphal tales and show him with a blindfold given to him by a Christian woman, and being martyred with **Peter**.

St. Paul is often linked to St. Peter in Christian symbolism, since they are considered joint founders of the Church, Paul representing the non-Jewish element and Peter the Jewish. Many churches are dedicated to both, and in art they are often shown standing on either side of Christ.

Caravaggio's characteristic traits of dramatic lighting and bold foreshortening are clearly evident in his portrayal of Paul being blinded by the heavenly light of Jesus, which is given vertical emphasis through the horse's white markings. This was another highly controversial painting by Caravaggio, not least because of the prominence given to the horse, from which Paul traditionally fell.

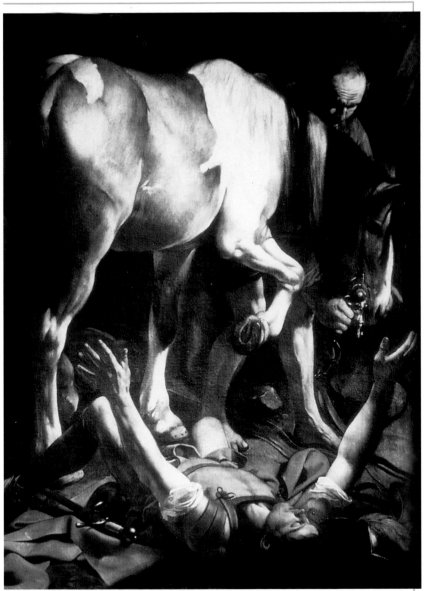

St. Peter

Leader of the twelve disciples

St. Peter's original name was Simon and he and his brother **Andrew** were fishermen on the Sea of Galilee. He received the name Peter from **Jesus**, who said, 'You are Peter, the Rock (*petros* in Greek); and on this rock I will build my church, . . . I will give you the keys of the kingdom of Heaven . . .' This was a sign of the founding role he was to play in the Christian Church. Keys have become his characteristic symbol.

As leader of the disciples, Peter appears frequently in the Gospels openly affirming his faith in Jesus as the Son of God. As one of those closest to Jesus, Peter was present at the most important events in his life, all of which are portrayed in art. With special reference to Peter, these include:

- Peter, while fishing in his boat, being summoned by Jesus to become a 'fisher of men' as his disciple; sometimes Peter and Andrew are shown catching a 'miraculous draught of fishes' in their nets.
- Peter receiving the keys to heaven from Jesus.
- Peter recoiling from having his feet washed by Jesus at the Last Supper.
- Peter cutting off the ear of the high priest's servant upon Jesus' betrayal by **Judas**.
- Peter weeping and repenting, as he hears a cock crow after he has three times denied being one of Jesus' followers, as Jesus had predicted.

Peter became head of the earliest Christian community in Jerusalem, and the Acts of the Apostles recount many stories from this period of Peter's preaching, visions and miracle-working. Popular subjects for artists include Peter healing the sick with his shadow, restoring the dead to life, and being freed from prison by an angel. **Luke** is sometimes shown alongside Peter, writing down his words.

Peter is traditionally associated with Rome and is accepted as the first Bishop of Rome, predecessor of the popes. Painted episodes from this part of Peter's ministry derive from apocryphal texts and include the magician Simon Magus falling to the ground after failing to fly with the help of demons; and the conversion of Peter and **Paul**'s jailers. Most popular is the *'Quo Vadis?'* tale, which tells of how Peter, escaping persecution, met Christ on the Appian Way, the road out of Rome. Peter asked, 'Where are you going, Lord?' *('Quo vadis, Domine?')* and Christ replied, 'To Rome, to be crucified again.' Whereupon Peter returned to Rome to meet his fate.

Peter was crucified c.64–67 AD, on an inverted cross since he considered himself unworthy to suffer the same fate as Jesus.

Biblical References:
Matthew; Mark; Luke; John; Acts.

Attributes:
Key(s), often crossed; cockerel; inverted cross; fishing boat and net; sheep; chains; papal tiara.

Major Paintings:
- Caravaggio: **The Crucifixion of St. Peter**, 1600–01, Cerasi Chapel, S. Maria del Popolo, Rome, Italy.
- Rubens, Peter Paul: **St. Peter**, c.1610, Prado, Madrid, Spain.
- Perugino, Pietro: **The Charge to Peter ('The Giving of the Keys')**, 1481–82, Sistine Chapel, Vatican, Italy.
- Raphael: **Liberation of St. Peter**, 1513–14, Stanza dell' Elidoro, Vatican, Italy.
- Carracci, Annibale: ***Domine Quo Vadis?***, 1601–02, NGL.

St. Peter gazes heavenward acknowledging his receipt of the symbolic keys of heaven, which were entrusted to him by Jesus.

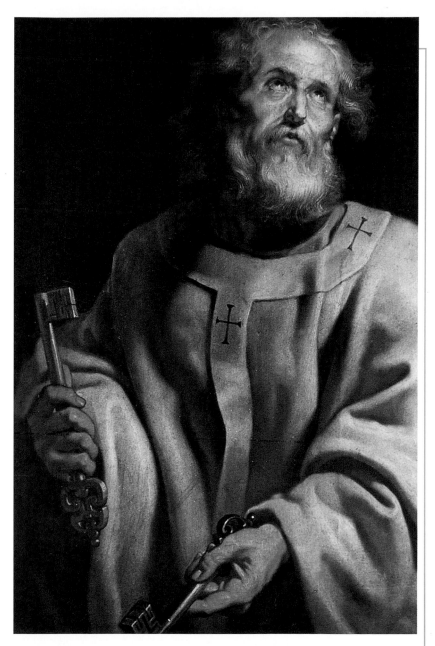

Rebecca

A future bride found at a well

Abraham had grown rich in Canaan with many flocks and herds and servants to attend him. He asked his trusted old servant, Eliezer, to find a wife for his son Isaac from among his own kinsmen living in his homeland, Mesopotamia. Eliezer set out with ten camels laden with jewellry and other gifts for the future bride and her family. He came to the city where Nahor, Abraham's brother, lived, and rested his camels beside a well.

Towards evening, the women came out of the city to draw water from the well. Eliezer prayed that the girl suitable for Isaac should be the one who, when asked to give him a drink, should also offer water to his camels. A young woman appeared carrying a pitcher and duly gave Eliezer a drink as well as drawing water for his camels and their drivers. After giving her gold bracelets and earrings, Eliezer learned that she was Rebecca, the granddaughter of Nahor, brother to Abraham.

Eliezer and his company were made welcome at Rebecca's home and told how Abraham was now a wealthy man wishing to find a wife for Isaac, his only son. He gave Rebecca gold and silver ornaments and her family other fine gifts. Rebecca agreed to marry Isaac and so left home to travel to Canaan. Isaac, seeing the camel caravan approaching, went to meet it and made Rebecca his bride.

The most popular depiction involves Rebecca at the well, allowing artists to paint a touching yet faintly exotic scene — not least due to the presence of camels.

Biblical References:

Genesis 24.

Attributes:

Camels; well.

Major Paintings:

- Rembrandt van Rijn: **Isaac and Rebecca (Jewish Bride)**, *c.*1666, Rijksmuseum, Amsterdam, The Netherlands.
- Hilton, William the Younger: **Rebecca and Abraham's Servant at the Well**, *c.*1833, Tate Britain, London, England.
- Claude Lorraine: **Landscape with the Marriage of Isaac and Rebecca**, 1648, NGL.
- Poussin, Nicolas: *detail from* **Eliezer Meets Rebecca**, 1659–61, Fitzwilliam Museum, Cambridge, England.
- Solimena, Francesco: **Rebecca and the Servant of Abraham**, *c.*1710, Accademia, Venice, Italy.
- Coypel, Antoine: **Eliezer and Rebecca**, 1700–02, Louvre, Paris, France.

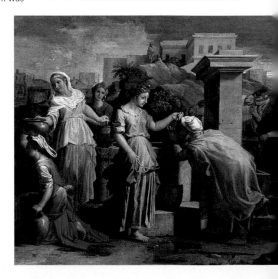

Rebecca, at the well, is entreated by Eliezer to give him and his men and camels a drink of water.

St Roch (Rock)

The plague saint

Roch, who lived in the fourteenth century, was one of the main saints invoked against the plague, a term applied indiscriminately in the medieval period to all fatal epidemic diseases, one of which, bubonic plague, known as the Black Death, was rife in the fourteenth and fifteenth centuries.

Roch made many pilgrimages during his life, and during one to Rome he caught the plague after tending its victims. To avoid spreading it, Roch hid deep in the forests or deserts where he was fed by a dog which brought him a loaf of bread a day (echoing stories about **St. Anthony Abbot** and **Elijah**). Here Roch allegedly worked miraculous cures. When he returned home to Montpellier in France, Roch was so disfigured by disease that he was not recognized. Accused of espionage, he was put in prison where he died. Miracles were then claimed at his tomb.

Roch's fame spread rapidly and, in the fifteenth century, his relics were removed to Venice where the Scuola di S. Rocco, a charitable body of citizens helping the sick, was established; its grand headquarters was decorated by Tintoretto.

St. Roch can be identified in pictures by the sore or 'bubo' on his thigh, a symptom of bubonic plague, which he generally points to; sometimes he is accompanied by the dog that fed him. As a pilgrim, he wears a pilgrim's hat and cloak often decorated with the pilgrim's scallop shell (see **James the Great**) and carries a pilgrim's staff, gourd (water container) and wallet for alms. The other main 'plague saints' are **St. Sebastian** and **St. Anthony of Padua**.

St. Roch, a saint popularly invoked against the plague, reveals his chief attribute – a sore.

Attributes:

Pilgrim's staff; gourd; wallet; scallop shells; plague sore; dog.

Major Paintings:

▶ Crivelli: **St. Roch**, c.1450–95, Wallace Collection, London, England.

● David, Jacques Louis: **St. Roch**, Musée des Beaux-Arts, Montpellier, France.

● Giorgione: **Madonna with the Child, St. Anthony of Padua, and St. Roch**, c.1500, Prado, Madrid, Spain.

● Metsys, Quentin: **St. Roch**, early 16th century, Alte Pinakothek, Munich, Germany.

Ruth

Moabite woman who became an ancestor of Jesus

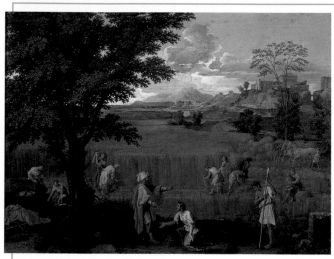

The timelessness
of Poussin's later
landscapes is evident
in this painting of
Ruth and Boaz.

Ruth was a daughter-in-law of Naomi who,
with her husband and two sons, fled from
Bethlehem to Moab because of famine. When
Naomi's husband and two sons died, she decided
to return to Bethlehem. Her two daughters-in-law
accompanied her although Naomi had advised
them to return to their own people, the Moabites.
Ruth refused, saying, 'Where you go, I will go,
. . . your people shall be my people and your
God my God. Where you die, I will die.'

At Bethlehem, Ruth gleaned in the fields,
gathering the stalks of grain left
behind by the reapers. One day she
was gleaning in a field owned by
Boaz, a wealthy kinsman of Naomi's
late husband. Noticing Ruth, Boaz
asked about her and was told of her
loyalty to Naomi, whereupon he
ordered his reapers to let Ruth glean
among the sheaves and to leave
behind handfuls of wheat and barley
for her. She was also to eat and
drink with his own servants. Naomi
was delighted to hear of Ruth's

meeting with Boaz
and explained the
family relationship.
She encouraged
Ruth to sleep at
Boaz' feet to
remind him of the
Israelite custom for
the nearest kin to
marry the widow of
a deceased relative. Although Boaz was not the
first next-of-kin but the second, he married Ruth.
Their son, Obed, was the grandfather of **David**,
King of Israel, and so an ancestor of **Jesus.**

Although the subject of Ruth is rare in
Italian art it became popular in the seventeenth
century with Flemish painters, as well as in
the nineteenth century as a subject for
landscape painting.

Biblical References:
Ruth.

Attributes:
Cornfields; reapers in fields.

Major Paintings:
● Millet, Jean-François: **Harvesters Resting (Ruth and Boaz)**, 1850–53,
Museum of Fine Arts, Boston, Massachusetts, USA.
▲ Poussin, Nicolas: **Summer. Ruth and Boaz**, 1660–64. Louvre, Paris, France.
● Schnorr von Carolsfeld, Julius: **Ruth in Boaz's Field**, 1828, NGL.

Salome

Danced before Herod and demanded the head of John the Baptist

Salome was the daughter of Herodias, wife of Herod Antipas, the ruler of Galilee. Her part played in the execution of **John the Baptist** is well represented in art due to its conflicting overtones of sensuousness and callousness.

John the Baptist had been imprisoned for censuring the incestuous marriage between Herod Antipas and Herodias, who was also the wife of Herod's brother. Herod would have put John to death but feared the reaction of the people who regarded John as a prophet. However, Salome, daughter of Herodias by her first marriage – and thus niece of Herod Antipas – was to exploit Herod's male weakness.

At a birthday banquet held by Herod, Salome danced before him. Herod was so entranced with her that he promised her anything she wanted. Prompted by her mother, she demanded the head of John the Baptist on a plate. Herod reluctantly agreed. John was beheaded in prison, and his head was brought on a dish and given to Salome who carried it to her mother.

Biblical References:
Matthew 14:1–12; Mark 6:17–29.

Attributes:
Dancing; head on a platter.

Major Paintings:
▼ Gozzoli, Benozzo: **Dance of Salome**, 1461–62, NGADC.
● Moreau, Gustave: **Salome**, 1876, NGADC.
● Titian: **Salome**, c.1515, Galleria Doria Pamphilj, Rome, Italy.

Artists depict Salome dancing in various states of undress; the beheading ('decollation') of John the Baptist, sometimes in the presence of Salome; Salome carrying the platter with John's head on it; Salome presenting the head to Herodias and Herod who shy away from or abuse it; and Salome dancing with the platter and head (the two episodes having been conflated).

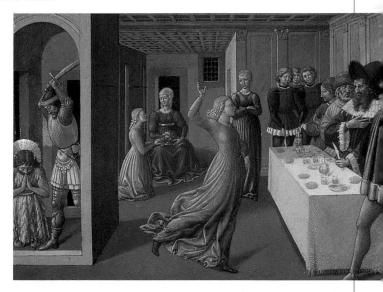

Set in a Renaissance court, Salome's dance before Herod is located centre stage, while the subsequent beheading of John the Baptist and the presentation of his head to Herodias is shown to the sides.

Samson

Swashbuckling warrior given strength by his hair

Samson was a 'judge' or leader in Israel at a time when the Israelites were oppressed by the Philistines. Samson's great physical strength was derived from his long hair which God had warned was never to be cut.

Samson proved his strength by killing a young lion with his bare hands, an achievement echoing that of **Hercules**. When Samson later passed by the lion's carcass on the way to his wedding, he saw that bees had made honey inside it. Intrigued, he bet thirty Philistine wedding guests they could not solve his riddle, 'Out of the eater came forth meat and out of the strong came forth sweetness.' The Philistines convinced his new bride to coax the answer out of Samson and taunted him with the words, 'What is sweeter than honey? And what is stronger than a lion?' To pay back the wager, Samson killed thirty other Philistines and gave their belongings to his gloating rivals as the reward. The father of his bride, repulsed by Samson's behaviour, gave her to another man, and so Samson took further revenge. He tied flaming torches to some foxes' tails and let them run through and burn the Philistine crops. When the Philistines tried to capture Samson, he killed 1,000 of them with the jawbone of an ass.

Then Samson fell in love with another Philistine woman named Delilah. Delilah was bribed by Philistine leaders to find the secret of Samson's strength. Three times Samson told her false stories, allowing himself to be chained up by the Philistines only to break free. Finally, worn down by Delilah's pleading, Samson told her the truth and Delilah lulled him asleep on her knees. An accomplice cut off Samson's hair and so rendered him powerless. The Philistines tied him up, cruelly blinded him and took him to prison to grind corn.

To celebrate Samson's capture, the Philistines held a feast for their god Dagon and brought Samson out of prison to mock him. They failed to notice, however, that his hair had grown again. Samson seized the pillars supporting Dagon's

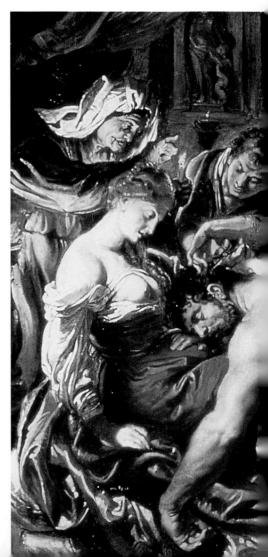

temple and pulled it down upon all the assembled Philistines, killing himself at the same time.

All the above elements in Samson's story have been portrayed by artists, although undoubtedly the most common is that of Samson and Delilah, due to the subtext of feminine guile and, more especially, to its sheer dramatic intensity and erotic pathos.

In this preparatory painting (*modello*) for his celebrated *Samson and Delilah* in the National Gallery, London, Rubens' passion for sensuousness is still evident. The poignancy of Samson's betrayal is emphasized by Delilah's reflective gaze and loving touch upon her lover, asleep in her lap, while the Philistines cut Samson's hair.

Biblical References:
Judges 13–16.

Attributes:
Long hair; lion; scissors; club; jawbone of an ass; temple pillars.

Major Paintings:
- Cranach, Lucas the Elder: **Samson Vanquishing the Lion**, *c.*1520–25, Kunstsammlungen zu Weimar, Weimar, Germany.
- Rembrandt van Rijn: **Blinding of Samson**, 1636, Staatliches Kunstinstitut, Frankfurt, Germany.
◀ Rubens: *detail from* **Samson and Delilah** (*modello*), *c.*1609, Cincinnati Art Museum, Ohio, USA.
- Solomon, Solomon J.: **Samson**, 1887, Walker Art Gallery, Liverpool, England.
- Dyck, Sir Anthony van: **Samson and Delilah**, 1620, Dulwich Picture Gallery, London, England.

Saul and Samuel

First king of Israel and last judge of Israel

Up until about 1020 BC the twelve tribes, or family groups, of Israel had been governed by judges or local elders rather than by a king. It was only when the danger from the Philistines became serious that they decided to appoint an overall king. It fell to Samuel, the last and greatest judge, to anoint Saul the first King of Israel.

Samuel's close relationship with God was evident from an early age. At the temple at Shiloh, he was called by God three times in the night and then dedicated to God by the priest Eli. He went on to become, as prophet, judge and priest, a figurehead for the people of Israel in their time of crisis when the Philistines had captured the Ark of the Covenant, the sacred wooden chest that symbolically represented the presence of God with Israel. Samuel led the Israelites in recapturing the Ark, and was then requested by his kinsmen to anoint a king. God told him it should be Saul.

Saul, unaware of his future role, enlisted Samuel's help in finding some asses which had gone astray, only to be told that the asses had been found and that he, Saul, had been chosen to lead the fight against the Philistines. Later, when all the tribes were gathered together, Samuel

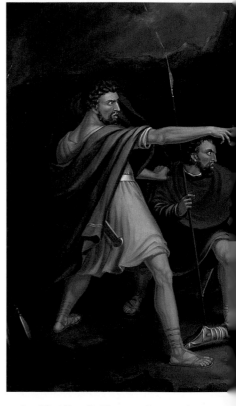

Biblical References:

1 Samuel 7–31.

Attributes:

Samuel – horn of oil; ghostly figure. Saul – javelin; sword.

Major Paintings:

▶ Mount, William Sydney: **Saul and the Witch of Endor**, 1828, Smithsonian Institution, Washington DC, USA.

● Rembrandt: **David Playing the Harp before Saul**, 1656, Mauritshuis, The Hague, The Netherlands.

● Rosa, Salvator: **Saul and the Witch of Endor**, 1668, Louvre, Paris, France.

● West, Benjamin: **Saul and the Witch of Endor**, 1777, Wadsworth Atheneum, Connecticut, USA.

anointed Saul King. Saul became a brave warrior king, winning victories against his foes, and started to transform the separate tribes of Israel into a unified nation able to defend itself.

Saul, however, proved to be a weak leader and fell into such disfavour with God that Samuel was commanded by God secretly to anoint **David**, a young shepherd boy and good musician, as King.

Saul, aware that he had lost authority, became subject to fits of depression which he tried to alleviate by listening to David playing the harp. Saul became increasingly resentful of David and

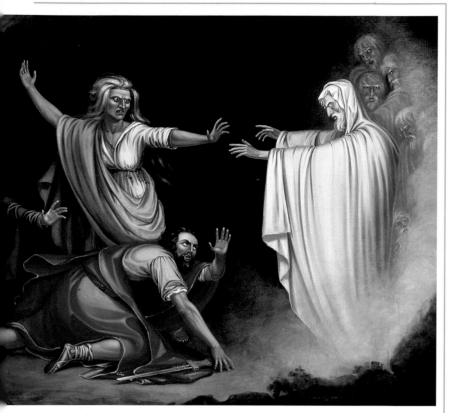

tried to enlist his son, Jonathan, and daughters, Merab and Michal, to ensnare his young rival. On more than one occasion Saul tried to kill David with a spear, and eventually drove him into exile.

A strange episode occurred at the end of Saul's life. About to face the Philistines in battle, Saul consulted a famous psychic, the Witch of Endor. He insisted that she summon up the spirit of Samuel, who had died some years previously, to give him guidance. The spirit of Samuel told Saul that he would lose the battle on Mt. Gilboa and that he and his sons would be killed – as indeed happened.

The spirit of Samuel is conjured up by the wild-looking Witch of Endor who stands between the ghostly figure and Saul; the latter, steadying himself, points in amazement at the apparition which predicts his imminent death.

St. Sebastian

Early Christian martyr

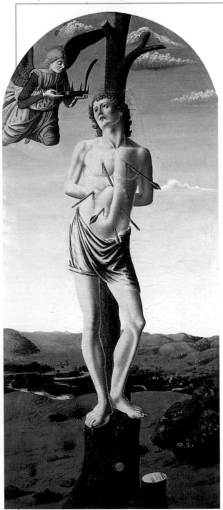

Sebastian was reputedly born in Gaul in the third century AD. As a young man he went to Rome where he joined the Roman army, rising to the rank of Captain of the Praetorian Guard under the Emperor Diocletian.

Once thought to be by the Italian artist Andrea del Castagno, this painting of St. Sebastian is now considered to be by his fellow countryman Francesco Botticini.

Sebastian was a Christian and converted many soldiers to his faith. When Diocletian – a notorious persecutor of Christians – learned of Sebastian's activities, he sentenced him to be shot to death with arrows. Left for dead, his apparently lifeless body was found by a Christian widow, Irene, who, realizing that the arrows had failed to kill him, tended his wounds.

On his recovery, Sebastian confronted the Emperor and denounced him for his cruelty. Diocletian again condemned Sebastian to death – this time by beating. The martyr's body was buried near the catacombs by another Christian woman following instructions she had received from him in a dream.

St. Sebastian's cult was very popular in the medieval period. His influence in this area probably derives from his attribute – arrows – for the ancient Greeks and Romans believed that disease was sent via the arrows of **Apollo**.

The first martyrdom of St. Sebastian was a favourite subject for Italian painters of the Renaissance. He is often depicted holding an arrow or, more gruesomely, pierced through the chest by arrows.

Attributes:

Arrows (held in the hand or pierced through the body); sheltering others from arrows.

Major Paintings:

- El Greco: **St. Sebastian**, 1610–14, Prado, Madrid, Spain.
- Holbein, Hans the Elder: **The Martyrdom of St. Sebastian**, 1515–17, Alte Pinakothek, Munich, Germany.
- Botticini, Francesco: **St. Sebastian**, c.1480, NYMet.
- Pollaiuolo, Antonio: **The Martyrdom of St. Sebastian**, 1475, NGL.

St. Simon the Zealot

An apostle

Simon, said to be from Cana in Galilee, followed **Jesus** and became an apostle. He is distinguished from the more famous Simon **Peter**, by being referred to as Simon the Canaanite or Simon Zelotes ('the Zealot'). The latter term signifies either that he was a member of the Zealots, an orthodox Jewish sect which resisted Roman rule, or merely that he was a zealous or fervent person.

Simon plays no special distinguishing role in the Gospels, and after Jesus' death when the apostles split up and spread Jesus' message, Simon's story becomes a matter of tradition and legend. Many countries, including far-flung places such as Britain, have claimed that Simon travelled there to preach. Simon's place and manner of death is also disputed. Some sources speak of Simon returning from his missions to become Bishop of Jerusalem, and having been crucified during the destruction of Jerusalem in 70 AD. Another relates that he did missionary work in Egypt and then preached the Gospel in Persia with the Apostle Jude, or Thaddeus, who was reputedly Simon's brother. There they argued with priests and prophets and overturned statues of the pagan gods, resulting in their execution. Simon traditionally met his death by being cut in two with a saw.

In art, Simon is often associated in painted altarpieces with St. Jude. Before the fourteenth century Simon usually holds a book or scroll, signifying the Gospels, but after this time Simon's main attribute is usually a two-handled saw. Jude's attributes are a club, halberd or spear. Artists also depict the two apostles toppling the pagan idols.

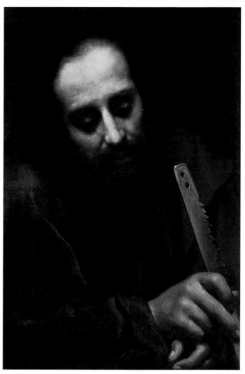

The popular Florentine artist, Carlo Dolci, shows a contemplative St. Simon holding a saw.

Biblical References:

Luke 6:15; Matthew 10:4; Mark 3:18.

Attributes:

Book or scroll; oar; cross; spear; saw.

Major Paintings:

- Rembrandt van Rijn: **St. Simon**, 1661, Kunsthaus, Zurich, Switzerland.
- Simone Martini, workshop of: **St. Simon**, probably c.1320, NGADC.
- Dolci, Carlo: **St. Simon**, c.1616–86, Palazzo Pitti, Florence, Italy.

Solomon

The wisest and richest king of Israel

Solomon was the son of King **David** and **Bathsheba** and reigned *c*.960–920 BC. Of all the kings mentioned in the Bible, Solomon was the wisest and richest. In a dream God asked Solomon what gift he would choose and, instead of asking for wealth or long life for himself, Solomon asked for an understanding heart to govern justly and to distinguish good from evil. God gave him both wisdom and wealth.

Proof of his wisdom came in the judgement he gave between two women who claimed the same baby. Both had given birth about the same time but one baby died and its mother swapped it with the other woman's child in the night. Subsequently, both women claimed the living child as their own. To determine the truth, Solomon called for a sword and threatened to cut the baby in half, giving one half to each woman. Immediately the real mother, displaying the loving nature of a true parent, renounced her claim to the living baby rather than let it die, while the false mother was willing to see it killed. This incident is widely depicted, as a vivid illustration of wisdom and justice.

Solomon's wealth was based on trade and treaties. He made Jerusalem an impressive capital city with a splendid royal palace and a magnificent golden temple on the spot where **Abraham** offered Isaac as a sacrifice. The Temple of Solomon, the greatest and holiest temple in Israel, was destroyed by the Babylonians in

586 BC. Later rebuilt several times, it was finally destroyed by the Romans in 70 AD, its only remnant being the Wailing Wall. The site is now occupied by the Dome of the Rock mosque.

Another commonly depicted episode is that involving Solomon meeting the Queen of Sheba. The Queen, who ruled over an Arabian or African country (perhaps Ethiopia), hearing of Solomon's fame, came to see his wealth and to test his wisdom. She arrived in Jerusalem with a large

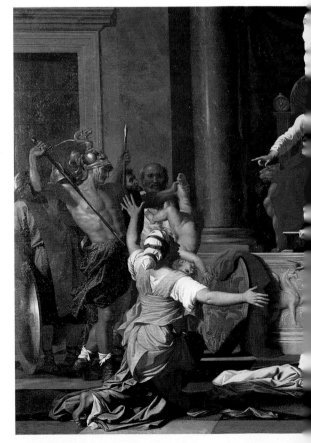

train of attendants, and camels laden with spices and great quantities of gold and precious stones. Having received her with much honour, Solomon answered all her questions and she conceded that his wisdom and prosperity exceeded the reports she had heard. She gave Solomon gold, spices and precious stones and in return Solomon gave her everything she desired.

Solomon is also sometimes shown riding into Jerusalem on an ass to be anointed king by Zadok the priest, foreshadowing Christ's (see **Jesus**) entry. Solomon is also depicted worshipping at the altars of pagan gods, since in his later years he became drawn to the cults introduced by his many, foreign wives.

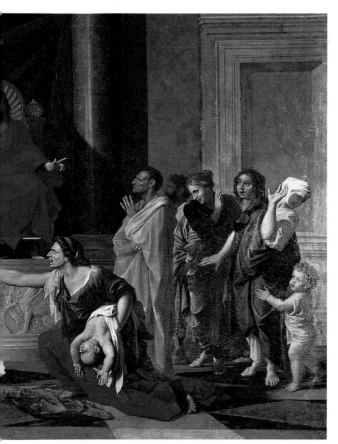

Biblical References:
Kings 1: 3–12.

Attributes:
Oriental robes; royal crown; golden throne; Temple of Solomon; judgement over infant with sword; coronation.

Major Paintings:
◀ Poussin, Nicolas: **Judgement of Solomon**, 1649, Louvre, Paris, France.
● Claude Lorraine: **Seaport with the Embarkation of the Queen of Sheba**, 1648, NGL.
● Poynter, Edward: **The Visit of the Queen of Sheba to King Solomon**, 1890, Art Gallery of New South Wales, Sydney, Australia.

Solomon sits regally in judgement as the false mother with her dead child points accusingly at the true mother, who is horrified at the fate of the baby held aloft by the soldier.

St. Stephen
The first Christian martyr

Stephen's story is told in the Acts of the Apostles and occurred at a time following **Jesus'** Crucifixion when the apostles were preaching and teaching in Jerusalem. The apostles chose seven men to help care for the needs of the early Christians, making them deacons, and among these was Stephen, a man 'full of faith'. Stephen worked wonders and miracles but was denounced by Greek-speaking Jews, jealous of his eloquence, who claimed that he blasphemed against **Moses** and God.

In making his defence, Stephen accused the Jewish High Council of killing the 'Righteous One' and then, sealing his own death warrant, said, 'Behold, I see . . . the Son of Man standing on the right hand of God.' This constituted blasphemy according to Jewish law, and Stephen was led outside the city walls and stoned to death, so becoming the first Christian martyr in c.36 AD. Among the onlookers was a devout Jew called Saul, who held the cloaks of the stone-throwers; he was later to convert to Christianity and become the Apostle **Paul**.

Stephen is nearly always shown as a young man, wearing his deacon's robes (dalmatic) and holding the Gospel. Alluding to the manner of his death, Stephen is usually shown with stones, which he may hold, which may be on his head, or which he may wear on his cloak. In non-devotional pictures, Stephen is frequently shown being stoned to death. Stephen is also often portrayed with another deacon, **Lawrence**, since they share a tomb in Rome to which Stephen's relics were reputedly transferred in the fifth century AD.

The outstanding Bolognese painter of his period, Francia, properly Francesco Raibolini, shows Stephen dressed in his deacon's robes praying in front of a window. Stones lying at the saint's feet allude to his death by stoning.

Biblical References:
Acts 6, 7:55–60.

Attributes:
Stones; deacon's robes.

Major Paintings:

- Carracci, Annibale: **Martyrdom of St. Stephen**, 1603–04, Louvre, Paris, France.
- Francia, Francesco: **St. Stephen**, c.1475, Galleria Borghese, Rome, Italy,
- Uccello, Paolo: **Stoning of St. Stephen**, 1435, Duomo, Prato, Italy.
- Cortona, Pietro da: **Stoning of St. Stephen**, c.1660, Hermitage, St. Petersburg, Russia.

Susanna
Innocent heroine falsely accused

Susanna (Hebrew for 'lily') was the virtuous, beautiful wife of a wealthy Jew who had a fine house and garden in Babylon during the Jewish exile. Two Jewish elders, both powerful but corrupt judges, saw Susanna bathing in her garden. They tried to seduce her but were rebuffed and she cried out for help. Whereupon they spread the false story that they had found her in the garden under a tree with a young man and so they accused her of adultery. At first the elders were believed and the innocent Susanna was condemned to death.

Inspired by God, the prophet **Daniel** intervened, declaring that the evidence was false. He interrogated the elders separately, asking them to identify the tree, and each one named a different tree. Their false testimony was exposed and Susanna was vindicated. Under Jewish law, the false witness was to suffer the same punishment as would have been meted out to the person he accused. The punishment for adultery was death by stoning and so the two elders were sentenced to this fate.

Depictions of Susanna appear in the earliest Christian art in the Roman catacombs, perhaps symbolizing virtue and courage in the face of adversity. Pictures of her bathing and being surprised by the elders were particularly popular from the Renaissance onwards since they provided a valid opportunity to portray a female nude.

Rubens' famous delight in the full-bodied female is given suitable scope for expression in the subject of Susanna bathing.

Biblical References:
Apocrypha: Daniel and Susanna.

Attributes:
Female nude bathing; old men hiding or surprising her.

Major Paintings:
- Reni, Guido: **Susanna and the Elders**, c.1620–25, NGL.
- Tintoretto, Jacopo: **Susanna and the Elders**, c.1570, Kunsthistorisches Museum, Vienna, Austria.
- Pellegrini, Giovanni Antonio: **Susanna and the Elders**, c.1708–11, National Gallery of Ireland, Dublin, Republic of Ireland.
- Lotto, Lorenzo: **Chastity of Susanna**, 1517, Uffizi, Florence, Italy.
- Rubens, Peter Paul: **Susanna and the Elders**, 1614, National Museum, Stockholm, Sweden.

St. Thomas the Apostle
'Doubting Thomas'

St. Thomas was one of the twelve chief disciples and is mentioned in all four gospels. He is sometimes referred to as Thomas Didymus, Thomas the Twin, although it is not clear whose twin he might have been. He is better known as Doubting Thomas.

Thomas' first doubts were expressed at the Last Supper when he said that he did not know where **Jesus** was going or how to get there. Jesus answered, 'I am the Way, the Truth, and the Life . . .'

Even more significantly, Thomas was disbelieving after being told by the other disciples that Jesus, crucified days before, had appeared to them in Thomas' absence. Thomas said that unless he actually saw the wounds and touched them, he would not believe it.

A week later the disciples were together when Jesus appeared among them. He told Thomas to touch the wounds on his hands and in his side. Thomas, now believing, said, 'My Lord and my God!' so declaring his belief in Christ's divinity. This occasion gave Jesus an opportunity to stress the overwhelming importance of faith, saying: 'Happy are they who have never seen me and yet have found faith.'

Apocryphal writings relate that Thomas also doubted the Assumption of the Virgin **Mary** until, as she rose to heaven, her girdle fell into his hands. He then reputedly travelled to India where, instead of building a palace for a king, he distributed the money for the project to the poor claiming he had built a heavenly palace. He was supposedly killed with a spear near Madras.

Biblical References:
John 11:16, 14:4–6, 20:19–29.

Attributes:
Spear or dagger; set-square or ruler.

Major Paintings:
◀ Rembrandt van Rijn: *detail from* **Incredulity of St. Thomas**, 1634, Pushkin Museum, Moscow, Russia.
● Caravaggio: **Incredulity of St. Thomas**, 1601–02, Neues Palais, Potsdam, Germany.
● Guercino: **St. Thomas**, 1621, NGL.

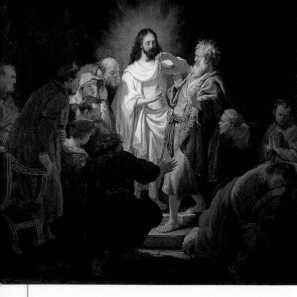

Rembrandt portrays Jesus' appearance to Thomas as a night scene to enhance the dramatic aspect of the risen Christ whose radiance lights the whole scene.

St. Thomas Aquinas
Medieval theologian friar

Thomas of Aquino (*c.*1225–74) was a major philosophical scholar and remains one of the greatest Christian thinkers and teachers. He was born into an aristocratic family from the area of Aquino near Naples, and began his education at the Benedictine monastery of Monte Cassino. Despite strong parental opposition Thomas left and went to the University of Naples, where he studied the works of the Greek philosopher Aristotle. He then entered the newly founded Dominican Order of friars which was dedicated to intellectual study and the combating of anti-Christian doctrine.

Thomas moved around European centres of learning, composing a stream of treatises on aspects of Christianity, and on classical philosophy. Rejecting the approach which maintained that secular philosophy and faith were mutually exclusive, Thomas reconciled Greek philosophy with Christian thought and

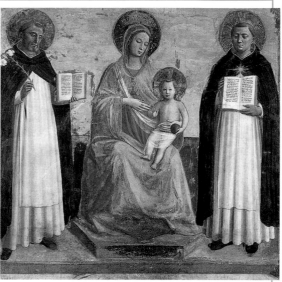

Dressed in the robes of the Black Friars and holding Bibles representing their theological studies, Thomas Aquinas is identified by the star on his cloak and St. Dominic by the lily.

successfully integrated reason and faith. His final great work, the *Summa Theologica* ('The Sum Total of Theology'), is still required reading in Catholic theological colleges. He was made a saint in 1323.

Paintings of St. Thomas often reflect his large, portly figure, a characteristic which, along with his quiet nature, led to his being nicknamed 'the dumb ox.' His revelation of 1272 is widely represented: after some of his ideas had been rejected by the Church, he prayed before a crucifix about this injustice, whereupon the voice of **Jesus** was heard saying, 'And what about my injustice?' Thomas' chastity was legendary – after driving a woman out of his chamber with a burning coal, **angels** gave him a girdle. He is often shown symbolically trampling underfoot the Islamic philosopher, Averroes, against whom he wrote a treatise refuting his errors.

Attributes:

Black and white robes of Dominican Order; star or dove (representing Holy Spirit); girdle or lily; book; ox

Major Paintings:

▲ Fra Angelico: **Virgin and Child with Sts. Dominic and Thomas Aquinas**, 1424–30, Hermitage, St. Petersburg, Russia.

● Traini, Francesco: **Triumph of St. Thomas Aquinas**, *c.*1340, S. Caterina, Pisa, Italy.

● Lippi, Filippino: **The Triumph of St. Thomas Aquinas**, 1488–93, Strozzi Chapel, S. Maria Novella, Florence, Italy.

Tobias and Tobit

The young man and his father helped by a guardian angel

The Book of Tobit tells the story of a Jewish captive and the adventures of his son Tobias. Tobit was a pious and charitable Jew deported to Nineveh when Jerusalem was captured by the Assyrians in the eighth century BC. At first Tobit prospered in Nineveh and was sent by the King on business missions to Media (northern Persia) where he deposited money with a fellow Jew named Gabael. Tobit was forever doing acts of kindness to other Jewish exiles, including illegally burying executed Jews. However, his goodness in the end only brought misfortune – his property was confiscated and he was blinded by bird droppings. In his final years he decided to help his son, Tobias, by sending him to recover the money left with Gabael.

Tobit prayed to God to protect Tobias on his journey and God sent the **angel** Raphael, in the guise of a young Jew, to accompany Tobias and his faithful dog on the journey.

On reaching the River Tigris, Tobias was attacked by a gigantic fish which the angel told him to catch and then to preserve its heart, liver and gall. The heart and liver would drive away a devil whilst the gall would cure blindness. Tobias and Raphael reached Media and stayed at the home of Tobias' uncle and his daughter Sarah.

However, Sarah was prey to a demon that had killed each of her seven husbands on their wedding night. Raphael told Tobias to marry Sarah but that to avoid the fate of her former husbands, he must first grill the fish heart and liver. Tobias followed these instructions and the resulting smell drove away the devil from Sarah.

Meanwhile Raphael recovered the money left with Gabael and returned with Tobias and Sarah to the blind Tobit. Again following Raphael's instructions, Tobias applied the fish gall to his father's eyes, and restored his sight. Then Raphael revealed his true identity, praising Tobit's charitable goodness and faith in God before disappearing.

This story, perhaps with its origins in Persian legend, has inspired many paintings. The two main episodes depicted are Tobias carrying a fish or jar of entrails accompanied by the angel and his dog, and the curing of blind Tobit. There was a certain vogue for families to commission pictures of Tobias and the angel if a son was setting out on travels as a type of protection. Similarly, people dedicated pictures of Tobias in the hope of a cure for blindness.

Biblical References:

Apocrypha: Book of Tobit.

Attributes:

Angel; fish; jar of entrails; dog.

Major Paintings:

- Rembrandt van Rijn: **Tobias Returns Sight to his Father**, 1635, Staatsgalerie, Stuttgart, Germany.
- Lippi, Filippino: **Tobias and the Angel**, c.1480, NGADC.
- Domenichino: **Landscape with Tobias Laying Hold of the Fish**, c.1615, NGL.
- ▶ Verrocchio, Andrea del, workshop of: **Landscape with Tobias and the Angel**, 1470–80, NGL.

Tobias, identified by the fish he carries, is guided by the Archangel Raphael, who holds the box of fish-gall that will cure Tobias' father, Tobit. This painting is not just by Verrocchio (c.1435–88), one of the outstanding Italian artists of his day (noted primarily for his sculpture), but also by other members of his large Florentine workshop; the little dog was possibly painted by a young Leonardo da Vinci.

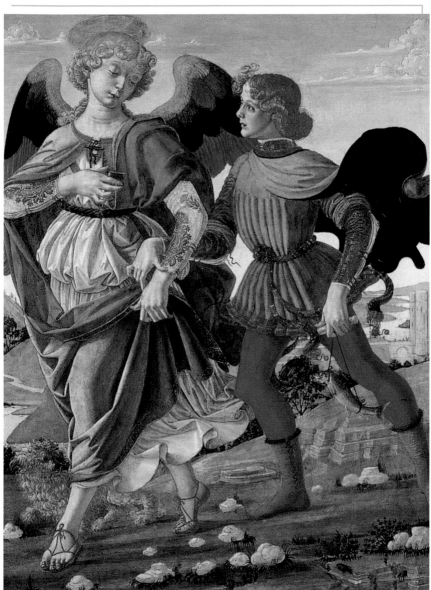

St. Ursula
Virgin princess and her 11,000 martyrs

Ursula's story has been greatly enriched over the ages, its popular version being recounted in the medieval *Golden Legend*.

Ursula, a Christian princess, was the daughter of a British king and betrothed to a pagan prince. She agreed to the marriage on condition that she was given ten virginal ladies-in-waiting and that both she and her ladies were served by a thousand virgins. Ursula and her enormous retinue went on a pilgrimage to Rome to baptize her pagan fiancé. They sailed up the Rhine to Cologne where she dreamed of her martyrdom, continued to Basle, and finally walked to Rome where they met the Pope. On their return they found Cologne occupied by the Huns, under Attila, who killed all 11,000 with arrows.

Archaeological evidence provides clues as to the origin of this story. Although Ursula's name does not appear until the ninth century AD, an inscription dating to *c*.400 in St. Ursula's church in Cologne states that the previous church had been restored in memory of several virgin martyrs. By the tenth century, Ursula's group of martyrs had increased to 11,000. This was probably due to the discovery of an inscription reading 'XIMV' –

standing for *XI Martyres Virgines*, meaning '11 Virgin Martyrs' – which was misread as *XI Millia Virgines*, meaning '11,000 Virgins'. This impressive number became fixed in St. Ursula's tale.

Ursula's cult was immensely popular in the Middle Ages. Depictions are often in cycles showing many episodes from her story. Ursula's huge retinue of maidens results in her being the patron saint of young girls – and she is sometimes shown sheltering girls under her cloak.

Attributes:

Crown; arrows; pilgrim's staff; ship.

Major Paintings:

- Carpaccio, Vittore: **Legend of St. Ursula**, 1490–95, Accademia, Venice, Italy.
- ▼ Claude Lorraine: **Seaport with the Embarkation of St. Ursula**, 1641, NGL.
- Memling, Hans: **Reliquary of St. Ursula**, 1489, Museum van het Sint-Jans-Hospitaal, Bruges, Belgium.

Ursula, in yellow and holding a flag, supervises the departure from Rome of her 11,000 maidens after their pilgrimage. They hold bows and arrows symbolizing their subsequent martyrdom by the Huns in Cologne.

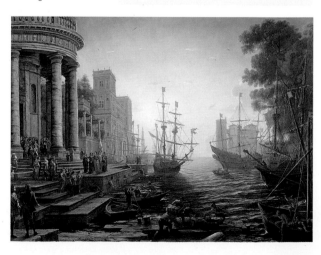

Zacharias (Zachariah or Zechariah)
Old Testament prophet / Father of John the Baptist

Zacharias (also Zachariah or Zechariah) is the
name of two very different biblical figures.

In the Old Testament Zacharias was a minor
prophet. His book in the Old Testament recounts
his eight visions and contains prophecies of the
rebuilding of the Temple of **Solomon**, the
future glory of Jerusalem, and the coming of
the Messiah. He announced that the Messiah
would be 'lowly and riding upon an ass'. **Jesus**,
when he approached Jerusalem during his final
days, instructed his disciples to fetch him an
ass which he then rode into the city, an event
which **Matthew** (21:1–5) saw as fulfilling
Zacharias' prophecy.

In the New Testament Zacharias was the
father of **John the Baptist**. He was a priest in
the Temple of Solomon and was offering incense
when the **angel** Gabriel appeared to him
announcing that his wife Elizabeth would give
birth to a son who would prepare the way for the
Messiah. Zacharias, disbelieving the angel since

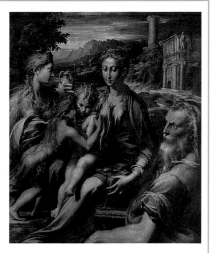

The foreground of Parmigianino's painting is dominated by
the figure of Zacharias, whose expression is still one of
astonishment at the unexpected birth of his son, John the
Baptist, who gently embraces the baby Jesus.

Biblical References:
Zechariah; Luke 1:5–25, 57–64.

Attributes:
Old Testament – scroll or book; New Testament – priest's
pectoral and mitre; tablet or book.

Major Paintings:
- Michelangelo: **Prophet Zacharias**, 1511–12,
 Sistine Chapel, Vatican, Italy.
- Eyck, Jan van: **Prophet Zacharias in the Ghent
 Altarpiece**, c.1432, Cathedral of St. Bavo,
 Ghent, Belgium.
- Parmigianino: **Madonna with St. Zacharias**,
 1527–33, Uffizi, Florence, Italy.
- Titian: **Madonna of the Cherries**, 1517–18,
 Kunsthistorisches Museum, Vienna, Austria.

his wife was barren and elderly, was struck
dumb. When John was born Zacharias' friends
and relatives asked him what the baby should be
named. Zacharias, who still could not speak,
wrote down on a tablet the name 'John' – and
he was immediately able to speak again.

Zacharias, father of John, can be depicted in
the garb of a Jewish high priest with pectoral and
mitre. Painted episodes include his being struck
dumb by the angel, his inscription of the name
of his son, and family scenes with his wife,
Elizabeth, and John the Baptist, as well as
with the Holy Family.

Glossary

Amazons In Greek myth, a race of fierce female warriors who lived on the edges of the known world. They fought several legendary battles with the Greeks.

Apocalypse Literally meaning 'unveiling', it is an alternative name for Revelation, the last book of the New Testament, which describes the second coming of Christ amid violent destruction upon Earth.

Apocalyptic beasts Four winged creatures representing the four Evangelists: an angel, usually representing Matthew; a winged lion, usually representing Mark; a winged ox, usually representing Luke; and an eagle, usually representing John. The 'beasts' are mentioned by the Old Testament prophet Ezekiel (1:5–14) and were equated by early Christians with the Evangelists. Since similar creatures appear in the Book of Revelation they are known as 'Apocalyptic' beasts.

Apocrypha Meaning 'secret writings', the Apocrypha is a collection of books excluded from the Hebrew Bible on grounds of validity but found in many Christian Bibles. They were written mostly between the 2nd century BC and the 2nd century AD. *Apocryphal* can mean either 'relating to the Apocrypha' (of the Bible), or 'of doubtful authenticity'.

Apostle From the Greek *apostolos*, meaning a person 'sent out' or 'messenger'. The title given to the twelve chief disciples and other early Christian missionaries who were charged with spreading the message of Christianity after Jesus' death and Resurrection.

Ark of the Covenant Small chest of gilded acacia wood which, traditionally, contained the written Covenant made between God and Israel at Sinai, including the Ten Commandments. It is generally supposed to have been destroyed when the Babylonians destroyed Solomon's Temple in Jerusalem in 587 BC.

Assyria Based originally in northern Iraq around the cities of Ashur, Nineveh and Kalhu (Nimrud), the Assyrian kingdom first flourished from *c*.1850–1760 BC before being assimilated into other empires. From *c*.1150–600 BC the Assyrians reasserted themselves and created a large empire conquering lands such as Babylonia, Syria, Israel and Egypt.

Babylon Ancient city of Mesopotamia located on the River Euphrates about 50 miles (80 km) south of modern-day Baghdad in Iraq. The Babylonian Empire flourished initially from *c*.1760–*c*.1150 BC, and then again after 615

BC when they defeated the Assyrians. The Babylonians' most famous king, Nebuchadnezzar II, captured Jerusalem in 586 BC, driving the Hebrews into exile in Babylon. Babylon declined after being captured by the Persians in 539 BC.

Baroque The dominant style of European art in the 1600s, coming between Mannerism and Rococo. Generally the style is characterized by dramatic movement, emotional intensity and dramatic lighting, all of which strive to create a detailed realism.

Bishop Derived from the Greek word *episkopos* meaning 'overseer'. A bishop was the chief priest and administrator over one or more churches in an area known as a diocese. An archbishop has jurisdiction over a number of bishops.

Byzantine art Art of the Byzantine, or Eastern Roman, empire which had its capital at Constantinope (formerly Byzantium, now Istanbul) from 330 to 1453 AD. The art was essentially religious in nature, stressing highly stylized, impersonal and generally frontal represent-ations of sacred personages. These 'icons', usually mosaics or paintings, were intended as objects of veneration.

Canaan The name in the Old Testament of the land to the west of the River Jordan, later known as Palestine. To the Israelites (Hebrews), Canaan was the 'Promised Land' – promised to them by God in the time of Abraham and to which they wandered for forty years during their Exodus out of slavery in Egypt.

Classical A general term for ancient Greece and Rome.

Classical Period The period in Greek history from 480 BC (the Battle of Salamis) until 323 BC (the death of Alexander the Great). The 'Golden Age' of Greek art and architecture.

Deacon Derived from the Greek word *diakonos* meaning 'servant', a deacon was originally a bishop's assistant.

Disciple Literally 'student'. Usually alludes to the group of twelve men that Jesus chose to live and work with him as his representatives and given powers to preach and heal, although Luke (10:1) mentions at least seventy other disciples whom Jesus empowered. The core twelve were: Simon called Peter, Andrew, John, James son of Zebedee, Philip, Bartholomew, Thomas, Matthew, James son of Alphaeus, Simon the Zealot, Thaddeus or Judas son of James, and Judas Iscariot.

Eucharist From the Greek for 'thanksgiving'. The central Christian ceremony involving bread and wine commemorating the Last Supper and Christ's suffering on the cross.

Evangelist Literally 'good-news messenger'. Anyone who preaches the message of Christianity. The Four Evangelists are the authors of the four Gospels – Matthew, Mark, Luke and John.

Golden Legend (*Legenda Aurea*) A medieval account of saints' lives and religious festivals, written by Jacobus de Voragine (*c.*1229–98) which mixed legend and history to emphasize morality and faith. Highly influential on the imagery of saints in art.

Gospels The four books of the New Testament which deal with Jesus' life, death and Resurrection. Each book is ascribed to one of the four Evangelists – Matthew, Mark, Luke and John.

Gothic Style of architecture in Europe dating from the 1150s to the 1500s, characterized by pointed arches and flying buttresses. The term was originally one of abuse since it was thought, wrongly, to have been developed by the Goths who destroyed superior Roman art.

Hebrews A name for the early Israelites.

Holy Spirit God's presence in the world. In Christianity the third person of the Trinity.

Israel The nation of the Hebrews, descendants of Abraham, who lived in and around the ancient land of Canaan. According to the Old Testament the kindred families were organized into twelve related tribes named after Jacob's twelve sons, which *c.*1000 BC became united into a single nation under their first king, Saul, and his successor David. The ancient kingdom of Israel at its greatest extent covered the modern territories of Israel, Jordan, and southern parts of Syria. The land was subsequently controlled at various times by the Assyrian, Babylonian, Persian, Greek and Romans empires before being conquered by Muslims in 634 AD. It remained largely in Muslim hands except for the period of the Crusades (1098–1197 AD). The modern state of Israel came into being in 1948.

Jerusalem The capital of ancient Israel. Originally established as capital of the ancient kingdom of Israel by King David, *c.*1000 BC, it was enlarged and fortified by King Solomon who built the great Temple where the Ark of the Covenant was housed. Despite subsequent conquest Jerusalem remained a centre of Jewish religion, not least because of the presence of the Temple which was rebuilt several times after its destruction by the Babylonians and Romans. Jerusalem became central to the Christian religion since it was the place where Jesus was crucified and buried. After the city came under Muslim control in 634 AD, the Dome of the Rock mosque was built on the site of the demolished Temple since it was the spot where Mohammed was believed to have ascended into heaven. Jerusalem was declared the capital of the modern state of Israel in 1950.

Mannerism A period in Italian art between High Renaissance and Baroque, i.e. *c.*1520–*c.*1580. Originally a term of approval meaning 'stylish', it later became a term of abuse when the art of this period was deemed lacking in the quality shown in the High Renaissance and characterized by exaggerated, capricious adaptations of earlier styles. Currently the term has a less negative implication, implying a style that is refined, artificial and self-conscious.

Mesopotamia The land that is literally 'in the middle of the rivers', lying between the Tigris and Euphrates, within modern Iraq. It was the centre of the earliest civilizations. Its cities included Babylon, Ur and Nineveh.

Messiah Hebrew for 'anointed one'. Jewish prophecies of the future often included the coming of a Messiah who would once more be a king on the throne of David. The Jewish people still wait for the Messiah but Christians believe he is Jesus Christ.

Middle Ages (Medieval) The period of European history from the fall of the Roman Empire in the West in the 5th century AD until the fall of Constantinople in 1453; or, more narrowly, the period *c.*1000–1453.

Mitre A tall, deeply cleft hat worn by bishops and abbots as a symbol of their office.

Neoclassicism The main style of art and architecture produced in Europe and North America from *c.*1750 until the early 1800s, characterized by the emulation of Graeco-Roman forms, spirits and ideals. Neoclassicism was not only a reaction to the Rococo style but also had a political side in France and America where its allusions to the 'democratic' governments of Greece and Republican Rome were seen as supportive of the revolutionary governments of France and America.

Palestine An ancient territory in the Middle East on the eastern coast of the Mediterranean Sea, also called the 'Holy Land' because of its links to Judaism, Christianity and Islam. Historic region now covered by modern Israel, Jordan and Syria.

Patriarch The male head of a tribe or family. Especially used for the early Hebrew leaders, particularly Abraham, Isaac, Jacob and his twelve sons who were the heads of the twelve tribes of Israel.

Persia Ancient country centred on modern Iran. Under King Cyrus the Great (c.550 BC) the Empire expanded to stretch from Egypt to the Indus River in India. Famous kings included Darius I and Xerxes, both defeated by the Greeks at the battles of Marathon (490 BC) and Salamis (480 BC). The Persian Empire was conquered by Alexander the Great in 331 BC.

Pharisee Member of strict traditionalist Jewish sect, determined to uphold Hebrew law and ritual.

Philistines A people who inhabited southwest Canaan (Palestine). Came into conflict with the early Hebrews settling in Canaan.

Phoenicia Ancient nation, part of the area now largely covered by modern Lebanon. From 1100 BC the city states of Phoenicia – including Tyre, Sidon, Byblos and Berytus (modern Beirut) – became a great trading nation. Although subjugated almost continuously from the eighth century BC on by the Assyrians, Babylonians, Persians, Greeks and Romans, their colony of Carthage on the coast of Tunisia became a mighty state in its own right between 500–146 BC.

Renaissance Term meaning 'rebirth' applied to the artistic and literary movements that began in Italy in the 14th century and culminated there in the 16th century, and which greatly influenced the rest of Europe. The 'rebirth' pertained to the revival of Greek and Roman learning and the rediscovery and emulation of their achievements in the arts, including progress toward naturalism in art and sculpture (as once achieved by the Greeks) and the imitation of classical models in architecture. The High Renaissance is the period c.1500–c.1520 when these artistic goals were seen to be achieved.

Rococo Style of art and architecture which evolved in France c.1700 and became a dominant influence for the rest of the 18th century throughout Europe (although less so in England). Rococo is characterized by a lightness and

frivolity that was regarded by some as excessively ornate and in the style of rocaille, a shell-pattern decoration, from which the term Rococo derives.

Romanticism An artistic movement from c.1800–1850, following Neoclassicism and related to it in its shared concern with the ideals and values of nobility, grandeur and virtue, yet with much greater emphasis on individual instinct and passion than Neoclassicism allows.

Semite A member of any of the peoples supposed to be descended from Shem, son of Noah, including Jews, Arabs, Assyrians and Phoenicians.

Symbolism An artistic movement which flourished c.1885–1910 where visual expression was given to emotional experiences. Although there was no specific style, colour and line were thought to express ideas, and the use of flattened forms and broad areas of colour were common features. There was an interest in mystical religious feeling, eroticism, sin and death, and many practitioners were drawn to classical subjects.

Titans In classical mythology the older generation of gods who existed before Jupiter (Zeus) and his Olympian dynasty overthrew them. The Titans were the children of Gaia ('Earth') and Uranus ('Sky'). Hesiod says there were six male Titans (Oceanus, Coeus, Crius, Hyperion, Iapetus and Cronus/Saturn) and six female Titans (Thea, Rhea, Themis, Mnemosyne, Phoebe and Tethys). Some of their children were also regarded as Titans, notably Helios, Atlas, Prometheus and Leto. The Titans were envisaged as gigantic, superhuman beings.

Trinity The three aspects of the Christian perception of God – the Father, the Son and the Holy Spirit.

Trojan War Legendary war between the Greeks and the people of the city of Troy, on the northwest coast of present-day Turkey, over the Greek queen, Helen, who had been abducted to Troy. It was the subject of *The Iliad* by Homer. The mythical Trojan War may be based on reality, for excavations have shown that Troy was destroyed by fire, possibly started by an earthquake, and then attacked c.1200 BC – the very time the ancient Greeks believed the war to have taken place.

Index

Credits

p17: Art Archive/Musee du Louvre.Paris p18: Art Archive/ National Gallery.London p19: Edimedia/ Metropolitan Museum of Art,New York p20: Edimedia/Pushkin Museum,Moscow p22/3: Edimedia/Ecole Nationale Superieure des Beaux-Arts,Paris p24/5: National Gallery of Art, Washington DC p26: Edimedia/Musee du Louvre,Paris p27: Philadelphia Museum of Art, Pennsylvania,USA p29: Edimedia/National Gallery, London p30: Philadelphia Museum of Art, Pennsylvania, USA p31: Art Archive/ Museo del Prado, Madrid p32: The Corcoran Gallery of Art, Washington DC p33: Art Archive/ Galleria d'Arte Moderna, Rome/ Dagli Orti p34: National Gallery, London p35: National Gallery of Art, Washington DC, Samuel H. Kress Collectio p36: National Gallery of Art, Washington DC, Samuel H. Kress Collection p37: Edimedia/National Gallery of Victoria, Melbourne,Australia p39: Edimedia/Musee du Louvre, Paris p41: National Gallery, London p42: Edimedia/Royal Museum of Fine Arts, Brussels, Belgium p43: Edimedia/Museo del Prado,Madrid p45: Edimedia/Musee du Louvre,Paris p46: Edimedia/Pushkin Museum, Moscow p48: Walker Art Gallery, Liverpool/ Bridgeman Art Library p50: Edimedia/Musee des Beaux Arts, Rouen, France p51: Art Archive/ Museo del Prado, Madrid/Dagli Orti p52: Art Archive/Uffizi, Florence/Dagli Orti p53: SuperStock/Villa Farnese, Rome p54: Art Archive/Museo del Prado, Madrid p55: Edimedia/Conde' Museum, Chantilly p56: Bequest of Collis P Huntington, Photograph 1988, Metropolitan Museum of Art, New York p57: Edimedia/Musee du Louvre, Paris p59: Art Archive/Musee du Louvre, Paris/ Dagli Orti p60: Reunion des Musees Nationaux/Musee du Louvre, Paris p61: Musee du Louvre, Paris/ Giraudon/ Bridgeman Art Library p62:Art Archive/ Musee du Louvre, Paris/Album Joseph Martin p63: Musee du Louvre, Paris/ Bridgeman Art Library p64: Edimedia/Museo del Prado,Madrid p65: University of Tucson, Arizona,USA p66-7: Bradford Art Galleries/Bridgeman Art Library p68-9: The National Gallery/ Bridgeman Art Library p71: Musee Granet, Aix-en-Provence/ Bridgeman Art Library p72: Art Archive/ Galleria Dorghese, Roma/ Dagli Orti p73: Art Archive /Galleria Sabaudia, Turin/ Dagli Orti p74: Edimedia/Metropolitan Museum of Art, New York p75: Palazzo Pitti, Florence/ Bridgeman Art Library p76: Edimedia/Musee du Louvre,Paris p77: Art Archive/ Galleria d'Arte Moderna, Turin/ Dagli Orti p78: Edimedia/National Gallery,London p79: Edimedia/Musee du Louvre, Paris p80: Tate Britain, London p81: Art Archive/Musee d'Orsay,Paris p82: Uffizi, Florence/Bridgeman Art Library p83: Manchester City Art Gallery/Bridgeman Art Library p85: Edimedia/Musee du Louvre,Paris p87: Edimedia/Musee du Louvre,Paris p89: Fogg Art Museum, USA/ Bridgeman Art Library p90: Farringdon Collection Trust, Buscot, UK/ Bridgeman Art Library p91: Edimedia/National Gallery of Art,Washington DC p92: Museum and Art Gallery, Leicester/ Bridgeman Art Gallery p93: Edimedia/Aberdeen Art Gallery,Aberdeen,Scotland p95: Art Archive/ Uffizi, Florence p96: National Gallery of Art, Washington DC/ Bridgeman Art Library p97: National Gallery of Art, Washington DC/Widener Collection p98-9: Fitzwilliam Museum, Cambridge/ Bridgeman Art Library p100: Barnes Foundation, Merion, Pennsylvania/Bridgeman Art Library p101: Art Archive/ Galleria d'Arte Moderna, Rome/ Dagli Orti p103: Art Archive, Museo Capitolino, Rome/ Dagli Orti p105: Edimedia/Museo del Prado,Madrid p106: Edimedia/Musee du Louvre, Paris p107: Art Archive/ Galleria Borghese,Rome/ Dagli Orti p108-9: Art Archive/ Museo Civico Treviso/ Dagli Orti p110-111: Ferens Art Gallery, Kingston-upon-Hull/ Bridgeman Art Library p112-113: Edimedia/Uffizi, Florence p114: Edimedia/Museo del Prado, Madrid p115: Edimedia/Uffizi, Florence p118-9: Edimedia/Musee des Beaux Arts, Caen, France p120A: Edimedia/AKG Berlin/ Museo del Prado, Madrid p.120B:Edimedia/AKG Berlin/Museo del Prado,Madrid p121: Edimedia/Gemaeldegalerie, Berlin p122: Edimedia/Alte Pinakothek, Muenchen,Germany p123: Art Archive/Palazzo Ducale, Urbino/Dagli Orti p124: Edimedia/Museo del Prado, Madrid p126: Edimedia/Snark/National Gallery of Art, Washington DC p127: Art Archive/ National Gallery, London p128: National Gallery of Art Washington DC, Widener Collection, USA p129: Edimedia/Scuola di San Giorgio degli Schiavoni, Venice p130: Edimedia/Museum of Fine Arts. Budapest p131: Museum of Fine Art, Houston, Texas/Edith and Percy Straus Collection/Bridgeman Art Library p132: Edimedia/Tretyakov Gallery,Moscow p133: Art Archive/ National Gallery, Londo p134: National Gallery of Art, Washington DC, Samuel H. Kress Collection p135: Tate Britain, London p136: Edimedia/ National Gallery, London p137: Edimedia/Alte Pinakothek, Muenchen,Germany p138: Kunstmuseum, Basle/ Bridgeman Art Library p139: Walker Art Gallery, Liverpool/ Bridgeman Art Library p141: Edimedia/Musee des Beaux-Arts, Nice,France p142: Edimedia/National Gallery, London p143: National Gallery of Art Washington DC, Samuel H. Kress Collection p144: Edimedia/Pushkin Museum, Moscow p145: Edimedia/AKG Berlin/Alte Pinakothek, Munich, Germany p147: Monasterio de El Escorial, Madrid/Bridgeman Art Library p149: Edimedia/Snark/National Gallery of Art Washington DC p151: Art Archive/Palazzo Barberini, Rome/Dagli Orti p152: Metropolitan Museum of Art, Rogers Fund, 1938. Photograph copyright 1981 p153: Art Archive/ Saragossa Museum, Saragossa/Dagli Orti p155: Edimedia/Gemaeldegalerie, Berlin p156: Brooklyn Museum of Art, New York/ Bridgeman Art Library p157: National Gallery of Art, Washington DC/ Giraudon/ Bridgeman Art Library p159: Sant' Emidio, Ascoli Piceno/ Bridgeman Art Library p160-1: Edimedia/Snark/National Gallery of Art, Washington DC p163: Dulwich Picture Gallery/ Bridgeman Art Library p165: National Gallery of Art, Washington DC, Rosenwald Collection p167: Edimedia/Cathedral of St. John, Valletta, Malta p169: Edimedia/Musee du Louvre, Paris p171: National Gallery of Art, Washington DC, Andrew W Mellon Collection p172: Edimedia/Scrovegni Chapel, Padua P173: Edimedia/ Hermitage, St Petersburg p174: Edimedia/Chapel of Nicholas V, Vatican, Rome p175: Edimedia/Snark/National Gallery of Art, Washington DC p176: Edimedia/ Snark/National Gallery of Art, Washington DC p177: Courtesy, Museum of Fine Arts, Boston, USA p178: Edimedia/Uffizi, Florence p179: Art Archive/National Gallery, London p181: Hatton Gallery, University of Newcastle-upon-Tyne, UK/ Bridgeman Art Library p182: Art Archive/ Museo del Prado, Madrid p183: Edimedia/National Gallery, London p185: Art Archive/Chiesa di Santa Maria dei Frari, Venice/ Dagli Orti p187: Edimedia, National Gallery, London p189: Edimedia/Chiesa di San Luigi dei Francesi, Roma p191: Gemaeldegalerie, Berlin/ Bridgeman Art Library p192: San Martino, Monte San Martino, Italy/ Bridgeman Art Library p193: Edimedia/Musee des Beaux-Arts, Besancon, France p195: Edimedia/Cerasi Chapel, Church of Santa Maria del Popolo, Rome p197: Edimedia/Museo del Prado, Madrid p198: Bridgeman Art Library p199: Wallace Collection, London/ Bridgeman Art Library p200: Art Archive/Musee du Louvre, Paris/ Dagli Orti p201: Edimedia/Snark/National Gallery of Art, Washington DC P202-3: Edimedia/National Gallery, London p204-5: Smithsonian American Art Museum, Washington/Scala SpA p206: Edimedia/Metropolitan Museum of Art, New York p207: Palazzo Pitti, Florence/Bridgeman Art Library p208-9: Edimedia/Snark/Musee du Louvre, Paris p210: Galleria Borghese, Rome/Bridgeman Art Library p211: Edimedia/National Museum, Stockholm p212: Edimedia/Pushkin Museum, Moscow p213: Edimedia/Hermitage, St Petersburg p216: National Gallery, London p217: Uffizi, Florence/Bridgeman Art Library